ENCYCLOPAEDIA OF BRITISH ART POTTERY

1870–1920

ENCYCLOPAEDIA OF BRITISH ART POTTERY
1870–1920

Victoria Bergesen

Edited, with a foreword, by Geoffrey A. Godden

BARRIE & JENKINS
LONDON

Photographic Acknowledgments

Abbey House Museum, Leeds: Figures 16 and 17; Colour Plates V–VII. Victoria Bergesen: Figures 13, 69, 81, 87, 101, 130, 137, 138 and 140; Colour Plates III, VIII, XIX and XX. Chris Blanchett Collection: Figures 26, 27, 31, 63, 92, 100, 118 and 133. Jan Champneys: Figures 28–30. Christie's: Figures 6, 8, 15, 23, 24, 32–36, 41, 42, 44, 45, 46, 48, 51–53, 59, 61, 66, 68, 79, 84–86, 93–96, 103, 107, 108–111, 114, 115, 120–123, 125, 126 and 147. Christie's Colour Library: Colour Plates X, XI, XIII, XV, XXII, XXVII, XXXIII, XXXV, XXXVI and XXXVII. City Museum and Art Gallery, Stoke-on-Trent: Figures 11, 19, 21, 67, 72, 76, 80, 83 and 117; Colour Plates IX and XXXIV. Exeter Museum, Figures 74, 75 and 77. Glasgow Museums and Art Galleries: Figure 62; Colour Plate I. Geoffrey Godden: Figures 2, 4, 5, 7, 20, 47, 50, 56, 58, 112, 142 and 151; Colour Plates IV and XVI. Grosvenor Museum, Chester: Figure 65. A. B. Harris & Sons: Figure 77. Hastings Museum: Figure 10. Tony Herbert: Figure 98; Colour Plates II, XVII, XXVI and XXIX. Private collectors: Figures 64, 72, 131, 132, 147, 148–150; Colour Plates XXI, XXVIII, XXXIX and XL. Royal Doulton Tableware Ltd: Figures 104 and 105; Colour Plates XXX and XXXII. Sotheby's: Figures 14, 37–40, 43, 49, 54, 55, 57, 70, 71, 89, 90, 97, 99, 106, 113 and 119; Colour Plates XII, XIV, XVIII, XXIII, XXIV, XXV, XXXI and XXXVIII. Special Collections, Library, University of Keele, Figures 1, 3, 9, 12, 18, 22, 25, 82, 88, 102, 116, 117, 124, 127, 129, 134–136, 138, 139, 142, 144, 145 and 146. Louis Taylor, Britannia Estate Agents, Hanley: Figures 91 and 128. Cover illustrations, Sotheby's.

First published in Great Britain in 1991
by Barrie & Jenkins Ltd
20 Vauxhall Bridge Road, London SW1V 2SA

Coyright © Victoria Bergesen 1991

A catalogue record for this book is available from the British Library.

0 7126 3822 9

Designed by Behram Kapadia
Typeset by Servis Filmsetting Ltd, Manchester
Printed and bound in Singapore by Kyodo Printing

Contents

Colour Illustrations

Foreword

by Geoffrey A. Godden F.R.S.A.

I feel extremely privileged to have worked with Victoria Bergesen on this book. I was originally asked to edit the proposed work and I envisaged, from long experience of editing, that I would be presented with a complete typescript which I would merely check for accuracy, deleting material that seemed out of place in a study of British art potteries.

Victoria does not work like that. From the outset I have been consulted as to the best approach, as to what should or should not be included, and as to whether this or that firm should be featured.

As each batch of typescript was completed, it was sent to me for comment and for checking. When I did suggest that a date was perhaps incorrect, Victoria would re-examine the facts and would probably come back to me to explain that I was wrong – and why! I make these points to show how thorough the author has been; nothing previously published has been accepted without in-depth research wherever contemporary source material is available.

The long list of source material listed in the bibliography in itself shows what a mass of material has been consulted. The monthly issues of the *Pottery Gazette*, for example, take months to wade through. This trade journal and other similar source material is closely packed with hard facts relating to potteries, techniques, new shapes and designs, dissolutions of partnerships, bankruptcies and so on. All these closely packed pages have to be read and the information on art potteries extracted, tabulated and put into readable form for the benefit of all. It is truly very hard, time-consuming and tiring work.

I have been astonished both by the lengths to which Victoria Bergesen has gone to gather so much information on British art potteries and by the large number of potteries and potters, painters and designers that she has been able to include in this book. Many are listed for the first time but, even in the case of well-known firms, I am sure that readers will find much new information.

The only aspect of the work that has perplexed us has been deciding which firms to include and which to reject, for art pottery is difficult to define. Some large commercial firms, for example, might have made only a little so-called art pottery, and, perhaps, for a brief period only. We have, however, thought it best to give the benefit of the doubt and include any potter or firm which, we feel, did produce at least some art pottery. Our listing certainly does not cover only the main specialist art-ware manufacturers or, for that matter, only the makers of beautiful wares. We have endeavoured to tell the whole story – warts and all!

The reader will find that some of the information, and some dates or even names given here differ from those quoted in other works. I am sure that you can depend on Victoria Bergesen's version being the correct one. I had no idea that another (!) author could be so painstaking in her search for truth, or that the fruits could be as helpful to others as this book will surely prove to be.

I trust that these researches will enable you to delve a little deeper into your collection and to learn more of the background to the pots and of the people who designed and made the wares that were so popular and so varied during the period covered by this authoritative book.

Acknowledgments

I must first of all offer my special thanks to Geoffrey Godden, who has edited this book. From this project's inception, he has made many suggestions and offered much sound advice. The fine scholarship in his many reference books and articles has served as an inspiration since I first became interested in ceramics. Geoffrey has generously given me access to notes and records in his library, which are the fruits of his own tireless research. Given the task of reading the lengthy manuscript, he has offered encouragement, made corrections and provided additional information.

Many other people have provided manuscripts and information, and have been generous with their time, advice and encouragement. They are: Helen Abdy; Paul Atterbury, who has kindly read and commented upon parts of the manuscript; R. C. Bell; John Bentley; Chris Blanchett; Virginia Brisco; Alan Caiger-Smith; Carol Cashmore; Chris Cashmore; John and Joyce Cockerill; Patricia Collins, Art Gallery & Museum, Kelvingrove, Glasgow; Mr and Mrs Wally Cole, Rye Pottery; Jim and Mary Cox; John Cushion; Christine Evans; Jonathan Gray; David Harris, A. Harris & Sons; S. Harvey, Bushey Public Library; Bob Hawes; Leslie Hayward; Tony Herbert; Honiton Collectors' Society; Leslie Jackson, Manchester City Art Gallery; Richard Jefferies and Hilary Morgan, The Watts Gallery; Joan Jones, Minton Museum, Royal Doulton Tablewares Ltd; Sheila Jordain, Saffron Walden Museum; Jonathan Kinghorn; Barry Lamb, Reference Works; Sarah Levitt, Bristol Museum & Art Gallery; John and Hilary Malam; Mason's Ironstone Museum, Hanley; Ian Merckel; H. S. Middleton, Maidstone Museum; Moorcroft Collectors' Society; Walter Moorcroft; Northern Ceramics Society; Martin Phillips, Special Collections, University of Keele; Mark Oliver, Phillips, London; Dr Catherine Ross, Laing Art Gallery, Newcastle-upon-Tyne; Deborah Skinner, Stoke-on-Trent City Museum and Art Gallery; K. Snowden, Grosvenor Museum, Chester; Helen Spencer, Birmingham City Museum and Art Gallery; Tile and Architectural Ceramics Society; Torquay Pottery Collectors' Society; Tyneside Ceramics Society; Francis Wagstaff, Wednesbury Art Gallery and Museum; Martin Winter, Castle Museum, Colchester.

The staff at the following libraries have also been very helpful: The British Library; The National Art Library; Central Reference Libraries at Birmingham, Bristol, Colchester, Glasgow, Hanley, Maidstone and Manchester. Local studies collections at Bushey, Chatham, Exeter, Farnham, Gillingham, Gravesend, Rainham, Sevenoaks, Sittingbourne and Tunbridge Wells.

Introduction

A plethora of very different wares were called art pottery during the period 1870–1920. "Art" was the operative word in three important movements in the decorative arts of the period: the Aesthetic Movement, the Arts and Crafts Movement, and Art Nouveau. While these are listed in chronological order, they did, in fact, co-exist and, while their proponents were often at one anothers' throats, the movements were not mutually exclusive and certain figures floated freely from one group to another. In 1889, *The Cabinet Maker* complained: "The manufacturer and artisan are so lectured to and at nowadays, by artists of all standings, as to what they ought and ought not to do, that one cannot wonder at their ideas getting somewhat confused." When a potter described his wares as "art pottery", he might have been describing them as in keeping with the tenets or style of any or all of the above movements. To understand this confusing state of affairs it is necessary to return to the Great Exhibition of 1851.

Although the vast majority of the millions who visited the Crystal Palace that year were thrilled by the accomplishments of the industrial revolution, there were a few artists, designers and critics who were horrified at the cacophony of styles. These latter were very few indeed, but their dissenting voices were to have an enormous impact on the decorative arts. Modern critics generally agree that the products of the industrial nations as pictured in the catalogue of the Great Exhibition were appalling. The pervading historicism obscured what little innovative design existed. These revival wares, whether in the Gothic, neo-rococo or Renaissance styles, almost universally suffered from over-decoration. This is understandable, for throughout history ornament and decoration had been synonymous with luxury. Now, for the first time, decoration was not limited by cost. Mechanisation and mass-production could pile on additional ornament without making prices prohibitive.

Much has been written condemning Victorian taste, but at the beginning of the era taste was a faculty limited to the upper and upper middle classes. The lower classes did not have "taste", for taste implies discrimination and choice. The lower classes had had neither. The Great Exhibition could be seen as a starting point in the formation of the tastes of the British masses. For the first time, they were exposed to an enormous array of goods, in fact nearly everything possibly obtainable in Britain, if not throughout the entire Western world. Even if one could not afford to buy, one could pick and choose; the servant girl could decide whether she preferred the neo-rococo to the Gothic, as could the duchess.

Henry Cole and Summerly's Art Manufactures
In 1846, Henry Cole, under the pseudonym Felix Summerly, won the Silver Medal in the Royal Society of Arts' design competition with a tea service produced by Minton. Encouraged by his success, Cole decided to launch a range of Art Manufactures employing as designers some of the best artists of the day. He cited

the design work of mediaeval artists as a precedent for this venture: ". . . there was scarcely a great medieval artist, when art was really catholic, who did not essay to decorate the objects of everyday life. Beauty of form and colour and poetic invention were associated with everything. So it ought still to be, and we will say, shall be again." The venture was not successful, partly because Henry Cole became distracted by his preparations for the Great Exhibition of which he was chief organiser, his new post as Secretary to the Design Schools and his new *Journal of Design & Manufactures* (1848–52). Although Summerly's Art Manufactures ceased trading in 1850, the ideas behind it were to be successfully revived by William Morris a decade later. As first director of the South Kensington (Victoria & Albert) Museum, he was responsible for amassing the collections which would serve as an inspiration and crucial design source for both industrial and art potters.

John Ruskin

A quick survey of Ruskin's views on any subject will necessarily be misleading. Ruskin was erratic and inconsistent. Social and art historians writing about the Victorian era have used his works to prove widely varying viewpoints. In his biography (*John Ruskin*, 1933), R. H. Wilenski noted the "strange varieties of character and quality and astonishing inconsequence in the writings". None the less, many of Ruskin's beliefs were understood and adopted by countless Victorians, and we must at least attempt to identify those which have a direct bearing upon the evolution of art pottery.

As John Ruskin stated in his very influential *Seven Lamps of Architecture* (1849):

> I believe the right question to ask respecting all ornament is simply this:
> "Was it done with enjoyment, was the carver happy while he was about it?"
> It may be the hardest work possible, and the harder because so much pleasure was taken in it, but it must have been happy too, or it will not be living.

From this remark came the strain of art potters who believed that fine art could not be produced in the grim working conditions typical of the Staffordshire potteries. Some perceived the correct antidote to be a paternalistic, rural organization such as that at Aller Vale and quite a number of more obscure art potteries. Others conveniently divorced themselves from the actual manufacture of pots and concentrated on the decoration of factory-made blanks. They organized studios, where ladies and gentlemen, artistically attired, might work "happily", far removed from the dust, heat and deadly chemicals which were unavoidable in pottery manufacture.

Another of Ruskin's ideas which greatly influenced art pottery came from *The Stones of Venice* (1853):

> Always look for invention first, and after that, for such execution as will help the invention, and as the inventor is capable of without painful effort, and no more. Above all, demand no refinement of execution where there is no thought, for that is slaves' work unredeemed. Rather choose rough work than smooth work, so that only the practical purpose be answered, and never imagine there is reason to be proud of anything that may be accomplished by patience and sand-paper.

Unfortunately this has often been misinterpreted to mean that imprecision was preferable to precision, encouraging lumpish, amateurish pottery.

William Morris

William Morris influenced art pottery in two ways, firstly through the products designed, produced or retailed by Morris, Marshall, Faulkner & Co. (Morris & Co. after 1875). The intentions behind the formation of this firm in 1861 were very like those of Henry Cole's Summerly's Art Manufactures. The influence of Morris & Co.'s style on art pottery was quite extraordinary, considering that the firm confined itself to decorating tiles, marketing William De Morgan's work and retailing cheap but cheerful Continental pottery. Ceramics were not even mentioned in the initial prospectus of 1861. The 1881 circular includes tiles, not mentioning any other sort of ceramic.

Contrary to popular conception, the firm did not initially embody the ideas of the later Arts and Crafts Movement in terms of the mode of production. The firm designed textiles, wallpapers, furniture and so on, the manufacture of which was then contracted out to other firms for production. Morris & Co. also decorated items such as tiles, which had been bought in from manufacturers. It was not until 1875 that William Morris began to experiment with manufacturing cloth himself, and this because he disliked the harsh colours produced by the aniline dyes then in general use.

The second way in which Morris influenced the course of art pottery was through the lectures which he gave in the 1880s. Now a committed socialist, Morris attempted to reconcile his personal tastes with his political ideals. This was achieved by a brand of Utopian socialism which idealized the distant past, particularly mediaeval times in Morris's case. The idea was that pre-industrial society had been more humane, and the mode of production cooperative. That this view was totally at variance with the realities of feudalism was largely ignored. From this stand-point, Morris laid down some rules for the art potter:

> Articles should not be moulded if they can be made on the wheel, or in some other way by hand.
> Pottery should not be finished by turning on a lathe.
> Excessive neatness is undesirable, especially in cheap wares.
> Pottery should not be decorated by printing and painted decoration should be confined to what can only be done on pottery.

Perhaps unfortunately, quite a number of art potters took his advice to heart. The first stricture was meant to ensure the individuality of the pots. It did not take into account, however, that a skilled thrower can churn out perfectly identical pots by the hundred. The second and third rules presumably hark back to Ruskin's recommendation of "rough work". It must here be noticed, however, that it appears terribly undemocratic of Morris, the socialist, to feel that the masses should be denied "neat" work. In actual fact it was the upper classes who found coarse work (which the poorer classes would have hated to use) quaint. The guidelines for decoration are rather vague, not making it clear whether he is referring to technique, shape or materials. Presumably techniques such as lustre, sgraffito, slip trailing and barbotine, which can only be used on pottery, were deemed appropriate, and the sort of china painting exhibited by Howell and James was being abjured.

The Aesthetic Movement

This movement is, even today, most readily associated with the images with which it was lampooned by its contemporaries: languishing ladies gazing at peacock feathers or Oscar Wilde walking the streets of London carrying a lily. We now look at objects produced in the 1880s and recognize aestheticism as a style in the decorative arts, but it was in fact a lifestyle, which we now identify by its artefacts. Adherents to the movement attempted to beautify their surroundings and dedicate themselves to artistic pursuits. By 1883, *The Cabinet Maker* observed: "During recent years art pottery has become a most important part of fashionable house furnishing, and now every reception room aspiring to be artistic must contain some specimens of the potter's skill."

As with the lifestyle movements of the twentieth century, there were many who were content to acquire the fashionable trappings of the movement without any serious examination of its philosophy or implications. Lewis F. Day remarked:

> The cant of art is just now in fashioin, and passes current everywhere! The business man appreciates its commercial value, and adopts it accordingly. There is no necessity, however, for him to provide art for his customers, when a gloss of pretence answers all his purpose. It is cheaper, too, than even the most modest art, and proportionately more marketable. (*Everyday Art*, 1882)

Thus the most famous symbols of the Aesthetic Movement, the sunflower, the lily and the peacock, along with Japanese motifs, soon found their way onto industrial as well as art wares.

Aestheticism is inextricably liked with *japonisme*, or the cult of Japan, which had only recently been opened up to the West. The Aesthetes, of whom few if any really understood Japanese art, admired the Japanese style for what they perceived as its artificiality. In fact, naturalism is a keystone of Japanese art, and Shintoism, the main religion of Japan, is in fact a worship of nature. The Japanese, however, perceived nature in a different way from Europeans, for they were attempting to capture its very essence. To portray a crane it was not necessary to paint every feather, for the essence of the crane is its flight and grace of movement, which the Japanese felt could be most effectively conveyed by a very few lines. A few of the very best ceramic artists, such as Hannah Barlow and Edwin Martin, learned this lesson. For most potters, however, the random application of Japanese motifs was sufficient to satisfy the craze. Despite the earnestness of some Aesthetes, the movement was linked to *fin de siècle* decadence, and was severely discredited by the conviction of Oscar Wilde, its self-appointed spokesman, for homosexual activity in 1895. The languid image of the Aesthete became associated in the public mind with moral laxity. The wholesome image of the Arts and Crafts Movement made its proponents more socially acceptable.

The Arts and Crafts Movement

A review of the Arts and Crafts Exhibition of 1896 in *The Studio* looked back upon the establishment of the Arts and Crafts Exhibition Society in 1888:

> The movement passing under the name of "Arts and Crafts" admits of many definitions. It may be associated with the movement of ideas characteristic of the close of the last century, and be defined to be an effort to bring it under the influence of art as the supreme mode in which human activity of all kinds

expresses itself at its highest and best . . . Or it may be associated with the revival, by a few artists, of hand-craft as opposed to machine-craft, and be defined by the insistence on the worth of man's hand, a unique tool in danger of being lost in the substitution for it of highly organized and intricate machinery, or of emotional as distinguished from merely skilled and technical labour or again . . . a movement to bring all the activities of human spirit under the influence of one idea, the idea that life is creation, and should be created in modes of art, and that this creation should extend to all the ideas of science and of social organisation . . . and besides the definitions attempted above, there are still others, some of them, indeed, concerning themselves only with the facilities to be afforded to the craftsman for the exhibition, advertisement and sale of his wares.

Contrary to popular belief, William Morris was not one of the founders of the Arts and Crafts Movement. Certainly his ideas inspired many of the members, but the Movement was formally established at a time when Morris was devoting nearly all his energies to socialism and the Kelmscott Press. The Art Workers Guild was founded in 1884, and Morris joined in 1888, becoming the Master for 1892. The Arts and Crafts Exhibition Society was formed in 1888 in order to exhibit members' work effectively. In its early stages the Movement was a proselytizing one but, partly because the arts and crafts mode of production made its wares prohibitively expensive, this was a failure. A review of the Arts and Crafts Exhibition of 1893 admits:

Outside, the ruling fashion of the hour is as reckless of all restraint as ever. Now it inclines to sobriety and good design, then it veers round to the inane vulgarity of a bastard rococo when it is to be feared the vulgar novelty chokes to death the seedlings that looked so vigorous. Yet, despite open attack, despite trade jealousies, and despite honest divergences of taste, it cannot but be good that a body of art-lovers should be united to set up a fixed standard, above caprice, even though it be more limited in its choice of styles, and more severe in their employment than a cosmopolitan would demand.

The high cost of handicrafts was to plague the Movement throughout its existence. This did limit the impact that its adherents had on public taste, and it also conflicted with the socialist ideals held by more than a few of the Movement's members. In 1893, Walter Crane, President of the Arts and Crafts Exhibition Society and himself a socialist, objected:

In some quarters it appears to have been supposed that our exhibitions are intended to appeal, by the exhibition of cheap and saleable articles, to what are rudely termed "the masses"; we appeal to *all*, certainly, but it should be remembered that cheapness in art and handicraft is well-nigh impossible, save in some forms of more or less mechanical reproduction. In fact, cheapness, as a rule, in the sense of low-priced production, can only be obtained at the cost of cheapness – that is, the cheapening of human life and labour; surely in reality a most wasteful and extravagant cheapness.

Art Nouveau
Art Nouveau was more a style than a movement. Unlike the Aesthetic and Arts and Crafts movements, it was not concerned with the mode of production or the

education of the consumer. Art Nouveau was meant to be a new art, a style at last freed from the historicism which had pervaded the decorative arts in the Victorian era. Ironically, part of the new art in Britain was a revival of Celtic motifs, particularly encouraged by Liberty & Co., who commissioned Celtic-inspired works from Compton Art Potters' Guild and others. Art Nouveau or New Art (as the more xenophobic called it) was not a major influence on British art pottery until the latter part of the 1890s.

Thereafter, the sinuous lines of the style found their way onto a wide range of wares, affecting both shape and pattern. Tube-lining, a refined slip-trailing, was found to be well suited to Art Nouveau patterns, and was used both on pottery and most especially on tiles, whose shapes could not, after all, be practically altered from the rectilinear. Many of the "art wares" of the early twentieth century were industrially produced pots in the new style. The style declined and was largely abandoned at the start of the First World War, when its luxuriance and sensuality were ill-suited to the stark realities facing the men in the trenches – or those on the home front.

The development of art pottery

Although Doulton & Co. (Ltd) stonewares, for instance, were made continuously well into the twentieth century, art pottery can be seen to have passed through five major stages. Although these overlapped, not necessarily being mutually exclusive, a useful categorisation can be made.

The earliest art wares were the stonewares as made at Doulton & Co. (Ltd), Lambeth and by the Martin Brothers, and the terracottas, such as those made at the Watcombe Terra-Cotta Co. (Ltd). These wares were initially historicist, although they did evolve styles of their own. The second major group were the painted wares closely associated with the Aesthetic Movement. These "china paintings" included Doulton & Co. (Ltd)'s Lambeth Faience, the wares decorated by Minton's Art Pottery Studio and the many wares produced in small studios and by amateurs and exhibited at Howell & James and other china retailers and art galleries. The third group was the wares made at country potteries which combined traditional forms and methods with new styles to produce a vigorous range of wares, such as those of C. H. Brannam (Ltd). The fourth movement was that of the chemists, who increasingly used glaze effects as the sole decoration on their pots. The last was the hand-painting movement, which would carry on well into the twentieth century, adapting itself to industrial production. These wares were distinct from the earlier china painting, in that they employed increasingly abstract decoration suited to pottery, especially tablewares.

Geographical distribution

It has often been asserted that art pottery manufacture was characterized by a decentralisation from the major pottery centres. In fact, with very few exceptions, art pottery was made in the traditional centres of pottery production. This confusion has arisen partly because many of the art potteries had previously been country potteries with local markets. As these potteries began to market their art wares nationally, they became known outside their localities for the first time, although the potteries had existed at those sites for many years.

William Morris claimed that "Those who are to make beautiful things must live in a beautiful place". However, in the Victorian and Edwardian eras, as ever before,

a pottery could only be successful if supplies of clay and fuel (wood or coal) were near at hand. The cost of hauling these two necessities to a remote and picturesque venue would have been prohibitive. Thus we see that art pottery was usually made where pottery had always been made in the past. By definition, however, production of art pottery by any firm must be relatively small (compared with mass-produced items); thus a small firm such as C. H. Brannam (Ltd) might be just as important in the market place as the art wares produced by a larger Staffordshire firm.

Country potters

As has been mentioned above, quite a few art potteries had previously been country potteries. These country potters, many of whom had carried on their work in the same vicinity for generations, fell on increasingly hard times during the latter half of the nineteenth century. They suffered growing competition from large industrial potters, especially those in Staffordshire. Improved transport, both by rail and canal, widened the markets of these larger potteries for everyday pottery. Furthermore, as William Fishley Holland points out in his autobiography, the market for the items traditionally made by these small country potters – dairy wares and bread ovens, for example – was contracting. Fewer households produced and preserved their own foodstuffs, so reducing demand for items such as ham-curing pans. Holland also mentions the increasing use of galvanized metal and, eventually, plastics for items previously made of pottery.

In the 1870s the country potters discovered that their rural mode of production was suddenly fashionable. The historicism of the Arts and Crafts Movement created an increased demand for traditionally decorated ware. The small scale of country potteries also enabled them to introduce small lines of art pottery to the designs of professional designers and artists, sometimes from local art schools. The question remains however, whether, with their production of art pottery, these potteries ceased to be country potteries. They usually did continue to produce flower pots, tiles and other traditional, utilitarian wares alongside of their new, decorative lines.

Bevis Hillier (*Pottery and Porcelain 1700–1914*) has discussed the folk artist's isolation, which resulted in his being "more or less immune to fashion". This isolation and immunity disappeared once the country potter began consciously to produce "art pottery". Hillier goes on: "The folk artist's isolation also means that he is not subject to written criticism. The only criticism to which he is open is that of his customer, the relationship between the maker and buyer is usually local and close." However, once country potteries such as A. Harris (& Sons)' Farnham Pottery and Belle Vue Pottery at Rye, or Fremington Pottery and C.H. Brannam (Ltd) in North Devon began to market their wares through Liberty & Co., Heal & Sons Ltd and the Army and Navy Stores, reviews and articles began to appear in trade journals such as *The Pottery Gazette* and art journals such as *The Studio*, that direct contact between producer and consumer was broken. The country potters, as folk artists, had been contaminated. The alternative, of course, would have been (and was for most country potters who continued in the old way) extinction.

Some of the most vigorous and attractive art pottery was produced by these country art potteries. Unlike firms set up by dilettanti or idealistic artists, these potters were extremely skilled and much of their output was of a very high quality for wares of their type. Moreover, just as the Arts and Crafts Movement "contaminated" the country potters, so the latter injected an authenticity into the

Movement's historicism, saving it from the enervating influences of aestheticism and, to a large, extent, Art Nouveau. One aspect of the country potters' influence was the use of traditional techniques such as sgraffito and slip-trailed decoration which were common to folk potters throughout Europe. Art pottery, on the other hand, brought the barbotine technique, by which slip was applied with a brush, to the country potters, who used it to great effect.

The chemist-potters

Chemistry played a large part in art pottery throughout its existence. The early Doulton & Co. (Ltd) stonewares offered a technical challenge, and the palettes of both Doulton & Co. (Ltd) and the Martin Brothers expanded as they developed oxides which could withstand the fierce heat necessary for firing stoneware. One of the great technical achievements of the mid-Victorian period was the majolica glazes, first developed by Léon Arnoux at Mintons. These lead glazes were further developed and used as the principal form of decoration at art potteries such as Burmantofts and Linthorpe. The lustre revival, led by William De Morgan, was the result of lengthy experimentation. In the 1890s the race was on among British potters to rediscover the high-temperature glaze effects of the Chinese.

The work of the French artist potters was known to many of Britain's chemist potters through international exhibitions, especially the Paris International Exhibition 1900, and press articles. Clement Massier's work at Vallauris was written up in *The Art Journal* in 1876. The Exhibition of the Champs de Mars in 1889 was the first major show to feature French art pottery. Here were pots by Auguste Delaherche ". . . relying for their decoration almost entirely upon the beauty of the coloured glazes which covered them", a case of Clement Massier's pots whose beauty relied ". . . upon the chance results obtained in the firing", pots by A. Bigot, including crystalline glazes, and pots by A. Dammouse of Sèvres (*Studio*, 1894).

The first two decades of the twentieth century saw an explosion of experiments in glaze effects. A number of new art potteries, among which were Ashby Potters' Guild, G.L. Ashworth & Bros, Iceni Pottery, Minton Hollins & Co. (Ltd) and William Howson Taylor's Ruskin Pottery concentrated their efforts on these wares. In 1905, Wilton P. Rix noted:

> Among the developments of the last two or three years, it is interesting to notice that the most striking have been chiefly influenced by the new advances in technical skill, such as the careful study of the behaviour of crystalline glazes, the efficient control of matt textures, and other similar results involving the obdurate treatment of vapour-reducing atmosphere in the kiln, which have all played an important part in securing new decorative effects.

He further observed:

> Indeed, it may be said that texture and colour have lately received quite a large share of consideration as elements in the modern designer's scheme, elaboration of detail and delicacy of finish being mostly relegated to a secondary position.

The potters generally took Chinese glazes as their inspiration. Chinese shapes were most often employed, as it was felt that these simple shapes would enhance

rather than detract from the glaze effects. In recent years there has been some debate about how close the effects achieved were to the Chinese glazes. In fact, although some contemporaries may have compared the two, there is little doubt that the chemist-potters themselves were under no illusions as to the originality of their wares. In 1909, *The Pottery Gazette* observed:

> Since the marvellous discovery effected by the science of chemistry [presumably the publication of Mendelieff's Tables in 1871], and the application of them to the pottery ornamentation, our chemist-potters have succeeded in producing glaze effects very similar to the mottled, streaked and variegated glazes, samples of which have come down to us authenticated as the work of the great potters of the East. Whether the means of producing them are the same or not is very doubtful, and will probably never be known. It is, however, matter for intense satisfaction that exquisitely beautiful results which for ages it has been thought impossible for modern potters to obtain, are equalled (if not strictly speaking reproduced) as the results of the patience and industry of chemist-potters to-day.

The decline of art pottery; its successors

Art potteries did not altogether disappear in 1920, but many of the firms discussed in this book had closed or ceased to produce art pottery at the outbreak of, or before, the First World War. Some, such as Tooth & Co. (Ltd), later evolved into industrial potteries. New art potteries began to appear in the early 1920s, but most were influenced by Bernard Leach and the studio pottery movement rather than the nineteenth-century "art" movements. Very simply, the art pottery movement was historicist; it looked back to the past not only for its modes of production but for design and decorative motifs. Even the art chemists were usually attempting to recreate the achievements of the Chinese potters of the past and usually their shapes were those found in Chinese ceramics. On the other hand, the studio potters sought an individual relationship with their materials and increasingly became sculptors who happened to work in clay. Their output was usually directed towards the artistic élite, and made no pretence at converting or educating the masses.

One way in which the art pottery movement, and more specifically Gordon Forsyth, influenced industrial pottery of the twentieth century was the pro-liferation of hand-painted wares industrially produced in the 1920s and 1930s. Yet, while potters and consumers were aware that hand-painted wares were aesthetically superior on Morrisian grounds, the wares would never have been made if they had not been economical to produce. Before the First World War, the cheap but cheerful end of the pottery market had been largely dependent upon German lithographic transfers. After the war, anti-German feeling largely closed this source. Wages, particularly for girl paintresses, were so low as to make hand-painting a practicable substitute.

Using this book

This encyclopaedia defines art pottery in its broadest sense. Any pottery which claimed that it made art pottery, or any pottery which was widely regarded by contemporaries as making art pottery, has been included. Although the reader may not consider some of these wares art pottery, this book documents the entire art pottery movement, not only the potteries of De Morgan, Doulton & Co. (Ltd),

Pilkingtons Tile & Pottery Co. (Ltd) and the Martin Brothers, who have been quite well documented, but the host of smaller concerns who produced or claimed to produce art pottery. Also included, unavoidably, are the "art wares" of the large industrial firms. The practice of installing an art pottery studio in the midst of industrial production was, of course, begun by Henry Doulton. Doulton & Co. (Ltd) was one of the largest industrial potteries in the world, yet no one disputes that the works of Hannah Barlow or George Tinworth are art pottery. Can we therefore exclude the "art wares" of the lesser-quality potteries?

There has been an explosion of interest in art pottery in the past fifteen years, with an accompanying array of publications about art potteries. While this book cannot replace those, it is the first comprehensive listing of British art potteries to be published. Each entry gives as much essential information about the history and wares of the firm as is known. Each entry is accompanied by a bibliography which lists the sources of the information given, and references to publications giving further details and photographs of the pottery's wares.

There are a number of biographical entries for people whose influence extended beyond the confines of one pottery. The criteria for inclusion are: firms who advertised themselves as manufacturers of art pottery during 1870–1920, or were described by contemporary sources as manufacturers of art pottery during 1870–1920; people (e.g. Edwin Martin) who were of such great importance to a single firm that their personal history is relevant; people who were connected with a number of different firms, often as designers (e.g. Christopher Dresser).

Entry format

1. Name, address and dates of operation; or name, and dates of birth and death.
2. Roughly chronological account. All cross-references marked with an asterisk. If a cross-reference occurs more than once in an entry, only the first occurrence is asterisked in that entry.
3. Marks.
4. References include primary sources, e.g. documents, directories and contemporary accounts, and secondary sources, e.g. books and magazine articles when they are helpful or supply unique information.

—Information found in general works is referred to by the author's name, e.g. Cameron. Bibliographical details can be found in the bibliography.

—In cases where more than one work by the author is to be found in the general bibliography, the date of publication distinguishes the work, e.g. Godden 1964.

—Where the reference relates only to that particular entry, it does not appear in the general bibliography and full bibliographical details are given in the entry.

—In the case of periodicals to which frequent reference is made, abbreviations are used; e.g. *The Pottery Gazette* is referred to as *PG*. A list of periodicals and their abbreviations is given in the bibliography.

—All works referred to were published in London, unless otherwise stated.

A

Adams & Co. (Ltd)

Scotswood-upon-Tyne,
Tyne and Wear
1880–1975

During the 1840s the Lister family established a brick and tile works at Scotswood. Sometime after 1858, W. C. Gibson acquired the works, operating under the style W. C. Gibson & Co. (Ltd). Apparently the firm was never very successful and by 1900 had incurred serious financial losses. Adams & Co. bought the firm in 1902, continuing to use Gibson's style for several years. The firm initially confined its production to sanitary wares made from local fireclay.

In 1904, Moses J. Adams began to manufacture Adamesk art pottery, also made with fireclay, but decorated with green, blue, yellow and bronze leadless feldspathic glazes developed by A. B. Searle. These were fired in a muffle kiln at 1200 degrees centigrade, producing novel colour effects. The wares included garden ornaments, bird baths, plant and fern pots, vases, cemetery urns, animal figures and baptismal fonts. The shapes were simple, and some were decorated in relief with Celtic-inspired designs. Adamesk was shown at the Glasgow Loan Exhibition of British Pottery in 1905. Production of these wares ended with the First World War.

Alan J. Adams joined the firm in 1912 and became director in 1921. He was a modeller and designed many sanitary wares, as well as ornamental tiles, plaques and busts. He also introduced Elan ware.

In 1975, the firm was placed in receivership and was briefly taken over by an American, Jim Lee, before going into voluntary liquidation. In 1977 Anderson Ceramics purchased some equipment, moulds, and the trade name Adamsez. They continued to manufacture sanitary wares at Scotswood until the factory's closure in 1980. The trade name Adamsez is still used by Anderson Ceramics for their sanitary wares.

Marks: "MJA" monogram (Moses J. Adams 1904–14); "ADAMESK" (1904–75); "Adamesk" in scrolls (1904–75); "AHM" monogram (Alan H. Adams 1912–75). Date codes were employed 1912–75 (e.g. "19 AW 20", for 1920).

References: Bell, R. C., *Maling and other Tyneside Pottery* (Shire Publications Ltd, Aylesbury, 1986); Bell, R. C., *Tyneside Pottery* (Studio Vista, 1971); Benwell Community Project Final Report, Series no. 8, *Adamsez: The Story of a Factory Closure* (Newcastle-upon-Tyne, 1980); Cameron; Coysh; "The Glasgow Loan Exhibition of British Pottery", *PG*, April 1905.

Aldourie Pottery

Dores, Inverness-shire,
Scotland
c.1900–14

This pottery was established as a sister to the Compton Art Potters' Guild* by Mary Watts, with the help of Louis Reid Deuchars, who had assisted with the mortuary chapel at Compton. Deuchars was a modeller who had trained at Glasgow School of Art. As the firm's pottery was designed by Mrs Watts, and made from clay shipped from Compton, it is very similar to Compton wares, e.g. garden pots and ornaments. When Deuchars left in 1903, he devoted himself to painting and sculpture, exhibiting at the Royal Academy and the New Gallery. The pottery

continued until the First World War, when the high cost of shipping the clay made the venture uneconomical.

Marks: A Celtic wheel impressed, with "ALDOURIE DORES" in the centre and "ThEIR WORK WAS AS IT WERE A WhEEL IN ThE MIDDLE OF A WhEEL".

References: Boreham, Louise, "Aldourie Pottery, Dores, Inverness-shire", *Scottish Pottery Review*, no. 9, 1984, pp. 37–39.

Allander Pottery
Milngavie, Dunbartonshire, Scotland
1904–08

The Scottish artist Hugh "Ugolin" Allan made pots briefly on the banks of the river Allander at Milngavie (pronounced Mullguy). His output was small and pieces are rare, but there is a representative collection in the Reserve Collection at the Art Gallery and Museum, Kelvingrove, Glasgow (Colour I). Allan's shapes are usually simple, inspired by the Chinese. They are decorated with brilliant low-fired glazes in green, turquoise, cobalt blue and pale pink. Allan used mottled and crystalline glaze effects, and one pot at Kelvingrove is decorated with pink lustre. Most of the wares are imperfect because of faulty glazing and firing.

Allan made his first pots in 1902, assisted by Robert MacLaurin, co-founder of the Scottish Guild of Handicraft Ltd, of which Allan became a member. When Allan decided to establish a pottery at Milngavie, MacLaurin, an industrial chemist and expert on fuels and combustion, built his kiln and helped to fire it. Allan probably hired workers from a local pottery to help with the throwing and various heavy tasks. Eventually he did learn to throw pots himself quite skilfully. Allan left his pottery in 1908 and died the following year.

Marks: "Allander" or "HA", incised, often dated. Occasionally a black-painted monogram, which may be the mark of an assistant.

References: Cameron; Coysh; Fleming; Kinghorn, Jonathan, "The Allander Pottery, 1904–08", *Antique Collecting*, May 1986, pp. 14–16; *Scottish Pottery Historical Review*, no. II, 1986–87, pp. 69ff.

Aller Vale (Art) Pottery
Newton Abbot, Devon
c.1868–1901

In 1866 J. Phillips was listed in *Kelly's Post Office Directory of Devonshire* as a clay merchant at Newton Abbot. Phillips probably purchased the Aller Vale Pottery in 1868 for, by 1870, *Morris's Directory of Devonshire* lists "Phillips, John & Co., manufacturers of architectural pottery and fire bricks".

Impressed by the success of the nearby Watcombe Terra Cotta Co. (Ltd)* and the Torquay Terra Cotta Co. (Ltd)*, John Phillips decided to produce terracotta art wares in 1881, following a fire at the pottery. He employed students from the Kingskerswell School of Art, which he had patronized since its establishment in 1879. Initially a "gipsy thrower" was engaged but soon the more promising students had been trained to throw the pots.

Phillips drew nearly all his labour force from the local community. In 1900 Snowden Ward reported in *The Art Journal* that, of sixty hands employed, only one was not a native of the district and that most had come into the works as boys. The manager, Herbert E. Bulley*, had begun as a driver. It was believed that this local character was responsible for the distinctive style of Aller Vale pottery (as opposed to that of the Watcombe Terra Cotta Co. (Ltd), which employed many men from Staffordshire). At Aller Vale all pots were made from clay dug on the site, thrown

and decorated by hand with slips and glazes prepared by the pottery.

Although the early wares were amateurish, by the mid-1880s the quality had improved. Most wares had a deep red body, but some pieces had a white body or a combination of red and white. These wares were heavily glazed and decorated with barbotine flowers and insects on blue, yellow, green or reddish-brown grounds (Colour II). Small decorative items predominated, often with quaint shapes, including features such as frilled rims, skewed handles (these jugs with handles passing through pierced rims were later copied by other firms) and flower vases with several necks, known as udder vases (Colour III).

By 1884, the pottery was advertising "faience, terracotta and domestic art pottery" in *The Pottery Gazette*. About 1885, the Isnik-inspired Persian pattern, with tulips, hyacinths and carnations, was introduced. By 1889 Aller Vale was exhibiting "faience with Rhodian decoration". One of the young men from the art school designed Abbotskerswell, or A.K., ware, which had a yellow exterior and a brown interior with green and brown decoration. From 1887 the firm was usually known as the Aller Vale Art Pottery. In this year it entered into a relationship with Liberty & Co.* of London which would last until 1901, giving it access to a lucrative national market.

It is believed that the firm was the first to introduce motto wares to the Torquay area. These were soon widely copied by many other firms. These early motto wares had a dark amber glaze and the mottos were written in standard English. Later wares had a clearer glaze and adapted an exaggerated Devonshire dialect to appeal to the tourist trade. The patterns most often used were Scandy (with a "tadpole" design), Cottages and Cockerels.

Some of the more popular patterns or decorative treatments were: Art Nouveau Crocus (1), Kerswell Daisy, Sandringham (blue scrolls on a white body), Scandy, Old Rhodian (2), Huacco Marble (streaky or mottled coloured slips), Ladybird (green or blue), Cottages, Normandy (running green glaze on a cream ground), and Black Lacquer (black glaze with oil-painted flowers), cottages and cockerels. Many of these patterns, particularly Scandy, the cottages and the cockerels, were copied by other Torquay firms. Princess Louise Ware, with a small blue butterfly, was introduced c.1895. The butterfly, which was thought to be unique to Britain, was

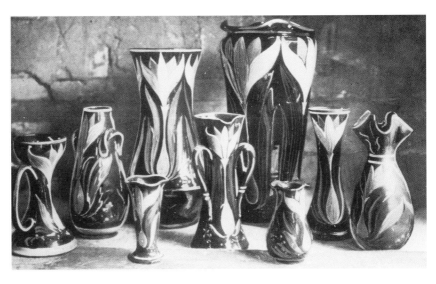

1 Aller Vale Pottery Crocus Ware, illustrated in *The Art Journal*, 1900.

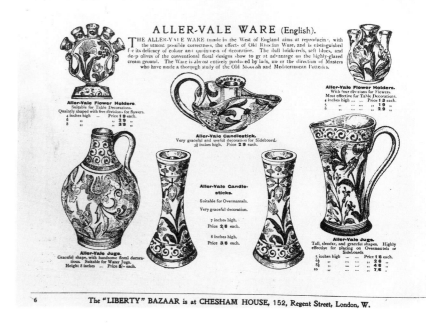

"LIBERTY" YULE-TIDE GIFTS. [Bazaar.

ALLER-VALE WARE (English).

THE ALLER-VALE WARE (made in the West of England) aims at reproducing, with the utmost possible correctness, the effects of Old Rhodian Ware, and is distinguished for its delicacy of colour and quaintness of decoration. The dull brick-reds, soft blues, and deep olives of the conventional floral designs show to great advantage on the highly-glazed cream ground. The Ware is almost entirely produced by lads, under the direction of Masters who have made a thorough study of the Old Moorish and Mediterranean Potteries.

Aller-Vale Flower Holders.
Suitable for Table Decorations.
Quaintly shaped with five divisions for flowers.
4 inches high ... Price **1 9** each.
6 ... ,, ,, **2 9** ,,
8 ... ,, ,, **3 9** ,,

Aller-Vale Flower Holders.
With four divisions for Flowers.
Most effective for Table Decorations.
4 inches high ... Price **1 3** each.
5 ... ,, ,, **1 9** ,,
6 ... ,, ,, **2 9** ,,

Aller-Vale Candlestick.
Very graceful and useful decoration for Sideboard.
3½ inches high. Price **2 9** each.

Aller-Vale Candlesticks.
Suitable for Overmantels.
Very graceful decoration.
7 inches high.
Price **2 6** each.
8 inches high.
Price **3 6** each.

Aller-Vale Jugs.
Graceful shape, with handsome floral decorations. Suitable for Water Jugs.
Height 8 inches ... Price **5/-** each.

Aller-Vale Jugs.
Tall, slender, and graceful shapes. Highly effective for placing on Overmantels or Sideboards.
5 inches high ... Price **1 6** each.
6½ ... ,, ,, **2 6** ,,
8½ ... ,, ,, **4 6** ,,
10 ... ,, ,, **7 6** ,,

6

The "LIBERTY" BAZAAR is at CHESHAM HOUSE, 152, Regent Street, London, W.

added to a Florentine-type pattern, when Princess Louise suggested that they should add a local character to the work.

When John Phillips died in 1897, the business was taken over by Hexter, Humpherson & Co. (Ltd)*, who later purchased the Watcombe Terra-Cotta Co. (Ltd) and amalgamated the two firms in 1901, under the style Royal Aller Vale & Watcombe Pottery Co. (Ltd)*. Although motto wares continued to be marked "Aller Vale", the works at Aller Vale closed in 1924.

Artists and decorators

SAMUEL "REB" BRADFORD. A jug and basin by Bradford and Thomas Lewis (a thrower) were shown at the Arts and Crafts Exhibition of 1893. He specialized in scroll decoration and later worked for the Longpark Pottery Co. (Ltd)*.

CHARLES COLLARD* joined the firm as an apprentice in 1886. He soon demonstrated his remarkable talent, for, in 1889, a vase designed and executed by him was exhibited at the Arts and Crafts Exhibition. He was the pottery's chief designer and decorator from the 1890s until his departure in 1902.

WILLIAM HART was listed as foreman as early as the 1881 census. He left Aller Vale in 1891 to become chief decorator for Cole & Trelease*, and with Alfred Moist established Hart & Moist* in 1896.

WILLIAM GEORGE HOWARD trained at Aller Vale. He was a skilled oil painter and wood carver. He received a certificate of merit from Princess Louise and is credited with a number of Aller Vale designs, including the 1902 and 1911 Coronation commemoratives. He later worked for Hart and Moist* and the Longpark Pottery Co. (Ltd)*.

S. KIRKHAM won a prize at the Cornwall Polytechnic Exhibition of 1884.

JAMES MAIN trained at Aller Vale, later working at the Watcombe Terra-Cotta Co. (Ltd)* and Longpark Pottery Co. (Ltd)*.

DOMINICO MARCUCCI. By 1890, this Italian artist had joined the firm. He is known for creating Italianate scroll patterns, and some pieces can be found with his name incised or painted within the decoration. The Arts and Crafts Exhibition in 1890 included a vase in "giallo ware" and two vases in "ceramic cameo decoration" by Marcucci.

T. MELLOR won a prize at the Cornwall Polytechnic Exhibition of 1884.

CHARLES PHILLIPS was listed as a modeller potter in the 1881 census.

CHARLES BUTLER STONEY's "panels or wall tiles" were shown at the Arts and Crafts Exhibition of 1890. He was an accomplished painter who exhibited at the Royal Academy and became Honorary Secretary of the Torquay Arts and Crafts Exhibition in 1890. He was probably not an artist regularly employed at the pottery.

W. F. YOUNG won a prize at the Cornwall Polytechnic Exhibition, 1884.

Marks: Aller Vale pieces were well marked from the mid-1880s. The many marks usually incorporated "Aller Vale" or sometimes "AV". An impressed "T" was also used. Painted or incised pattern codes are also frequently found, e.g. "B1". These are listed in Barber. Painted or incised shape numbers were also used, e.g. "1476".

References: "Aller Vale Jugs", *TPCS Magazine*, October 1988, pp. 12–13; "Aller Vale Pottery", *Country Life*, 9 March 1901, pp. 299–300; A&CXS 1889, 1890, 1893; Barber, Pat, "Early Aller Vale", *TPCS Magazine*, July 1985, pp. 6–9; Barber, Pat, "Aller Vale Pattern Codes", *TPCS Magazine*, January 1990, pp. 21–23; Blacker; "Bottoms Up – identifying the marks on your pots", *TPCS Magazine*, October 1987, pp. 8–12; Brisco, Virginia, "The Torquay Potteries in 1881", *TPCS Magazine*, April 1986, pp. 8–11; Brisco, Virginia, "Unusual Aller Vale Patterns", *TPCS Magazine*, April 1989, pp. 20–21; Cameron; Cashmore, Carol, "Still More on Scrolls!", *TPCS Magazine*, October 1988, pp. 14–15; Cashmore, Chris, "The Aller Vale Tobacco Jar", *TPCS Magazine*, July 1988; Cashmore, Chris, "Adverts for the Torquay Potteries in *The Pottery Gazette 1883–87*", *TPCS Magazine*, April, 1984, pp. 9–13; Cashmore 1983, 1986; Coysh; Godden 1964, 1972; Jones; *KPOD, Devonshire, 1866–1923*; Levy; Monkhouse, Cosmo, "The Aller Vale Potters", *MA*, vol. XIV, pp. 349–52; *Morris's Directory of Devonshire*; Patrick; Thomas 1974, 1978; *TPCS Magazine*; TPCS 1986, 1989; Ward, Snowden, "Two Devonshire Potteries", *AJ*, 1900, pp. 119–23.

Anchor Art Tile & Pottery Co.

Anchor Pottery, Albion Works, Longton, Staffordshire
c.1890

This firm advertised in *The Pottery Gazette* from April to June 1890: "Manufacturer of Hand Painted Tiles for Hearth and Sills, Slabbed Hearths. Plain, printed and majolica tiles. Special attention given to white glazed tiles, also toilet and tea sets, jugs etc."

Art Pavements and Decorations Co.

7 Emerald Street,
Theobalds Road, London
c.1906–11+

Established by Conrad Dressler* after the closure of the Medmenham Pottery*, the firm exhibited tiles designed by Dressler and decorated by Kate Hillesch and Emma Barrat at the Arts and Crafts Exhibition in 1906. The firm is best known for providing the tiling for Harrod Ltd's Meat Hall in 1911.

References: A&CXS 1906; Williamson.

Art Pottery Co. *See* J. Lamb & Sons.

Art Tile, China & Glass Painting Co.,
81 Finsbury Pavement and 38 Moorfields, London
c.1882

E. V. Kelley was the manager of this firm, which advertised: "Hand-Painted Tiles, China Plaques (Hand-Painted, Portraits on China), Ecclesiastical Glass, Domestic Glass, Art Window Blinds, Hall Lamps, Screens in Gold, &c. Estimates and Designs furnished." (*Decoration*, March 1882).

At the Building Exhibition they had ". . . a very attractive exhibit comprising stained glass and hand-painted pottery. Among this art collection particular attention was attracted by the portraits on stained glass and the china roundels with female heads, beautifully painted in shades of bluish grey." (*Decoration*, May 1882).

References: *Decoration*.

Art Tile Co. *See* Art Tileries, Stourbridge, Worcestershire.

Art Tileries
Stourbridge, Worcestershire
c.1895–1907+

As the Art Tile Works, Stourbridge, this firm registered designs for moulded tiles in 1890 (nos 160–196) and 1891 (nos 165576). Their letterhead of *c.*1914 reads: "Manufacturers of Enamelled, Embossed, Incised and Hand Painted Tiles and Encaustic Tile Pavements. Please address Telegrams and Orders to the Works, Kingswynford, Staffs." (Letter at Gladstone Pottery Museum, Wenger Papers)

References: Austwick; Barnard; Lockett; *PG Diary*, 1907.

Art Workers Guild
1884 to the present day

Although the ideals of what would become the Arts and Crafts Movement had been gaining currency since the Gothic Revival of the 1840s, the movement had no formal existence until the formation of the Art Workers Guild. Walter Crane*, one of the founder-members, describes the beginnings thus:

> Up to about 1880, artists working independently in decoration were few and far between, mostly isolated units, and their work often absorbed by various manufacturing firms. About that time, in response to a feeling for more fellowship and opportunity for interchange of ideas on the various branches of their own craft, a few workers in decorative design were gathered together under the roof of Mr Lewis F. Day*, on a certain January evening known as Hurricane Tuesday, and a small society was formed for the discussion of various problems in decorative design and kindred topics, meeting in rotation at the houses or studios of the members. The society [sometimes called The Fifteen] had a happy if obscure life for several years, and was ultimately absorbed into a larger society of designers, architects, and craftsmen, called "The Art Workers Guild" . . .

There have been very few potters among the Guild's members over the years. In fact, during the period 1870–1920, there were only four (William Burton*, Frederick Garrard*, Robert Wallace Martin* and Léon Victor Solon of Mintons*) However, influential designers such as Robert Anning Bell*, Walter Crane and Lewis F. Day* were active members. Some members listed as architects or sculptors,

such as William Henry Cowlishaw (Iceni Pottery*) or Conrad Dressler*, were also engaged in ceramics. The Guild has continued to provide fellowship and act as a forum for the changing approaches to art and design up until the present day.

References: Brighton 1984; Crane, Walter, *The English Revival of Decorative Art* (1892).

Arts and Crafts Exhibition Society
1888–1957

The Arts and Crafts Exhibition Society was founded after an unsuccessful attempt to persuade the Royal Academy to mount an exhibition of the decorative arts. According to Walter Crane*, the Society's President, they sought to demonstrate "... the actual state of decorative art in all its kinds as far as possible. They desired to assert the claims of the decorative designer and craftsman to the position of artist, and give everyone responsible in any way for the artistic character of a work full individual credit, by giving his name in the catalogue ..." Many of the members of the Art Workers Guild* became members of the Society but, unlike the Guild, the Society extended membership to women, and non-members were allowed to exhibit. Exhibits included the work of large firms such as Doulton & Co. (Ltd)*, J. Wedgwood (& Sons Ltd)*, and Mintons*, smaller firms such as the Della Robbia Pottery* and William De Morgan*, and the attempts of now-obscure amateurs. As the designer and executor of every item are given, the exhibition catalogues are a rich source of information about art pottery.

References: A&CXS 1888–1957; Crane, Walter, *The English Revival of Decorative Art* (1892).

Ashby Potters' Guild
Woodville, near Burton-on-Trent, Derbyshire
1909–22

In 1898, E. R. Tunnicliff took over a pottery in which he had for some time held an interest. Renamed the Victoria Pottery, it produced yellow domestic wares. Tunnicliff's son, Pascoe, joined the business after training as an engineer. In 1909, the Tunnicliffs and the Camm family (Smethwick manufacturers of stained glass and tiles) established the Ashby Potters' Guild, named after the nearby village of Ashby-de-la-Zouch. The Guild shared premises with the Victoria Pottery but otherwise operated separately. The "director and chemist-potter", Pascoe H. Tunnicliff, was assisted by a staff of about ten. The artists, some of whose initials may be found on pieces, were Annice Buck, J. W. Davies, George Hopkinson, Maurice Hall and Norman Hull. Thomas Camm designed the early shapes.

As early as 1910 the Guild won a gold medal for its Vasco and Aventurine Wares at the International Exhibition in Brussels. *The Pottery Gazette* noted in November 1910: "The mottled effect on some of the vases is very pretty, and with the exception of some of the yellow ware, it was noticeable that no two pieces had come out of the ovens exactly alike in colour or shading. Some very fine specimens of Chinese and metallic lustres were included in this exhibit." At the Turin International Exhibition in 1911 the Guild introduced its "very pleasing dove-grey Copenhagen glazes" with faintly visible gold crystals at irregular intervals, exhibiting also "vases and bowls, of simple and graceful shapes, with mottled, striated, opalescent, flammé, and crystalline glazes and lustres" (*PG*, July 1911).

We know very little about the actual organization of this Guild, but it clearly meant to embody the Arts and Crafts Movement's ideals. *The Pottery Gazette* noted in November 1911: "'Vasco Ware' ... appeals to the artistic taste of its possessors

because there is nothing rigidly mechanical about its production. Each piece has in it some expressions of the craftsman's feelings." From 1911 to 1922 the Guild advertised Vasco Ware as "a true art pottery that 'appeals to the cultured'".

At the Arts and Crafts Exhibition of 1912, the Guild exhibited a wide range of ornamental wares designed by Tunnicliff and decorated by Annice Buck, J. W. Davies and Maurice Hall. Although the pottery shut down during the First World War, the Guild displayed a number of ornamental wares by Tunnicliff at the 1916 Arts and Crafts Exhibition.

The Guild reopened after the War, and was exhibiting again at the British Industries Fairs of 1918 and 1921. Figure 3 shows wares typical of the period. Its wares were particularly successful at the 1921 fair:

> From biscuit boxes to table lamps, in all sorts of shapes from Roman to tolerably modern the range was full of interest. As for the colourings, it was at once apparent that considerable advancement has been made since the work was resumed after the Armistice. Some very rich new colour shades have been added, including a very attractive yellow mottling and a very striking Chinese purple. (*PG>R*, April 1921)

The deep orange lustre "bordering on a flambé" was popular in 1920.

> The craze for floating flower bowls has led to considerable development in this particular article, which was shown in many charming artistic colourings. The articles comprised vases (covered and uncovered), pot-pourri jars, biscuit caskets, tobacco jars, cake-stands, inkstands, candle-sticks, table-lamp standards &c. (*PG>R*, April 1920)

3 Ashby Potters' Guild, "Some interesting Lustred and Crystalline Effects", illustrated in *The Pottery Gazette*, April 1920.

In 1922, the firm was amalgamated with William Ault & Co.* to form Ault & Tunnicliff Ltd*.

Marks: "ASHBY GUILD", impressed in an oval, sometimes accompanied by the artist's initials.

References: A&CXS 1912, 1916; Brown; Cameron; Coysh; Godden 1964; Haslam 1977; Lockett; Pemberton; *PG*; *PG>R*.

Ashworth, G. L. & Bros (Ltd)
Hanley, Staffordshire
c.1861–1968

Ashworth's are best known as the largest British producers of ironstone, owning the original Mason's moulds. John S. Goddard purchased the firm in 1883, continuing ironstone production. In 1909, the firm introduced Estrella and Lustrosa art wares. The proprietors, J. S. Goddard and F. L. Johnson, had engaged Dr L. Basch, an Austrian chemist, to develop the glazes used on these wares. Basch was assisted by Vivian Goddard, son of J. S. Goddard, who was an enthusiastic chemist-potter. The experiments had taken over a year to produce satisfactory results (4).

The Pottery Gazette described Estrella Ware thus:

> No two pieces of the ware develop, in the firing, exactly alike, so that each example is an original masterpiece. Some of the effects are weird, but beauty is always attained, and to the originality of the decoration is added grace of outline in the shape and infinite variety in the colour effects. Some of the pieces bear a striking resemblance to the much prized Chinese vases in *rouge flambé*, *sang-de-bœuf*, and peach bloom.

Lustrosa ware had a "kaleidoscopic" effect and the shapes were "quaint" (*PG*, May 1909).

4 G. L. Ashworth & Bros. (Ltd), Estrella and Lustrosa wares.

The art wares were exhibited at the International Exhibitions in Brussels in 1910 (where several items were reported sold) and in Turin in 1911. Basch apparently returned to Austria when the First World War broke out and production ceased.

Marks: "ASHWORTH" with "LUSTROSA" or "ESTRELLA".

References: Cameron; Godden 1964; Godden, Geoffrey, *Mason's China and the Ironstone Wares*, third edition (Antique Collectors' Club, Woodbridge, 1991); *PG*.

Ault & Tunnicliff Ltd

Swadlincote, near Burton-on-Trent, Derbyshire

1922–36

In July 1922, Ault & Tunnicliff Ltd was established as a private company. The object was:

> To acquire the potteries, mills, clay works, and other buildings and premises of W. Ault, at Swadlincote, and P. H. Tunnicliff, at Woodville, both in Derbyshire, and used by them in their business, and to carry on the business of manufacturers of, and dealers in, earthenware, stoneware, china, porcelain, Parian, and other ceramic wares, terra cotta, tiles, glass sanitary ware and fire goods, etc.

The permanent directors were P. H. Tunnicliff and W. H. Giles. An advertisement that month explained that the new firm was incorporating William Ault*, The Ashby Potters' Guild* and P. H. Tunnicliff, the Victoria and Thorn Street Potteries, Woodville. Products advertised included Vasco Ware, Ault Ware and four types of domestic wares: Chocolate Ware, Fireproof Ware, Bristol Stoneware and yellow ware.

When William Ault retired from the business in June 1922, Tunnicliff, as managing director, supervised the overhaul and remodelling of the works. Although continuing to produce the same classes of ware as before the merger, Tunnicliff lost no time in bringing out new designs in Ault Ware and a new Celeste Lustre in Vasco Ware. By February 1923, Tunnicliff had renamed the combined products of the firm Aultcliff Wares (Colour XX), and introduced Ivoril Ware, an imitation of carved ivory. He revived some of Ault's majolica shapes for this new treatment. In 1924 he introduced Bronzite, a brown-bodied ware with bronze-like ornament. The wide range of shapes employed included at least one made from an old Linthorpe Pottery* mould.

W. H. Giles was appointed receiver for the company in 1926, and Tunnicliff left the following year. Giles, William Ault's son-in-law, kept the firm going by producing primarily domestic wares. In 1937 the firm was reorganized as Ault Potteries Ltd. When Giles retired in 1962, he sold the firm to Pearson's of Chesterfield. Pearson's continued to operate the pottery until 1975.

Marks: "Aultcliff" or "AT" monogram.

References: Brown; Cameron; Godden 1964; *PG>R*.

Ault, William & Co.

Ault Pottery, Swadlincote, near Burton-on-Trent, Derbyshire

1887–1922

William Ault* established the Ault Pottery on the former site of James Woodward's Swadlincote Pottery in 1887. Using glossy majolica glazes which had become *passé*, Ault manufactured a range of decorative wares, concentrating on large relief-moulded items such as plant pots, pedestals and umbrella stands (5). These were called Ault Faience, although they were no more closely related to French

faïence (an earthenware with a tin glaze) than majolica was related to Italian maiolica.

The Ault wares were art pottery in the sense that they were "artistic" and the use of them was supposed to elevate public taste. *The Pottery Gazette* pointed out: "The public are indebted to Mr Ault and other high-minded manufacturers . . . who take the pains to direct the public taste in the right direction when they perceive it is degenerating or merely erratic. Lovers of art must be gratified to see culture displayed in a choice of articles of artistic design . . ." (July 1907)

As for the mode of production, the pottery was commended because: "The rooms are light and well ventilated, and there is an air of systematic procedure not always seen in a pottery . . . Mr Ault provided steam power far beyond his immediate requirements. He evidently had an eye to developments and extensions." (*PG*, July 1907) This then was no cottage industry but a modern manufactory. In extenuation, if such is necessary, it should be pointed out that Ault's wares were sold at "popular prices" and that, while they may not have been great works of art, they offered an affordable alternative for the middle classes. In July 1915, *The Pottery Gazette* explained; "he has instituted and popularised a type of art pottery which, though it at first claimed to be nothing more than art pottery has gradually evolved into a class of ware capable of fulfilling the function of utility as well as of appealing to the artistic impulses . . ."

5 William Ault & Co. Ault Faience in an advertisement in *The Pottery Gazette*, 1898.

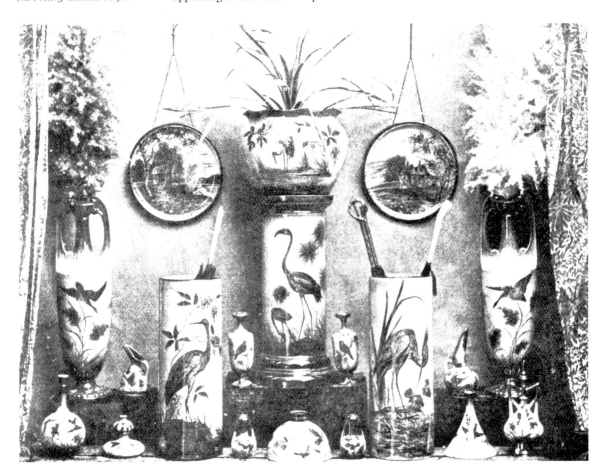

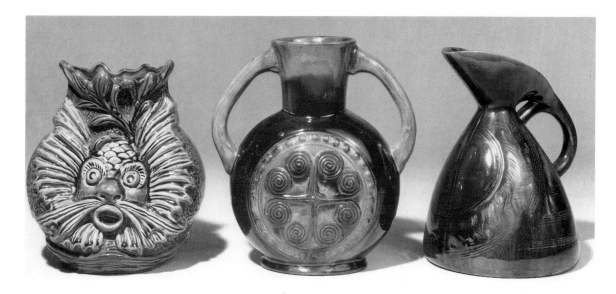

6 William Ault & Co. pottery designed by Christopher Dresser.

Ault's wares were and still are most valued for the rich colours of their thick, glossy glazes. He was particularly known for the "shaded art effects" which he seems to have invented, but which were before long being copied by many firms. In 1903, he brought out the "brown to green and green to brown again", "crimson blending with gold and green" and "crimson and turquoise". These strong colours were continually noted by commentators: "There are several of these colour schemes that could only have occurred to an original artist. If he had failed they would have been execrable and we should never have seen them. He succeeded, and so we admire them." (*PG*, February 1907)

Ault acquired many of the moulds of the Linthorpe Pottery* in 1890. These were used for many years. Little is known about Ault's designers, except for Christopher Dresser* (6 and 61), who designed for Ault from 1892 to 1900, and Charles Collis*, who worked for Ault from 1906 to 1912. In various articles "an artist" or "a student" from South Kensington is credited with a new design. Ault admitted that he himself never designed the wares.

In 1905, Art Nouveau took Ault's fancy: "The principal novelties this year are decorations in accord with the taste of the day, which is for conventional designs (on what are commonly called 'new art' lines – English is good enough for me –) in association with combinations of colour – either in harmony or contrast." (*PG*, March 1905) The Floris pattern illustrated is so *nouveau* that it is difficult to tell whether the flower is an iris, a lily or a daffodil.

In 1907 a coloured slip-decoration was introduced: "The designers and decorators at Swadlincote have evidently a free hand to great extent, and work independently of mechanical methods and of conventional theories. The result is the remarkable originality in decorative designs and colour schemes which is the striking characteristic of the new pieces now on show." (*PG*, February 1907)

In 1911, Ault, aged 70, was joined by his nephew, Stewart Rowley, who had been trained in the Staffordshire Potteries. The body and glazes improved considerably after Rowley joined his uncle. It was in this year that they produced their first tablewares, in self art colours, principally *rose du Barri*, Saxe blue and holly green. *The Pottery and Glass Record* pointed out that Rowley had ". . . made

both an artistic and utilitarian side in the productions of his firm. But even in those articles of pure utility nothing is done either in shape or colour that offends the artistic feelings of his buyers." (*P&GR*, February 1918)

Unlike many art potteries, Ault announced in September 1914: "BUSINESS AS USUAL. During the present crisis, the situation will be greatly relieved if, wherever possible, Business houses will transact business as usual. Orders and enquiries will receive prompt and careful attention." The firm continued to advertise "*English* Art Pottery" regularly and to bring out new shapes and decorations (e.g. Landscape and Harvest) throughout the First World War. They were not above seizing whatever opportunities were afforded them. An advertisement in *The Pottery Gazette* of December 1916 announced: "NOW IS THE TIME! Don't wait until the public are being summoned wholesale for contravening the Restricted Lighting Order; but order your Candlesticks now and ensure having the goods to hand when the demand arrives."

In 1922 the firm merged with Pascoe Tunnicliff's Ashby Potters' Guild* and his other works, to form Ault & Tunnicliff Ltd*. William Ault retired in the same year.

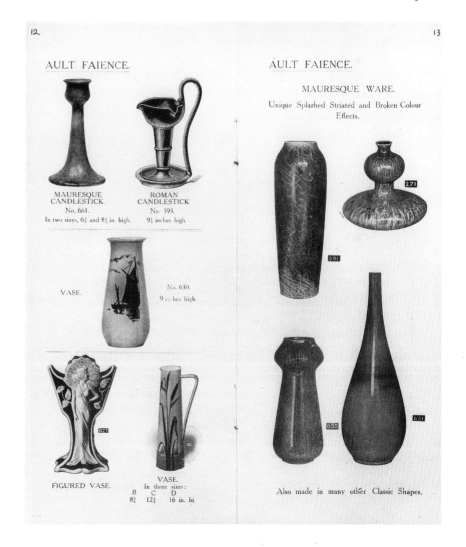

12 13

AULT FAIENCE.

MAURESQUE
CANDLESTICK.
No. 661.
In two sizes, 6¾ and 8¾ in. high.

ROMAN
CANDLESTICK
No. 393.
9¼ inches high

VASE.

No. 630.
9 inches high

FIGURED VASE.

VASE.
In three sizes:
B C D
8¾ 12½ 16 in. hi

AULT FAIENCE.

MAURESQUE WARE.
Unique Splashed Striated and Broken Colour Effects.

271

591

605

651

Also made in many other Classic Shapes.

7 William Ault & Co. wares illustrated in a catalogue *c.*1910.

Wares introduced by Ault 1908–12
(Quotations are from *The Pottery Gazette*)

ANTIQUE WARE (1908), glaze effects in pink, heliotrope, green to pink, and brown and green, or deep yellow on simple shapes.

AVENTURINE WARE (1911), glaze effects on "quaint" shapes. Goldstone Aventurine introduced *c.*1913.

CORONA WARE (1911), scroll decoration on "Helio" (pale purple) or turquoise grounds.

CREKE WARE (1909), "A free conventional design on a light body, the other parts of the pieces being shaded from burnt red into pale pink."

EBONITE WARE (1912), a rich black ground with Pierrot, Stella or pink Poppy decoration. Apparently the earlier pieces were less than successful, as later pieces are described as being "a striking advance upon the original ones".

GROTESQUE WARE (1909), Modern, as opposed to Gothic, these figures are weird and unsettling rather than quaint.

MAURESQUE WARE (1909), marbled, mottled and broken glaze effects on plain shapes (7).

MÉTALLIQUE WARE (1909), "a good imitation of antique bronze. It looks like dark brown metal, and as all the forms are such as used to be made in beaten metal, the illusion is perfect."

RUSTIC WARE (1908), ". . . vases, jugs, spills, flower pots and a number of nicely modelled quaint forms, including classical and modern artistic shapes. These have conventional floral, rustic, and bust embossments in green, on a dark brown ground."

SANG-DE-BOEUF (1909), imitating the red high-fired transmutation glazes being made by Bernard Moore* and others.

SGRAFFITO WARE (1909), "decorated with graceful geometrical designs and scroll patterns of foliage and flowers".

References: "Art Pottery by Mr William Ault, from the designs of Dr Dresser", *CM*, June 1894; Ault, William, *Ault Faience*, List No. 25 (no date); Blacker; Brown; Cameron; *Christopher Dresser* (Fine Art Society and Haslam & Whiteway Ltd, 1990); Collins, Michael, *Christopher Dresser* (Camden Arts Centre, Middlesbrough, 1980); Coysh; Dennis, Richard and John Jesse, *Christopher Dresser* (Richard Dennis, John Jesse and The Fine Art Society, 1972); Godden 1964, 1972; Halén, Widar, *Christopher Dresser* (Phaidon, 1990); "Mr. E. S. Rowley", *P&GR*, February 1918, p. 164; Pinkham; *PG*; Rhead; Thomas 1974.

Ault, William
1841–1929

Born near Burslem and orphaned in infancy, Ault was educated at the village school. Aged fifteen, he started work as a packing-house boy at Henry Wileman's Foley Works, Longton. In 1863 he was promoted to a post at Wileman's Church Gresley Works. Upon Wileman's death in 1864, these works were purchased by T. G. Green & Co. (Ltd)*, for whom Ault worked until 1867. After undergoing a course in shorthand, he worked briefly for a firm of accountants in Birmingham before Green persuaded him to return.

In 1882, Ault and Henry Tooth* founded the Bretby Art Pottery at Church Gresley, operating under the style Tooth & Ault* until 1887. Tooth continued the Bretby pottery as Henry Tooth & Co. (Ltd)* thereafter. In 1886, Ault purchased a

site in Swadlincote, where he ran William Ault & Co.* until his retirement in 1922. His obituary noted:

> Mr Ault was a man of culture and refinement, deeply interested in literature and art, and his character was such as to inspire not only respect but also the affection and trust of those who came into contact with him . . . he carried the principles of the Christian religion into the business world, where his conscientiousness and uprightness were known to all who dealt with him. By two attributes will [he] long be remembered – a unique potter and a staunch Christian. (*PG>R*, April 1929)

References: Brown; "Familiar Faces in the Pottery Trade", *PG*, July 1907; *PG*; "William Ault, Obituary", *PG>R*, April 1929; "Mr William Ault on the Tariff Question", *PG*, August 1904. (*See also* William Ault & Co.; Ault & Tunnicliff Ltd.)

B

Bailey, C.J.C. & Co.
Fulham Pottery, London
1864–89

The pottery where John Dwight had made his famous salt-glazed stonewares during the late seventeenth century had all but fallen into ruin by the middle of the nineteenth century. Macintosh & Clements, succeeded by Clements and Co., were the proprietors of the Fulham Pottery for two years prior to Charles Irvine Conynham Bailey's acquisition in 1864. *Morris's Business Directory* first lists C. J. C. Bailey as a wholesale potter in 1867. Initially he made only brown stonewares and terracotta.

During the 1870s Bailey began to make Doulton-type art wares. He employed Jean-Charles Cazin*, an instructor at the Lambeth School of Art, as designer *c.*1871–74. Cazin designed and modelled figured jugs, mugs and cannettes in stoneware, often inspired by antique Rhenish designs. His wares were often decorated with armorials or impressed medallions.

During this period the firm also produced some porcelain figures and flower-pieces modelled by Hopkinson, allegedly from Dwight's original recipe. There are two porcelain figures in the Victoria & Albert Museum, and a vase in the Birmingham City Museum and Art Gallery.

In 1872 Robert Wallace Martin* became a designer and modeller for Bailey. Among other things he modelled clock cases, window boxes and fireplaces. During this time he became acquainted with Cazin, whose influence can be seen in Martin's early work. In 1873 Martin established a studio at Pomona House, next to the Fulham Pottery, where his work was fired. Eighteen months later, Martin established his own studio and kilns at Southall. C. J. C. Bailey pots are known

marked with the initials of Edward Kettle* and of the sculptor Ebenezer Bennett, as well as those of Martin and Bailey. The firm also executed architectural work to the designs of the architect John Pollard Seddon (8).

In 1882, the firm's advertisement in *The Pottery Gazette Diary* offered: "Artistic Pottery. Decorated Coloured Stoneware, Terra Cotta, Balusters, Window Heads, Any Designs Worked out for Architects, Garden Vases, Tiles for Hearths, Halls, Conservatories, etc." By 1887, their output was "principally if not entirely, sanitary ware" (*JDA*, May 1887).

Bailey became insolvent in 1888 but stayed on as manager, the firm continuing to appear in *Morris's Business Directory* under his name until 1891. In March 1891 the new owners took over, operating under the style Fulham Pottery and Cheavin Filter Co. Ltd.

Marks: "BAILEY FULHAM"; "C. J. C. BAILEY FULHAM POTTERY LONDON". Incised monogram "C. J. C. B." or names or initials of E. Bennett, E. Kettle (who also used a kettle rebus) or of R. W. Martin may be found. Some pieces may be dated.

References: Beard, Charles, *A Catalogue of the Collection of Martinware formed by Mr. John Nettlefold. Together with a short history of the firm of R. W. Martin & Bros. of Southall* (Waterton & Sons Ltd, 1936); Blacker; Cameron; Coysh; "Doulton & Co., Lambeth Potters", *JDA*, May 1887, pp. 71–78; Drew, David, "Artist Potters Working in Fulham and Chelsea 1870–1930", *The Antique Collector*, January 1979, pp. 78–81; Godden 1964, 1966, 1972, 1988; Haslam, Malcolm, *The Martin Brothers* (Richard Dennis, 1978); Haslam 1975; Hazelgrove, Dennis and John Murray, editors, "John Dwight's Fulham Pottery 1672–1978, *A Collection of Documentary Sources*, Journal of Ceramic History, no. 11 (Stoke-on-Trent City Museums, 1979); *MBD*; "Late Robert Wallace Martin", *PG>R*, September 1923; *Merchants & Manufacturers Pocket Dictionary* (London, 1868); Oswald; Rhead; Rose; Thomas 1974.

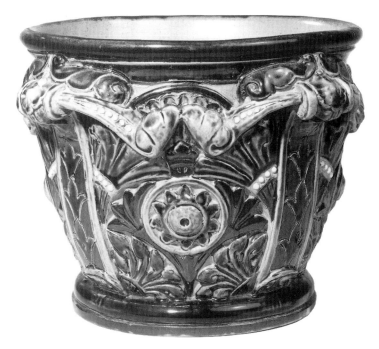

8 C. J. C. Bailey & Co. stoneware jardinière designed by J. P. Seddon, covered in blue, green and brown glazes, impressed "Fulham Pottery, Fulham, London SW", h. 21.4 cm.

Barker, F. H. & Rhead, Ltd
Atlas Tile Works, Vine Street, Hanley, Staffordshire
1908–10

This pottery was worked by W. Burton in the middle of nineteenth century and produced common earthenware and cottage ornaments. From 1860 until 1875, John Buckley made sanitary wares here. Then Sherwin & Cotton* made tiles here until c. 1890, when they left for a new and more spacious factory. Tiles continued to be made here by Pidduck & Maguire, Elliots Ltd and Francis Theimeicke. The business was then purchased by F. H. Barker and Frederick Rhead*, trading as F. H. Barker & Rhead Ltd. Both Charlotte Rhead* and her sister Dolly worked here. Although the only extant pattern book shows no tube-lined art tiles, it is likely that some may have been made.

References: Bumpus; Rhead.

Barnard, Harry
1862–1933

Originally trained as a silversmith, Barnard studied at the Royal College of Art. He joined Doulton & Co. (Ltd), Lambeth* in 1879, working as a modeller and decorator under Mark V. Marshall, until he was made under-manager of the studio c.1884. After falling out with Wilton P. Rix, Doulton's art director, Barnard was lured to Staffordshire by Corbett Woodall, Chairman of James Macintyre & Co. (Ltd)*. Barnard joined the firm as Art Director from February 1895, introducing his Gesso Faience. Despite the success of this new line and his many tableware designs, Barnard was treated badly by the Macintyre management. In February 1897, at the end of his two-year contract with Macintyre, he joined J. Wedgwood (& Sons Ltd)*, where he had been working two days per week since 1896.

Barnard is credited with introducing tube-lining to the Staffordshire Potteries. This refinement of the slip-trailing technique, which had been used in the Potteries since the seventeenth century, was particularly suited to the sinuous lines of Art Nouveau decoration. As a designer for Wedgwood he worked with bone china, jasper, majolica, stoneware and tiles. He developed a range of art ware with tube-lined, sgraffito and pierced decoration. He became manager of the tile department in 1899 and manager of the London showrooms in 1902. He returned to Etruria in 1919, also travelling internationally to promote and lecture on Wedgwood. He continued to design and decorate until his death. His *Chats on Wedgwood* was published in 1924.

References: Atterbury, Paul, *Moorcroft* (Richard Dennis & Hugh Edwards, Shepton Beauchamp, revised edition, 1990); Batkin; Bumpus, Bernard, "Tube-line Variations", *The Antique Collector*, December 1985, pp. 59–61; Cameron; Eyles, Desmond, *The Doulton Lambeth Wares* (Hutchinson, 1975); Reilly.

Baron, William Leonard
1863–1937

Like many of his fellow students at Lambeth School of Art, Baron worked for Doulton & Co. (Ltd), Lambeth*. His only recorded signed Doulton pots are dated 1883. He left sometime in 1884 to take up a position as modeller and designer for C. H. Brannam (Ltd)*. Baron continued his education at the Barnstaple School of Art and, having earned his Master's Certificate, began to teach. He meanwhile continued his job at Brannam's until 1893, when he decided to strike out on his own. Not having the capital to establish a pottery, he arranged for his pots to be fired at Edwin Beer Fishley's Fremington Pottery*.

In 1895 he established Baron's Rolle Quay Art Pottery Works* in Barnstaple. He was assisted from c.1910 by his son Billy, who drowned tragically in 1935. Baron's

grandson, also Billy, took no interest in the pottery and, on Baron's death in 1937, the business was sold to Brannam's.

References: Edgeler; *PG*.

Baron's Rolle Quay Art Pottery Works

Barnstaple, Devon
1895–c.1937

William Leonard Baron* established his own pottery in 1895. Baron has been unfairly dismissed as a mere copycat of C. H. Brannam's* wares, but many of the similarities between the two can certainly be explained by Baron's having been responsible for many of Brannam's designs for nearly ten years. None the less, Baron had been influenced both by Brannam and the Fishleys at Fremington*. The wares, very easily identifiable as North Devon art pottery, are characterized by thick, richly coloured glazes, sgraffito decoration, the use of coloured slips and sometimes elaborate modelling (9). Some of his early employees are known to have come from the Lauder* Pottery, which would have further strengthened the wares' connection with the local styles and techniques.

Baron's advertisements show that he had a very definite idea of what art pottery should be and how it should be made: "The Barnstaple Art Pottery. Decorated, Grotesque, & Motto Wares (Rich in Colours & Glazes). Made and Decorated by hand. No two pots exactly alike. No copying, tracing or transferring." (*PG*, 1903–20s) As late as April 1923 *The Pottery Gazette & Glass Trade Review* commented: "We should describe Mr Baron as being an artist before being a potter; he is simply a potter because he has found that to be a facile method of expressing his art. Every piece is made on the wheel and finished by turning, the pot being painted in coloured slips and subsequently glazed."

Grotesques formed a large part of the firm's output. At the Brussels International Exhibition in 1910, it was noticed that: "He makes many grotesques, ugly yet not repellent." His grotesques were again noticed at the Turin International Exhibition: "the ever-popular grotesque cats, frogs, teddy-bears, &c., which must be called artistic, because they are like nothing natural." (*PG*, July 1911) In June 1911 he showed a large selection of green-glazed Devonshire Art Pottery: "The pieces are adapted for souvenirs, and consist for the greater part of small pots, jugs, flower stands, dishes and fancy lines." (*PG*, June 1911)

Earthenware buttons with metal shanks were also made *c.*1910–20. Although Baron's exhibition at the British Industries Fair of 1918 was lacking in novelty, it

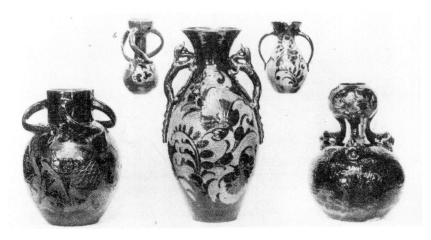

9 Baron's Rolle Quay Art Pottery Works, Barnstaple Art Pottery wares, illustrated in *The Pottery Gazette*, July 1904.

included "metal shank buttons in blues, greens and a variety of iridescent shades and hues of pinks and mauves, following the colour line of the pottery." (*P&GR*, February 1918)

Peter Brannam recalled a bitter feud which arose between Baron and the Brannams in the 1930s. With the increasing use of motor cars, the tourist trade provided a welcome sideline to both firms. According to Brannam:

> This astute operator . . . erected a sign at the very entrance to the town saying quite simply "To the Pottery" with an arrow pointing to his own establishment . . . The fury of my uncle and father was further fuelled by the discovery that this wily competitor had made himself known to all the Coach Proprietors in Ilfracombe and doled out a shilling to every driver who brought a load of passengers to his pottery!

The Brannams retaliated in kind and the feud continued until Baron's death in 1937, when Brannam took over the Rolle Quay Pottery. Production wound down and the pottery closed for good during the Second World War.

Marks: Variations of "W. L. Baron Barnstaple", incised. Pieces marked "Baron & Hill" or "B&H", with dates of 1895 or 1896, have been recorded but not readily explained. Shape numbers as high as 471 have been recorded.

References: *BAPS*; Brannam, Peter, *A Family Business* (Peter Brannam, Devon, 1982); Cameron; Coysh; Edgeler; Edgeler, Audrey, "Baron 'Piece Numbers'", *BAPS*, January 1991, pp. 5–11; Godden 1964; *PG*; *PG Diaries*; *PG>R*; *P&GR*.

Beardmore, Frank, & Co. Ltd
Sutherland Pottery, High Street, Fenton, Staffordshire
1903–14

The Sutherland Pottery had been successively worked by Mason, Minton, Taylor, Forester & Hulme, Hulme & Christie and finally Christie & Beardmore, before Frank Beardmore took it over in 1903. He was described by G. W. Rhead as "a maker of commercial wares of an artistic character".

Beardmore's early advertisements offer "Artistic Pottery", but in 1905 he introduced Sutherland Art Ware, a mass-produced ornamental ware with Art Nouveau-influenced shapes and decoration. The Landscape series, marketed as "A Bit of Old Country", are easily recognized by their dark grounds at the bottom and lighter grounds at the top. Those known include Wayside Inn, Surrey Scenes and Sussex Homesteads. Also offered were a "Dutch" style of decoration with windmills, florals, girls bathing and a series illustrated after Kate Greenaway (Colour IV). In 1909 a Chinese design "slightly suggestive of Willow" was introduced.

In March 1906 Beardmore was shown, along with his wares, in a *Pottery Gazette* advertisement, urging: "I cordially invite buyers visiting England to call and see me. You will probably find me as depicted above talking about my Sutherland Art Ware. The new samples for 1906 possess strong individuality and are money makers all the way. If you are seeking originality at a popular price consult me."

Glasian Ware, introduced in 1909, was "treated with glaze effects in great variety. Several of the coloured effects obtained are excellent, including the famous Chinese red." (*PG*, April 1909) Other art wares made during this period were Basaltine (Greek figures on a matt black ground) and Athenian (Greek figures with coloured draperies on so-called Grecian shapes).

The Pottery Gazette Diary of 1915 reported: "The whole effects of Frank

Beardmore & Co. Ltd, Sutherland Pottery, Fenton sold by public auction 16 & 17 June 1916." Although the purchasers of best-selling shapes and designs are listed, there is no mention of the art wares themselves.

Marks: A circular mark with a dove bearing an olive branch in the centre surrounded by "FRANK BEARDMORE & Co." with "SUTHERLAND ART WARE" beneath.

References: Beardmore, Frank & Co., *Catalogue* (no date); Blacker; Cameron; Godden 1964; Meigh; *PG*; *PG Diary*; Rhead.

Beech & Adams,
John Street, Stoke-on-Trent, Staffordshire
1889–92

This firm advertised in *The Pottery Gazette* of January 1889; "Beech & Adams, (Late Harvey Adams & Co.) . . . Manufacturers of the Art Majolique Ware, New designs, Unique, Artistic, Grotesque, Shapes & Colours to suit all buyers of Art Pottery." This was apparently an effort to make the outdated majolica appeal to the still-growing market for art pottery.

References: Bergesen; Godden 1972; Meigh; *PG*.

Bell, Robert Anning
1863–1933

Best known for his book illustrations, Bell also painted, sculpted and designed mosaics, stained glass and ceramics. While head of the Liverpool School of Architecture, he met Harold Rathbone. Bell had been working with plaster bas-reliefs for some time, and the idea of turning to fired ceramics may have come from Walter Crane*, who noted: ". . . coloured plaster decoration is not permanent, its colours are liable to fade, and its material easily damaged . . . Possibly with further experiment some worker to-day may be as fortunate at this art of coloured relief work as Luca della Robbia, who, we are told, found suddenly a glaze of almost endless durability . . ." The Della Robbia Pottery* catalogue for 1900 lists Bell as a modeller for the pottery and in that year *The Studio* commended a vase designed by Bell for Della Robbia. Lockett illustrates a Della Robbia plaque which was based upon a plaster relief designed by Bell. At the Arts and Crafts Exhibition, 1903, Minton Hollins (& Co.) (Ltd)* exhibited a panel of tiles for a wall diaper designed by Bell.

A member of the Art Workers Guild* since 1891, Bell became Master in 1921. He was a regular exhibitor at the Royal Academy from 1885, and at the Royal Society of British Artists from 1880 to 1893. From 1918 to 1924 he was Professor of Design at the Royal College of Art. Bell's views that British design was too derivative and that an English style was urgently needed were widely disseminated, and influenced industrial ceramics in the early twentieth century.

References: A&CXS 1903; Brighton 1984; Cecil, Victoria, "The Birkenhead Della Robbia Pottery," *The Connoisseur*, September 1980, vol. 205; Crane, Walter, "Notes on Gesso Work", *Studio*, vol. 1, 1893, p. 45; FAS 1973; Hannah; Jervis; Johnson; Lockett; "A New Treatment of Bas-Reliefs in Coloured Plaster", *Studio*, vol. 1, 1893, pp. 53–55; *Robert Anning Bell* (FAS, 1934); *Studio*, vol. XX, 1900. p. 86; *Studio*, vol. XXIV, 1902, p. 261; Tilbrook; Williamson.

Belle Vue Pottery

Ferry Road, Rye, Sussex
1876–1939
Rye Pottery
1947 to the present day

William Mitchell was manager of the Cadborough Pottery, brown ware potters at Rye, by *c.*1834. By 1859 W. Mitchell & Sons had become the proprietors of Cadborough. Along with his lodger, William Watson, Mitchell began to experiment with the applied decoration which became typical of Rye pottery.

In 1876, Mitchell established the Belle Vue Pottery on Ferry Road, Rye. The pottery specialized in rustic ware whose surface imitated tree bark, and sprigged pieces, often bearing hops (10). His revival of the traditional Sussex pig was very popular. The pots were glazed with green or brown lead glazes.

William's sons, Henry and Frederick, had been helping him at the Cadborough Pottery for many years, and Frederick succeeded him at the Belle Vue Pottery. Frederick is credited with having introduced pin dust (powdered brass, a waste product from pin-making, which was imported from Belgium), obtaining from it a rich green glaze.

When Frederick Mitchell died in 1875, his widow, Caroline, who is said to have been a skilled potter, continued the pottery. She favoured copies of Continental wares but also produced Trojan Ware, which consisted of some eighteen different shapes after the pottery excavated at Troy by Dr Schliemann. These were exhibited at the South Kensington Museum. In 1877 *The Art Journal* commented:

> The hand, or rather the fingers, have been freely used in moulding the shapes, and it is obvious that they have been directed by an artistic spirit, although as yet Art has not greatly aided them, for the works are still in their infancy . . . Even now the productions are numerous and varied; some vases, pilgrims bottles, water jugs, &c., are of considerable excellence.

In 1882, Frederick's nephew, F. T. Mitchell, joined the firm, continuing alone after Mrs Mitchell's death in 1895. He returned the pottery's output to the traditional wares produced by his uncle. Although his work was of a higher

10 Belle Vue Pottery wedding plate.

standard than that of his predecessors, some feel that it lacks the naïve charm of earlier Rye wares. He introduced Palissy wares with modelled snakes, lizards and molluscs. He also experimented with blue-gold lustres, which were used on miniatures. After his death in 1920, his widow, Edith, continued for ten years with the help of Edwin Twort.

In 1930 the pottery was purchased by Mrs Ella D. Mills, who turned it to producing green-glazed souvenir wares for the tourist trade. Hop Ware and Rustic Ware, now known as Sussex Art Pottery, continued to be made, however. Some blue-gold lustre miniatures were also made.

In 1939, black-out regulations forced the pottery to close. The wood-fired kilns had to be kept burning continuously for seventy-two hours in order to fire the wares, and the flames escaping from the bottle-neck kilns were highly visible.

In 1947 the pottery was reopened as the Rye Pottery by John and Walter Cole. Trained as sculptors and studio potters before the war, they now wanted to turn their hand to making useful wares, and for some years the pottery was known for its well-designed contemporary tablewares. The pottery is now run by Walter Cole's son and is particularly well known for its large figures of Chaucer's Canterbury pilgrims and other ornamental wares.

Marks: Incised marks "SRW Rye" or "SAW Rye" (after 1930). Pieces with "Rye, FTM, Sussex Ware" or some variations of these are also found. Codes for the clay take the form of an incised score mark, and dates were occasionally added.

References: *AJ*, vol. 16, 1877; Baines; Brears 1971, 1974: Cameron; Coysh; Godden 1964, 1972; Hampson; *KPOD, Sussex* 1859–1934; "Keramics", *Artist*, 1888, vol. IX, p. 249; Matthews, Oliver, "Rediscovered Sussex Pottery", *The Antique Collector*, September 1979, pp. 65–67.; "Old Sussex Pottery", *PG*, November 1911, pp. 1242–43; *Rye Pottery 1869–1969*, Rye Museum, 1969; Thomas 1974.

Benthall Pottery

See Salopian Art Pottery.

Bevington, Thomas

Burton Place Works, Hanley, Staffordshire
1869–91
Mayer Street Works, Hanley,
*c.*1892–99

Formerly a partner in the firm of J(ames) and T(homas) Bevington, Thomas, by 1883, was advertising himself as an art pottery manufacturer. Rhead very frankly assessed the firm's wares:

> Made from 1870–85 very large quantities of fancy china, chiefly "flowered" ware with flowers modelled in high relief. Originated the "lotus" ware, afterwards carried to great perfection by Bernard Moore*. Thomas Bevington also made the "mossed" china, which was artistically vile but commanded a large sale. He, however, made some good wares, and employed for some years the modellers [William Wood] Gallimore and Rowland Morris.

The firm became the Hanley Porcelain Co. in 1899.

Mark: a six-pointed star surrounding a crown and the initials "T B", or "T. B." only, printed.

References: Bergesen; Godden 1964, 1972, 1988; Meigh; *PG*; *PG Diary* 1883; Rhead.

Bingham, Edward

See Castle Hedingham.

Blythe Pottery

See Newsham Pottery.

Bourne & Leigh (Ltd)
Albion Pottery, Burslem,
Staffordshire
1892–1941

This firm, which produced table and toilet wares, advertised Bon Ton Art Ware in 1906. In May 1909, *The Pottery Gazette* reported: "The 'Bon Ton' is a most suitable decoration to accompany certain styles of furniture that are popular just now. It is a hand decoration with freedom of treatment. The same decoration is shown on flower pots in various sizes." The wares were mentioned again in 1911.

References: Godden 1964; *PG*.

Bourne, Joseph & Son (Ltd)
Denby Pottery, near Derby,
Derbyshire
1809 to the present day

11 Joseph Bourne & Son (Ltd), Danesby Ware vase, buff stoneware with blue, brown and green glazes, marked "Danesby Ware BOURNE DERBY ENGLAND". h. 23.5 cm.

The Denby Pottery, established in 1809 and acquired by Joseph Bourne in 1812, has always been known for its fine-quality brown stonewares. Advertisements throughout the nineteenth and early twentieth centuries promoted such domestic items as baking dishes, foot warmers, jugs, filters and even fowl fountains. These were usually known under the trade name Denby Ware, which is still used today. In September 1904 *The Pottery Gazette* announced the introduction of Danesby Ware: "This is a new colour scheme with pretty mottled effects. It is applied to all tableware and also to art vases, flower pots, &c." These wares were seldom mentioned in the firm's advertisements or reviews of their wares in the trade press but, in June 1921, *The Pottery Gazette & Glass Trades Review* reported that in the Danesby wares "... are to be seen some broken glaze effects which, for stoneware of this type, can only be regarded as a ceramic achievement." (11)

It seems that it was in 1925 that Danesby ware progressed beyond "glaze effects" to an art pottery which very much resembled wares being made by other firms some three decades before. The new Danesby wares were tube-lined with "mottled electric blue or green grounds, broken up with other bright colours embodied in the design" (*PG>R*, September 1925). In 1928, Danesby Orient, a salt-glazed ornamental ware with a matt crystalline glaze, was introduced.

In later years, the firm continued to concentrate on domestic wares. Their stoneware body was ideally suited for the oven-to-tablewares so popular in the late twentieth century. The firm has undergone several changes of ownership and style in the past decade, with all styles incorporating the trade name Denby.

Marks: "Danesby Ware", printed in script.

References: Blacker; "Bournes of Denby Celebrate 150 Years", *PG>R*, January 1959; Bunt; "Denby Pottery Centenary", *PG*, September 1909; Godden 1972; Jewitt; Niblett; Oswald; "Pottery from the Peak District Foothills", *PG>R*, June 1953; *PG*; *PG>R*; Rhead.

Brain, E. & Co. Ltd
Foley China Works, King
Street, Fenton, Staffordshire
1904–58; *Coalport Works,*
Fenton 1958–67

The Foley Pottery was built for Robinson & Son in 1850; it was they who first adopted the trade name Foley China (later used by Wileman & Co.*). In 1885 Elijah Brain (1845–1910), after a thirty-year career with Baker & Co., purchased the business with partners A. B. Jones and W. Hawker, continuing to trade under the style Robinson & Son until 1903. By then, George Thomas Hawker had succeeded

his father, W. Hawker, and Elijah's son, William Henry Brain had joined the firm. Elijah Brain died in 1910, and G. T. Hawker retired in 1912, leaving W. H. Brain in sole control. Ill health forced him to retire in 1921, and the pottery was then run by Bert Wright until his death in 1930. W. H. Brain then returned and ran the pottery until his death in 1937. His son, E. W. Brain, succeeded and in 1958 acquired Coalport China Ltd, to whose Fenton works the firm moved. J. Wedgwood (& Sons Ltd) acquired the firm in 1967.

Although best known for their china tablewares, E. Brain & Co. Ltd produced two lines of art wares before the First World War. In 1903 they introduced Harjian Faience, with free-hand decoration in "modern art style"; the wares included tea services and vases. In 1904 they introduced another art ware, Peacock Pottery.

Marks: "Foley Art China" with a Staffordshire knot surrounding the initials "R & S L", with "Harjian England"; "Foley Art China Peacock Pottery, England Rd.", with picture of a peacock.

References: Bunt; Cameron; "A China Manufacturer in the Antipodes", *PG*, December 1906, pp. 1411–12; Godden 1964, 1988; "A Hundred Years of Foley China", *PG>R*, May 1952, pp. 747–49; Meigh; *PG*; *PG Diary*; *PG>R*; Rhead; Stuart; Watkins.

Brannam & Son

c.1875–81
Brannam, C.H. (Ltd)
Barnstaple, Devon
1881 to the present day

Potters have been working in both Litchdown Street and the North Walk area of Barnstaple for many centuries. In 1847 Thomas Brannam rented the North Walk pottery. Although his products were primarily red domestic earthenware, tiles and pipes, he made some more elaborate wares with sgraffito decoration which won a bronze medal at the Great Exhibition of 1851. In 1853 Thomas purchased the Litchdown Street pottery.

Charles H. Brannam (1855–1937) had the advantage of gaining practical experience at his father's pottery and receiving artistic education from Barnstaple's art school. After a period of working for his brother-in-law, a photographer, he was taken into his father's business. As early as 1875, the firm advertised in *Morris's London Business Directory* as Brannam & Son. Apparently, Thomas Brannam was suspicious of his son's desire to make art pottery, allowing him to experiment only if he paid the costs of materials and firing. In 1879, the business was faring badly, and Thomas agreed to let Charles rent the Litchdown premises for art pottery production. The quick success of these wares is almost incredible. In 1880, Brannam signed a contract with Howell & James*, one of whose partners was a Barumite. When Thomas retired in 1881, the firm's style was changed to C. H. Brannam. Although Charles now had control of both potteries, useful wares continued to be made at North Walk, as indeed they have been continuously throughout the firm's history.

In 1882 Brannam signed a contract with Liberty & Co.*, who became the sole London agent for Barum Ware (Barum being the Roman name for Barnstaple) until 1914, and remained one of the pottery's agents until the 1930s. This retail outlet influenced Brannam's designs, firstly when Liberty's was in the forefront of the cult of Japan, and later when it became synonymous with Art Nouveau. None the less, the pottery was able to absorb these influences, and even fads, without losing the integrity of its North Devon traditions. The early wares were sgraffito wares not unlike those which had been produced in the region for many years. In

1882, *The Artist* admired the grotesque figures, birds and arabesque designs, all of which were to continue to characterize Brannam's pottery for decades to come. Decoration with coloured slips was introduced *c.*1884. It may be coincidental that W. L. Baron*, who had used the technique at Doulton & Co. Ltd, Lambeth*, arrived at Brannam's at about the same time.

From 1885, when the firm received the first of many royal warrants from Queen Victoria, the wares were named Royal Barum Ware. Brannam's grotesques, introduced in the 1890s, remained very popular until the First World War. At the 1910 Brussels International Exhibition, they displayed "a goodly array of 'freak cats' – such animals as 'never were on land or sea . . .'" (*PG*, August 1910). In 1912 Brannam advertised: "Buttons, earrings, hat pins, and links in beautiful soft Blues, Greens, Blue and Green-shaded &c." (*PG*, April 1912)

In 1914 C. H. Brannam became a limited company, the business being continued by Charles's sons, Charles William and John Woolacott Brannam. John, who had spent three years training and studying in the Staffordshire Potteries, managed the pottery and Charles, who had trained in a bank, managed the office and sales. In 1915, they acquired the Fremington Pottery*, which was used for the production of redware until it was demolished in the late 1920s.

Although the pottery suffered the loss of a number of its workers during the First World War, a considerable number of its men were over age, having been with the firm for many years, and the remainder of the workforce was made up of women. Perhaps because it was able to rely on its steady output of useful wares, the pottery survived the war and even managed to introduce some new lines (12). In 1916 it introduced Artavia Ware, a red-clay toilet ware, with only the inside glazed, cheap and suitable for "cottage or bungalow" and a matt black glaze. In 1917 the pottery introduced mottled green matt glazes.

Nevertheless, with the retirement of C. H. Brannam, the pottery seemed to lose its impetus. Photographs of the art pottery in the 1920s show wares very similar in style to those made three decades earlier, although the decoration had been

12 C. H. Brannam Ltd Royal Barum Ware illustrated in *The Pottery Gazette*, September 1915.

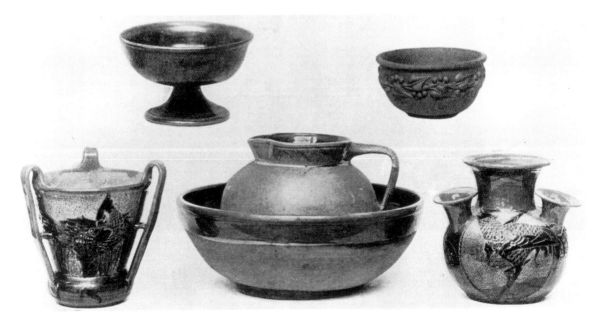

simplified for economy's sake (13). The firm increasingly relied on useful wares, especially flower pots. The Trebarum ware designed by Harry Trethowan of Heal & Sons Ltd, and retailed exclusively by them, was one of the few innovations of the pottery between the wars.

The firm was run for many years by Peter Brannam, J. W. Brannam's son. It is now owned by the Fox family, proprietors of the Candy Pottery in Newton Abbot for over a century.

Designers, decorators and modellers before 1920

Dates refer to periods at which individuals are known to have worked at C. H. Brannam. Dates in brackets are those of birth and death.

As late as 1882, *The Artist* reported that "with the exception of perhaps one pupil, he [C. H. Brannam] employs no one to assist him in his work, but throws, designs and finishes his own productions." Brannam later employed trained assistants for the design and decoration of his art wares. Of the eight pots exhibited at the Arts & Crafts Exhibitions of 1889 and 1890, only four were designed by Brannam and two executed by him.

JOHN ARTHUR BAMKIN *c.*1886–*c.*1902. His work was exhibited at the Arts and Crafts Exhibition of 1889. He was probably hired straight from the Barnstaple Art School, which he attended 1886–95. Work uncommon. Mark: "AB".

WILLIAM L. BARON*, *c.*1884–93. His work was exhibited at the Arts and Crafts Exhibitions of 1889 and 1890. Mark: "WB".

FREDERICK BOWDEN (1865–1917), *c.*1880–1917, was known for his high-relief modelling, especially reptiles. His work was exhibited at the Arts and Crafts Exhibitions of 1889 and 1890. Mark: "F. B".

FREDERICK BRADDON (b. 1874) worked intermittently *c.*1890–1934. He designed

13 C. H. Brannam Ltd vase with sgraffito and slip decoration, *c.*1914–30. Impressed "C. H. BRANNAM LTD BARNSTAPLE, MADE IN ENGLAND". h. 18 cm.

many of the vases for Liberty & Co. His pieces are mostly in the Art Nouveau style. His work was exhibited at the Brussels International Exhibition in 1910. He later worked at Poole and Honiton. Mark: "FB".

R. G. COWIE worked c.1907. A charger with his signature and the date July 1907 was exhibited by the Fine Art Society in 1973.

OWEN DAVIS (d. 1913) was a Barumite who had found success as an interior decorator of the Revivalist school. In 1880, Brannam successfully copied one of his designs, leading to other commissions.

JAMES DEWDNEY, 1881–1906+. His work was exhibited at the Arts and Crafts Exhibitions of 1889 and 1890, and in 1890 in Torquay. During the period 1897–1903 he was the highest paid-employee in the pottery. Mark: "JD", "J. D." or a monogram.

HORACE ELLIOTT* designed a pot made by Brannam's and exhibited at the Arts and Crafts Exhibition in 1889. Elliott was a good friend and adviser to C.H. Brannam from 1880.

GARLAND was a decorator in 1897.

FRANK CARUTHERS GOULD, another successful Barumite, was a well-known caricaturist for *The Westminster Gazette*. He designed grotesques, including a series of bird jugs, e.g. Eared Grebe, and political grotesques, e.g. Chamberlain as Brer Fox and President Kruger as Brer Rabbit, which he introduced in 1899; other caricatures included Lord Lansdowne, Lloyd George (as a Welsh Terrier) and the Lord Halbury Toby Jug of c.1913.

W.R. LETHABY, of Liberty & Co.*, designed tiles shown at the Arts and Crafts Exhibition, 1889.

THOMAS ARTHUR LIVERTON (b. 1875), working c.1888–c.1913. His work was exhibited at the Brussels International Exhibition in 1910 and is distinguished by Art Nouveau floral themes. Mark: "TL" or "LT".

REGINALD PEARSE, c.1900–04, made modelled and grotesque pieces. Mark: "RP".

A.B. RICE decorated pottery shown at the Arts and Crafts Exhibition, 1890.

FRANK THOMAS, c.1897–1902+, had a particular gift for the fantastic. Mark: "FT" or "F. t."

STANLEY WILLIAMS, c.early 1890s–c.1898, modelled grotesques and dragons. Mark: "SW".

BEAUCHAMP WHIMPLE (1880–1905) c.1895–1902. A vase exhibited by the Fine Art Society in 1973, marked "CBW 1900", may be his work. Mark: "BW".

Marks: A wide variety of incised marks incorporating "C. H. Brannam" and/or "Barum Ware", perhaps including the designer/decorator's mark (see above). An impressed mark was used from c.1900, and "Ltd" was added from 1914.

References: *A&CXS* 1889. A. F., "Royal Barum Ware", *MA*, vol. XXIII, 1898, pp. 568–69; *BAPS*; Blacker; Brannam, Peter, *A Family Business* (Peter Brannam, Devon, 1982); Cameron; Coysh, "Devon Pots First Became Different at Brannam's Barnstaple", *Devon Life*, October 1977, pp. 30–31; Edgeler; FAS 1973; Forsyth; Godden 1964, 1972; Hampson; Haslam 1975; James, Susan, "Barum Ware", *The Antique Collector*, August 1973; Jervis, W. P.; *KPOD Devonshire* 1866–1923; "Keramics", *Artist*, January 1882, vol. III, p. 20; Levy; Lyons, Harry, *C.H. Brannam Barum Ware* (Bloomsbury Antiques, 1991); *MBD* 1875–1930; Monkhouse, Cosmo, "Some Original Ceramists', *MA*, vol. V, 1882, pp. 443–50 (reprinted in Haslam 1975); Morris; Phillips, J., "The Potter's Art in Devonshire", *Report and*

Transactions of the Devonshire Association, vol. 13, 1881, pp. 214–17; *PG*; *PG Diary*; *P&GR*; "A Short Visit to Some North Devonshire Potteries", *PG*, January 1913; Rhead; "Royal Barum Ware", supplement to the Easter Annual, *AJ*, 1902; Sabretasche, "Barum Ware", *Artist*, July 1881, vol. II, p. 212 (reprinted in Haslam 1975); Strong, Hugh, *Industries of North Devon, 1889* (North Devon Journal 1888–89; David & Charles, 1971); Thomas 1974.

Braunton Pottery Co. (Ltd)

Station Road, Braunton, Devon

1912–71

William Fishley Holland* built this pottery in 1912 for its owner Mr Hooper, a solicitor. As manager, Holland had a free hand and produced some interesting wares. His grandfather's blue glaze, which he learned to make while working at the Fremington Pottery*, was his most successful line before the First World War. He briefly hired a decorator, whose initials were A. J. and who had also worked at Fremington. Holland did not keep him long, as he saw the fashion for highly decorated wares changing. "I found a few shops in London that specialized in peasant pots, and with their custom and other orders I managed to keep four men fully employed in the pottery," he wrote. As Holland's conscription category was low, he was able to remain at the pottery during the early years of the war. He began to make slipwares copied from Continental wares, the supply of which had been interrupted by the war. He developed a clear green glaze which was to become a William Fishley Holland trademark. When Holland was eventually called up for service, his wife ran the business and one of his throwers ran the pottery. After the War interest in hand-made pottery increased, as did the demand for bright colours, at which Holland excelled.

Despite the pottery's success, in 1921 Hooper went bankrupt, and the pottery was sold to William Henry Garnish, who had trained at Barnstaple School of Art and Baron's Rolle Quay Pottery*. The pottery specialized in domestic wares in the clear glaze colours developed by Holland (Colour XIX). Disappointed in his efforts to purchase Braunton himself, Holland and his assistant, George Manley, moved to Clevedon, where Sir Edmund Elton's* son, Ambrose, was attempting to keep the pottery going. When Garnish retired in 1959, the pottery was taken over by Henry Chichester, who had been with the pottery since 1928, and Frederick Luscombe.

Marks: "BRAUNTON POTTERY DEVON", black printed mark, "BRAUNTON POTTERY", impressed; "WFH" monogram incised on early pieces.

References: Edgeler; Holland, W. Fishley, *Fifty years a Potter* (Pottery Quarterly, Tring, 1958); Godden 1964; *KPOD Devonshire*.

Brewer Bros

Shiphay, Collaton, Cockington, Torquay, Devon

1895–c.1903

William and James Brewer operated this pottery in partnership with Ralph Willott (formerly of the Longpark Terra Cotta (China) Works*). It has been stated that the firm made slip-decorated wares similar to those which the brothers had made with their father, Henry Brewer*, at the Broomhill Pottery, but this has not been substantiated. The firm probably made only domestic terracotta. The pottery was purchased by some former employees of the Aller Vale Pottery*, becoming the Longpark Pottery Co. (Ltd)* c.1903.

References: Cashmore, Chris, "Longpark Guesses", *TPCS Magazine*, October 1985, pp. 8–9; *KPOD Devonshire*; Thomas 1978; *TPCS Magazines*.

Brewer Bros & Lamy
Park Road, St Marychurch,
Torquay, Devon
c.1908–14

The pottery was established by William and James Brewer after they sold their share of the Longpark Pottery *c.*1903. Their partner is believed to have been the French artist P. F. Lamy. The pottery seems to have closed at the beginning of the First World War, and James Brewer returned to work at the Watcombe Pottery. There are no known wares or marks.

References: Cameron; Thomas 1978.

Brewer, Henry
The Broomhill Pottery,
St Marychurch, Torquay,
Devon
c.1889–93

Henry Brewer, formerly of J. Wedgwood (& Sons Ltd)* and the Watcombe Terra Cotta Co. (Ltd)*, set up his own pottery after Watcombe's closure in 1883. He was assisted by his sons, William and James (*see* Brewer Bros). Although it is likely that Brewer, at least initially, made terracotta wares of the Watcombe type, Thomas attributes Aller Vale-type slip-decorated wares incised "Brewer/Barton/Torquay" to this pottery.

References: Cameron; Thomas 1978.

Bristol "Cat & Dog Pottery"

See Pountney & Co. (Ltd).

Bristol "Cock & Hen Pottery"

See Pountney & Co. (Ltd).

Bristol "Fiscal Pottery'.

See Pountney & Co. (Ltd).

Bristol Leaded Lights Pottery

See Pountney & Co. (Ltd).

Bristol Pottery

See Pountney & Co. (Ltd).

British Fine Art Pottery Ltd
Longton, Staffordshire
c.1911

The Pottery Gazette carried announcements of this firm's liquidation (March 1911), appointing a receiver (April 1911), and ending the receivership (February 1912). *Morris's Business Directory* listed the firm as art pottery manufacturers 1911–13.

Broomhill Pottery

See Brewer, Henry.

Browne, Leach & Senior

See Leeds Art Pottery (& Tile Co.) Ltd.

Buchan, A. W. & Co. (Ltd)

Thistle Potteries, Portobello, Edinburgh, Scotland
1867–1973; Thistle Pottery, Crieff, 1973 to present day

The Portobello or Waverley Pottery was first established in 1770. After numerous changes of ownership, A. W. Buchan acquired the lease in 1867, ultimately purchasing the property. By 1874, J. F. Murray of the Caledonian Pottery, Glasgow, had joined the firm, which then operated under the style Murray & Buchan. When Murray retired in 1877, the style changed to A.W. Buchan & Co. The pottery produced large quantities of domestic stoneware of every description, including Waverley Art Stoneware (*PG*, June 1890). Cruikshank illustrates a stoneware pot with sprigged decoration in several coloured clays which was probably characteristic of these wares. He also mentions another art ware – Portobello Faience.

Marks: An impressed or printed star mark.

References: "Buchan of Portobello", *PG>R*, April 1966, pp. 411–13; Cruikshank; Fleming; Godden 1964; Jewitt.

Bulley, Herbert Edward

Bulley began at Aller Vale (Art) Pottery* as a lorry driver and worked his way up to sales representative and finally manager. He left Aller Vale in 1905, apparently because of his dislike of the new owners, Hexter, Humpherson & Co. (Ltd)*. With several partners, he founded the Longpark Pottery Co. (Ltd)*, of which he was manager and secretary from 1905 until 1913.

References: Cashmore 1983; Thomas 1978; *TPCS Magazines*; Ward, Snowden, "Two Devonshire Potteries", *AJ*, 1900, pp. 119–23.

Burlington Art Pottery Co.

Granville Works, Hanley, Staffordshire
c.1910

This firm advertised itself as "Manufacturers of Art Pottery, faience, and Specialities in Bright Colours, Plaques, Ash Trays. Jardinières, Vases, Miniatures from 1½ ins. to 14 ins. high, Hat-Pin Heads, Trays &c." (*PG*, July 1910) Carlo Manzoni* had operated the Granville Works c.1894–98.

References: Godden 1964, *PG*; Williamson.

Burmantofts Pottery

Burmantofts, Yorkshire, Wilcock & Co., 1863–88; The Burmantofts Co. Ltd, 1888; Leeds Fireclay Co. Ltd, 1889–1964+.

William Wilcock and John Lassey acquired land for a colliery at Burmantofts in 1842. Clay was discovered on the site and by 1845 they were mining coal and making bricks. In 1858 John Lassey died, his widow Margaret continuing the firm. By 1861 the firm had added sanitary tubes to their production. This was an extremely lucrative trade in a period when so many new sewers were being laid down. In 1863 Mrs Lassey sold her interest to John Holroyd, and the firm styled itself Wilcock & Co. In 1870 Holroyd turned over his responsibilities as joint manager of the firm to his son, Ernest Etches Holroyd. Salt-glazed bricks and other architectural goods were manufactured. John Holroyd died in 1873, and William Wilcock in 1878.

Ernest Etches found other business matters too engrossing, and, in 1879, his brother James became manager. Within eighteen months, James had begun the production of tiles, art pottery and architectural faience. A meeting with Maurice B. Adams resulted in the architect designing a wide range of architectural goods for the firm. The 1882 *Catalogue* included his fireplaces in faience and wood, centres, cornices, panels and strips in faience, domestic windows in construction faience, porches, and a public refreshment bar entirely clad in faience and tiles.

The same *Catalogue* illustrated a wide variety of art pottery. Early wares included bottles and jars in the African style and some judicious use of relief-moulded Japanese motifs. The influence of two French artists, V. Kremer and B. Sicard, who had been trained by Palissy revivalists, can be seen in the numerous vases adorned with modelled reptiles. Also included are figures of a lioness and her cubs and Leda and the Swan. These were dipped in majolica glazes in the popular "art colours" of the period: olive green, lemon yellow, brown and dark blue. Although the glazes, in combination with relief moulding, were the sole decoration on most pieces, a variety of decorative techniques was sometimes employed. Modelled figures such as snakes, dragons and lizards were applied to vases and other ornamental wares. Sgraffito and barbotine (mistakenly called *pâte-sur-pâte*) techniques were sometimes also used (14–17 and Colour V–VII).

In 1888 the style changed to The Burmantofts Co. Ltd. The following year the company amalgamated with five local fireclay companies to form the Leeds Fireclay Co. Ltd. This was the largest clay-working company in the country, with a share capital of £1 million. James Holroyd died that year, to be succeeded by his son, James Junior. In 1896, the latter was in turn succeeded by Robert Bond, who had been with the pottery since the 1870s.

During this period there had been a change in the nature of art pottery production, as demand increased. In 1881, a reporter on *The Artist* exclaimed: "Each piece is unique . . . there are no *pairs*!" More than twenty years later, mass production, albeit "artistic", was certainly the order of the day:

> There is a freedom of conception in the forms and a like unlimited latitude
> allowed in the ornamentation that tends to artistic work. It is a feature of
> most of their productions that both the modeller and decorator have a free
> hand. Of course the company do make hundreds of pieces that are exact

14 Burmantofts Faience dragon vases in green and brown glazes. Moulded mark "E.H.", impressed "Burmantofts", with "Burmantofts Faience" mark, h. 67.4 cm.

15 Burmantofts Faience charger decorated in blue, turquoise, green and amethyst, impressed "Burmantofts Faience", painted marks "DK DSG 101558", h. 45.6 cm.

Below, **16** Burmantofts Anglo-Moresque jardinière, *c.*1900.

Below right, **17** Burmantofts plaque.

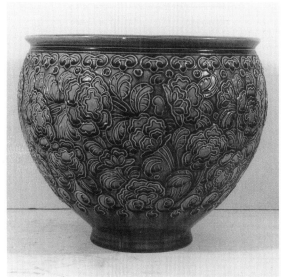

reproductions of each other, and they are very good even then. But, on the other hand, they make pieces that are unique, in that each piece is the free work of an artist who has ideas of his own and carries them out . . . (*PG*, August 1903).

The vast majority of Burmantofts' output consisted of relief-moulded jardinières, flowerpots, pedestals and umbrella stands, items which *The Pottery Gazette* reporter politely described as "bulky" (*PG*, January 1900). They also offered a line of small "uglies and grotesques", which were dipped in the famous glazes.

Speciality lines included Anglo-Persian Ware introduced in 1887, Anglo-Moresque Wares introduced in 1900 and Floruda Ware, which was unglazed terracotta with painted floral decoration. Later wares were increasingly in the Art Nouveau style.

Burmantofts' tiles are distinguished by their typical glazes. The designs are relief-moulded and in some cases nearly obscured by the thick majolica glaze. Birds and lizards appear on some tiles, although floral designs are most commonly found. Tiles and panels were decorated with barbotine. The 1882 catalogue showed a very strong Japanese influence, for example in the animal tiles with bamboo backgrounds. The aesthetic sunflower was also much in evidence.

By 1904 Burmantofts had increased their range of colours, including "novelties in running glazes" and, under the influence of Art Nouveau, were offering pinks, rich red, light green and dark green (*PG*, May 1904). Many of the later pieces had shaded or running glazes. These efforts to appeal to changing taste were not very successful and art pottery manufacture ceased later that year.

The firm continued to produce architectural terracotta and faience. In 1908 it introduced Marmo, a matt glazed terracotta in imitation of Doulton's Carrara. This was both cheaper and said to weather better than the marble that it imitated. Used for the entire façades of buildings, Marmo continued to be popular after the First World War.

Designers, decorators and modellers

MAURICE BINGHAM ADAMS (1849–1933), working from 1880, designed a wide range of architectural items illustrated in the 1882 *Catalogue*.

ROWLAND BROWNE was later a partner in Browne, Leach & Senior (*see* Leeds Art Pottery (& Tile Co.) Ltd).

ESTHER FERRY came from Linthorpe Pottery* c.1889.

WILLIAM FERRY came from Linthorpe Pottery* c.1889.

E. W. GODWIN designed Japanese-style relief-moulded tiles c.1881.

GEORGE C. HAITÉ (1855–1924) was a prolific freelance designer who designed architectural faience for Burmantofts.

E. HAMMOND, working c.1882, formerly with Minton's Art Pottery Studio*.

F. HAMILTON JACKSON designed panels illustrating the art of music in the 1882 *Catalogue*.

V. KREMER, principal artist, modeller from c.1881. A French ceramist who had been trained by Palissy revivalists, he designed Anglo-Persian Wares.

HAROLD LEACH was later a partner in Browne, Leach & Senior (*see* Leeds Art Pottery (& Tile Co.) Ltd).

P. MALLET painted faience c.1886.

W. J. NEATBY worked at Burmantofts as a designer and decorator c.1880–90.

E. T. RADFORD* threw at Burmantofts 1880–86, having left the Linthorpe Pottery*.

B. SICARD was a French ceramic artist.

J. MOYR SMITH designed relief-moulded tiles and panels, including *Deerstalking, The Tennis Player, Skating* and *Dancing*.

E. CALDWELL SPRUCE, a sculptor, was the principal modeller from the late 1880s to the early 1890s.

HENRY TAYLOR, working c.1890–1904, was Head Glazier and Ceramic Artist.

RACHAEL TAYLOR, *née* Smith, came from the Linthorpe Pottery* c.1889. She was the wife of Henry Taylor.

WILLIAM H. THORP designed dados, strings and cornices in terracotta and constructive faience illustrated in the 1882 *Catalogue*.

Marks: "BURMANTOFTS FAIENCE" impressed; "BF" monogram, painted or incised; various painted or incised initials or monograms by artists.

References: "The Art Industries of England – I. Ceramics & Faience", *Decoration*, January 1889, pp. 3–4; Austwick; Barnard; *Burmantofts Pottery* (Corporation Art Gallery, Bradford, 1984); Cameron; *CM*; Coysh; Day, Lewis F., "Tiles", *AJ*, 1895; *Decoration*; Godden 1964, 1972; Hart, Clive W., *Linthorpe Art Pottery* (Aisling Publications, Cleveland, 1988); Haslam 1975; Hurst; "J. Moyr Smith", *The Biographer*, October 15 1894, reprinted *GE*, no. 9, spring 1985, pp. 11–12; Jervis; Jewitt; Lawrence; "The Leeds New Art Faience", *Artist*, January and September 1881, vol. II, pp. 3–4 and 267–68 (partially reprinted in Haslam 1975); Lockett; Monkhouse, Cosmo, "Burmantofts Faience", *MA*, vol. VIII, pp. 471–77; Morris, Barbara, "Burmantofts Pottery", *Arts Review*, 27 April 1984; Rhead; Thomas 1974; van Lemmen, Hans, "Burmantofts' Marmo", *GE*, summer 1983, pp. 1–2; Wilcock & Co., *A Catalogue of Burmantofts Faience and Decorative Terra-Cotta* (Leeds, November 1882).

Burne-Jones, Sir Edward C., Bart
1833–98

A Pre-Raphaelite painter well known for his designs in stained glass, Burne-Jones also designed and decorated tiles for Morris, Marshall & Faulkner and later for Morris & Co.*. In 1862 he designed *Cinderella* and *Beauty and the Beast* tiles, which were painted in blue, yellow, olive-green and violet slip by Kate and Lucy Faulkner, and fired at Morris, Marshall & Faulkner's premises in Red Lion Square. Burne-Jones exhibited designs for tiles at the Arts and Crafts Exhibition of 1893. A set of panels, *The Six Days of Creation*, was executed by the Della Robbia Pottery* after Burne-Jones's stained glass designs (Colour XI). At the exhibition of 1916, a retrospective included his 1861 panels of tiles representing Chaucer's *Legend of Good Women*, versions of which later appeared on stained glass and tapestries. In 1923 another retrospective included a red lustre William De Morgan* plate, executed by Fred Passenger* and designed by Burne-Jones.

References: A&CXS 1893, 1916, 1923; Fitzgerald, Penelope, *Edward Burne-Jones* (Hamish Hamilton, 1975); Waters, William, *Burne-Jones* (Shire Publications Ltd, Aylesbury 1989).

Burton, William
1863–1941

A designer, historian, teacher and brilliant ceramic chemist, Burton was working as a Manchester schoolmaster when he won a scholarship to the Royal School

of Mines in 1885. Without having completed his training, Burton joined J. Wedgwood (& Sons Ltd)* as a ceramic chemist in 1887. His experiments in lustre were the foundation of Daisy Makeig-Jones's lustre wares. Working with Thomas Allen, he introduced Vellum Ware c.1890. His book of trials, which survives at Barlaston, records experiments with *sang-de-bœuf*, ruby lustre and majolica glazes.

In 1892 Burton went to Clifton Junction to manage Pilkingtons Tile and Pottery Co. (Ltd)* pottery, where he remained until 1915. He had the unusual opportunity of designing the factory. Here, with his brother Joseph, he developed the Lancastrian and Lancastrian Lustre Pottery for which Pilkingtons gained renown.

A member of the Art Workers Guild* from 1897 to 1923, Burton was one of the most respected potters of his era. He took a great interest in education, encouragement of the arts and crafts worker and working conditions in the potteries. He wrote some seven books relating to ceramics between 1899 and 1922, along with numerous papers and articles. He catalogued several important collections, including the Salting bequest of pottery at the Victoria & Albert Museum.

References: A&CXS 1906; Batkin; Brighton 1984; Burton, William, "The Palette of the Potter", *Journal of the Society of Arts*, 26 February 1896, pp. 319–35; Burton, William, "Material and Design in Pottery", *Journal of the Society of Arts*, 8 October 1897, pp. 1127–32; Burton, William, "Lustre Pottery", *Journal of the Society of Arts*, 7 June 1907, pp. 756–71; Burton, William, "Crystalline Glazes and their Application to the Decoration of Pottery", *Journal of the Society of Arts*, 27 May 1904, pp. 595–601; Cameron; Cross; Lomax; Reilly & Savage.

Bushey Heath Pottery
Bushey, Hertfordshire
1921–33

Ida and Henry Perrin acquired the property known as The Cottage in 1900. The forty-room "cottage" was a country home for the Perrins, who also had a residence in Kensington. Mrs Perrin (1860–1956) was a painter whose works were exhibited at the Royal Academy in 1888 and 1891, and elsewhere as late as 1925. She is best remembered for her botanical paintings. The pottery was also known as the William De Morgan Pottery Works. Fred Passenger* worked here, making William De Morgan*-style lustrewares from 1923 until 1933. Six of his pots were exhibited by Mrs Perrin at the Arts and Crafts Exhibition in 1926. An exhibition of Bushey Heath's "Persian and Lustre Pottery" was mounted at Patersons Gallery, Old Bond Street, London, in 1932. The pottery apparently had five kilns, which leads to the assumption that its output must have been considerably larger than could have been decorated by Passenger and Mrs Perrin alone. After 1933 The Cottage was used as a school and later a country club. It has since been demolished.

References: A&CXS 1926; Cameron; *The Dictionary of British Artists* (Antique Collectors' Club, Woodbridge, 1976); Godden 1964; Graves; White, H. C., *Bushey's Painting Heritage* (B. S. P. Industries, 1972).

Calvert & Lovatt,
Langley Mill,
near Nottingham
c.1883–95

Formerly James Calvert & Son, this firm produced mainly ginger beer bottles, ink bottles and blacking bottles. In 1883 Albert and John Lovatt became partners and, as early as 1885, they advertised "Art and Stone Pottery" in *The Pottery Gazette Diary*. James Calvert retired in 1895 and the Lovatt brothers took over under the style Lovatt and Lovatt Ltd*.

Marks: "NORTH SHIPLEY POTTERY/LANGLEY MILLS".

References: "Albert Lovatt, Obituary", *PG*, January 1913; *MBD*; *PG Diary*.

Carter & Co. (Ltd)
East Quay, Poole, Dorset
1873–1921
Carter, Stabler & Adams,
1921–63
Poole Pottery Ltd, 1963 to
the present day

Jesse Carter (1830–1927) purchased the East Quay works in 1873 and in less than a decade Carter & Sons had become well known for their tile and mosaic murals. In 1895 Carter acquired the Architectural Pottery, from whom William De Morgan* had purchased tile blanks. Jesse's sons Ernest Blake (1856–83), Owen (1862–1919) and Charles (b. 1860) had joined the business before 1881, and some art pottery was being produced. As technical and artistic director, Owen Carter would later produce relief-moulded pots with coloured glazes and some Art Nouveau lustrewares.

Inspired by the Paris International Exhibition of 1900 and De Morgan's work, Owen Carter began experiments in glaze techniques with the aid of James Radley Young* and Alfred Eason. Eason, who had worked for W. T. Copeland (& Sons Ltd) and for Mintons*, came to Poole in 1888, as works manager. These lustres, some of which are on display at the Poole Pottery Museum, are remarkable for their very rich tones. A panel of lustre tiles on the exterior of the pottery has survived extraordinarily well. By 1905 Wilton Rix was commenting:

> Among other examples, the very admirable productions of ruby lustre on both matt and full-glazed surfaces, which have lately rewarded the efforts of Mr Owen Carter, deserve mention. The amazing variety of iridescence to be obtained by the vaporous method of kiln-firing always adds a charm to this type of ware.
>
> Extreme care is demanded in deciding the most opportune moment for the evolution of wood smoke in the muffle which can alone produce the desired effects, and this most always taxes the best skill of the potter. The pieces reproduced are good examples, and may be said in many respects to deserve a place among the well-known works of Maw, De Morgan and Lachenal.

At the outbreak of the First World War, the demand for tiles declined and Owen Carter increased his manufacture of art pottery. James Radley Young, the chief thrower, was put in charge of the art pottery department. Blue-striped ware and pots decorated with simple flower sprigs were the first pieces produced. The most typical art wares were buff-bodied, painted with bands of geometric decoration.

Although these were unglazed, they were said to be "impervious". The art pottery department introduced red-bodied ware dipped in greyish slip before decoration, and "Delft" tin-glazed wares (18).

During the war, Carter became friendly with Roger Fry, who was soon learning to throw, glaze and decorate pots at Poole for sale at the Omega Workshops*. The crude Omega pots which resulted may have influenced Carter in his increasing use of tin-glazed wares decorated with simple abstract forms.

At the British Industries Fair in 1917, Carter & Co. (Ltd)'s display included "grey-brown unglazed and decorated handcraft glazed pottery, and . . . some glistening lustre vases." (*PG*, April 1917) The following year the firm again showed lustre wares and "an interesting series of vases, jars, pitchers and candlesticks of hard-burnt clay, sufficiently vitreous in itself to dispense with any necessity for glazing. The shapes were quaint and homely and the decorations appropriately simple, being for the most part composed of dark blue or yellow lines and dots sparingly applied to the warm greyish-brown body." (*PG*, April 1918) The wares in Egyptian and Moorish styles excited interest, as did the "Portuguese striping in a combination of blue and white, and green and white" (*P&GR*, February 1918). In 1920 Monastic ware was introduced, being "a semi-dull green ware with a sober decoration in black" (*PG>R* April 1920).

Owen Carter died suddenly in 1919, and in 1921 the firm became Carter Stabler and Adams (Ltd). Although the firm continued some of its earlier productions, Phoebe and Harold Stabler, and John and Truda Adams changed the wares radically over the next decade.

A fine collection of the wares made by Carter & Co. Ltd and its successors may be seen at the Poole Pottery Museum, Poole.

Marks: "Carter & Co. Poole" or "Carters Poole", printed, impressed or incised.

References: Austwick; Barnard; Cameron; Coysh; Godden 1964, 1972; Haslam 1975; Hawkins, Jennifer, *The Poole Potteries* (Barrie & Jenkins, 1980); Lockett; Posner, Piers, "Pottery Unveiled", *The Antique Dealer and Collectors' Guide*, August 1990; *PG*; *PG>R*; *P&GR*; Rix; Shorrocks, Pamela, "Carter Tiling – A Fishmongers' Mural", *GE*, no. 15, winter 1987, p. 2. (*See also* Omega Workshops.)

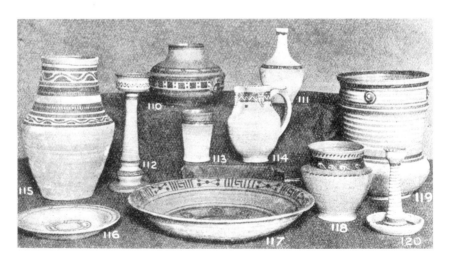

18 Carter & Co. Ltd "Hand-made Pottery of Antique Shapes and Simple Decorations", illustrated in *The Pottery Gazette*, April 1920.

Cartlidge, George
1868–1961

After training at Hanley School of Art, Cartlidge became an apprentice artist/designer at Sherwin & Cotton* in 1882. Later as Art Director, he introduced *émail ombrant* portrait tiles using a photographic process. He left Sherwin & Cotton *c.*1900 and, from 1901, produced art pottery in his studio at Daisy Bank, Rudyard, Staffordshire (19 and Colour IX). He established Adams & Cartlidge (Ltd), Vine Street Works, Hanley, with Messrs Adams and Colman to produce portrait and tube-lined tiles. These were the former premises of Sherwin & Cotton and of F. H. Barker & Rhead Ltd*. The firm appears in *The Pottery Gazette Diary* 1912–21. Cartlidge is also believed to have modelled portrait tiles for J. H. Barrett & Co. and Craven Dunnill & Co. Ltd*. He designed Morris Ware for S. Hancock (& Sons)*, each piece bearing his signature. These elaborate tube-lined art wares were introduced at the British Industries Fair of 1918 (*P&GR*, February 1918).

During the period 1919–26, Cartlidge divided his time between the United States and England. He had several associations in Kentucky, apparently establishing a pottery with a Mr Stinson. He also designed for the Alhambra Tile Co., Newport, Kentucky, and the Cambridge Art Tile Works in nearby Covington, Kentucky. It seems that Cartlidge held some sort of patent on his portrait tile process, and that such tiles were being produced illegally in the United States. In later years he stated that, although he designed and modelled portrait tiles while in Kentucky, the tiles themselves could only be manufactured in England. As a number of American firms were making such tiles at that time, he was probably referring to some patent on the process, rather than a lack of technical ability to produce them.

When in Britain, Cartlidge had continued to work at his Daisy Bank Studio and design for S. Hancock (& Sons)*. From 1926, he produced art pottery from Yeaveley, near Ashbourne, until his retirement in 1954. A collection of his work is in the Reserve Collection of the City Museum and Art Gallery, Hanley.

19 George Cartlidge plaque in buff-coloured eathenware with relief-modelled and coloured glaze decoration, marked "G. Cartlidge Rudyard 1904 INVT & Del", h. 19 cm.

References: Austwick; Bergesen; Cameron; Evans, Paul, *Art Pottery of the United States* (Feingold & Lewis, New York, second edition, 1987); Godden, Geoffrey, *Antique China and Glass under £5* (Arthur Baker, 1955); Kovel, Ralph and Terry, *The Kovels' Collectors' Guide to American Art Pottery* (Crown Publishers Inc., New York, 1974); Lehner, Lois, *Lehner's Encyclopaedia of U. S. Marks on Pottery, Porcelain and Clay* (Collector Books, Paducah, Kentucky, 1988); Lockett; Meigh; Meeson, Graham B., *Photoceramics and the Work of George Cartlidge*, unpublished BA thesis; *PG*; *PG Diary*; *P&GR*; Rhead; Stuart; Watson, Pat, "Happily taken over by Hancock: Collecting Pottery by S. Hancock & Sons", *Antique & Collectors' Fayre*, October 1989.

Castle Hedingham Art Pottery

Castle Hedingham, Essex
1837–99
Essex Art Pottery Co.
1901–c.1903
Royal Essex Pottery
c.1903–c.1905

Edward Bingham senior established the Castle Hedingham Pottery in 1837 to produce coarse redwares. The pottery was only marginally successful and, although Edward junior (1829–1914) experimented with making ornamental wares, he was obliged to support himself by working as a bootmaker, a teacher and an auctioneer's clerk; he also ran a boys' school (c.1859–63) and subsequently (c.1874) became a sub-postmaster.

Both Binghams are listed in the local directory for 1855, Edward senior as an earthenware manufacturer and Edward junior as a "manufacturer of terra cotta and ornamental pottery". Apparently they used the same pottery in tandem, and this situation continued until Edward senior's death in 1872. Edward junior exhibited his wares at Hertford & Sudbury in 1874 and at Chelmsford in 1875. An article in *The Art Journal* 1880 describes how he produced the pottery using home-made equipment, including decorating tools made from chicken bones: "Later on he seems to have made further experiments in mixing clays, and attempts at glazing; and after repeated failures his efforts have been, to a certain extent, crowned with success."

By 1886 Edward Bingham and his son Edward W. Bingham (b. 1862) were producing a wide range of wares, most notable for their historicism and applied high-relief decoration (20 and 21). Between three and four hundred old pieces were copied, apparently from engravings in books and periodicals. The Castle Hedingham Wares are very poorly potted, the modelling is often crude and the sprigging sloppy. The body was very coarse and most pieces suffer from firing cracks. Although the glazes are of a poor quality and highly inconsistent, some remarkable blues and greens were occasionally obtained. None the less, the Binghams brought to their work such striking originality that it is immediately recognizable, its naïve quality appealing to many collectors.

The pottery's modest success was insufficient to support Edward W. Bingham's fourteen children. In 1899 he took over from his aged father. Two years later he sold out to Hexter, Humpherson & Co. (Ltd)*, who renamed the firm the Essex Art Pottery Co. After patronage by Queen Alexandra, the style changed to the Royal Essex Pottery. Despite these grand honours, the pottery was not working to its full capacity. A wages book dating from January to March 1904 records only seven employees: two men who threw pots and fired the kilns and five women decorators. They were firing a kiln every ten days and producing about a thousand items per kiln.

Edward W. Bingham continued as manager until he emigrated to the United States in 1905. According to Ripper, Edward kept the pottery running for "a year

Left, **20** Castle Hedingham Art Pottery plaque, *c*.1890, incised "E. W. Bingham Castle Hedingham. Essex England, No. 179", applied castle with banner beneath reading "Hedingham", h. 25.5 cm.

Right, **21** Castle Hedingham Art Pottery frog mug, marked "Made in Essex England, no. 35, E. BINGHAM, Bingham", h. 17.7 cm.

or two" before following his son to New York; however, letters from Edward in New York survive from as early as May 1906. Edward died in Rhode Island in 1914 and his son was killed in an industrial accident.

Although Hexter, Humpherson & Co. (Ltd) continued to advertise Hedingham Ware until 1917, there is no evidence that the pottery operated after 1905. The pottery does not appear in the local directories after 1903. It seems likely that the advertisements were placed to sell off the remaining stock. An article in *The Pottery Gazette* of August 1917 announced:

> The Royal Aller Vale and Watcombe Art Potteries of Newton Abbot, Devon, are finding an active demand for their Royal Essex ware, made at the Castle Hedingham Pottery. There is good reason for this, too, as since the production is suspended and many of the pieces of this historic ware are unique in design and execution, they may be expected to acquire before long a collectors' market as their merits become more widely known to connoisseurs.

A fine collection of Castle Hedingham Pottery may be seen at the Hollytrees Museum, Colchester, Essex.

Marks: a wide variety of marks incorporating any or all of the following: "E. Bingham" or "E. W. Bingham"; "Castle Hedingham"; a picture of the castle. These may be impressed, incised or applied pads. Incised shape numbers from 1 to 232 have been recorded.

References: Bradley, R. J., "The Story of Castle Hedingham Pottery," *The Connoisseur*, 1968, pp. 77–83, 152–57; 210–16; Brears; Cameron; Clay, Henry, "Edward Bingham, Potter of Castle Hedingham", *The Connoisseur*, vol. 94, 1934 (2 pts); Coysh; Godden 1964, 1972; *KPOD Essex*; *PG*; *PG Diary*; Ripper, H. T., *Recollections of an Old Woodpecker: An Autobiography* (Cambridge, privately printed, 1948); Smith, C. Fell, "The Essex Jug", *The Essex Review*, vol. XXXVII, 1928

CLARK

(Bonham & Co. Ltd, Colchester); W. W., "East Anglian Pottery", *AJ*, vol. 19, 1880, p. 88; Wondrausch.

Cazin, Jean-Charles
1841–1901

A painter, engraver and teacher as well as a ceramist, Cazin became a professor of architecture in 1866. In 1868 he became Director of the Ecole des Beaux Arts in Tours and curator of the city's museum. Fleeing the aftermath of the Franco-Prussian War in 1871, Cazin came to England with Alphonse Legros with the intention of starting an art school. When this fell through, he took a post as an art instructor at the South Kensington and at the Lambeth Schools of Art, where Edwin and Walter Martin* were his pupils.

As a young man, Cazin had made pottery for a hobby, receiving advice from Houry, an art potter at Sèvres. He continued making pots while at Tours. From 1871 to 1875 he designed pottery for C. J. C. Bailey* where he influenced R. W. Martin* and Walter Martin*. Upon his return to France in 1875, he painted landscapes, although he continued to produce stonewares, experimenting with high-temperature glazes.

References: Bénézit; Cameron; Coysh; F. G., "J. C. Cazin", *The Connoisseur*, August 1928, pp. 239–40; Godden 1972; Haslam 1977; Haslam, Malcolm, *The Martin Brothers* (Richard Dennis, 1978); Rose.

Chambers, John

Chambers was a freelance artist who had worked for J. Wedgwood (& Sons Ltd)* and Doulton & Co. (Ltd), Lambeth*. In 1893, he became the first designer employed by Pilkingtons Tile & Pottery Co. (Ltd)*. He rose to head the architectural pottery department, working with Lewis F. Day*, Walter Crane* and C. F. A. Voysey*. Besides tiles, he designed some Royal Lancastrian Pottery shapes and decorated some pots and tiles.

References: A&CXS 1896, 1906; Cameron; Cross.

Chaplin, Alice

Alice Chaplin exhibited a terracotta panel at the Arts and Crafts Exhibition in 1889. In 1910 she exhibited a covered dish executed by the Dumb Friends Pottery and a stoneware jug.

References: A&CXS 1889, 1910.

Chelsea Art Pottery

See Hollinshead & Griffiths.

Clark, Uriah & Nephew (Ltd)
Dicker Pottery, Lower Dicker, Sussex
1845–1959

In 1845 the Clark family acquired the Dicker Pottery, which had been established *c.*1774. Originally this firm's wares had been mostly domestic red earthenwares, along with the traditional Sussex country wares such as money boxes, harvest barrels, bottles and jars. The early art wares had a red clay body which was incised, impressed with printers' type or sprigged. Some pieces were decorated with inlays of white clay, and a thick honey glaze was used. These were all techniques typical of the traditional Sussex potter; many of these pots were deliberate reproductions of antique wares.

Art pottery was introduced early in the twentieth century. By 1917 Dicker specialized in "quaint and historic shapes" in metallic and lustre glazes (*PG*, April 1917). Most of these were decorative wares but some small useful wares such as candlesticks and butter dishes were also made. Business developed considerably with the advent of tourists, who found the pottery an attraction and purchased small souvenirs. In 1920 and 1921, most of the pottery's art wares were decorated in black ironstone lustre, although coloured glazes, principally greens and amber, were also used (*PG>R*, April 1920; April 1921). During the 1920s, the pottery further developed its glaze effects – marbling, for example – and expanded its range of colours.

However, these were not successful in the Jazz Age. One critic remarked: "'Dicker' ware . . . is subdued, restrained, even severe. If we might be permitted to venture a suggestion, some really modern styles of decoration might well lift it out of a rut. Some new features would be an advantage." (*PG>R*, April 1929) The pottery struggled on until 1941, when the Army requisitioned the premises. The pottery was rebuilt by the Ministry of Defense after the Second World War. When it reopened under new ownership, employing many of the former workmen, the pottery produced "Art-ware" in ironstone and opaque coloured glazes. These were not successful enough for the Pottery to withstand Purchase Tax and Board of Trade Restrictions, and it closed in 1959.

Marks: "DICKER", incised; "DICKER, SUSSEX", impressed; "U. C. & N. THE DICKER SUSSEX", impressed; "DICKER WARE", impressed; "Old Sussex Ware", incised, often with date; "DICKER WARE MADE IN ENGLAND", impressed or printed in circular form after the Second World War.

References: Baines; Brears, 1971; Godden 1964; Lewis, Griselda, "Some Small Country Potteries", *Antique Collecting*, May 1987, pp. 8–11; *PG*; *PG>R*.

Clews, George & Co. (Ltd)
Brownhills Pottery, Tunstall, Staffordshire
1906–61

Although best-known for their teapots, Clews began to produce art pottery in 1914. Their aim was the "commercialisation of crystalline and opalescent glazes, rouge flambés, &c". A special white body was employed for such items as lustred, splashed and veined vases. One critic was impressed by its "semi-matt bronze rouge flambé", saying that this was the first firm to achieve a matt rouge flambé. Also

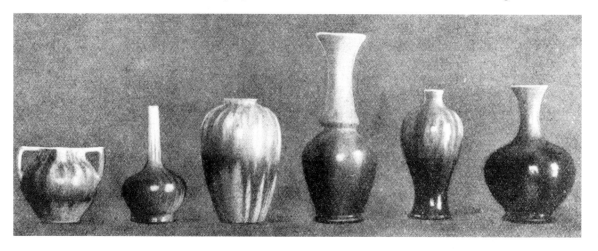

Opposite, **22** George Clews &
Co. (Ltd), "A Group of
Crystalline Glaze Vases"
illustrated in *The Pottery
Gazette,* April 1915.

introduced were Hispano-Moresque wares with freehand raised enamel line
decoration, a vellumed glaze with rouge flambé painting and an egg-shell glaze
(*PG,* August 1914). By 1915, the firm had added metallic opaline, crystalline and
aventurine glazes (*PG,* April 1915) (22).

The electric blue matt glaze which is commonly found on pieces marked
"Chameleon Ware" was introduced in 1920 (*PG>R,* March 1920). The wares
were already well known as Chameleon Ware in 1927 and the firm had continued
with its earlier experiments: ". . . adding, modifying, eliminating, stabilising, until
to-day, when they are at a point where they are able, as the result of fourteen years
of practical experience with the same broad class of goods, to offer to a trade a line of
ornamental wares which, from the dual aspect of price and quality, is exceptional."
(*PG>R,* July 1927).

Marks: "CHAMELEON WARE", impressed or incorporated in a variety of printed
marks.

References: Godden, 1964; *PG; PG>R.*

Colclough & Co.

*Anchor Works, Anchor Road,
Longton, Staffordshire*
1890–95
*Goddard Works, Goddard
Street, East Vale, Longton*
*c.*1896–1937
other addresses

This firm was formerly run by Herbert Joseph Colclough and Thomas Henry
Hawley, the latter leaving the partnership in 1894 to form Hawley-Webberly &
Co.*. Primarily a manufacturer of majolica flowerpots and jugs, the firm also
advertised art pottery. *Morris's Business Directory* listed this firm as Art Pottery
Manufacturers in 1894–95. In 1899 Colclough's advertised "Shaded Art Pottery.
Rich Colours, New Shadings". Relief-moulded jardinières in the Rugby, Arno and
Elgin shapes were illustrated. China tea sets were first advertised in 1899, although
the firm continued to advertise majolica (*PG,* September 1899). The following year
it offered "New Art Pottery. New Process. New Colour Effects" in the Windsor,
Titan and Belmont shapes. The firm ceased its production of earthenware in 1900,
continuing as a manufacturer of bone china teawares until its merger with Thomas
Booth & Sons in 1948.

Marks: "H.J. C." above "L".

References: Bergesen; *British Bulletin of Commerce,* pt 2, November 1954;
Cameron; Colls, R. H., "The House of Booths & Colcloughs", *P&G,* August 1951,
pp. 73–75; Godden 1964, 1983, 1988; *London Gazette,* 28 December 1894, no.
26583; *MBD;* Meigh; *PG; P&GR.*

Cole & Trelease

*Exeter Art Pottery, Exeter
Street, Exeter, Devon*
1891–96

Trelease was probably the potter, Cole, the financier, and William E. Hart, trained
at Aller Vale (Art) Pottery*, the pottery's chief decorator. In 1893 Alfred Moist
joined the firm. An article in *The Pottery Gazette* of October 1894 reported: "The
glazes and painted flowers run on very similar lines to the Aller Vale Pottery. For
sea side shops, bazaars, and some of the large stores they have very saleable goods
in vases, tobacco jars, art pots, eggs, tidies, mottoed jugs, tankards, tumblers &c."
The wares were typical Torquay redwares with slip and/or sgraffito decoration.
Their advertisements always state: "Artistic in form, colour, and decoration.
Standing firmly, and holding water perfectly."

The following advertisement heralded the firm's decline: "Special offer of
splendid value . . . Have an excess of stock, which they wish to clear on

exceptionally advantageous terms." They offered between 120 and 150 items, including post and packing, for £5 (*PG*, November 1896). Upon the pottery's closure, the firm's goodwill, some of their workers and possibly some of their undecorated stock were purchased by Hart & Moist*, who started the Devon Art Pottery in 1896. Some pieces have therefore been recorded with the marks of both firms, leading to confusion.

Marks: various impressed marks, including "EXETER ART POTTERY ENGLAND", sometimes with three castle towers. Some pots bear incised pattern numbers and impressed shape numbers. Over 200 pattern numbers have been recorded, starting with pattern number 1.

References: Cashmore 1983; *KPOD Devonshire*, 1893; Patrick; *PG*; Randell, Keith and Mary, "Exeter Art Pottery – Pottery Marks", *TPCS Magazine*, January 1991, pp. 9–10; Thomas 1978; *TPCS Magazines*.

Coleorton Pottery
Ashby-de-la-Zouch, Leicestershire
c.1898–99

Potteries making yellow and white earthenwares were located here at least as early as 1811. Carlo Manzoni* moved here after a fire at the Granville Pottery* in 1898. He left in 1898–99 to join the Della Robbia Pottery*.

References: Brears; Godden 1964; Williamson.

Collard, Charles Henry Fletcher
1874–1969

Having served an apprenticeship at the Aller Vale (Art) Pottery*, Collard quickly became one of its best decorator/designers; one of his pieces was exhibited at the Arts and Crafts Exhibition in 1889 (Colour II). After John Phillips's death in 1897, the Aller Vale (Art) Pottery passed into the ownership of Hexter, Humpherson & Co. (Ltd)*. When, in 1901, the latter amalgamated Aller Vale with the Watcombe Terra-Cotta Co (Ltd)*, under the style Royal Aller Vale & Watcombe Pottery Co. (Ltd)*, Collard moved to Watcombe. Collard was unhappy working for the new owners and, in 1902, went to work for Hart and Moist* in Exeter. Less than a year later, he moved to the Longpark Pottery Co. (Ltd)*.

In 1905 Collard established the Crown Dorset Art Pottery* at Poole under the style Charles Collard & Co. (Ltd) (28 and 29). Although quite successful for a number of years, the pottery suffered severe set-backs with the advent of the First World War, and Collard left in 1915, selling the pottery in 1917. He spent the remainder of the war in Ilminster, where he intended to form a partnership with Gus Arlidge, making perfumed pottery. This partnership did not materialize, although Arlidge did establish the Crown Art Pottery*, making perfumed pottery and possibly having purchased the method from Collard (*PG*, April 1920).

In 1919 Collard established the Honiton Pottery, where he continued until his retirement in 1947. He then lived in Torquay, where he made studio pots until, at the age of eighty, blindness intervened.

Those interested in the work of Charles Collard may wish to contact The Honiton Pottery Collectors' Society, by writing to the Membership Secretary, Reg Adams, 10 Selby Rise, Uckfield, West Sussex.

References: A&CXS 1889; Cashmore 1983; Cashmore, Carol, "Honiton: A Neglected English Pottery", *The Antique Dealer and Collectors' Guide*, May 1987, pp. 49–51; *Honiton Pottery Collectors' Newsletters*; *PG*.

Collard, Charles & Co. (Ltd) *See* Crown Dorset Art Pottery.

Collier, S. & E. (Ltd)
Coley and subsequently
Grovelands Potteries,
Reading, Berkshire
1848–1957

Samuel J. Collier, pottery and glass merchant in Minster Street, Reading, purchased a small pottery and brickworks at Coley, where he devoted his entire output to the manufacture of red clay flowerpots and bricks, in 1848. He soon began to supply these to other retailers and eventually gave up the retail business altogether. The introduction of machine-made socketed drainpipes ensured the success of the firm.

When the Coley clay bed was exhausted, Samuel Collier junior and his brother, Edward P. Collier, purchased property at Grovelands and established a pottery. By 1897 Edward had died and his son, George, took his place. By 1905 they had established several factories, each with its own kilns, covering an area of some five acres. The firm became a limited liability company in 1902. The directors were Samuel junior's son, E. P. Collier, and his two nephews, George Collier and D. F. Cooksey. In 1905 they were manufacturing chimney pots, drain pipes, roofing and wall tiles, red ridge tiles, ridge tile finials, pier balls, caps and terminals, ornamental and architectural terracotta, terracotta bricks and mural tiles. They produced these from the Reading orange clay which burnt to a much-admired orange red. At that time both sides of Queen Victoria Street in Reading were almost entirely faced with Grovelands terracotta.

The firm also produced an enormous array of horticultural wares and a variety of vases, pots and umbrella stands to be painted by amateurs. Glazed wares included a wide variety of the standard domestic wares of the period. Inspired by the excavations of the Roman site at Silchester (1890–1909), Silchester ware was produced *c.*1907 in simple "Roman" shapes. These wares were of the distinctive orange terracotta body, covered by dark brown or sometimes blue glazes.

Marks: "SILCHESTER WARE" within a pointed oval.

References: Coysh; Godden 1964; "How a Pottery was Started", *PG*, August 1905. pp. 903–04; "S. & E. Collier's Terra Cotta Works", *Architecture*, supplement November 1897, p. 8.

23 Della Robbia Pottery vases decorated by Charles Collis, both with Della Robbia mark. *Left*: with artist's mark, h. 31.6 cm. *Right*: with decorator's mark, h. 35.8 cm.

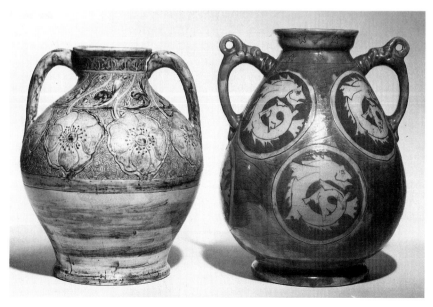

Collis Charles
1879–1952+

Charles Collis was a student at the Laird School of Art, Birkenhead, in 1895, when he was hired by Harold Rathbone as a painter at the Della Robbia Pottery* (23). He then worked for Doulton & Co. (Ltd), Burslem* from 1900 until 1902, and briefly for Wardle & Co. (Ltd)*, while studying at the Wedgwood Institute. He returned to the Della Robbia Pottery from 1902 to 1904. He decorated tiles for John Swift & Son, of Liverpool, from 1904 to 1905, returning yet again to Della Robbia from 1905 to 1906. He was employed by William Ault & Co.* from 1906 to 1912. Collis later became a poster artist and publicity agent. He returned to the Laird School of Art as an instructor in 1952.

References: Godden, Geoffrey, unpublished manuscript.

Commercial Art Pottery Co.

See Commondale Brick, Pipe and Pottery Co. Ltd.

Commondale Brick, Pipe and Pottery Co. Ltd
near Stokesley, North Riding of Yorkshire
1872–81;
Commercial Art Pottery Co.
1881–84

In 1872 John Crossley purchased The London and Cleveland Firebrick Co. Ltd (established 1860), forming The Commondale Brick, Pipe and Pottery Company Ltd. He produced art and domestic pottery from 1880, employing about thirty people. While Crossley managed his builders' retail business in Stockton, the pottery was run by his son, Alfred.

Most of the pottery's skilled workers were recruited from Staffordshire. The 1881 census showed that the pottery's artist, Arthur William Beech, as well as the potters, throwers and turners, had been born in the Potteries. One reporter noted: "The peculiar and beautiful amber tint of the Commondale clay is well brought out, and there are some excellent artists at work at the place. The painting on terracotta ware of birds, flowers, insects, etc. is very superior." (*PG*, August 1880) Wares listed in *The Whitby Gazette* of 31 July 1880 included plaques, biscuit jars, tobacco jars, water bottles, ornamental baskets, mustards, peppers and salts, candlesticks, teapots, cream jugs and so on. Glazed wares were apparently also attempted for a very brief period.

Early in 1881, John Crossley sold the Commondale works to the Commercial Art Pottery Company, which "intended to push the art pottery department" (*PG* May, 1881). This does not seem to have been successful.

Alfred Crossley left for the United States in 1882, not to return for twelve years. By the time he left, most of the Staffordshire potters had departed. It is thought that the potters found the Yorkshire climate and rural isolation uncongenial. They may also have had some disagreements with the new management. In April 1883, *The Pottery Gazette* announced that Commondale planned to *recommence* working, confining their efforts to terracotta. By the following year, art pottery manufacture had ceased and the works were thereafter dedicated principally to the manufacture of bricks and pipes, although some terracotta horticultural and useful wares were made.

Marks: "COMMONDALE POTTERY", impressed in circular form; "CROSSLEY COMMONDALE", impressed.

References: Cameron; Cockerill, John, "Commondale Clay and Staffordshire Knowhow", *NCS Newsletter*, no. 74, June 1989, pp. 7–8; Cockerill, John and Joyce, "The Commondale Works and Pottery", *Cleveland and Teeside Local History Society Bulletin*, no. 59, November 1990; Coysh; Godden 1964; Grabham; Lawrence; *PG*; Richardson.

Compton Art Potters' Guild

Compton, near Guildford,
Surrey
1901–51
Compton Potteries Ltd
1951–56

Mary Watts (*née* Fraser-Tytler) studied at the Slade and South Kensington Schools of Art before her marriage to the celebrated Victorian painter, George Frederick Watts. In 1895, when Compton Parish Council acquired land for a new cemetery not far from Limnerlease, the Watts's home, they decided to donate a mortuary chapel, which Mary designed. As Mary was an advocate of the Home Arts and Industries movement, which sought to give interesting and aesthetically satisfying work to the underprivileged, she decided to train local residents to decorate the chapel, using clay which had been discovered at Limnerlease. Some of those who began to study terracotta modelling at evening classes became so skilled that, in 1899, after the completion of the chapel's exterior, Mary built a small studio.

The potters began work on a commercial basis as the Compton Art Potters' Guild in 1901. They achieved much praise and publicity, not entirely unrelated to their patrons' celebrity. In 1906 *The Art Journal* reported:

> . . . though a big piece like a baptismal font is now within the range of achievement, and the garden and memorial pottery is in considerable demand, yet the localisation of the work is so strong, its character as an industry of local material and skill so determined, that it belongs naturally to the successes of the Home Arts and Industries. This year beside the big-lined pots, the font and the cinerary casket, where Mrs Watts's gift of symbolic design had fitting expression, the Compton potteries showed work wax-coloured in subdued tones. The candlesticks illustrated, with their finely modelled figures of saintly life, are good examples of an art that in an interior fitted to show its quiet charm would be as effective as the broad harmonious forms of the larger pieces are in their right setting.

By 1912 the pottery employed sixteen men, who came to the works direct from the Board Schools. Several of these young apprentices were to remain with the pottery until its closure. *The Pottery Gazette* explained:

> The Guild may be regarded as a benevolent one, but it is conducted on commercial lines, and provides an artistic and remunerative occupation for villagers . . . In the Potters Art Guild the workers keep before them the knowledge that a great national art springs from fine national craftsmanship. While they are endeavouring to supply things that are commonly required by the public, their work is marked by a distinction of manner and is calculated to extend appreciation of the true principles of beauty. (*PG,* February 1912)

The wares were mostly unglazed terracotta garden furniture: bird baths, urns, sundials, window boxes, benches, terrace balustrades and statues, for example (24 and 25). Mary Watts designed these using Renaissance motifs or, most especially, Celtic motifs. These won gold and silver medals from the Royal Botanic Society and Royal Horticultural Society. Several major retailers, including Liberty & Co.*, sold these goods.

The Guild's small ornamental pieces were decorated with unfired tempera colours, because the kilns could not sustain an adequate temperature for glazing. As these colours rubbed or washed off, very few have withstood the ravages of time. The ornamental wares included figures of saints, fruit bowls, bookends, plaques, commemorative tankards and even buttons (which were of course highly unsuitable as they had to be removed each time the garment was washed).

In 1923 fire destroyed the thatched pottery, which was reconstructed the following year. It prospered until 1929 but, apart from the effects of the overall slump in trade, the terracotta wares began to lose their market share to cast concrete ornaments. After the death of Mary Watts in 1936, the pottery continued on a small scale through the Second World War.

In June 1951, the 100 percent purchase tax on ornamental goods, the increased cost of coal and Board of Trade restrictions forced the pottery to close. Later that year, David Dunhill, a BBC announcer, his wife Barbara Dunhill, a local art teacher who was to design some of the wares, Mrs Dunhill's father, Charles Bone, who was an industrial designer, and P. B. Smith, a Guildford solicitor, purchased the pottery, operating under the style Compton Potteries Ltd. They planned to produce hand-painted tablewares and lithographic transfers. Unfortunately, their attempts to alter the kiln so as to enable it to reach a temperature suitable for glazing were unsuccessful. A small electric kiln was acquired but the pottery did not prosper and closed in 1956.

The West Surrey Ceramic Co. was then formed to continue the production of Compton's patterns under the control of I. A. Tippetts, formerly a director of Compton Potteries Ltd. Key members of the Compton staff joined in this venture, which also included Kingwood Pottery. A small collection of Compton pottery may be seen at the Watts Gallery, Compton, near Guildford. The Watts Mortuary Chapel nearby is also open to visitors.

Marks: Various impressed marks incorporating "COMPTON POTTERY GUILD-FORD"; "Designed and Manufactured for Liberty & Co.", impressed; a paper label,

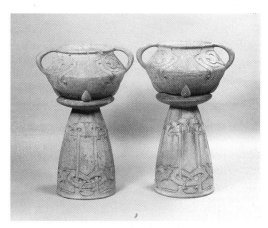

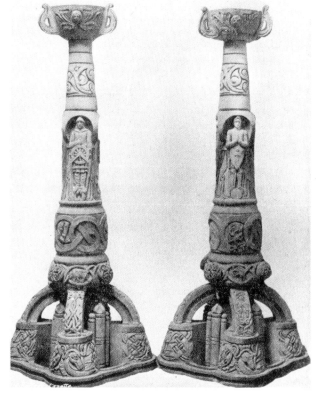

Above, **24** Compton Art Potters' Guild jardinières and stands designed by Archibald Knox for Liberty & Co, impressed "Designed and Manufactured by Liberty & Co.", h. 102 cm.

Right, **25** Compton Art Potters' Guild commemorative pillars, illustrated in *The Pottery Gazette*, February 1912.

"THE POTTERS ARTS GUILD COMPTON GUILDFORD ENGLAND", in a circle around "UNFIRED COLOURS OR CLEAN OR POLISH USE A HARD BRUSH DO NOT WASH" Celtic wheel, impressed.

References: "Art Handiwork & Manufacture", *AJ* 1906; Barnes, Vernon, unpublished manuscript; Blunt, Wilfred, *England's Michelangelo. A Biography of George Frederick Watts* (Hamish Hamilton 1975, Columbus Books, 1989) Blunt, Wilfred, *A Guide to The Watts Gallery and Mortuary Chapel* (Watts Gallery, Compton, 1977); Cameron; Cecil, Victoria, "For House and Garden", *The Antique Collector*, January 1981; "Compton Potteries Close Down", *PG>R*, August 1956, p.1186; Coysh; Erskine, Mrs Steuart, "Mrs G. F. Watts's Terra-cotta Industry", no date; Godden 1964; Gould, Veronica, *Compton, Surrey* (Arrow Press, Farnham, 1990); Gregory, Edward W., "Home Arts and Industries", *Artist*, vol. XXII, 1901; Levy; Morris; Potters' Art Guild, *Catalogue*, 1932; *PG*, February 1912; V., E. F., "Home Arts and Industries", *AJ*, 1900; "A Village Pottery", *PG>R*, November 1951; Rix; Watts, Mrs George Frederick, *The Word in the Pattern* (The Astolat Press, 1895; Watts Gallery, 1989).

Cooper's Art Pottery Co.

Anchor Works, Brewery Street, Hanley, Staffordshire
1899–1930
Cooper & Co.,
1930–36
Coopers (Anchor Pottery) Ltd
1936–41 and *c.*1947–58

Formerly Physick & Cooper, this firm was continued by William Cooper, a decorator of Cobridge. Nothing is known of its wares.

Marks: "ART POTTERY Co. ENGLAND" with a crown, printed.

References: Godden 1964; *LG*, 27 January 1899, no. 27046; Meigh.

Cox, George James

Mortlake, Surrey
*c.*1910–13

Trained at the Royal College of Art, George Cox established the Mortlake Pottery in 1910. Here he experimented with high-temperature glazes. Five of his vases were exhibited at the Arts and Crafts Exhibition in 1912.

Although his book, *Pottery for Artists, Craftsmen and Teachers*, emphasized the potter as artist, it also provided much technical information, such as kiln diagrams. In an era when little information was available for the aspiring studio potter, this book was invaluable. In his chapter on glazes and lustres he explains:

> It is in this department of pottery, with its surprises, difficulties and disappointments, its rare but exciting successes, that for most potters the greatest interest lies. To those of a scientific bent it is perhaps the summit of the craft, but the artist groping amidst formulas and methods may take heart. The first work in pottery was not produced by scientists alone and does not depend altogether upon the quality of its paste, its unique colour, or strange lustre.

Although Cox's enthusiasm for experimenting with glazes is apparent, he was not a purist. He cautions:

> There is among young potters a false pride that prevents them using, and among old potters acknowledging, the use of the manufactured article. Why

this should be is a little difficult to understand . . . These resources should be used intelligently, not mechanically, or by the book – artistically, inventively, secretly if you will, but they should be used – until the multitudinous experiments have borne fruit and repeated trials convince you that at last you possess some gem of research worth, as well it may be, the months of patient toil engendered in its production.

In 1914 Cox emigrated to the United States, where he taught at Columbia University's Teachers' College, New York.

Marks: ''MORTLAKE'' or monogram.

References: A&CXS 1912; Cameron: Cox, George, *Pottery for Artists, Craftsmen and Teachers* (Macmillan, 1914); Haslam 1975, 1977; Rose.

Crane, Walter
1845–1915

As designer, author, illustrator and painter, Walter Crane exerted an enormous influence over the decorative arts during his lifetime. He is known to have designed pottery and tiles for J. Wedgwood (& Sons Ltd)* (c.1867–71); Maw & Co. (Ltd)* (tiles from 1874; art pottery c.1887) (98 and Colour XXVII); the encaustic tile manufacturers, London Decorating Co. (from c.1880); Mintons* (Henri Deux Wares); Steele & Wood*; and Pilkingtons Pottery & Tile Co. (Ltd)* (from 1900). He was a founder-member of the Art Workers Guild* and its master in 1888–89. He was also a founder-member of the Arts and Crafts Exhibition Society*, and its first president (1888–1912). His ceramic designs, among many others, appeared at exhibitions from 1888 to 1912. Many of his children's book illustrations were pirated and used as designs for nursery tiles in both Britain and the United States.

References: ''The Art of Walter Crane'', *MA*, vol. 1, 1903, pp. 95–97; A&CXS, 1888–1912; Brighton 1984; Cameron; *A Catalogue of a Collection of Designs by Walter Crane ARWS* (FAS, 1891); Coysh; Crane, Walter, ''The English Revival of Decorative Art'', 1892; Crane, Walter, ''The Work of Walter Crane'', *AJ, Easter Annual*, 1898, pp. 1–32; Cross; FAS 1973; Jervis; Konody, P. J., *The Art of Walter Crane* (Bell & Sons, 1902); Lockett; Lomax; Reilly; Tilbrook.

Craven Dunnill & Co. Ltd
Jackfield Works, Jackfield, Shropshire
1870–1951

William Powell Dunnill came to manage Hargreaves & Craven in 1867, becoming a partner in the new firm of Hargreaves, Craven & Dunnill Co. in 1870. The firm's style apparently was changed again in 1871, to Craven Dunnill & Co. The demolition of the old works, which were badly dilapidated, began. New purpose-built tile works were opened in 1874.

Best known as a manufacturer of encaustic and mass-produced wall tiles, Craven Dunnill also made mosaic, hand-painted art tiles and a small amount of lustred art pottery (26 and 27). A review of the firm's display at the Manchester Jubilee Exhibition noted: ''A large proportion of their tiles are too natural in treatment for our taste, for we hardly believe in tiles treading upon a domain which strictly belongs to picture painting.'' (*CM*, July 1887) In 1890 Craven Dunnill exhibited a panel in ruby lustre designed by C. Jones at the Arts and Crafts Exhibition. The firm's lustre has been criticized as being heavy, dull and oily.

The Jackfield Tile Works now house a museum showing Craven Dunnill's and other local art wares and tiles. This is part of the Ironbridge Gorge Museum complex.

26 Craven Dunill & Co. Ltd
Persian-pattern tile, red plastic
clay body, with yellow slip
ground and polychrome hand-
painted decoration, impressed
"CRAVEN DUNNILL & CO.
LIMITED, JACKFIELD, NR
IRONBRIDGE SALOP".

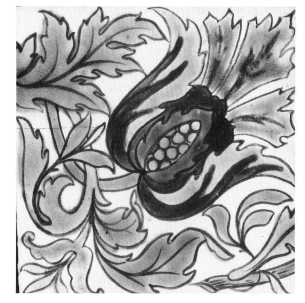

27 Craven Dunnill & Co. Ltd
tiles, hand-painted in sepia
under the glaze, cream dust-
pressed body, moulded mark
"CRAVEN DUNNILL & CO,
JACKFIELD, SALOP".
20.3 cm sq.

Marks: a smoking bottle-kiln mark with the initials "CDJ"; various printed, impressed or painted marks; "Craven Dunnill & Co., Jackfield".

References: A&CXS 1890; Austwick; Barnard; Bergesen; Cameron; *CM*; Coysh; Craven Dunnill catalogues at Ironbridge Gorge Museum Trust Library; Day, Lewis F., "Tiles", *AJ*, 1895; *Decoration*; Godden 1964; Herbert, Tony, *The Jackfield Decorative Tile Industry* (Ironbridge Gorge Museum Trust, Telford, 1978); Lockett; Messenger; Meyers, Richard, "Lustres from Lesser Mortals", *GE*, 10, pp. 6–7; *PG*; Strachan, Shirley, "Henry Powell Dunnill: a Victorian Tilemaster", *Journal of the Tiles and Architectural Ceramics Society*, vol. 3, 1990, pp. 3–9; van Lemmen 1986, 1990.

Crown Art Pottery

Ilminster, Somerset
c.1917–c.1927

It is thought that Charles Collard* went to live at Ilminster in about 1917 with the intention of starting a pottery with Augustine "Gus" Arlidge. C. & A. Arlidge were the proprietors of the Donyatt Pottery* in nearby Donyatt. Apparently this did not come about, but Arlidge was soon producing the perfumed pottery for which Collard's Crown Dorset Pottery* had been famous, and it is probable that he sold this process to Arlidge. In April 1920, *The Pottery Gazette and Glass Trade Review* reported that this pottery had been making coloured body wares and perfumed pottery "for some time past". The wares illustrated were decorated with floral patterns on simple shapes. The proprietor, C. [sic] Arlidge, was planning to build a new factory.

In 1923 the firm was amalgamated with the Donyatt Pottery at Donyatt, Ilminster, as the Somerset Art Pottery Co. Ltd. C. Arlidge was the managing director. Probably after financial reverses, the firm was reorganized as the Somerset Art Pottery (1925) Ltd, with A. Beck as the managing director. Between 1927 and 1931, Donyatt became a separate entity, Donyatt Pottery Ltd. Somerset Art Pottery Co. Ltd was listed as located in Cheddar, but there is no further mention of the pottery at Ilminster.

References: Cashmore 1983; *KPOD Somerset*; *PG>R*.

Crown Dorset Pottery

Green Road, Poole, Dorset
1905–27

Charles Collard* established the Dorset Art Pottery in 1905. Although the pottery's products were mostly motto wares and other slip-decorated wares of the types produced at Aller Vale (Art) Pottery* (28 and 29), Collard developed many original designs. Two vase shapes favoured by the firm were those with an elevated rim and a wavy rim. The grotesques so popular at the time were also made in large quantities. Later wares were seldom slip-decorated and usually had coloured glazes.

In about 1910, the name of the pottery was changed to Crown Dorset. Crown Dorset's exhibition at the Turin International Exhibition in 1911 included "quaint figures" and motto wares (*PG*, July 1911). Perhaps the most complete description of the firm's wares comes from 1912:

> They include tea pots, coffee-pots, jugs of many shapes, vases, artistic and quaint in many shapes, gipsy kettles, covered jars, cream jugs in many sizes, flower bowls, handled cans, and reproductions of Roman and other antique forms. Those enumerated are mostly small pieces, but many larger pieces with figure and landscape decorations on shaded grounds are included, with well-modelled busts (*PG*, September 1912)

28 Crown Dorset Art Pottery Cottage pattern wares.

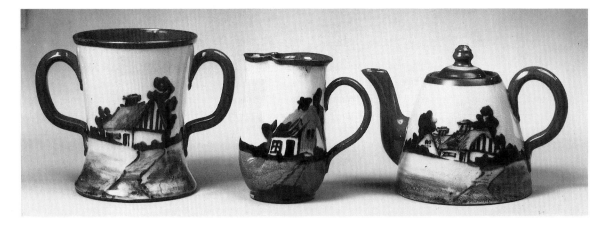

Only one of these busts (of Thomas Hardy) is now known, though presumably a number of different celebrities were so honoured. A line in green-glazed wares included those with incised or painted decoration under the glaze. Perfumed pottery, first mentioned in 1913, was to become the firm's largest-selling ware after 1920; the pottery was impregnated with scent by a patent process.

Although relatively successful for a number of years, the business suffered severe set-backs with the advent of the First World War, and, in 1917, Collard sold it to George Paine. Paine sold the company to Dorset Art Pottery Ltd shortly afterwards. The post-Collard firm specialized in hand-painted terracotta and ebony perfumed pottery. As these efforts met with little success, a liquidator was appointed in 1925 and the firm closed down in 1927.

Marks: Various impressed or incised marks, including "COLLARD POOLE DORSET" or "Crown Dorset" with a crown. Pattern and shape numbers also appear.

References: Cashmore 1983; Cashmore, Carol, "Honiton: A Neglected English Pottery", *The Antique Dealer and Collectors' Guide*, May 1987, pp. 49–51; *Honiton Pottery Collectors' Newsletters*; *PG*; *PG>R*.

29 Crown Dorset Art Pottery Windmill pattern jug.

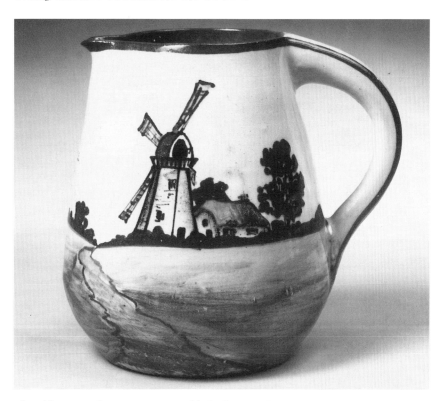

Cumnock Pottery Co.

Glaisnock Street,
Old Cumnock, Strathclyde,
Scotland
c.1786–1920

The old Cumnock Pottery was established c.1786 by James Taylor. On his death in 1825, the pottery was taken over by the Nicol family. In 1882 the proprietor was James McGavin Nicol. In 1907 the business was sold by trustees of the late James M. Nicol to David Dunsmoor and William Nicol. The dissolution of partnership between David Robert Dunsmoor and William Nicol was announced 17 December 1920. The pottery was then sold to the local gas company.

30 Cumnock Pottery Co.
Scottish Motto Wares,
unmarked.

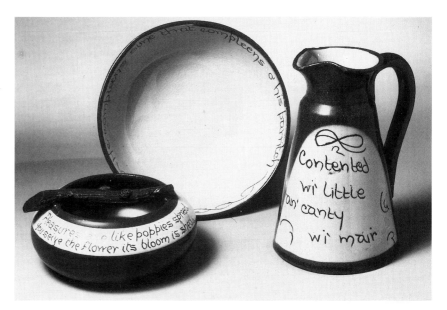

Although Cumnock's chief production was utilitarian brown earthenware and glazed flower pots, the firm also "made a special feature of old Scotch motto ware, of which they claim to be the originators. At any rate they have made it for upward of a century" (*PG*, August 1905). This was advertised as "YE AULD SCOTTIS MOTTO WARE" (*PG*, July 1905). These wares had a red body with the motto scratched through a coating of yellow slip (30).

References: Coysh; Cruikshank; Fleming; Jones; *PG Diary*; *PG*; *PG>R*.

Daison Pottery

See Lemon & Crute.

Day, Lewis Foreman
1845–1910

Day's designs and writings greatly influenced the decorative arts during the last quarter of the nineteenth century. He worked for Lavers & Baraud, stained-glass manufacturers, and as keeper of cartoons for Clayton & Bell. He set up his own design firm in 1870. He designed wallpapers, furniture, silver, jewellery, textiles and ceramics. Day designed vases which the Torquay Terra-Cotta Co. Ltd* displayed at the Universal Exhibition in Paris, in 1878. He also designed tiles for Maw & Co. (Ltd)*, J. Wedgwood (& Sons Ltd)*, Craven Dunnill & Co. Ltd* and J. C.

Edwards* (63). Tiles and pottery that he designed for Maw's were shown at the Arts and Crafts Exhibitions of 1888, 1889 and 1890. He designed tiles for Wedgwood's Marsden Patent range, and Pilkingtons Tile and Pottery Co. (Ltd)* also used his designs for pottery and tiles. From 1899, he had a contract worth £100 a year with Pilkingtons and agreed to design tiles exclusively for them. Some of his tiles for Pilkingtons were exhibited at the Arts and Crafts Exhibitions of 1896 and 1903, and his Lancastrian and Lancastrian Lustre Pottery in 1906. He also acted as general artistic adviser to William Burton*, thus influencing the output of the firm beyond his numerous designs.

Day designed a series of sunflower-dial clocks, as well as patterns for Howell and James*. In 1880 he founded The Fifteen, the nucleus group which later became the Art Workers Guild*, becoming the Honorary Treasurer in 1884–7 and Master in 1897. He was also a founder-member of the Arts and Crafts Exhibition Society* and the author of some seventeen books on design and ornament, his most influential being *Everyday Art* (1882). Some elements of Day's style are now seen as forerunners of Art Nouveau, a style which he in fact detested.

References: A&CXS 1888, 1889, 1890, 1896, 1903, 1906; Aslin, Elizabeth, *The Aesthetic Movement* (Ferndale Editions, 1981); Batkin; Brighton 1984; Brisco, Virgina, "Early Days at the Torquay Terracotta Co.", *TPCS Magazine*, July 1989, pp. 15–17; Cameron; Cross; Day, Lewis F., *Everyday Art, Short Essays on the Arts Not-Fine* (1882); Jervis; Ross, D. M., *Lewis Foreman Day, Designer and Writer on Stained Glass* (Cambridge, 1929); Rycroft, Elizabeth, "Lewis Foreman Day, 1845–1910", *The Journal of the Decorative Arts Society*, vol. 13, pp. 19–26; Tilbrook.

Dean, S.W., (Ltd)
Newport Pottery, Burslem, Staffordshire
1904–19

This firm succeeded Edge, Malkin & Co. (Ltd). Rhead described the wares as "of commercial character, but with some artistic qualities". Spencer Edge designed some of the wares (*PG*, February 1904). The firm was succeeded by Deans (1910) Ltd.

Marks: Most commonly "S. W. Dean Burslem England", printed around a greyhound and surmounted by a Staffordshire knot and a crown, but other marks employed.

References: Godden 1964; *PG*; Rhead.

Decorative Art Tile Co.
(Also known as the Art Tile Co.)
200–202 Bryan Street, Hanley, Staffordshire
1881–1906

Primarily a firm of decorators, using blanks from many other firms, the Decorative Art Tile Co. registered 195 designs during the period 1881–1904. At the time of its incorporation in 1887, the principal shareholders were the managing director, George Beardmore Ford (an architect from Burslem), and William Parrish (a tile decorator). The firm's designs were predominantly transfer prints but relief-moulded majolica tiles were also decorated. It also produced some charming hand-painted panels (31).

Marks: Registration numbers are often the only means of identifying this firm's work, as it decorated other firms' blanks.

References: Austwick; Barnard; Clegg, Peter and Diana, "Discovering the Decorative Art Tile Company", *Journal of the Tiles and Architectural Ceramics Society*, vol. 2, 1987, pp. 28–35; Lockett; Meigh; *PG*.

31 Decorative Art Tile Co. tiles. *Left: The Mistletoe*, hand-painted over transfer-printed outline, white dust-pressed body, moulded back with aesthetic design incorporating fan, stork and foliage, marked "England". *Right*: hand-painted in polychrome over the glaze, on white plastic clay blank, combed back.

Della Robbia Pottery

2a Price Street, Birkenhead, Cheshire
1893–1900
Della Robbia Pottery and Marble Co.,
1900–06

Harold Rathbone and Conrad Dressler* established the Della Robbia Pottery on 9 December 1893. It took the name of the famous family of Florentine Renaissance potters, and some of the work that it produced, particularly the architectural faience, was in the Renaissance style. In line with Arts and Crafts Movement philosophy, Rathbone desired "to restore to the worker the individual interest and pleasure in daily work and creation". The controlling council of the pottery, consisting of William Holman Hunt, G. F. Watts, John Lea, H. J. Falk, Edmund Ware and Philip Rathbone (Harold's father), hired Harold Rathbone and Conrad Dressler as managers. In practice, however, there is no evidence that the council took any active part in the enterprise.

In keeping with the tenets of the Arts and Crafts Movement, the pottery was to use local clay, local labour and no machinery. However, the local clay proved unsuitable, and the local labour untrained and inept. Against Dressler's wishes, Rathbone imported clay and hired a thrower from Doulton & Co. (Ltd)*. Dressler left in 1896 to form his own venture, the Medmenham Pottery*.

Throughout the pottery's life, Rathbone used his many connections in the art world to obtain royal patrons, testimonials from famous artists and designs from well-known designers, attracting a constant stream of publicity from the art press. The goods were marketed by Liberty & Co.* during the period 1894–1901, and by Morris & Co.*. None the less, the pottery struggled for survival throughout its short existence. The fault may have lain in Rathbone's poor business ability, but much of

Della Robbia Pottery's work was poorly executed. The firm's artistic aspirations frequently surpassed its technical expertise.

Apart from those of the skilled artists and sculptors actually working at the pottery, designs by well-known artists were used. *The Six Days of Creation* panels (Colour XI) were adapted from stained glass designs by Edward Burne-Jones*. An albarello with scenes after Burne-Jones's *Love and Beauty* is also known. A series of twelve panels, of figure subjects after Ford Madox Brown, were shown at the Arts and Crafts Exhibition of 1896.

The architectural work largely consisted of press-moulded tiles, friezes and panels. The Della Robbia-style pieces employed techniques similar to those that had been used by the Renaissance Della Robbias, but lead glazes were substituted for less durable tin glazes. The art pottery included a wide range of ornamental wares, many of which were decorated using the sgraffito technique. More rarely, tube-lined decoration was used. Rathbone gave his artists considerable latitude in their designs, but apparently had one inflexible rule – that every design must incorporate the colour green. The useful wares were deliberately fantastic:

> It was the object thus to make the articles in everyday use comely and entertaining in shape, design and colour treatment so that the ordinary meal would have the comparative air of a banquet like those beautiful dishes that one sees in the pictures of banquets by Sandro Botticelli and others . . . Marmalade pots (with the hole for the spoon) and porridge plates, egg stands and muffin dishes, and milk and water jugs are amongst these useful articles, not to mention rose bowls, inkstands for the use of the boudoir. (*AJ*, 1896)

The year 1898 saw the erection of a Della Robbia Fountain in the courtyard of the Savoy Hotel. The fourteen-foot fountain in blue and white was designed by Harold Rathbone and the architect T. E. Colcutt (*AJ*, 1898). At the Arts and Crafts Exhibition of 1899, the firm exhibited a fountain, a vase, a figure of St Francis of Assisi and three panels.

Carlo Manzoni* joined the firm *c.*1899, following a fire at his Granville Pottery* and a brief sojourn at the Coleorton Pottery*. Although he was given responsibility for the architectural department following Dressler's departure, his distinctive style of symmetrical and geometric pattern design influenced the art pottery as well.

In 1900 the firm was amalgamated with Emile de Caluwé's ecclesiastical sculpture works and adopted the style Della Robbia Pottery and Marble Co. It was hoped that the Della Robbia Pottery could be put on a firm financial footing by concentrating on the ecclesiastical market, to which Caluwé had access. Although the firm's 1900 catalogue consisted almost entirely of ecclesiastical wares, the future of the art pottery was at least partly insured by Mrs Marianne de Caluwé's interest and, indeed, her participation as a designer and decorator.

At about this time, the Art Nouveau tendencies of the Della Robbia Pottery became more pronounced. At the Home Arts and Industries Exhibition of 1900, a critic remarked on a "noticeable loosening of the traditional bonds and an effort towards freer and more modern methods of design" (*Studio*, 1900). The vases illustrated were distinctly Art Nouveau in shape and decoration. Among the items of interest displayed at the Glasgow Loan Exhibition of British Ceramics were the panel *Isota da Rimini*, a Joan of Arc figure (76.3 cm high), vases, tureens and a font (*PG*, January and April 1905). The Glasgow Corporation purchased £45-worth of these goods, including *Joan of Arc* (*PG*, June 1905).

An advertisement in 1905 listed no less than five royal patrons and "Autographed Testimonials from Lord Leighton, G. F. Watts, Sir Alma Tadema, Walter Crane, W. Holman Hunt, T. E. Colcutt, and many other Leading Artists and Architects". Despite these glowing recommendations for their "Panels, Medallions, Heraldic Devices, Friezes, Fountains, for Architectural Enrichment, and Decorative Vases with Unique Design and Glowing and Harmonious Colouring", (*PG*, March 1905) the firm was failing. On 9 May 1906 it was resolved that the firm should close down (*PG*, June 1906) and in December the entire stock was sold at auction. "Bidding was generally keen and good prices were realised" (*PG*, January 1907).

Some designers, modellers and decorators

Della Robbia Pottery Birkenhead 1894–1906, published by the Williamson Art Gallery and Museum, provides a detailed dictionary of marks, with biographical notes. The entries below are either of special importance or include new information. Dates refer to periods at which individuals are known to have worked at the Della Robbia Pottery. Dates in brackets are those of birth and death.

Ted Ackerley, *c.*1901. Mark: "A". *See* Colour X.

Ruth Bare (1880–1962), 1898–1904, was the daughter of the artist and architect Henry Bloomfield Bare. She exhibited at the Walker Art Gallery 1902–06. Marks: ".R..B." or ".B.". *See* Colour X.

Robert Anning Bell* (1863–1933), listed in the 1900 catalogue as a modeller. In 1898 *The Art Journal* noted that his "charming panels in low relief were reproduced very successfully" and illustrated his *Ariadne*. Bell also designed the firm's galleon trade mark.

A. E. Bells specialized in realistic floral decoration. He may have been the Welsh boy who won a gold cross for originality of design (*MA*, 1896). Marks: "AEB", often accompanied by an elaborate Della Robbia galleon. *See* 35.

Gwendoline Buckler, *c.*1896. She exhibited *St George and Merrie England* at the 1896 Liverpool Autumn Exhibition and a tea caddy at the Arts and Crafts Exhibition of 1896. Her work also appeared at the Home Arts and Industries Exhibition of 1900. Mark: "GEMB".

Charles Collis* joined the firm at the age of sixteen, working intermittently 1895–1900; 1902–04; 1905–06 until it closed. He was both a modeller and a decorator, and his work is reminiscent of that of Walter Crane*. *See* 23.

Conrad Dressler* worked at the pottery for only two years, but his designs were used throughout the pottery's existence. His most famous work is the thirteen-panel frieze, *Justice*, for the Law Society Common Room.

John Fogo (d.1980), brother-in-law of William Williams, worked at the Della Robbia Pottery for three years after leaving school. He then began an apprenticeship at Laird's shipyards. Marks: several "JF" monograms are attributed. *See* 32.

Arthur Heele. A Dutch vase of his design was shown at the Arts and Crafts Exhibition of 1896.

Alice Louisa Jones, a paintress, who worked 1904–06. Her recollections of the pottery were published by Williams. She designed jewellery which was exhibited at the Walker Gallery. Mark: "AL".

Carlos Manzoni*, *c.*1898–1906, was in charge of the architectural department but also influenced the firm's art pottery. His pieces are seldom signed.

Aphra Peirce, a sculptor, modeller and designer, worked until 1900. Her designs

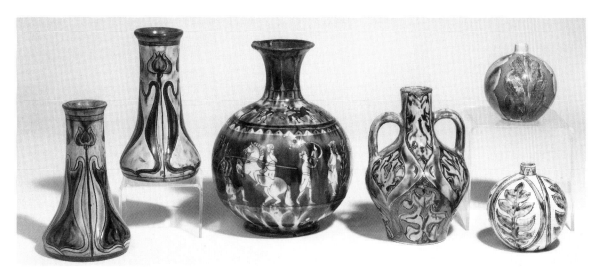

32 Della Robbia Pottery vases, all with incised Della Robbia mark. *Left to right*: pair of vases decorated by John Fogo, decorator's monograms "J.F.", 14.4 cm; globular vase, incised initials "CS", 18.4 cm; two-handled vase, incised decorators' marks, 14.7 cm; two globular vases, incised decorator's marks.

often include cherubs and animals. Her *Cupids and Tiger* was exhibited at the Walker Art Gallery Annual Exhibition of 1896. A vase made to her design was exhibited at the Arts and Crafts Exhibition of 1899. Her work is signed or monogrammed.

EDMUND RATHBONE, Harold's architect brother, designed the *Boys and Grapes* frieze shown at the Arts and Crafts Exhibition of 1896. Another of his designs was shown at the Walker Art Gallery's Autumn Exhibition of 1894. With others, he partly designed the scheme of Della Robbia work at the Wallasey Unitarian Church, which remains intact to this day. His Bacchanalian frieze was illustrated in *The Art Journal* in 1896.

HAROLD STEWARD RATHBONE (1858–1929). The pottery's artistic director, Rathbone was also a designer and modeller. He had trained as an artist in Paris and at the Slade School of Art in London. Through his father's position as Chairman of the Art and Exhibitions Sub-Committee of the Walker Art Gallery in Liverpool, he met many of the prominent artists of the day. He studied with Ford Madox Brown for three years, principally while the latter was working on the frescoes for Manchester Town Hall.

ELLEN MARY ROPE (1855–1934) was a well-known sculptor, modeller and designer who regularly exhibited in Liverpool, Manchester and London. She trained at the Slade School of Art in London and contributed a variety of items to the Arts and Crafts Exhibitions between 1889 and 1906. In the firm's 1900 catalogue she was listed as a designer of friezes and panels. She is best known for her portrayals of children, which are notable for their liveliness. Her *Piping Boy* and *Guardian Angel* panels were illustrated in *The Art Journal* in 1896. A long illustrated article about her work appeared in *The Artist* in 1899: "Miss Rope is an ideal sculptor of children; she reproduces to perfection the dainty roundness of their limbs, their artless grace of gesture, their expression of inmost mischief or limpid candour. For them she becomes a child again, and she glories in portraying their fresh beauty." She was an exhibiting member of the Women's Guild of Arts. After the pottery had closed, she worked with the architects Horace Field and Arnold Mitchell.

GERTRUDE RUSSELL. A paintress, working 1904–06. Her recollections of the pottery were published by Williams. Mark: "GR" monogram.

CASSANDIA ANNIE WALKER, was one of the firm's most prolific designers and decorators. Her Art Nouveau panel, *The Apple Gatherer*, shown at the Home Arts and Industries Exhibition of 1900, was highly commended. It was noticed that her "name was associated with some of the best work on the stand". (*Studio* 1900). Mark: her signature or initials. *See* 33.

ELIZABETH (LIZ) WILKINS, later Mrs Sergeant, 1895–1904. Her work was commended as "admirable in ornament and colour!" (*Studio*, 1900). Marks: "LW" or monogram. *See* 33–35 and Colour X.

WILLIAM WILLIAMS, working at least 1896–99, designed a large vase executed by Harold Rathbone and shown at the Arts and Crafts Exhibition Society in 1896.

EMILY MARGARET WOOD, *c*.1900, may also have been the pottery's book-keeper. Mark: "EMW". *See* 36.

Marks: Many pieces bear the distinctive Della Robbia galleon with "DR" painted or, more rarely, impressed. Some have only a long series of numbers which indicate the coloured glazes used and the date (after an oblique). Artist's marks or monograms are also frequently found.

References: A&CXS 1896, 1899, "Art Handiwork and Manufacture", *AJ*, 1906, pp. 210–15; "The Arts and Industries of To-Day", *AJ*, 1898; Blacker; *The Builder*, 13 January 1894, p. 28; Cameron; Cecil, Victoria "The Birkenhead Della Robbia Pottery", *The Connoisseur*, September 1980, vol. 205, pp. 16–21; Coysh; Dunford; Godden 1964; Haslam 1975; Hillhouse, David, "Della Robbia, Birkenhead", *Arts Alive Magazine*, no. 124, May 1981; "The 'Della Robbia' Pottery Industry", *MA*, 1896, vol. XX, pp. 6–8 (reprinted in Haslam 1975); "Home Arts and Industries"; *Studio*, vol. XX, 1900, pp. 86–87; Johnson; Kendell, B., "Miss Ellen Rope, Sculptor", *Artist*, vol. XXVI, 1899, pp. 206–11; "Keramics", *Artist*, February 1894, p. 62; Levy; Lockett; *PG*; Rix; Simpson, Colin M., "Della Robbia Pottery, Birkenhead, 1894–1906", *GE*, autumn/winter 1981, p. 3; Tattersall, Bruce, "The Birkenhead

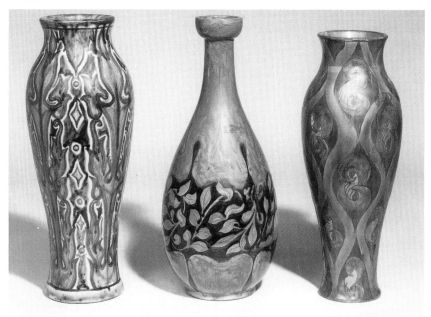

33 Della Robbia Pottery vases, with painted and incised Della Robbia marks. *Left and right*: decorated by Cassandia Annie Walker, decorator's initials "CW", h. 29.4 cm. *Centre*: decorated by Elizabeth Wilkins, decorator's initials "LW", dated 1898.

34 Della Robbia Pottery and Marble Co. vases, with incised Della Robbia mark. *Left to right*: vase, h. 34 cm; two-handled vase, incised initial "F", 35.2 cm; vase decorated by Elizabeth Wilkins, decorator's initials "LW", dated 1901, h. 34 cm.

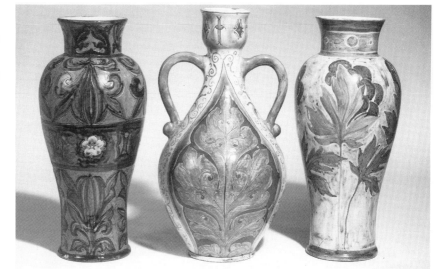

35 Della Robbia Pottery vases, with incised Della Robbia mark. *Left to right*: vase decorated by Elizabeth Wilkins and A. E. Bells, decorators' monograms "LW", "AEB" and "(Lizzie 1895)", h. 26.3 cm; vase with decorator's signature "Enid", h. 34.8 cm; vase.

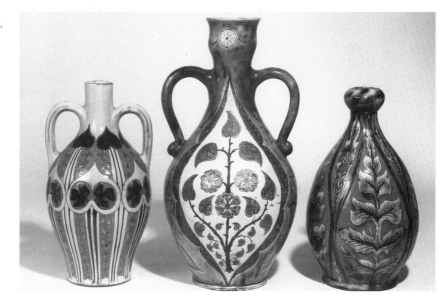

36 Della Robbia Pottery dishes, with incised Della Robbia mark. *Left to right*: dated 1895, d. 26.2 cm; decorator's monogram "WHW", d. 37.2 cm; decorated by Emily Margaret Wood, incised "Birkenhead", painted decorator's initials "EMW", dated 1895, d. 48.7 cm.

Della Robbia Pottery'', *Apollo*, vol. XCVII, 1973, pp. 164–68; ''The Potter's Art and Aestheticism'', *PG*, February 1895, p. 122; Spielman, M. H., *British Sculpture and Sculptors of To-Day* (Cassell & Co. Ltd, 1901); Walker, Robert, ''Medmenham Pottery and Conrad Dressler'', *GE*, summer 1986, no. 12, pp. 8–10; Williams, Helen, ''Recollections of the Della Robbia Pottery'', *Echoes and Reflections* (Northern Ceramics Society, 1990; reprint from *NCS*, no. 29); Williamson; *The Women's Guild of Arts Exhibition*, 1912.

De Morgan & Co.

See William De Morgan.

De Morgan, William Frend

1839–1917
Chelsea
1872–81
Merton Abbey
1882–88
Fulham
1888–1908

De Morgan studied briefly at London University, where his father was Professor of Mathematics, before turning his attention to art. After studying for three years at the Royal Academy, he admitted: ''I certainly was a feeble and discursive dabbler in picture making. I transferred myself to stained glass window making and dabbled in that too till 1872.'' He exhibited paintings at the Royal Society of British Artists in 1863 and 1864. In 1869 he decided to replicate on pottery the iridescent silver lustre on the back of stained glass. He began his experiments with the aid of a small kiln in the cellar of his home at 40 Fitzroy Square. After setting the house on fire in 1871, he abandoned his experiments and returned to stained-glass work. The lure of lustre proved irresistible and De Morgan moved to Cheyne Row, Chelsea, where a garden shed housed his kiln. His efforts soon met with enough success to necessitate removal to larger premises in Cheyne Row. Here De Morgan perfected his lustre and devised his technique for painting in Persian colours under the glaze. He began to make large panels of tiles, which soon became popular with shipping companies, especially P & O.

In the early 1860s De Morgan had become very friendly with members of the Pre-Raphaelite circle, expecially with Edward Burne-Jones* and William Morris*. Throughout his ceramic career, his efforts were applauded by these friends. Morris & Co.* retailed his work, and incorporated his tiles into their decorative commissions.

Despite De Morgan's close friendship with William Morris, he did not embrace all the ideals of Arts and Crafts Movement. He decorated blanks made by the Architectural Pottery, Poole, as well as blanks from J. Wedgwood (& Sons Ltd)* and other Staffordshire potteries. He was concerned about the quality of these wares, though not about their origins. In 1876, dissatisfied with poor firing results obtained from dust-pressed tiles, he began to make his own (37, 39 and 41; Colour XIII). After much experimentation, he produced a frost-resistant tile. As one of De Morgan's aims was to see the extensive use of exterior tiling, this was a vital step. He also used some commercial preparations for glazing. In one letter he complained:

> The present defects in our lustre are not in the process, but in the ground – I do not know how it is, but no really good thing ever comes from the Potteries – and it's stranger in the case of Wenger's enamel than in other things, because I fancy Wenger doesn't *weng* it at all, but gets it from some foreign Wenger.

De Morgan had no grand schemes for educating his workers, or providing them with delightful and satisfying work. He wanted his designs copied precisely and was

I Allander Pottery vases, variously dated, h. of tallest 27.5 cm.

II Aller Vale (Art) Pottery
two-handled vase,
probably by Charles
Collard.

III Aller Vale (Art) Pottery wares. *Left to right*: udder vase, impressed
"ALLER VALE" and inscribed "901M11", h. 13 cm; Normandy jug,
impressed "ALLER VALE" and inscribed "648 G1", h. 14.5 cm; jug,
impressed "ENGLAND" and inscribed "648 M1", h. 14.5 cm.

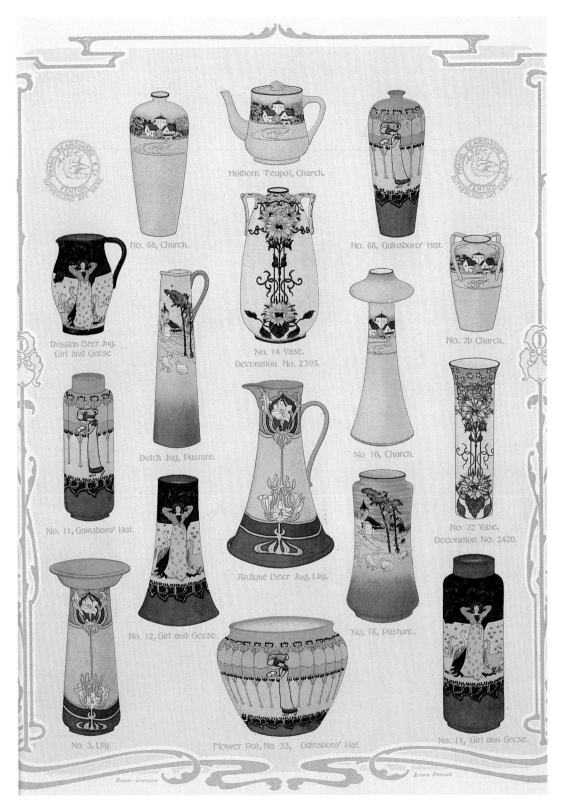

IV Frank Beardmore & Co. Ltd, page from a catalogue.

V Burmantofts Pottery vase.

VI Burmantofts Pottery two-handled vase.

VII Burmantofts Pottery vases.

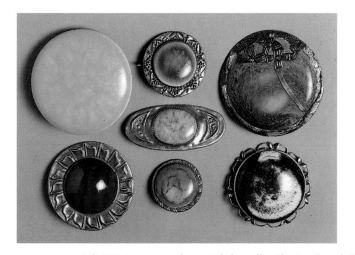 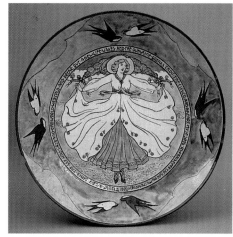

Left, VIII Assortment of mounted glaze-effect "buttons", probably by William Howson Taylor.

Right, IX George Cartlidge sgraffito plaque, red earthenware body with white slip and coloured glazes, incised "Geo. Cartlidge Rudyard Nov 1902".

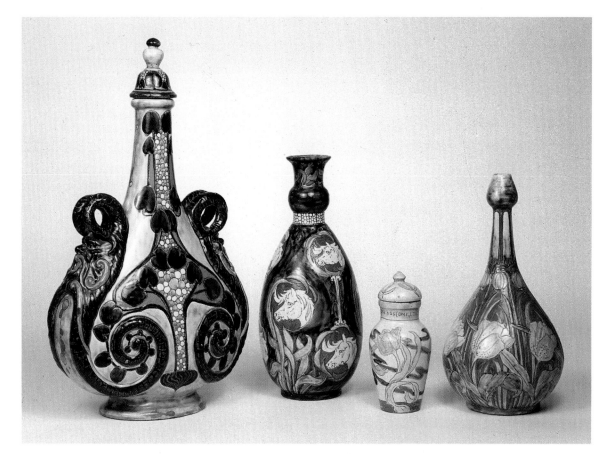

X Della Robbia Pottery wares, with incised Della Robbia marks. *Left to right*: covered vase decorated by Ruth Bare, decorator's monogram "RB", h. 53 cm; vase decorated by Liza Wilkins, painted decorator's initials "LW", h. 35.6 cm; covered vase. unidentified decorator's monogram "GHS", h. 19.5 cm; vase, possibly decorated by Ted Ackerley, decorator's monogram "A", h. 34 cm.

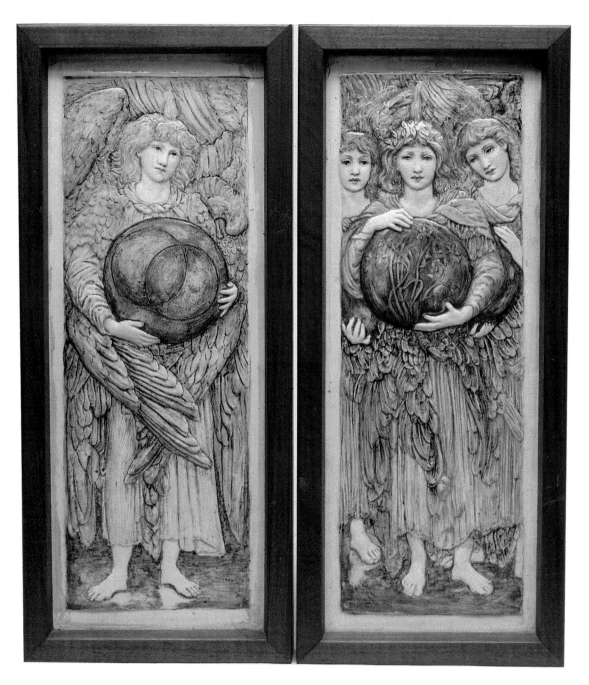

XI Della Robbia panels from the series *The Six Days of Creation*, after Edward Burne-Jones,
painted marks, 55.5 cm by 21.5 cm.

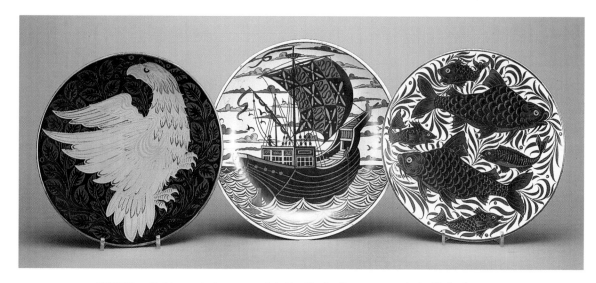

XII William De Morgan lustrewares, painted by Charles Passenger, marked with "CP" monogram. *Left to right*: plaque, d. 25 cm; dish, painted mark "W.D.M., FULHAM", d. 26 cm; *Sunlight and Moonlight Suite* plaque, d. 25 cm.

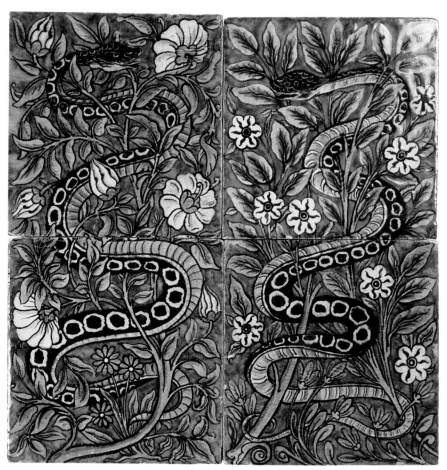

XIII William De Morgan four-tile panel, impressed "W. de Morgan Merton Abbey", 41.2 cm sq.

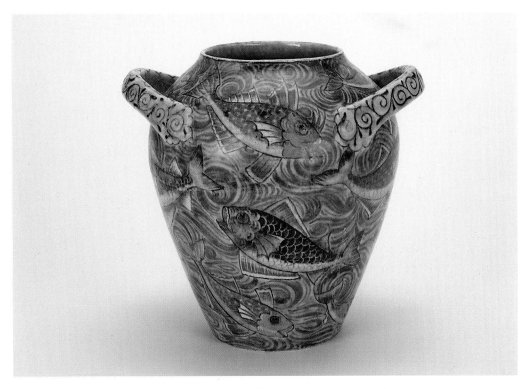

XIV William De Morgan Isnik vase, painted by Fred Passenger, marked "W. DE. MORGAN. & CO., F.P." in script, h. 22 cm.

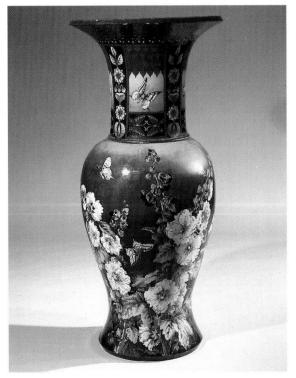

XV Doulton & Co. (Ltd), Lambeth Faience vase, decorated by Florence Lewis. Painted monogram "FL", numbered 273, h. 113 cm.

XVI Doulton & Co. (Ltd), Lambeth Ware vase decorated by Edith Lupton.

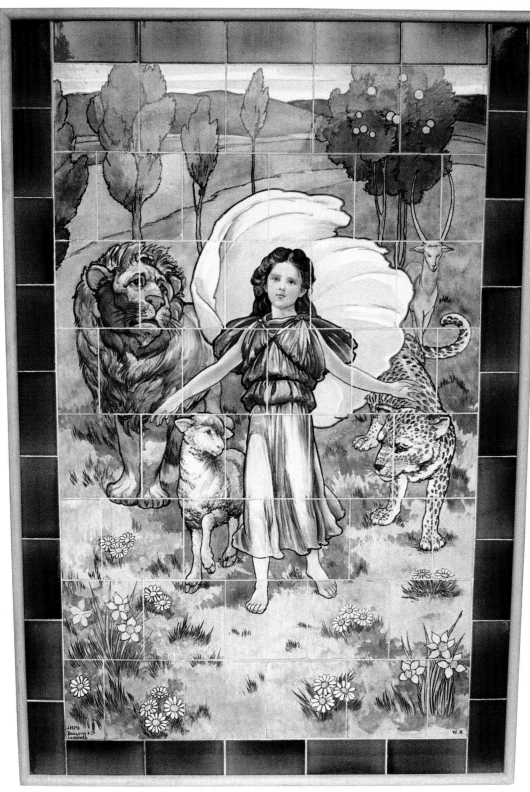

XVII Doulton & Co. (Ltd), Lambeth panel *A Little Child Shall Lead Them*, tube-lined and hand-painted by William Rowe. From Royal Portsmouth Hospital, *c.*1908.

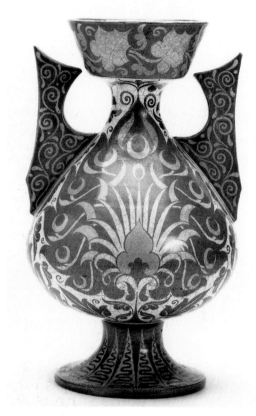

Above, **37** William De Morgan tile panels, total l. 511 cm.

Above right, **38** William De Morgan Persian vase, painted by Joe Juster, "W. DE. M." in script and "J.J." monogram, 29 cm.

Right, **39** William De Morgan Persian tiles, 1888–97, impressed with "Sands End Pottery" mark. Tiles in panels, *left to right*: 15.5 cm sq; 15.5 cm sq; 15.8 cm sq; 25.5 cm sq.

known to smash perfectly beautiful pots because they were not exact replicas of his designs. He once warned his decorator, H. Bale: "Please understand I don't pay you to think. If you think again, you must think elsewhere!" This is not to say that De Morgan was an unkind man; he was an artist-chemist and the pots were his art

40 William De Morgan dish in pink and ruby lustres, *c.*1898–1911, impressed "BODLEY & SON", d. 23 cm.

41 William De Morgan tile panel, 31.1 cm by 46.7 cm.

42 William De Morgan red lustre chargers, *Left to right:* impressed "J. J. Davies, H.", d. 29.5 cm; 29.8 cm; 30 cm.

and his obsession. Today the words "artist" and "chemist" are commonly perceived as being diametrically opposed. Then, however, the fact that the man of science requires imagination and vision as much as does the artist was better appreciated.

De Morgan was a member of the Arts and Crafts Exhibition Society*, showing at the society's exhibitions from 1888 to 1899. The society included a De Morgan retrospective in its Twelfth Exhibition in 1923. He was also a member of the Century Guild.

William De Morgan is best known for his revival of the use of lustres produced by reduction firing. The smoky depths of tone obtained by the method he devised are very different from the colours given by commercial liquid lustres (40 and 42). His Persian colours were also a result of much experiment and the rich tones obtained are quite exceptional. Both his lustres and Persian colours were copied by many other manufacturers, most notably Maw & Co. (Ltd)*. That De Morgan was influenced by and aspired to the quality of so-called Persian designs is undeniable. However, when his designs are compared with the Moorish patterns in Owen Jones's *Grammar of Ornament* (1856), the vigour and originality of De Morgan's work is striking.

De Morgan's work is conveniently divided into three periods, according to the sites of his potteries. The Chelsea period ended in 1882, when he moved to Merton Abbey. William Morris persuaded De Morgan that they ought to combine their factories under one roof. Finding a suitable venue proved so difficult that De Morgan christened the works the "fictionary". Once they had settled upon Merton Abbey, it turned out that Morris & Co. would after all require the entire factory, and so De Morgan surrendered his sub-lease and built his own factory nearby.

In 1888, De Morgan's health deteriorated. He therefore took on Halsey Ricardo as a partner, and moved his pottery back to London to avoid the strenuous journeys to Merton Abbey. After 1892 De Morgan passed his winters in Florence, hoping to combat the family susceptibility to tuberculosis. He soon found that sending his designs to London left him insufficient control over the pottery. He thus set up a workshop in Florence, where Italian painters would paint tissue paper to his designs. The tissue papers were then sent to London, where they were applied to the tiles, glazed and fired. During firing, the tissue burned away leaving the pattern under the glaze.

The pottery was never a financial success. *The Art Journal* reported in 1897 that:

> ... the comparative lack of appreciation shown by the public is possibly due in some measure to insufficient acquaintance with the wares produced at the Chelsea pottery. They are not advertised in any way and the rooms in which they can be seen are in an old-fashioned house in Great Marlborough Street – a thoroughfare which is rarely traversed by those who would be likely to purchase such goods.

Both Halsey Ricardo and De Morgan's wife Evelyn invested heavily to keep the kilns burning.

In 1898, the burden of his architectural commissions forced Ricardo to retire. De Morgan then went into partnership with Frank Iles and Charles and Fred Passenger*. De Morgan retired in 1905, but the Passengers and Iles continued to produce De Morgan-style wares until 1911.

De Morgan devoted the remainder of his life to writing novels. In the preface to

A. M. W. Stirling's biography of De Morgan and his wife, Sir William Richmond R. A. opined that it was likely "that De Morgan will live in future more by reason of his writings than his designs or superb pottery". Even De Morgan's obituary in *The Pottery Gazette* reported that "Late in life he found his true vocation by writing a series of admirable novels" (February 1917). While De Morgan's first novel, *Joseph Vance*, is perhaps underrated today, his other seven are painfully slow for the modern reader. As *romans à clef*, however, they are a treasure trove for those who delight in the lives and loves of the Pre-Raphaelites. These novels, rated by contemporaries as the equal of Dickens's, are out of print and forgotten. De Morgan's ceramics, however, command enormous prices at auction and are the subject of numerous books and articles.

De Morgan's assistants and associates

WILLIAM AUMONIER (d. 1913) modelled a "Della Robbia" panel and a small lily panel shown at the Arts and Crafts Exhibition of 1889. A noted woodworker and modeller, Aumonier was a member of the Art Workers Guild* from 1885 and a member of its committee from 1896 to 1898.

J. STAINES BABB designed a panel illustrated in *The Studio* in 1899. He exhibited paintings at the Society of British Artists in 1874 and 1876.

H. BALE started working with De Morgan in the early 1870s. A panel of tiles painted by Bale was shown at the Arts and Crafts Exhibition of 1889. In 1893 Bale exhibited a ruby lustre bowl and two frames of tiles, designed by himself and executed by W. Way of the Rural Industries Society. Bale contributed a long passage on De Morgan to A. M. W. Stirling's biography.

MRS BEATTY was a paintress at Chelsea.

J. BIRCH painted pottery shown at the Arts and Crafts Exhibitions of 1889 and 1893.

C. and G. BOLDRINI painted tiles for decorating ocean liners. Examples were illustrated in *The Studio* in 1899.

TORQUATO BOLDRINI painted the *Jerusalem* tile panel for P&O's *SS Malta* with Fred Passenger. It was shown at the Arts & Crafts Exhibition of 1896. His *Justitia* was illustrated in *The Studio* in 1899.

DRING is mentioned in a letter from De Morgan in Florence (quoted by Stirling).

S. ELLIS threw pottery shown at the Arts and Crafts Exhibition of 1890.

A. FARINI was one of De Morgan's Florentine painters. His work was fired at Cantagalli, Florence, *c.*1901.

H. F. FAWCETT was an artist who later worked with the Martin Brothers*.

EWBANK managed the pottery for a period while De Morgan was in Florence.

JIM HARLEY painted pottery shown at the Arts and Crafts Exhibition of 1896.

J. HERSEY painted pottery shown at the Arts and Crafts Exhibitions of 1889, 1893, and 1899. Greenwood lists John and James Hersey. Mark: "JH".

R. HODKIN threw a vase shown at the Arts and Crafts Exhibition of 1888.

FRANK ILES was De Morgan's kiln man from the early days at Chelsea. He was one of De Morgan's partners from 1898 to 1907.

JOE JUSTER painted owl panels and other pottery shown at the Arts and Crafts Exhibitions of 1889, 1893, 1896 and 1899. Mark: "J. J." *See* 38 and Colour XXVII.

WILLIAM MORRIS* designed only three tiles produced by De Morgan, including Trellis & Tulip and Poppy.

CHARLES PASSENGER* painted panels and pottery shown at the Arts and Crafts Exhibitions of 1889, 1890, 1893, 1896 and 1899. His *Troy Town* tile panel was shown at the Arts and Crafts Exhibition of 1893. He was one of De Morgan's partners from 1898 to 1907. He made De Morgan wares at Brompton Road from 1907 to 1911. Mark: "C. P.". *See* Colour XII.

FRED PASSENGER* painted tiles for ocean liners, and a vase shown at the Arts and Crafts Exhibition of 1888; his Luca Della Robbias, small lily panels and other pottery, were shown at the Arts and Crafts Exhibitions of 1889, 1890, 1893, 1896 and 1899. He painted the *Jerusalem* tile panel for P&O's liner, the *Malta*, shown at the Arts and Crafts Exhibition of 1896 with Torquato Boldrini. He was one of De Morgan's partners from 1898 to 1907. He continued to make De Morgan-style wares at Brompton Road from 1907 to 1911 and, later, at the Bushey Heath Pottery*. Mark: "F. P.". *See* 119 and Colour XIV.

EDWARD PORTER painted pottery shown at the Arts and Crafts Exhibitions of 1889 and 1890. Mark: "E. P."

M. RAVA painted tiles shown at the Arts and Crafts Exhibition of 1890.

HALSEY RALPH RICARDO (1854–1928). This architect and designer was De Morgan's partner from 1888 to 1898. He managed the firm while De Morgan spent winters in Florence and injected much-needed capital into the ailing firm. His known designs include a chimneypiece shown at the Arts and Crafts Exhibition of 1888, the *Troy Town* tile panel shown in 1893 and the *Camelot* panel (*Studio*, 1899). He became a member of the Art Workers Guild* in 1893, and was Master in 1910. Mark: possibly "H. R.".

H. ROBINSON painted a *Luca Della Robbia* panel and other pottery shown at the Arts and Crafts Exhibitions of 1889 and 1890.

B. AND F. SIROCCHI painted a panel illustrated in *The Studio* in 1899. Mark: "S".

REGINALD THOMPSON, a great friend of De Morgan's and eventually his brother-in-law. He "took part in the designing, and some of his productions and reproductions are extremely clever, particularly those of animals and birds, in which he excelled. He and De Morgan would vie with each other in inventing grotesque beasts and monsters . . ." (Stirling)

Marks: Chelsea period, 1872–81, "W. DE MORGAN", impressed; Merton Abbey period, 1882–88, "W DE MERTON ABBEY", impressed with a picture of the abbey, or "W DE MORGAN MERTON ABBEY", impressed in an oval; early Fulham period, 1888–97, various marks incorporating "Sand's End" or "Fulham"; late Fulham period, "DM" or "DIP", impressed.

References: Anscombe, Isabelle, "Willian de Morgan Lustreware", *Art & Antiques Weekly*, 12 January 1980, pp. 28–30; A&CXS 1888–1923; "The Arts and Industries of Today", *AJ*, 1897, pp. 251–52; Austwick; Blacker; Blunt, Reginald, *The Wonderful Village* (1918; reprinted in part in Haslam 1975); Caiger-Smith, Alan, "De Morgan Colours Discovery", *GE*, spring 1983, pp. 5–6; Cameron; Catleugh, Jon, *William De Morgan Tiles* (Van Nostrand Reinhold Co., 1983); Church, A. H., "A New Lustred Pottery", *The Portfolio*, 1876, p. 114 (reprinted in Haslam 1975); Coysh; Day, Lewis, F., "Tiles", *AJ*, 1895, pp. 343–48; De Morgan, William, "Lustre Ware", *Journal of the Society of Arts*, no. 40, 1892, pp. 756–64 (reprinted in Haslam 1975); Godden 1964, 1972; Gaunt, William and M. D. E. Clayton-Stamm, *William De Morgan*, Studio Vista, 1971; Greenwood, Martin, *The Designs of William De Morgan* (Richard Dennis and William E. Wiltshire III,

Ilminster, 1989); Haslam 1975; Haslam, Malcolm, *The Martin Brothers* (Richard Dennis, 1978); Hawkins, Jennifer, *The Poole Potteries* (Barrie & Jenkins, 1980); Johnson; Lockett; *MBD*; Myers, Hilary, "Wightwick Manor", *GE*, autumn/winter 1981, pp. 1–2; Pinkham, Roger, *Catalogue of Pottery by William De Morgan* (Victoria & Albert Museum, 1973); Pinkham, Roger, "A Morris and De Morgan Tile Panel", *Victoria and Albert Museum Masterpieces*, no. 13 (Victoria & Albert Museum, 1977); Pinkham, Roger, "Willian De Morgan – Tilemaker Par Excellence", *The Antique Dealer & Collectors' Guide*, December 1975, pp. 104–06; Sparrow, W. Shaw, "William De Morgan and his Pottery", *Studio*, vol. XVII, 1899, pp. 222–31; Stirling, A. M. W., *William De Morgan and his Wife* (Thornton Butterworth, Ltd., 1922); Thomas; Tilbrook; Van Lemmen; "Mr. William F. De Morgan", *PG* February 1917; "William De Morgan: Potter", *PG>R*, April 1923, pp. 639–40.

De Morgan Pottery Co. *See* Bushey Heath Pottery.

Denby *See* Joseph Bourne (Ltd).

Dennis, Joseph,
Mount Pleasant Works, High Street, Longton, Staffordshire c.1899

Dennis advertised "Art Flower Pots in Newest Shapes and Colours (*PG*, November 1899).

Devon Art Pottery *See* Hart & Moist; Alexander Lauder; Lauder & Smith.

Devonshire Tor Pottery *See* Tor Vale Pottery.

Dicker Pottery *See* Uriah Clark & Nephew (Ltd).

Dimmock, J. & Co.
Albion Works, Hanley, Staffordshire 1862–1904

Dimmock introduced its Cliff Art Ware in 1885:

> It is quite different from the present art pottery so much in vogue. The colours are not stained glazes, but are made in slip clay, and are thus incorporated with the body when in the green state. As it is passed through the biscuit and glost ovens the beautiful and delicate colours are imperishable and cannot craze, as they become part of the body itself. The shapes are chaste, and the hand-painting boldly executed in the best manner. The Cliff Art Ware is of a decidedly high-class character and cannot be sold cheap . . . (*PG*, February 1885)

Marks: "CLIFF ALBION CHINA", impressed.

References: Godden 1964; *PG*.

Doel, William
New Inn Pottery, Bridgend, Ewenny, Clwyd, North Wales c.1880–94

The Ewenny potteries go back to the fifteenth century. The New Inn Pottery is believed to have been part of the expansion which took place in the 1860s. William Doel acquired this brick and tile works in the late 1870s. A former employee of Doulton & Co. (Ltd) Lambeth*, Doel styled himself an art pottery manufacturer in

Kelly's Directory of 1884. The only piece attributed to him is a good-quality plaster bust. Selina Jenkins had succeeded him by 1895.

Marks: "Doel Art Pottery Bridgend".

References: Lewis, J. M., *The Ewenny Potteries* (National Museum of Wales, Cardiff, 1982).

Donyatt Pottery
Donyatt, Ilminster, Somerset
c.1914–22

William John Arlidge was listed as a potter in Donyatt in the Somerset directory for 1902. By 1914 the pottery had been taken over by Augustine "Gus" Arlidge, under the style C. & A. Arlidge, Donyatt Potteries. In 1919 they were listed as "manufacturers of flower pots, glazed and unglazed, earthenware, art pottery, bricks, tiles, pipes, flooring squares, etc.". In 1923 the firm was amalgamated with the Crown Art Pottery* at Ilminster as the Somerset Art Pottery Co. Ltd. C. Arlidge was the managing director. The firm, probably after financial reverses, was reorganized as the Somerset Art Pottery (1925) Ltd, with A. Beck as the managing director. Between 1927 and 1931, Donyatt became a separate entity, Donyatt Pottery Ltd, and Somerset Art Pottery Co. Ltd were listed as being located in Cheddar.

References: *KPOD Somerset*.

Dorset Art Pottery

See Crown Dorset Art Pottery.

Doulton & Co. (Ltd)
Lambeth Art Pottery,
Lambeth, London
1858–1956

Having been apprenticed at the Fulham Pottery, where he became a noted big ware thrower, John Doulton purchased the Vauxhall Pottery in 1815. When John Watts, foreman and manager of the pottery, had become Doulton's partner, the firm traded as Doulton & Watts (1820–58). In 1828 the pottery was moved to High Street, Lambeth.

After Watts's death, John Doulton continued the business in partnership with his sons, John and Henry, under the style Doulton & Co. Henry Doulton (1820–97) was an inventive and innovative businessman. In 1846 he introduced the manufacture of stoneware pipes, which were soon in great demand, for thousands of miles of water pipes and sewers were being laid all over Britain at the time.

Canon Gregory, later Dean of St Paul's, established the Lambeth School of Art to teach drawing and art in its elementary stages. The foundation stone was laid by the Prince of Wales in 1854 and in 1856 John Sparkes was appointed director. During the next decade Henry Doulton was approached several times by his friends Edward Cressy and John Sparkes about a co-operative venture between the school and the pottery. Although Henry was very actively engaged in religious, intellectual and artistic pursuits outside business hours, he was not initially enthusiastic about these proposals.

Between them, Cressy and Sparkes finally won him over and, during the late 1860s, Doulton fired some of the student's efforts. The idea was to imitate the Grés de Flandres stonewares, which were Cressy's passion. However, their earliest efforts were far from successful, as the pigments dissolved in the fierce heat of the stoneware kilns. Consequently, only brown and blue were used on the early wares, as other colours were destroyed by the high temperatures. At the International Exhibition in London in 1867, Doulton's included a few of these pots in their

display, and they met with unexpected success. Efforts were redoubled and a display of some sixty specimens shown at the South Kensington Exhibition of 1871 were received with great acclaim.

In 1873 the art studio's marginal existence ended with the official opening of especially equipped studios and the arrival of the first major contingent of Lambeth students. Lambeth Faience was introduced and decorated in a workshop separate from the Doulton stonewares. By 1874 thirty women artists were employed under the superintendence of Mr Sparkes, aided by Mr Bennet, who directed the painting. Professor Archer mentioned that the studio had produced some 2,000 pieces in that year alone.

Although reports of Henry Doulton's relations with his artists seem too good to be true, there is little doubt that a large measure of the Lambeth art pottery's success can be attributed to the "cordial relations existing between him and his staff . . . Loyalty and heartiness on both sides brought forth the best in each, and that devoted band of artists, though ravaged by the callous hands of time, still loves and lives in its work . . ." (Blacker 1915)

Doulton's display at the International Exhibition in Vienna in 1873 excited considerable interest:

> . . . generally very admirable in design and execution. The colour in some of the examples being particularly successful. Several of the large specimens are most striking in character, and show a thorough mastery over the *technique*. The forms are good and the details well considered in their adaptation to the forms. Sometimes they run into extreme ornate [*sic*], and the "beaded" effects are a little overdone. (*AJ* 1874)

In 1876 Doulton's sent 1,000 pieces to the Philadelphia Centennial Exhibition, where they were well received. The colossal group, *America*, sculpted by John Bell for the Albert Memorial, was faithfully reproduced by Doulton's in terracotta and was the largest piece ever to be executed in that material. Doulton's artistic terracotta was displayed in a terracotta temple.

In 1877, against all advice, Henry Doulton acquired an interest in Pinder, Bourne & Co., of Nile Street, Burslem (*see* Doulton & Co. Ltd). Some Pinder, Bourne blanks were imported to the Lambeth studio for decoration, probably when pressure of work prevented the Lambeth factory from supplying their own.

With the 1880s came a period when technical problems had been resolved. As a result, the pottery was in danger of becoming swamped with over-elaborate decoration, including gilding. Numerous novelty wares were introduced. Yet the reputation of the firm continually grew. In 1887 Henry Doulton became the first potter ever to be knighted. Even a severe fire in 1888 did not set the business back too badly, for the works were quickly rebuilt. By 1890, 350 artists and assistants were employed.

On Henry Doulton's death in 1897, the firm was continued by his staff and his heirs. At the Paris International Exhibition of 1900, Doulton's once again surpassed itself with George Tinworth's fountain, which stood twelve and a half feet high and incorporated a circular basin twelve feet in diameter. At the Louisiana Purchase Exhibition at St Louis in 1904, by contrast, Doulton's emphasized "the useful side of their Lambeth productions, by a display of jugs, tankards, flowerpots, spills, spirit bottles, candlesticks, &c. The old time 'Toby Fillpot' figure jug – a Lambeth specialty." The pottery was in decline, however, and, by 1913, fewer than

100 artists and assistants were employed. In these latter years the firm's advertisements in *The Pottery Gazette* listed shape numbers beside the illustrations, an indication of the mass-production of its wares.

Types of wares

BLACK LEATHER ware, produced *c.*1890–1901, in imitation mediaeval leather vessels.

BROWN STONEWARES with sprigged white decoration, with Egyptian or Assyrian themes. The tops of these wares were dipped in a dark brown ochre glaze.

CARRARA WARE, produced 1887–96, with slight matt glaze enamelled to resemble marble. Decorated with pierced work, low-relief modelling, foliate patterns or strapwork and ornamentation in dull red or sage. It was also painted with scenes by Lambeth Faience artists, sometimes with the addition of gilding and lustre. This should not be confused with the Carrara used for architectural work, which was made by Doulton 1885–1939.

CHINÉ WARES (also known as Doulton and Slater's Patent) produced 1886–1914. In a process developed by John Slater, fabrics such as lace were impressed into the soft clay. The fabric burned away in the kiln, leaving an impressed pattern on the body of the wares. These were then enamelled and sometimes gilded. Stoneware was usually used, but the technique was sometimes used on faience, which made for a softer effect. These wares required four separate firings.

COPPER WARES, produced from *c.*1894, were copper lustre wares that imitated copper vessels, complete with rivets, seams and dents.

CROWN LAMBETH WARE produced 1891–1900. This version of faience had a finer biscuit body, which allowed for subtler colour variation. It had a clear glaze rather than the yellow-tinged glaze of Lambeth Faience. It required three firings (four when gilded) and was discontinued as a result of heavy kiln losses. It was decorated with underglaze painting, often by the studio's best artists.

CYPRUS WARE, produced *c.*1878–9. These wares were made in imitation of the archaic pottery of Cyprus. They were impressed "CYPRUS" to commemorate the annexation of Cyprus to Britain in 1878 by the Treaty of Berlin.

DOULTON ANTIQUE WARES were salt-glazed wares decorated with a series of colours, with a semi-matt glaze. Generally they were large pieces of horticultural ware.

DOULTON WARE, produced late 1860s until 1956, was a stoneware decorated by a wide variety of techniques including sgraffito, carving, sprigging and applied, modelled ornaments.

IMPASTO WARE, produced late 1870s–*c.*1914. Lambeth Faience body decorated with coloured slips using the barbotine technique.

LAMBETH FAIENCE, produced 1873–1914. Underglaze painted earthenware with a yellow-tinged lead glaze, which was replaced with a clear leadless glaze in 1900. Three firings were required, and a fourth if gilded.

LEOPARD SKIN STONEWARE, produced from *c.*1910.

MARQUETERIE WARE was patented by Wilton P. Rix and Doulton in 1887 and introduced in 1889. They used thin slices of different-coloured clays to obtain marbling effects (similar to eighteenth-century agate ware) or unique patchwork effects. Discontinued in 1906. *See* 43.

NATURAL FOLIAGE, or *Repoussé*, wares were made by a technique similar to that used for Chiné, although leaves were used instead of fabric.

43 Doulton & Co. (Ltd),
Lambeth Marqueterie Ware
vases, printed mark
"12.7.1887 Doulton & Rix's
Patent, Marqueterie", with
painters' marks "DF 156Y S"
and incised "EP", h. 21.5 cm.

PERSIAN WARE, originally produced 1884–1900, was revived and made in limited quantities 1919–22, mostly by W. Rowe and H. Simeon. A coarse clay body was dipped in white slip and given Isnik-inspired decoration.

SILICON WARE, produced c.1883–1912 and 1923. Walter Armstrong announced that Doulton's had perfected its Silicon body "within the last few months" (AJ, 1883). This was a smear-glazed stoneware with applied decoration. Pâte-sur-pâte, gilding and copper lustre were sometimes used, but carved incised or perforated decoration are more commonly found. Silicon ware was revived in 1923 for Egyptian wares, celebrating the opening of Tutankhamun's tomb.

VELLUMA WARE, produced 1911–14. Burslem blanks were printed with etchings by A. E. Pearce and W. Rowe, and lightly painted with colours which sunk into the glaze during firing at 1000 degrees centigrade.

VITREOUS FRESCO, a terracotta with matt faience enamels painted on slabs and tiles.

Artists, Senior Assistants and Designers at Doulton Lambeth

Dates refer to periods at which individuals are known to have worked at Doulton Lambeth. Dates in brackets are those of birth and death.

The Lambeth studios were organized in a very strict hierarchy. Most senior were the Artists, who painted, modelled and designed the pottery. Immediately below came the Senior Assistants, and lastly, the Junior Assistants. The Assistants decorated wares to the designs of the Artists, or decorated borders to frame the Artists' work. Surprisingly, few of the Junior Assistants seem to have been

promoted, whereas a number of Senior Assistants seem to have become Artists. Most of those who worked at the studios were students at the Lambeth School of Art, where they continued to attend classes in the evenings.

The working dates given for Doulton artists are based on marked and dated pots or primary documents; as new pots are recorded, these dates are continually revised. The symbol † indicates artists included in the 1882 Presentation Album given to Henry Doulton by the staff.

MATILDA S. ADAMS, c.1878–88, Lambeth Faience Artist. Mark: "MSA".

MARGARET AITKEN†, c.1875–83, Doulton Ware Artist. Mark: "MA" monogram.

MARY AITKEN†, c.1875–c.1895, Doulton Ware Senior Assistant, decorated stonewares and Silicon ware, Mark: "MA".

FANNIE J. ALLEN†, c.1882–5, Lambeth Faience Artist, decorated Impasto wares. Mark: "FJA" monogram.

LIZZIE ANFORD†, Doulton Ware Senior Assistant. Mark: "a" with two squares.

HELEN A. ARDING†, c.1878–84; Lambeth Faience Artist. Mark: "HA" monogram.

MARY M. ARDING†, c.1879–83, Lambeth Faience Artist, specialized in flowers and birds. Mark: "M. M. A".

MARGARET M. ARMSTRONG†, c.1880–9, Lambeth Faience Artist, specialized in painting plaques. Mark: "MA" monogram.

WILLIAM ASKEW, c.1896–1906. Askew threw salt-glazed stoneware vases, bowls and pots that were shown at the Arts and Crafts Exhibitions of 1896, 1899 and 1906.

ELIZABETH ATKINS†, c.1876–98, Doulton Ware Artist. Mark: "EA".

LOUISA AYLING†, Doulton Ware Senior Assistant. Mark: "a".

AGNES E. M. BAIGENT, c.1901–c.1909, Faience Artist known for Art Nouveau floral. Her work was shown at the Louisiana Purchase Exhibition, St Louis, 1904. Mark: "AEMB" monogram.

EDITH H. BALL†, c.1882–4, Doulton Ware Senior Assistant, decorated Silicon ware. Mark: "B" with line above and below or "bq".

ELIZA S. BANKS†, 1873–83, trained at the Lambeth School of Art. Doulton Ware artist using *pâte-sur-pâte* as well as carved and incised decoration. John Sparkes said: "She has . . . invented and executed some excellent designs in a larger and more picturesque ornamental scale than anyone else. Her work is recognised by a certain freedom of brushwork which perhaps occasionally verges on the natural side of the line that is conventionally held to divide nature from ornament." Mark: "ESB" monogram.

ALICE M. E. BARKER†, Doulton Ware Senior Assistant. Mark: "B" underlined, or "b" with two small squares.

CLARA S. BARKER†, c.1877–84, Doulton Ware Artist. Mark: "CSB".

ARTHUR BOLTON BARLOW (1845–79), 1871–76, was left a cripple by an inflammation of the hip joint when only thirteen years old. At the suggestion of his doctor, he took up wood carving, at which he proved very adept. A family friend, W. G. Rogers, the well-known wood-carver and sculptor, became Arthur's tutor. Arthur joined his sister Hannah in London, studying modelling at the Lambeth School of Art in 1869. John Sparkes noted: "His ornament is original – a flowing tumbling wealth of vegetable form wreaths around the jug, now and then fixed by a boss, or pinned down by a point of modelled form." He

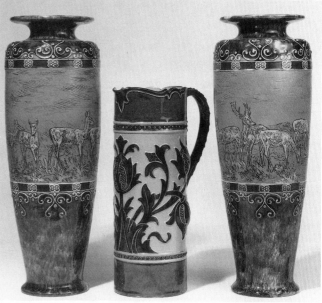

Left, **45** Doulton & Co. (Ltd), Lambeth Ware vases, impressed circle, crown and lion mark, "hd", and "мв", inscribed, h. 36.2 cm.

Right, **46** Doulton & Co. (Ltd), Royal Doulton Lambeth Ware. *Left and right*: pair of vases decorated by Hannah Barlow, impressed lion, crown and circle mark, incised artist's monogram, h. 35.2 cm. *Centre*: jug decorated by Mark V. Marshall, impressed circle, crown and lion mark, "Art Union of London", incised "мvм 688", h. 26.5 cm.

Left, **44** Doulton & Co. (Ltd), Lambeth Ware. *Left to right*: jug decorated by Arthur B. Barlow, silver mounting hallmarked for 1872; two-handled vase and cover decorated by Eliza Simmance, impressed "Doulton Lambeth, England, Art Union of London", h. 30.5 cm; vase decorated by Edith D. Lupton, impressed "Doulton Lambeth 1880", with inscribed artist's monogram "EDL" 587, h. 22.9 cm.

studied at the Royal Academy from 1872, while continuing his studies at Lambeth. In 1876, his health deteriorated and he remained an invalid until his death in 1879. Some of his work was shown at the Philadelphia Centennial Exhibition 1876. Mark: "ABB" monogram. *See* 44 and 47.

FLORENCE ELIZABETH BARLOW† (d. 1909), 1873–1906, followed her sister Hannah to London. She made particular use of *pâte-sur-pâte* and her later work shows the influence of Art Nouveau. Her watercolours were exhibited at the Royal Academy (1884–85), the Dudley Art Gallery, the Royal Society of British Artists (1883–89) and the Walker Art Gallery. Her work was shown at the Philadelphia Centennial Exhibition 1876 and the Louisiana Purchase Exhibition at St Louis, 1904. Mark: "FEB" monogram. *See* 48 and 49.

HANNAH BOLTON BARLOW† (1851–1916), 1871–1906. Hannah's idyllic childhood was cut short by her father's death. Aged sixteen and having to make her own living, she moved to Vauxhall and trained at the Lambeth School of Art from 1868, where she studied under Jean-Charles Cazin*. She worked briefly as a freelance decorator and designer for Doulton's in 1870 and then for Minton's Art Pottery Studio*. She joined Doulton's permanently in 1871. Hannah's childhood love of animals never left her; the sketches of animals that she made from her own menagerie and from nature formed the basis of her sgraffito decorations on Doulton stoneware. The scratched decoration was filled with pigments which gave it the immediacy of a sketch. Although best known for sgraffito, she was also a skilled paintress. John Sparkes noted: "She possesses a certain Japanese facility of representing the largest amount of fact in the fewest lines, all correct, and all embodying in a high degree the essential character of her subject." Although women had been employed in the pottery industry for many years as decorators, Hannah was exceptional in that she became a designer, not only of surface patterns to be executed by other decorators, but having learned to throw on the wheel, she also designed shapes.

Hannah won a prize in the Society of Arts' Art Workmanship Competition, for a frieze of animals on a bowl, modelled, etched, carved and slipped (*Decoration*, July 1889). Her sculpture and paintings were exhibited at the Dudley Art Gallery, Royal Society of British Artists (1880–90), Society of Women Artists, Walker Art Gallery and Royal Academy (1884–90). Her pottery was exhibited at every major international exhibition between 1873 and 1904. She received medals for her ceramic work at Nice in 1884, Paris in 1900 and St Louis in 1904. Mark: "BHB" monogram. *See* 46, 47, 50 and 58.

LUCY ANNA BARLOW, 1882–85, assisted her sisters, Hannah and Florence, in their studio for several years, afterwards becoming their housekeeper. Mark: "L. A. B".

HARRY BARNARD†*, 1879–95. Since Barnard started at Doulton's as an assistant to Mark V. Marshall, it is not surprising that he excelled at grotesques, although he later developed his own distinctive style. By 1884 he was under-manager of the studio. He also modelled portrait medallions and decorated some of the Burslem wares. Mark: "HB" monogram.

WILLIAM LEONARD BARON*, *c.*1883–84. Having trained at the Lambeth School of Art, Baron worked in *pâte-sur-pâte* decoration. Several of his pots are recorded with dates of 1883. Some time in 1884, he left London to work for C. H. Brannam*.

GILBERT BAYES, a modeller, exhibited models and alto reliefs in wax with the Royal

47 Doulton & Co. (Ltd), Lambeth Ware. *Left to right*: jug decorated by Arthur Barlow, *c.*1872; vase decorated by Hannah Barlow, *c.*1878; jug decorated by Hannah Barlow, dated 1873. All signed with initials.

Left, **48** Doulton & Co. (Ltd), Lambeth Ware vases decorated by Florence E. Barlow, incised artist's monogram "FEB 590 LT 68", and impressed Doulton, Lambeth seal. h. 38.9 cm.

Right, **49** Doulton & Co. (Ltd), Lambeth, stoneware vases decorated by Florence Barlow, impressed marks, incised monograms. *Left and right*: h. 44.5 cm; centre, h. 64 cm.

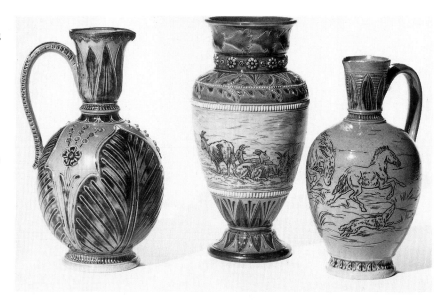

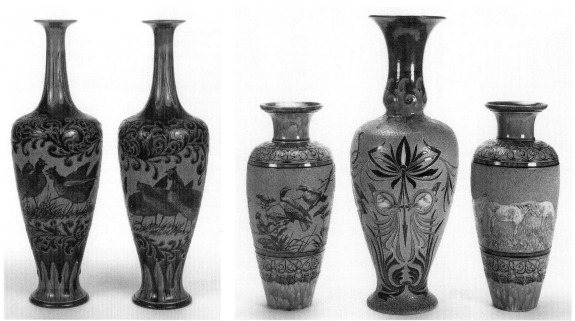

Society of British Artists in 1890 and 1892. *See* 53.

GEORGE W. BEARNE†, 1881–90. Artist's Assistant. Mark: "GWB" monogram.

ARTHUR BEERE, *c.* 1877–82. Modeller of stoneware *Four Seasons*, *Waiting* and *Valour* figures, medallions and architectural terracotta.

JOHN BELL. This famous sculptor modelled the *America* group for the Albert Memorial which was reproduced in terracotta by Doulton and exhibited at the Philadelphia Centennial Exhibition in 1876. He exhibited regularly at the Royal Academy (1832–79) and the Royal Society of British Artists (1833–76).

MR BENNET directed the painting in the Lambeth Faience studio in 1874. According to Clayton, he was an artist from Staffordshire.

50 Doulton & Co. (Ltd), Lambeth Wares decorated by Hannah Barlow, signed with monogram, and Doulton mark. Jug dated 1873, h. 19 cm.

JONATHAN BINES designed a glazed pipe bowl which was shown at the Arts and Crafts Exhibition of 1889.

ERNEST R. BISHOP†, c.1881–84, Artist's Assistant. Mark: "eB" monogram.

SIR ARTHUR BLOMFIELD (d. 1935) designed a niche with a terracotta group of the Madonna and Child executed by George Tinworth and shown at the Arts and Crafts Exhibition of 1889. He exhibited at the Royal Academy 1889–1921.

MR BONE executed the underglaze painting on a tile, *Philosophy*, c.1879.

JESSIE BOWDITCH†, Doulton Ware Senior Assistant. Mark: "B".

ELIZA BOWEN†, Doulton Ware Senior Assistant. Mark: "bb" with two small squares.

JOHN BROAD† (1873–1919) principally worked modelling figures in terracotta, although some were in salt-glazed stoneware or even the hard-paste porcelain developed at Lambeth for laboratory ware. He designed monuments in terracotta which were exported all over the world, and modelled portrait medallions and jugs. His ceramics were shown at the Arts and Crafts Exhibitions of 1890 and 1910 and the Chicago World's Fair of 1893. His work was exhibited at the Royal Academy (1890–1900). Mark: "JB" monogram. *See* 51.

ROSINA BROWN†, c.1876–1904, Doulton Ware Senior Assistant. Mark: "R. B".

ALICE E. BUDDEN†, c.1880–91, Doulton Ware Senior Assistant, promoted to artist 1884. Mark: "AEB." or "b".

EMMA A. BULLOWS†, Doulton Ware Senior Assistant. Mark: "o b".

ALICE L. BURLTON†, Doulton Ware Senior Assistant. Mark: "ALB." or "B".

GEORGINA BURR†, Doulton Ware Senior Assistant. Mark: "b + ".

ELEANOR BURRELL†, Doulton Ware Senior Assistant. Mark: "b" in a circle.

FRANK A. BUTLER†, 1871–1911, began his career as a stained glass artist. Although he was deaf and dumb, he excelled as a designer and decorator of salt-glazed stoneware. Sparkes said: "A bold originality of treatment and the gift of invention are characteristic of his work . . . A certain massing together of floral forms and ingenious treatment of discs, dots and interlacing lines indicate his hand." He also worked with Carrara ware. His work was shown at the

51 Doulton & Co. (Ltd), Royal Doulton stoneware figures, *The Bather*, modelled by John Broad, marked "Royal Doulton Lambeth, England", with artist's and assistant's monograms, 33.5 cm.

Philadelphia Centennial Exhibition of 1876 and the Arts and Crafts Exhibition of 1889. He won a prize in the Society of Arts' Art Workmanship Competition, for a decorated salad bowl (*Decoration*, July 1889) Mark: "FAB" monogram. *See* 52.

MARY BUTTERTON†, *c.*1874–94, was a Lambeth Faience Artist who used stylized natural forms in combination with geometric patterns. She also decorated Carrara and Marqueterie ware. Her work was included in the Philadelphia Centennial Exhibition of 1876. Mark: "MB" monogram.

JAMES E. CALLAHAN, 1883–1936, etched landscapes, figure subjects and formal border ornamentation. He exhibited at the Royal Academy (1895–98).

MARY CAPES†, *c.*1876–83, had a wide repertoire of styles, reflecting both conventional and Japanese influences. As her skill was commended by Clayton in 1876, she had probably been at Doulton's for some time previously. Mark: "MC" monogram.

KATE J. CASTLE†, Doulton Ware Senior Assistant. Mark: "c".

MARGARET M. CHALLIS†, *c.*1877–83. Lambeth Faience Artist specializing in floral designs. Mark: "MCM" monogram.

EMILY M. CHANDLER†, *c.*1879–82. Doulton Ware Senior Assistant. Mark: "EC" monogram or "C" over two wavy lines.

Left, **52** Doulton & Co. (Ltd), Lambeth Ware vase designed by Frank Butler, impressed Royal Doulton mark, and incised artist's monogram "FAB", h. 47.8 cm.

Right, **53** Doulton & Co. (Ltd), Lambeth stoneware "post" figure, *Taylor*, modelled by Gilbert Bayes, h. 49 cm.

FANNY CLARK†, *c.*1876–84. Doulton Ware Senior Assistant. Mark: "FC".

F. M. COLLINS. *See* Mrs F. M. Vale.

MINNA L. CRAWLEY†, *c.*1876–*c.*1885. Lambeth Faience artist specializing in Isnik-inspired floral painting. Sparkes mentioned that she had: ". . . studied the Persian and Rhodian ornament, and now produces these beautiful examples of similar style to the great originals just mentioned, with clear drawing and excellent colour and distribution." As she was commended by Clayton in 1876, she had probably been at Doulton's for some time. Edwards noted in 1879: "She covers the surface of her plaques and vases with the threadlike stems and small leaves and flowers of twining plants of the most delicate form and colour imaginable'. Mark: "MLC" monogram.

JAMES R. CRUIKSHANK†, *c.*1881–89, was an artist who painted historical scenes on tile panels, and figures (especially heads) on plaques. He assisted John Eyre*. Mark: "CJ" monogram or "J. Cruikshank".

CHARLES M. CUE, *c.*1896. Modeller and designer.

MISS A. M. CUMMINGS designed a repeat tile pattern in Parian (*PG*, July 1907).

W. OR A. CUND, *c.*1878–81, was a modeller specializing in animals, particularly dragons.

ANNIE CUPIT†, Doulton Ware Senior Assistant. Mark: "cc".

L. A. LILIAN CURTIS†. Doulton Ware Senior Assistant. Mark: "C" or "c" with two squares.

LIZZIE MARIE DAINTREE†. Doulton Ware Senior Assistant. Mark: "do".

KATE M. DAVIS†, c.1881–82. Doulton Ware Senior Assistant. Mark: "K. D".

LOUISA J. DAVIS†, c.1873–c.1895. Doulton Ware Artist who specialized in stylized flowers and foliage. According to Sparkes, Louisa ". . . has had considerable influence in a certain direction in enlarging the plan of treatment of the same Persian motives in their stoneware translation, and has treated certain natural plants – notably reeds, sedges and grasses – with a masculine vigour and power of drawing that remind one of old Gerard's woodcuts." Mark: "LJD" monogram.

MARY A. DAVIS†, c.1882–84. Doulton Ware Senior Assistant. Mark: "MD" or "d + ".

MARY A. DENLEY, c.1885–c.1894, was a Lambeth Faience Artist who also decorated Carrara ware, mostly with Renaissance-inspired ornament. Her work was illustrated in *The Journal of Decorative Art*, May 1887. She executed a large vase for the Chicago World's Fair of 1893 and sold designs to B. J. Talbot for four years (*Decoration*, June 1881). One of her designs for stained glass was shown at the Royal Academy in 1889. Mark: "DM" monogram.

ADA DENNIS†, c. 1881–94, specialized in painting children and rustic scenes on Lambeth Faience, Crown Lambeth ware, Silicon ware, Marqueterie ware and Carrara ware. Her work was illustrated in *The Journal of Decorative Art*, May 1887. She won a prize in the Society of Arts' Art Workmanship Competition, for a Carrarra vase with panels of figure subjects enamelled on the glaze (*Decoration*, July 1889). Her painting was exhibited at the Royal Academy in 1898, by which time she had married Walter Gandy. Mark: "AD" monogram or "d" followed by two squares.

WILLIAM EDWARD DUNN, c.1882–95. Artist. Mark: "WED" monogram.

BEATRICE DURTNALL†, c.1881–1900. Lambeth Faience Senior Assistant specializing in flower painting. She painted a vase for the Paris International Exhibition of 1900, which was illustrated in *The Pottery Gazette* (April 1900).

JOSEPHINE A. DURTNALL†, c.1877–95. Lambeth Faience Junior Artist in 1882, promoted by 1889. Mark: "JD".

L. IMOGEN DURTNALL†, c.1880–1901. Doulton Ware Senior Assistant. Mark: "dd".

FLORENCE EARL†. Doulton Ware Senior Assistant. Mark: "e" followed by four squares.

ALICE ECKENSTEIN†. Doulton Ware Senior Assistant. Mark: "eeo".

EMILY J. EDWARDS (d. 1876), c.1871–76, was the sister of Catherine Sparkes (*née* Edwards). She studied at the Lambeth School of Art and, by 1876, had been at Doulton's for "three or four years" (Clayton). She specialized in carved, incised and coloured foliage, freely drawn as well as formalized. According to Sparkes,

> Her work is ornament, made up of an ingenious mixture of classical or conventional forms with natural growths. There is usually a great flatness of treatment in her work, with which elaborately diapered backgrounds in no wise interfere. The colour clings to the small stamped patterns on these backgrounds, and flows into the deeper depressions, to the manifest enrichment of the piece. She often gives indication of close study of antique methods of decoration.

Her work was shown at the Philadelphia Centennial Exhibition of 1876. She trained many of the new artists who arrived at Doulton in the 1870s. Mark: "EE" monogram.

LOUISA E. EDWARDS†, c.1873–90. Doulton Ware artist. Louisa may have been the sister of Emily Edwards and Catherine Sparkes (*née* Edwards). There were six daughters in the family. According to Sparkes, Louisa ". . . may be taken as representing a style of decoration taken remotely from the Indian and Persian conventional flowers, but drawn with clear lines of perfect construction, and distributed with judicious thought, taste, and skill". Mark: "ELE" monogram.

FANNY ELLIOTT†, c.1882–1904. Lambeth Faience Artist. An exceptionally versatile artist, Fanny worked with faience, Carrara, and Doulton Ware, using incised and *pâte-sur-pâte* decoration. Her work was shown at the Louisiana Purchase Exhibition at Louis, 1904. Mark: "FE" monogram.

HERBERT ELLIS†, c.1877–c.1910. Artist and modeller in stoneware and terracotta who collaborated with John Broad. He won a prize in the Society of Arts' Art Workmanship Competition for a modelled ewer in Silicon with a Bacchanalian subject (*Decoration*, July 1889). Mark: "HE" monogram.

MARY ELLIS, c.1889, won a prize in the Society of Arts' Art Workmanship Competition for a vase painted under the glaze (*Decoration*, July 1889).

BERTHA EVANS†, c.1882–c.1885, Doulton Ware Senior Assistant. Mark: "BE" monogram or "e".

KATE EVERETT†, Doulton Ware Senior Assistant. Mark: "e e".

JOHN EYRE*†, c.1884–97. This remarkable ceramic artist painted on both faience and Crown Lambeth ware, sometimes using the *impasto* technique. He had previously worked for both Minton's Art Pottery Studio* and W. T. Copeland (& Sons Ltd). His panels illustrating the life of Bewick were commended by *The Journal of Decorative Art* (May 1887). An enormous pair of vases painted by Eyre with scenes from the legends of Perseus, Ariadne and Andromeda and eight panels illustrating Agriculture, Commerce, Columbus's Life and so on, designed by Eyre, were shown at the Chicago World's Fair of 1893. His ceramic work was also shown at the Paris International Exhibition of 1889 and the Arts and Crafts Exhibition of 1890. His paintings were shown at the Royal Academy (1877–1919) and the Royal Society of British Artists (1906–18). Mark: "JE" monogram.

ELIZABETH FISHER†, c.1873–88. Doulton Ware Artist who also decorated Carrara ware. Her formal incised decoration was elaborate early in her career, later becoming simplified. Mark: "EF" monogram.

SARAH FISHER†, c.1879–82, Doulton Ware Senior Assistant. Mark: "SF" or "f" in circle.

EMILYN A. FOSSEY†, Doulton Ware Senior Assistant. Mark: "fo".

LIZZIE FRENCH†, c.1882–1910. Doulton Ware Senior Assistant who in later years decorated Natural Foliage wares. Mark: "ff".

ADA GANDY. *See* Ada Dennis.

JESSIE GANDY†, c.1882–89. Doulton Ware Junior Assistant. Some salt-glazed stoneware designed and executed by Walter and Jessie Gandy was shown at the Arts and Crafts Exhibition of 1889. Jessie was Walter Gandy's sister. Mark: "J.G." or "go" with two squares.

WALTER GANDY, c.1880–1932, won a prize in the Society of Arts' Art Workmanship Competition, for a jar decorated with seaweed (*Decoration*, July

1889). He was Director of the Architectural Office and the Catalogue Section from 1890. Gandy had an exceptional knowledge of art history, upon which the Lambeth artists freely drew. Gandy excelled as a colourist and was chief colourist from 1900; every artist, with the exception of Eliza Simmance, had to submit their work to him for colouring specification. His designs were executed by his sister, Jessie, and later by his wife, Ada Gandy (*née* Dennis). His pottery designs were shown at the Arts and Crafts Exhibitions of 1889 to 1916. He was also an accomplished musician and watercolourist. He won a gold medal at the Louisiana Purchase Exhibition in St Louis, 1904. His paintings were exhibited at the Royal Academy (1910–13) and the Royal Society of British Artists (1893–94).

NELLIE GARBETT†, *c.*1879–1915. Doulton Ware Senior Assistant. Mark: "EG" or "g".

ELLEN GATHERCOLE†, *c.*1881–82, Doulton Ware Senior Assistant. Mark: "NG" or "gg" with four squares.

SARAH T. GATHERCOLE†, *c.*1879–82. Doulton Ware Senior Assistant. Mark: "g" in circle.

ANNIE GENTLE†, *c.*1873–86. Doulton Ware Senior Assistant. Mark: "A.G".

FRANCIS GIBBONS*. Art Director in the 1870s, "where he designed many of their world-renowned ceramic productions" (*PG*, November 1918).

KATE R. GIBBIER†, Doulton Ware Senior Assistant. Mark: "G" or "go".

EMILY J. GILLMAN, *c.*1898–1913. Her Lambeth Faience was shown at the Paris International Exhibition of 1900, and the Louisiana Purchase Exhibition in St Louis, 1904. Some of her work shows an Art Nouveau influence. Mark: "EJG monogram".

MARY A. GOODE†, Doulton Ware Senior Assistant. Mark: "gg".

ALBERTA L. GREEN†, *c.*1878–87. Lambeth Faience Artist. Mark: "AG" monogram.

LAURA GREEN†, Doulton Ware Senior Assistant. Mark: "g" with two squares.

ALICE GROOM†, *c.*1882–86, Doulton Ware Senior Assistant Mark: ".G."

ALICE HALL (*née* Shelley)†, *c.*1877–82. Lambeth Faience Artist, who specialized in natural flowers and foliage. Mark: "AS" or "ASH" monogram.

ELIZABETH HAMILTON†, Lambeth Faience Artist. Mark: "E. H".

ARTHUR LESLIE HARRADINE was apprenticed at the Lambeth factory 1902–12. After the First World War and an extended stay in Canada, he returned to Britain and designed for Doulton Burslem* on a freelance basis 1920–60. His early work was shown at the Arts and Crafts Exhibition of 1912. His Doulton Lambeth Designs include: *Walking Girl, Woman with Child, A Dutch Woman, A Reaper, A Coachman, A Sower, A Peasant, A Peasant Girl, Mermaids, Boy on a Rock* figurines, Charles Dickens characters slip-cast in cream stoneware, a series of spirit flasks depicting politicians in brown salt-glaze, a Roosevelt mug in white salt-glaze, stoneware birds decorated with coloured slips, commemorative busts, North African Spahis, studies of dogs, cockatoos and other animals. Mark: "LH".

EDITH HARRINGTON†, *c.*1882–3. Doulton Ware Senior Assistant. Mark: "hoo".

ROSINA HARRIS†, *c.*1879–82. Doulton Ware Senior Assistant. Mark: "R H".

EMILY HARRISON was commended as a paintress of Lambeth Faience by Clayton in 1876.

W. HASTINGS, *c.*1855–91, was a modeller in the classical and Renaissance styles. He won a prize in the Society of Arts' Art Workmanship Competition for a salt-

glaze vase with a figure frieze and a group on the lid, with piscatorial decoration and trophies. (*Decoration*, July 1889).

LIZZIE HAUGHTON†, 1881–83. Lambeth Faience Artist who painted Impasto wares. Miss L. Haughton exhibited "two pretty plaques of May blossom" at Howell and James in 1883 (*Artist*, 1883). Mark: "LH" monogram.

EMILY HAWKSBY†, Doulton Ware Senior Assistant. Mark: "hh" with two squares.

ELIZA L. HERBERT†, Doulton Ware Artist. Mark: "ELH".

ALICE M. HESPETH†, Doulton Ware Senior Assistant. Mark: "H" or "h" with two squares.

HARRIETT E. HIBBERT†, c.1876–85. Doulton Ware Senior Assistant. Mark: "HEH" monogram.

ELIZA J. HOLLIS†, c.1882–1901. Doulton Ware Senior Assistant. Mark: "hho".

AGNES S. HORNE†, c.1881–c.1895, Doulton Ware Senior Assistant. Mark: "H" with a line above and below or "ho".

LIZZIE HOUGHTON, c.1883. Decorated Impasto wares.

ELIZA L. HUBERT†, c.1876–83. Doulton Ware Artist who assisted Tinworth and Butler. Mark: "ELH".

FLORENCE L. HUNT†, c.1879–82. Doulton Ware Senior Assistant. Mark: "F. H".

JANE S. HURST†, c.1879–1906. Doulton Ware Senior Assistant. Mark: "JH". monogram, which may look like an H with the first upright slightly hooked at the bottom.

JOHN HUSKINSON†, c.1878–83. Doulton Ware Artist. Mark: "JH" monogram.

ERNEST JARRETT, c.1885–89, won a prize in the Society of Arts' Art Workmanship Competition for an incised stoneware vase elaborately decorated (*Decoration*, July 1889).

FLORRIE JONES, c.1905–25. Royal Doulton Assistant; also decorated Silicon ware.

ROSA KEEN†, c.1882–90. Lambeth Faience Artist who decorated Impasto wares. Mark: "R K".

EDITH L. KEMP†, c.1880–82, Doulton Ware Senior Assistant. Mark: "EK" or "K".

PERCY KEMP, c.1881–1890. Black and white artist and etcher of outline designs for colouring; left to work for the press.

EDWARD KERNEYS, c.1893. Artist.

ALICE LACY†, Doulton Ware Senior Assistant. Mark: "II" above "o".

CHARLOTTE LAMB†, c.1879–82, Doulton Ware Senior Assistant. Mark: "CL".

UBIQUE LARCHER†, Lambeth Faience Artist. Mark: "UL" monogram.

FLORENCE LEE, c.1885–95. Doulton Ware Artist.

FRANCIS E. LEE†, c.1875–94. Doulton Ware Artist who designed and decorated with incised and carved flowers and foliage, sometimes using *pâte-sur-pâte*. Mark: "FEL".

HARRIET E. LEE†, Doulton Ware Senior Assistant. Mark: "L" or "II".

E. D. LEEFTON's work was illustrated in *The Journal of Decorative Art*, May 1887.

ESTHER LEWIS†, c.1875–1897. Lambeth Faience Artist specializing in landscape painting, particularly on tile panels. She also decorated Carrara, Crown Lambeth and Impasto wares. John Sparkes described her painting on Lambeth Faience as ". . . entirely satisfactory as broad, breezy representations of nature in quiet grey and warm tones". Her painting on Lambeth Faience, exhibited at Howell and James*, was commended in *The Art Journal* of 1875 and by Cosmo Monkhouse in 1884. Her paintings of mountain scenery were praised by Edwards in 1879. Mark: "EL" monogram or signature.

FLORENCE E. LEWIS†, *c.*1875–97, working freelance until her death 1917. Lambeth Faience Artist who trained at the Lambeth School of Art before coming to Doulton in 1875. She painted flowers, foliage and birds on a wide range of wares, also using the *pâte-sur-pâte* technique. Sparkes commented that Florence had "a remarkable power of design and skill in painting, that is seldom surpassed".

Her painting on Lambeth Faience exhibited at Howell and James* was commended in *The Art Journal* in 1875, *The Magazine of Art* in 1879 and *The Artist* in 1883. She trained a group of seventy Lambeth Faience assistants and her book, *China Painting*, was published by Cassell & Co. in 1883. In 1897, Florence received an inheritance and gave up full-time work at Doulton. Her Lambeth Faience was shown at the Universal Exhibitions in Vienna in 1873 and Paris in 1878; the Chicago World's Fair in 1893 and the Paris International Exhibition in 1900. She travelled widely and exhibited watercolours and oil paintings at the Royal Academy (1881–1915), the Royal Society of British Artists (1892–94), Dudley Art Gallery (1873–1917), the London Society of Women Artists and others. Mark: "FL" monogram. *See* Colour XV.

ISABEL LEWIS†, *c.*1876–97 (working freelance thereafter). Lambeth Faience artist specializing in butterflies, birds and flowers. She was the sister of Florence Lewis, and apparently gave up full-time work at Doulton's at the same time as her sister. Her painting on Lambeth Faience was shown at the International Exhibition in Paris in 1900. Mark: "IL" monogram.

FRANCES M. LINNELL†, *c.*1878–85. Lambeth Faience Artist who decorated Impasto wares with flower paintings. Mark: "FML" monogram.

ADA LONDON†, Doulton Ware Senior Assistant. Mark: "I".

EMILY A. LONDON†, *c.*1882–83, Doulton Ware Senior Assistant. Mark: "EA" or "L".

EDITH D. LUPTON†, *c.*1875–96. Doulton Ware Artist trained at Lambeth School of Art, sometimes using barbotine, *pâte-sur-pâte* or pierced-work decoration. She also decorated Carrara and Silicon wares. She retired *c.*1890 but continued to work freelance until her death. Her ceramic work was shown at the Arts and Crafts Exhibition of 1889. Her paintings were exhibited at the Royal Academy (1873) and the Royal Society of British Artists (1871–80). Mark: "EDL". *See* 44 and Colour XVI

ALICE MARSHALL, *c.*1897–1914, daughter of Mark V. Marshall. She specialized in floral decoration on faience and Crown Lambeth wares.

MARK VILLARS MARSHALL†, *c.*1874–1912. Designer, modeller and sculptor. Trained at Lambeth School of Art, and was working in Farmer & Brindley's masons' yard, when he became reacquainted with his former school friend, R. W. Martin*. When Martin had set up his studio at Pomona House, he employed Marshall during slack times at the masons' yard. When Marshall's hopes of a partnership with Martin were dashed, he left, joining Doulton *c.*1874. There he mainly concentrated on architectural terracotta modelling. He excelled at the modelling of lizards and other reptiles, frogs, salamanders and dragons to be applied to pots or used as figures. The 1890 Borrogrove Vase, inspired by Lewis Carroll's *Jabberwocky*, was modelled in the form of an animal, half-hedgehog and half-fish. Other modelled wares included chess pieces, portrait jugs, plaques and commemorative figures. He also worked in Leopard Skin stoneware and Carrara ware. His work was shown at the Arts and Crafts Exhibitions of

54 Doulton & Co. (Ltd),
Lambeth Ware jardinière and
stand by Mark V. Marshall,
1879–1912, impressed crown,
and circle marks. Jardinière
impressed "6084 MVM 98", h.
128 cm.

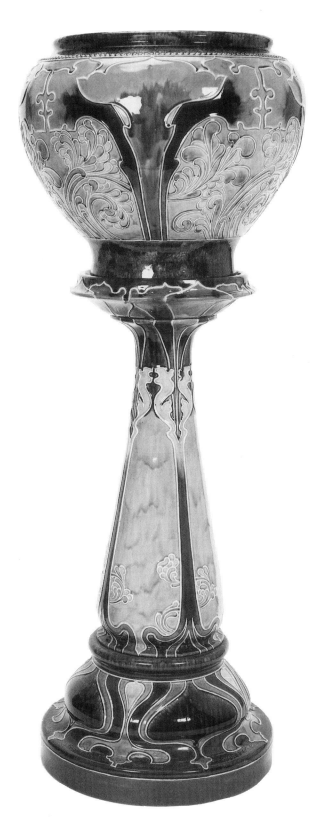

1889 to 1912 and the Chicago World's Fair in 1893. He designed *The Evangelists* panels in tube-lined faience (illustrated in *The Art Journal* in 1898), three four-foot-high vases for the International Exhibition in Paris in 1900 and grotesques for the Louisiana Purchase Exhibition in St Louis in 1904. His bowl and pedestal in Antique ware was illustrated in *The Pottery Gazette*, July 1907. Mark: "M.V.M." While his unique pieces have incised initials, those meant for larger production are unsigned. *See* 46 and 54.

ELIZA MARTIN†, Doulton Ware Senior Assistant. Mark: "mm".

EMMA MARTIN†, *c*.1875–84. Doulton Ware Senior Assistant. Mark: "EM".

LOUISA MATTESSON†, Doulton Ware Senior Assistant. Mark: "mo".

EMILY W. MAYNE†, *c*.1882–*c*.1884, Doulton Ware Senior Assistant. Mark: "EM".

JOHN HENRY McLENNAN†, *c*.1880–1910. Trained at Lambeth School of Art and became a Doulton Ware Artist specializing in tile panels and murals, particularly figure painting. He also decorated faience and Crown Lambeth vases. He painted ornamental panels of Lambeth Faience tiles with three scenes from Malory's *Morte d'Arthur*, shown at the Louisiana Purchase Exhibition in St Louis in 1904. His later work was influenced by Art Nouveau. Mark: "JHM" or signature.

MISS MILL. Her painting on Lambeth Faience exhibited at Howell and James* was commended in *The Art Journal* in 1875.

ISABELLA MILLER†, *c*.1878–84. Doulton Ware Senior Assistant. Mark: "IM" monogram.

MARY MITCHELL†, *c*.1874–87. Doulton Ware Artist who incised designs of children, flowers and foliage, stylized or naturalistically rendered. Mark: "MM".

JOSEPH H. MOTT *c*.1888–1950 (Art Director 1897–1935, afterwards acting as a consultant). Mott's knowledge of bodies, glazes and colours helped to modernize Lambeth wares. He designed simple shapes which were suitable for new glaze effects, and developed the Leopard Skin stoneware. He designed and coloured salt-glazed stoneware vases and bowls shown at the Arts and Crafts Exhibitions of 1896 to 1916.

W. J. NEATBY, *c*.1890–1907. After ten years at the Burmantofts Pottery*, Neatby joined Doulton to head the architectural department. He modelled Carrara in the

55 Doulton & Co. (Ltd), Lambeth Ware owl-shaped vase and cover by Bessie Newberry, impressed "DOULTON LAMBETH ENGLAND" and incised "BN", h. 19.5 cm.

Art Nouveau style and excelled at mural painting. His terracotta tile panels included a set painted with life-size women for the Blackpool Winter Garden (1896), the façade for a Bristol printing works depicting famous printers, and hunting and pastoral scenes for Harrod Ltd's Food Hall. His technical achievements included the development of an eggshell glaze for Carrara wares and the introduction of Della Robbia wares for interiors (salt-glazed stonewares dipped in white slip and covered with bright enamel colours). In *The Studio* in 1903, Aymer Vallance commented: "[It is] the strength of Mr Neatby's work that he is no mere theorist, but at once a designer, vivid in imagination and a handcraftsman who has thoroughly mastered the ways and means of his material".

BESSIE NEWBERY†, *c.*1882–1922. Originally a Lambeth Faience Junior Assistant, later becoming a Doulton Ware Senior Assistant. Mark: "BN". *See* 55 and 57.

JOSEPHINE E. NEWNHAM†, *c.*1880–82, Doulton Ware Senior Assistant. Mark: "N".

W. J. W. NUNN, *c.*1886–90. Tile painter. Mark: signature.

LIZZIE PADBURY†, Doulton Ware Senior Assistant. Mark: "P".

WILLIAM PARKER†, *c.*1878–92. Doulton Ware Artist. His work was shown at the Arts and Crafts Exhibition of 1889. Mark: "wp".

EMILY J. PARTINGTON†, *c.*1875–1915. Doulton Ware Senior Assistant. Mark: "EP". *See* 43.

ARTHUR E. PEARCE†, *c.*1873–1930. Engraver and watercolourist whose work was mostly architectural, including the design of Doulton exhibition stands. He studied architecture at the South Kensington School of Art and design at Julien's studio in Paris. His etched patterns were used on Velluma ware and advertising ware, especially spirit flasks. His work was shown at the Arts and Crafts Exhibition of 1890. His paintings were shown at the Royal Academy (1901) and the Royal Society of British Artists (1882/3), and his etchings appeared in *The Portfolio* and other art magazines. Mark: "AEP" monogram.

FREDERICK W. POMEROY, 1857–1924, working *c.*1880s. Modeller and designer. Pomeroy's sculpture was exhibited at the Royal Society of British Artists (1890–91) and at the Royal Academy (1885–1924), to which he was elected Associate in 1906 and Royal Academician in 1917. He received a silver medal at the Paris International Exhibition in 1900.

FRANCIS "FRANK" C. POPE†, *c.*1873–1923. Assistant Artist in 1882, Pope was later promoted. He designed and decorated in both terracotta and stoneware. He used natural forms such as gourd-shaped vases, sometimes decorated with modelled grotesques. He also worked with Leopard Skin stoneware and Copper Ware. His work was shown at the Arts and Crafts Exhibitions 1899–1916 and at the Louisiana Purchase Exhibition in St Louis in 1904. A vase that he decorated with modelled flowers, foliage and a lizard was illustrated in *The Art Journal* in 1898. Mark: ".P." or "F.C.P."

JANE RABBIT†, Doulton Ware Senior Assistant. Mark: ".rro."

FRANK W. READER†, *c.*1882–83. Assistant Artist. Mark: "R".

CONSTANCE E. REDFORD†, Doulton Ware Senior Assistant. Mark: "CER" monogram or "r" with two squares.

J. ARTHUR REEVE, an architect who designed an altar candlestick for Lambeth parish church (*PG* July 1907). He exhibited church designs at the Royal Academy in 1887 and 1891.

GEORGE WOOLISCROFT RHEAD†*, Lambeth Faience Artist. Mark: "GWR" monogram.

ALICE M. RITCHIN†, c.1880–82. Doulton Ware Senior Assistant. Mark: "A R".

WILTON P. RIX, c.1868–97 (Art Director 1870–97) Rix supervised the studio at the height of its powers. He developed the high temperature colours which could withstand the salt-glazing technique and in 1887 became a joint patentee with Doulton for Marqueterie ware.

EMMELINE "EMMIE" ROBERTS†, c.1882–1912. Lambeth Faience Artist who painted wares influenced by Italian maiolica and Isnik pottery. She later supervised the decoration of Natural Foliage and other wares. Her work was illustrated in *The Journal of Decorative Art*, May 1887. Her Carrara bowl was shown at the Arts and Crafts Exhibition of 1890. Mark: "E R".

FLORENCE C. ROBERTS†, c.1879–1930. Doulton Ware Artist. She used carved, incised and relief-modelled decoration. A covered jar that she decorated was shown at the Arts and Crafts Exhibition of 1893. Mark: "FER" monogram.

ALICE ROBJINT†, Doulton Ware Senior Assistant. Mark: "r" in circle.

EDITH ROGERS†, c.1880–84. Doulton Ware Artist. She used incised, carved and *pâte-sur-pâte* decoration on Doulton's Silicon, Carrara and Impasto wares. The daughter of W. G. Rogers, a friend of the Barlow family who had taught Arthur Barlow*, she introduced Hannah Barlow* to the Lambeth School of Art. Mark: "EER".

KATE ROGERS†, c.1880–93. Lambeth Faience Artist who painted flowers on Impasto and Carrara wares. "She has a strong firm touch, and the thick colour is laid on with the decision that comes from long experience and practice" (*JDA*, May 1887). Her watercolours were exhibited at the Royal Society of British Artists (1884–85) and the Royal Institute of Painters in Water Colour. Mark: "KR" monogram.

MARTHA ROGERS†, c.1879–85. Doulton Ware Artist using incised or *pâte-sur-pâte* decoration on Silicon and Doulton Wares. Mark: "MMR".

LETITIA ROSEVEAR†, Doulton Ware Senior Assistant. Mark: "r".

WILLIAM ROWE, c.1883–1939. Artist and designer who studied at Lambeth and Westminster Schools of Art. He decorated Crown Lambeth ware, painted tile panels, prepared etchings for Velluma Ware and designed Persian wares with H. Simeon c.1919–22. He continued to work occasionally after his retirement until 1945. Mark: "WR" monogram. *See* Colour XVII.

ELLEN RUMBOL†, Doulton Ware Senior Assistant. Mark: "ER" or "RO".

JANE RUMBOL†, c.1882–96. Doulton Ware Senior Assistant. Her work was shown at the Arts and Crafts Exhibitions of 1893 and 1896. Mark: "roo".

L. RUSSELL. c.1889. He won a prize in the Society of Arts' Art Workmanship Competition for a vase (*Decoration*, July 1889).

A. SAYERS†, c.1877–82. Doulton Ware Senior Assistant. Mark: "AS" or "sO".

ELIZABETH A. SAYERS†, c.1877–1883. Doulton Ware Artist. Mark: "EAS".

ALICE SHELLEY. *See* Mrs Alice Hall.

EMMA SHUTE†, c.1880–86. Doulton Ware Senior Assistant. Mark: "ES".

HARRY SIMEON, c.1896–1936. Simeon worked with his father as a monumental mason while studying modelling and sculpture at Huddersfield School of Art. He won a scholarship to the South Kensington School of Art 1894–96. He worked with Leopard Skin stonewares. His work was shown at the Arts and Crafts Exhibitions of 1912 and 1916. He collaborated on the designs of Persian ware

with W. Rowe (c.1919–22) and designed Tobyware jugs (1924–30). He also designed stoneware plaques in the 1920s. Mark: "HS".

ELIZA C. SIMMANCE†, c.1873–1928. Doulton Ware Artist who also decorated Faience, Silicon and Carrara Wares. She studied at the Lambeth School of Art where she was influenced by the Italianate style of Hugh Stannus. Her early work took the form of foliate decoration around panels which were filled in by other artists. She later specialized in a *pâte-sur-pâte* technique. Her work was shown at the Arts and Crafts Exhibition of 1889 and illustrated in *The Studio* (1902). She was for a time influenced by Art Nouveau but developed a distinctive style after 1900, when she decorated only individual pieces. She also designed pieces for decoration by other artists. Mark: "ES" monogram. *See* 44.

ELIZABETH M. SMALL†, c.1879–84. Doulton Ware Artist. Mark: "EMS" monogram.

KATHERINE "KATIE" BLAKE SMALLFIELD†, c.1881–1912. Lambeth Faience Senior Assistant, later promoted to Artist. She specialized in figure subjects, sometimes in the Art Nouveau style. Her work was shown at the Louisiana Purchase Exhibition in St Louis in 1904. Mark: "K.B.S".

MILDRED B. SMALLFIELD†, Lambeth Faience Senior Assistant specializing in painting floral designs on faience, tiles and Carrara ware. Mark: "MBS".

MISS SMALLMAN decorated Lambeth Faience that was shown at the International Exhibition in Paris in 1900 and the Louisiana Purchase Exhibition in St Louis in 1904.

ELLEN B. SMITH†, Doulton Ware Senior Assistant. Mark: "S." or "ss."

GERTRUDE SMITH†, Lambeth Faience Senior Assistant. Mark: "GS" monogram.

CATHERINE SPARKES (*née* Edwards) (1842–91) studied at the South Kensington School of Art (1858–62), the Lambeth School of Art (1861–66) and the Royal Academy (1862–68). She married John Sparkes in 1868. She is known to have undertaken numerous commissions for Doulton, particularly enormous tile panels. Her sister, Emily Edwards, was also a Doulton artist. Her painting on Lambeth Faience exhibited at Howell and James* was commended in *The Art Journal* in 1875. Her large monochrome painting, with a scene from *Comus*, on Dutch tiles (ten feet long and four feet high) was exhibited at the International Exhibition in South Kensington, in 1872, afterwards hanging in Henry Doulton's billiard room. Her thirty-six-foot-long tile panel, *The Pilgrim Fathers*, in Lambeth Faience, was shown at the Philadelphia Centennial Exhibition in 1876. She exhibited her paintings at the Royal Academy (1866–90) and Dudley Art Gallery. She also did wood drawing for book illustrations.

FANNY STABLE†, c.1879–83. Lambeth Faience Artist. Her repertoire included Persian, Rhodian, Rococo and Japanese designs. Mark: "F. S."

MARY STAREY, Doulton Ware Senior Assistant. Mark: SMS or s with two squares.

R. BREMNER STOCKS modelled a terracotta bust of General Gordon dated 1885.

EMILY E. STORMER†, c.1875–95. Doulton Ware Artist who specialized in seascapes, also decorating Carrara ware. Mark: "EES".

KATIE STURGEON†, c.1875–83. Lambeth Faience Artist who specialized in tile and plaque painting. She had previously worked at Minton's Art Pottery Studio*. Her genre watercolours were exhibited at the Royal Academy (1890–95), the Royal Society of British Artists (1881–91), the Royal Institute of Painters in Water Colours, the Society of Women Artists and the Walker Art Gallery. Mark: "KS" monogram.

GEORGE HUGO TABOR†, c.1878–90. Doulton Ware Artist. Mark: "GTH".

A. EUPHEMIA THATCHER†, c.1877–82. Lambeth Faience Artist specializing in flower painting. Mark: "AET" monogram.

MARGARET E. THOMPSON†, 1889–1926. Decorated stonewares, faience and tile panels, particularly nursery scenes. Her Art Nouveau paintings of women on vases are very distinctive. Her work was shown at the Louisiana Purchase Exhibition in St Louis in 1904. *The Studio* (1902) illustrated her work, commenting that she was, "especially successful in her use of the human figure in flat decoration on some tall and shapely Faience vases finished in smooth glazes". Mark: "MET" monogram.

MARY ANN THOMSON†, c.1875–85. Doulton Ware Artist who modelled grotesques. Mark: "MT".

MINNIE THOMPSON†, c.1882–88. Doulton Ware Senior Assistant. Mark: "MGT".

WALTER THORNEMAN†, Assistant Artist. Mark: "WT" monogram.

GEORGE TINWORTH†, (1843–1913), 1867–1913. Tinworth was the son of a wheelwright, in which trade he himself worked for a number of years. His mother was deeply religious, which was reflected in Tinworth's many religious subjects. He studied at Lambeth School of Art and eventually gained life membership of the Royal Academy Schools, where he started in 1864, and in 1867 won his first silver medal in the antique school, all the while working as a wheelwright by day.

John Sparkes introduced Tinworth to Henry Doulton in 1867, and he was soon employed as a modeller of such items as terracotta water filters. During the next four decades he was to complete more than a hundred large panels in terracotta. Although he is best known for his biblical scenes, his genre scenes are of greater interest today. He also decorated vases in his early years at Doulton (according to Sparkes, in 1874 he had already "done quite a thousand" of these). Sparkes remarked further:

> His delight is a spiral band or ornamental ribbon, sometimes deeply interdigitated, or elaborately frilled. The ornament usually covers as much surface as the ground, and creeps or flies over the surface in wild luxuriance; bosses, belts or bands of plain or carved moulding keep this wild growth to its work, put it in its place and subject it to its use.

Tinworth found relief from his solemn biblical masterpieces by modelling humorous figures, most notably mice.

Tinworth's style was described by Professor Archer as "a really new art, with, however, an old smack about it". This archaic look remained characteristic of Tinworth's productions as Art Nouveau swept the country. Although he was still appreciated as a great craftsman, his work was regarded as unfashionable. Tinworth's sculptures were exhibited at the Royal Academy (1866–85) and the Royal Society of British Artists (1889–93), to which he was elected member in 1889. Mark: "GT" monogram. *See* 56 and 57.

LOUISA E. TOMKINS†, Doulton Ware Artist. Mark: "LET" monogram.

MISS E. TOSEN executed a salt-glazed stoneware vase shown at the Arts and Crafts Exhibition of 1896.

F. M. VALE (*née* Collins) c.1878–80 (d. 1880). Best known for her Impasto ware decoration. Mark: "CFM" monogram.

BESSIE M. VARNEY†, Doulton Ware Senior Assistant. Mark: "v".

56 Doulton & Co. (Ltd),
Lambeth stonewares modelled
by George Tinworth.

57 Doulton & Co. (Ltd)
Lambeth Ware vases by George
Tinworth and Bessie Newberry,
1885–95, impressed "Doulton
Lambeth", with "GT"
monogram impressed on sides,
base of one vase incised "BN",
h. 43 cm.

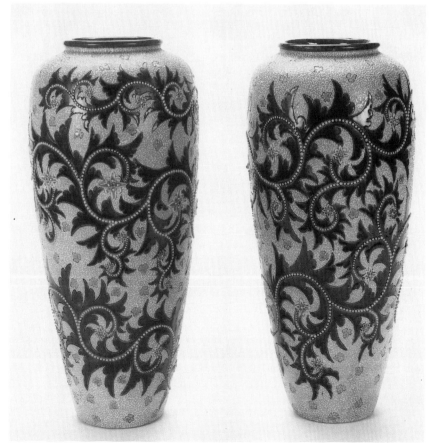

C. VIGOR, c.1878–81. Modeller of relief-moulded panels and tiles, particularly with subjects from Greek mythology. He became a well-known society portrait painter, exhibiting at the Royal Academy (1885–1917).

EMILY M. VINER†, Lambeth Faience Senior Assistant. Mark: "E. V."

LOUISA WAKELEY†, c.1879–82. Doulton Ware Senior Assistant. Mark: "LW" or "w".

LINNE WATT†, c.1875–1890. Lambeth Faience Artist who studied at the Lambeth School of Art from 1874. Her speciality was rustic scenes and figures painted in slip. Her work was exhibited at the Paris Universal Exhibition in 1878. Her painting on Lambeth Faience exhibited at Howell and James* was commended in *The Art Journal* in 1875 and by Edwards in 1879, when she won a silver medal for her *Gathering Spring Flowers*. She won the Princess Alice prize for *Primrosing* at Howell and James's exhibition in 1880. Cosmo Monkhouse commented on her work at Howell and James in 1884:

> Miss Linnie Watt whose dainty pictures of English country, enlivened with not less charming or less English figures of girls and children, remind me of Miss Allingham. Much that is characteristic of the tender beauty of woodland and meadow she has learnt how to suggest with a simple expressive touch especially suited to her materials and the decorative character of her work. Taken altogether, the decorative pictures of Miss Linnie Watt are perhaps the most novel and satisfactory product of the taste for painting on china in England. They are especially fitted for daily companionship, eloquent of grace and beauty when appealed to, and at other moments silently adding by their light and colour to the general cheerfulness of the room.

An accomplished painter, she exhibited regularly at the Royal Academy (1877–1901), Dudley Art Gallery, Dowdeswell Galleries, Glasgow Institute of Fine Art, Manchester City Art Gallery, Royal Society of British Artists (1875–89), Society of Women Artists and Walker Art Gallery. She had her own show, "Dinan and Other Places", at the Dore Gallery, London, in 1908. Mark: her signature or "L Watt" monogram.

EMILY M. R. WELCH†, c.1881–90. Doulton Ware Senior Assistant. Mark: "EW".

GEORGINA WHITE†, c.1877–82. Doulton Ware Senior Assistant who also decorated faience. Mark: "G.W.".

ONSLOW E. WHITING, c.1889. Sculptor, modeller and designer who exhibited at the Royal Academy (1895–1933).

ARTHUR WILCOCK†, Assistant Artist. Mark: "AW" monogram.

EDGAR W. WILSON†, c.1880–93. Assistant Artist who painted and etched plates for reproductions on stoneware. He was later an art critic on the *Pall Mall Gazette*. His work was shown at the Arts and Crafts Exhibition of 1889 and the Royal Academy (1889–90). Mark: "EW" monogram.

EDITH H. WOODINGTON†. Lambeth Senior Assistant. Her *Lilies* was shown at the Howell and James* exhibition of 1883 (*The Artist*, June 1883). Mark: "W".

BESSIE J. YOUATT†, c.1873–90. Doulton Ware Artist who also designed and decorated Marqueterie ware. Mark: "BY" monogram.

Marks: All Doulton ware bears one of the pottery's many marks, all incorporating the word "Doulton". After 1902 most wares were marked "Royal Doulton".

58 Doulton & Co. (Ltd), Lambeth Ware jug, the base showing Hannah Barlow's monogram between the incised date 1873 and impressed "Doulton-Lambeth" oval mark.

Dating from 1873 to the 1880s was plainly written and from 1902 onwards was in code. Artists' marks appear in profusion, as more than one artist frequently worked on a single piece.

References: Archer, Professor, "The Lambeth Potteries", *AJ*, vol. 13, 1874, pp. 66–67; Armstrong, Walter, "The Year's Advance in Art Manufacturers: VI-Stoneware, Fayence, etc.", *AJ*, 1883, pp. 221–23; "Art Handiwork", *AJ*, 1905; Atterbury, Paul and Louise Irvine, *The Doulton Story* (Royal Doulton Tablewares Ltd, Stoke-on-Trent, 1979); Barnard; Bénézit; Blacker; Blacker, J. F., "Doulton's Lambeth Wares", *The Connoisseur*, *c.*1915; Blaikie, J. A., "The Tinworth Exhibition", *AJ*, 1883, pp. 178–80; Buckley; Callen, Anthea, *Women in the Arts and Crafts Movement 1870–1914* (Astragal Books, 1979); Cameron; Clayton; Coysh; *Decoration*; Dennis, Richard, *Doulton Stoneware Pottery 1870–1925* (Richard Dennis, 1971); Dennis, Richard, *Doulton Pottery from the Lambeth and Burslem Studios, 1873–1939* (Richard Dennis, 1975); "Doulton & Co.", *Architecture*, supplement, November, 1897, p. 9; *Doulton & Co. Ltd: Their Works & Manufactures with a Description of their Exhibits at Paris* (1900); "Messrs Doulton's Stoneware", *AJ*, 1872, vol. XI, p. 12; *Doulton Wares* (sale catalogues), Phillips, Fine Art Auctioneers, 1985–90; Dunford; Edwards, W. H., "Lambeth Faience", *MA*, vol. II, 1879, pp. 39–42; Edwards, Rhoda, *Lambeth Stoneware. The Woolley Collection, including Doulton Ware and the Products of other British Potters* (Borough of Lambeth, 1973); Eyles, Desmond, *The Doulton Lambeth Wares* (Hutchinson, 1975); "Famous Art Workers: Doulton & Co.", *JDA*, May 1887, pp. 71–78; "The Fourth Annual Exhibition of Paintings on China", *MA*, vol. II, 1879, p. 269 (reprinted in Haslam 1975); "George Tinworth, Obituary", *The Art Chronicle*, October 1913, p. 81; "George Tinworth: A Preacher in Clay", *PG*, February 1911; Godden 1964, 1972; Goodby, Miranda, "George Tinworth: an Artist in Terracotta", *Journal of the Tiles and Architectural Ceramics Society*, vol. 3, 1990, pp. 15–21; Gosse, Edmund, *Sir Henry Doulton* (Hutchinson, 1970); "Miss H. B. Barlow, Obituary", *PG*, December 1916, pp. 1251–52; Haslam 1975; Haslam, Malcolm, *The Martin Brothers* (Richard Dennis, 1978); "International Exhibition", *AJ*, 1874, p. 241; Irvine, Louise, "Neatby's Work with Doulton", *Architectural Review*, vol. CLXV, 1979, pp. 383–84; Johnson; Laseron, Charles F., *The Renaissance of English Pottery, Being a Descriptive Guide to the Collection of Doulton Wares in the Sydney Technological Museum* (Alfred James Kent, Sydney, 1930); [Mawley, R.] *Pottery and Porcelain in 1876: An Art Student's Ramble through some of the China Shops of London* (Field & Tuer, 1877); "A Memorial to George Tinworth", *PG*, March 1914; Miller, Fred, "Doulton's Lambeth Art Pottery", *AJ*, August 1902; Monkhouse, Cosmo, "'The Royal Academy' of China Painting", *MA*, 1884, pp. 245–50; "New Reredos in Lambeth Church", *Decoration*, November 1888, p. 69; "Paintings on China by Lady Amateurs and Artists", *Artist*, June 1883, pp. 183–84; Petteys; "The Philadelphia Centennial Exhibition", *AJ*, vol. XV, 1876, p. 250; "The Renaissance of Fine Art Pottery in Lambeth", reprinted from *Architecture*, *c.*1897; Rhead; Rose, Peter, *Hannah Barlow, A Doulton Artist* (Richard Dennis, 1985); Royal; *Sculpture in Terra Cotta by George Tinworth* (Doulton & Co. Ltd, 1906); Thomas 1974; "A Tinworth Exhibition", *PG*, June 1914; Sparkes, John, "On the Further Development of the Fine-Art Section of the Lambeth Pottery", *Journal of the Society of Arts*, vol. XXVIII, 1880, pp. 344–55 (reprinted in Haslam 1975); Sparkes, John, "On Some Recent Inventions and Applications of Lambeth Stoneware, Terra Cotta, and

other Pottery for Internal and External Decorations", *Journal of the Society of Arts*, vol. XXII, 1874, pp. 557–66 (reprinted in Haslam 1975); "The Universal Exhibition, Vienna", *AJ*, vol. 12, 1873, p. 375; Vallance, Aylmer, "The Lambeth Pottery", *MA*, 1897, pp. 221–24; Warner, Alex, "John Charles Lewis Sparkes, 1833-1907", *The Journal of the Decorative Arts Society*, no. 13, pp. 9–18; Whitley, W. T., "The Arts and Industries of To-day'", *AJ*, 1898.

Doulton & Co. Ltd
Nile Street, Burslem,
Staffordshire
1882–1955
Doulton Fine China Ltd
1955 to the present day

Against all advice and in the face of much resentment from local people, Henry Doulton bought a controlling interest in the Nile Street Pottery of Pinder, Bourne and Co., in 1877. When, as predicted, the pottery continued to lose money, Doulton defiantly increased his stake, taking over the pottery completely in 1882. The success of the firm was largely brought about by the combined talents of John C. Bailey, who was engaged as General Manager, John Slater as Art Director, and C. J. Noke as Chief Designer. Bone china was introduced in 1884 and from that time, the better-quality wares were made in that body. However, a few groups of wares that could be considered art pottery were produced.

Rembrandt Ware, produced *c.*1898, was made from marl clay, the coarse grade used for saggars. Pieces were thrown, but not turned, so as to produce surface irregularity. They were then painted in slip with portraits of historical figures or Shakespearean characters in dark greens and brown, and covered with a thick glaze. C. J. Noke is credited with creating Rembrandt Ware. It was usually decorated by Walter Nunn.

Royal Blue earthenware was used mostly for vases and painted with portraits of celebrities, landscapes, cattle groups and other subjects.

References: Eyles, Desmond, *The Doulton Burslem Wares* (Barrie & Jenkins, 1980); Laseron, Charles F., *The Renaissance of English Pottery, Being a Descriptive Guide to the Collection of Doulton Wares in the Sydney Technological Museum* (Alfred James Kent, Sydney, 1930); O'Fallon, J. M., "Recent Artistic Staffordshire Pottery", *AJ*, 1896, pp. 51–54; Rix.

Dresser, Dr Christopher
1834–1904

An architect, author and botanist, Dresser was also a designer who worked in many media, including ceramics. He is most closely linked with the Linthorpe Pottery* but is also known to have designed for William Ault & Co.*, Mintons*, Minton's Art Pottery Studio*, Old Hall Earthenware Co. Ltd, J. Wedgwood (& Sons Ltd)*, Worcester Royal Porcelain Co. Ltd and probably the Watcombe Terra-Cotta Co. (Ltd)*. *See* 6, 59–61, 84–86.

Dresser's influence went far beyond his designs. In his *Principles of Design*, he cast aside the Victorian canon, heralding modernism instead. He preferred shapes that could be thrown on the wheel and despised "fancy moulds". He abhorred the gross unsuitability of character jugs and cow creamers, urging: "Let us work the material in a simple and befitting manner, and satisfactory results are almost sure to accrue." His advice to the designer was to ". . . study carefully exactly what is required, before he proceeds to form his ideas of what the object proposed to be created should be like, and then to diligently strive to arrange such a form for it as shall cause it to be perfectly suited to the want which it is intended to meet."

Dresser was educated at Henry Cole's School of Design in London, lectured in Science and Art at the South Kensington School of Art, and received a Doctorate of

Right, **59** Vase with *sang-de-bœuf* striations designed by Christopher Dresser, impressed signature "Chr. Dresser" and 47H", h. 50 cm.

Far right, **60** Jug with ochre glaze, designed by Christopher Dresser, impressed signature "Chr. Dresser 1895", h. 18.4 cm.

61 Wares designed by Christopher Dresser. *Back*: pair of vases with white and green streaked glazes on a brown ground, incised signature, h. 43 cm. *Front, left and right*: Ault vase with olive green and brown glazes, relief-moulded Ault mark, impressed "457", h. 17.9 cm. *Centre*: Linthorpe Pottery lidded vase with white,

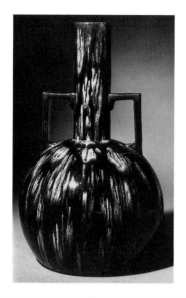

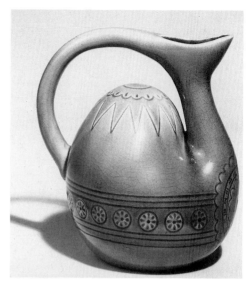

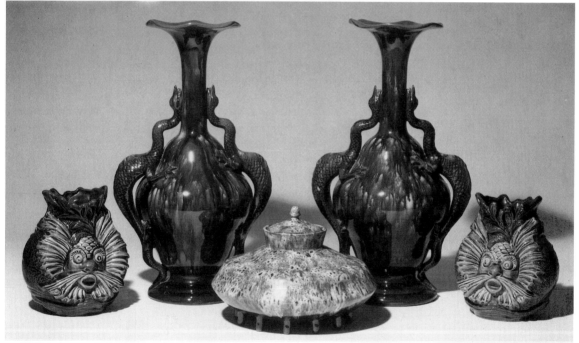

amber and green splashes of glaze on a dark brown ground, impressed "Linthorpe, C. Dresser, 277", h. 17 cm.

Philosophy from Jena University. In 1876 he travelled to Japan, which resulted in his writing *Japan, Its Architecture, Art and Art-manufacturers* (1882). Dresser was one of the first Western artists to appreciate Japanese art, and he communicated his enthusiasm through his writings.

Marks: "Christopher Dresser", signature, impressed or moulded.

References "Art Pottery by Mr William Ault from the designs of Dr Dresser", *CM*, June 1894; Batkin; *Christopher Dresser 1834–1904* (The Fine Art Society and Haslam & Whiteway Ltd, 1990); Brisco, Virginia, "Christopher Dresser and

Watcombe'', *TPCS Magazine*, January 1989, pp. 7–9; Collins, Michael, *Christopher Dresser 1834–1904* (Camden Arts Centre, 1979); Dennis, Richard and John Jesse, *Christopher Dresser* (Richard Dennis, John Jesse and the Fine Art Society, 1972); Dresser, Christopher, *Principles of Decorative Design* (1880); Dresser, Christopher, *Studies in Design* (Cassell, Petter & Galpin, 1876), reprinted as *The Language of Ornament* (Studio Editions, 1988); Halén, Widar, *Christopher Dresser* (Phaidon, Oxford, 1990); Halén, Widar, "The Dresser Pattern Books from Charles Edward Fewster's Collection", *The Journal of the Decorative Arts Society*, no. 12; Brighton; Lockett; Tilbrook; "The Work of Christopher Dresser", *Studio*, vol. XVI, 1899, pp. 104–14.

Dressler, Conrad d'huc
1856–1940

A sculptor and designer, Dressler exhibited widely, at the Royal Society of British Artists, of which he was a member (1905–20), and the Royal Academy (1883–1907), for example. During his lifetime he also established three potteries. In December 1893 he established the Della Robbia Pottery* with Harold Rathbone. Dressler was in charge of the architectural pottery; he must have had some previous ceramic experience because he had exhibited a coloured terracotta panel, *Boy and Lantern*, at the Arts and Crafts Exhibition earlier in the year. Dressler left in 1896, because Rathbone had violated the original Arts and Crafts Movement ideals of the firm by bringing in better-quality clay and hiring skilled workers from Staffordshire.

In 1897 Dressler established the Medmenham Pottery* at Great Marlow, which closed in about 1907. By 1906 he had established the Art Pavements & Decorations Co.*, which continued at least until 1911. Although he devoted his life to producing pottery in keeping with Arts and Crafts Movement ideals, and was a member of the Art Workers Guild*, Dressler is probably best known for inventing the Dressler Tunnel Oven, which revolutionized firing in industrial potteries. The first of such ovens was installed in 1913, and many are still in operation today.

References: A&CXS 1893–1906; Bénézit; Brighton 1984; Cameron; Curtis, Helene, "Conrad Dressler as Artist", *GE*, no. 12, summer 1986, p. 10; Graves; Johnson; Royal; Spielman, M. H., *British Sculpture and Sculptors of To-Day* (Cassell & Co. Ltd, 1901); Walker, Robert, "Medmenham Pottery and Conrad Dressler", *GE*, no. 12, summer 1986, pp. 8–10; Williamson.

Dunmore Pottery (Co.)
Stirlingshire, Scotland
1860–1911

The Airth Pottery was established in the early part of the nineteenth century to produce coarse domestic crockery and tiles from local red clay. After Peter Gardner acquired the pottery in 1860, he brought clay from Devon and Cornwall with the aim of improving the quality of the wares. Gardner's expertise with glazes, gained from experience at his family's pottery in Alloa, soon brought recognition. These Rockingham brown, cobalt, yellow, crimson and copper green glazes were admired for their depth of colour and softness.

The pottery was situated on the estate of the Earl of Dunmore, who took an active interest in Gardner's work. According to a prospectus published by Gardner, the Earl, the Countess and the Dowager-Countess had all contributed designs to the pottery. Through their good offices, Gardner found outlets among the better class of china retailers in London. After a visit to the factory by the Prince of Wales in 1871,

62 Dunmore Pottery lidded jar with relief-moulded decoration.

the wares became quite fashionable.

The Dunmore Pottery exhibited at the Glasgow and Edinburgh Exhibitions, winning a medal in Edinburgh in 1886. Gardner retired in 1903, but the pottery continued in operation until 1911. The firm's earlier products had initially been of good quality, but declined during these later years.

Although Gardner's shapes have been described variously as unorthodox or exotic, they mostly consisted of the sorts of leaves, fruit and animals that were typical of the period (62). In 1880, Professor Archer commended "the classical style, or simple quaintness of shape, and its unobtrusive character". An advertisement of 1885 lists "Vases, Afternoon Tea Sets, Garden Seats, Flower Pots, Dessert Plates, Leaves, Mantelpiece, Dining room and Toilet Table ornaments, etc.".

During the 1880s Dunmore wares were imitated by the Fife Pottery* and by David Methven & Sons* at the Kirkcaldy Pottery.

Marks: "DUNMORE" or "DUNMOR", impressed; circular mark with "Peter Gardner" in the outer frame, impressed.

References: Archer, Professor, "The Potteries of Scotland", *AJ*, vol. XIX, 1880; Bergesen; Cameron; Coysh; Cruikshank; Davis, Peter and Robert Rankine, *Wemyss Ware* (Scottish Academic Press, Edinburgh, 1986); Fleming; Godden 1964, 1972; McVeigh, Patrick, *Scottish East Coast Potteries 1750–1840* (John Donald, Edinburgh, 1979); Monkhouse, Cosmo, "Vallauris and its Allies", *MA*, vol. VI, 1883, pp. 30–36; *PG*; *PG Diary*; *Archivists' Newsletter*, no. 2; Scottish Pottery Society.

Edwards, J.C.

Trfynant Works, Ruabon, Clwyd, North Wales
1870–1958
Pen-y-bont Works, Rhos Works (after 1883) and Plaskynaston Potteries.

Manufacturer of architectural faience and terracotta, encaustic and other floor tiles, majolica and printed and lustred wall tiles. Although J. C. Edwards was a novice when he established his pottery, by 1896 he was employing a thousand men and producing some two million articles per month. Although decorated wall tiles were only a small part of his output, he is remembered today for his ruby lustre and Anglo-Persian tiles made in imitation of those by William De Morgan*. These were designed by L. A. Shuffrey and Lewis F. Day* (63). Edwards's catalogue described the lustre tiles as "Rivaling the finest Mediaeval Italian and Spanish examples, combining with the gorgeous effects of burnished metals the iridescent colours of the Rainbow". The Anglo-Persian tiles were offered in "a large variety of designs and colourings". The firm also produced *émail ombrant* portrait tiles. On

63 J. C. Edwards tile, off-white body, with ruby lustre peony design by Lewis F. Day, moulded mark "J. C. E. & TM".

Left, **64** Ewenny Pottery green glazed three-handled reed tube designed by Horace Elliot, incised "Ewenny Pottery 1905", h. 29 cm.

Above, **65** Ewenny Pottery jug designed by Horace Elliot.

Edwards's death in 1896, his two sons, E. Lloyd and J. Aster Edwards, took over the business.

Marks: "JCE" monogram.

References: Austwick; Barnard; Edwards, J. C., *Catalogue of Patterns*, second edition *c*.1884; *Decoration*; Furnival, William James, *Leadless Decorative Tiles, Faïence and Mosaic*, (Stone, 1904); Jones, Derek, "St John the Evangelist Church, Rhosymedre, Clwyd and J. C. Edwards", *GE*, no. 14, spring/summer 1987, pp. 7–8; Lockett; Myers, Richard J., "Lustres from Lesser Mortals", *GE*, no. 10, summer 1985, pp. 6–7; *PG*.

Elliott, Horace W.
Bayswater
1885–97
Chelsea
1902–05

A London designer, decorator and dealer in art pottery, Elliott first visited the Ewenny Potteries in 1880. During the visit he arranged to stock the wares of both the Doel Pottery* and the Jenkins Brothers' Ewenny Pottery* in his shop in Bloomsbury. Elliott was listed in *Morris's Business Directory* as a manufacturer of "useful artistic and decorative pottery" with a studio and storerooms in Bayswater and later in Chelsea. Elliott visited Ewenny regularly between 1883 and 1913, spending weeks or even months there at a time. His designs for the pottery were stamped with his *fleur-de-lys* trademark. Elliott registered numerous designs between 1886 and 1894, many of which were used at Ewenny. As he was an enthusiast of Esperanto, mottos in that language appeared on Ewenny pottery.

Elliott regularly showed at the Arts and Crafts Exhibitions. In 1889 he displayed an amphora, a "Cleopatra vase" and a "Three-handled tube for reeds", all three in soft red clay and executed by J. Nicolls; two vases and two bowls in sgraffito and slip decoration executed by C. H. Brannam* (to whom he was a friend and advisor); an Oriental vase with twisted handles and conventional Japanese decoration, and a large vase with two handles in yellow glazed ware executed by David and Edwin Jenkins of the Ewenny Pottery; four earthenware pots; and a redware amphora on a wrought-iron stand executed by David Knight. In 1890 he exhibited a four-handled *grès de Flandres* jar executed by Karl Letschert and Frau Binder. In 1893 he exhibited a Rebekah jar and a three-handled vase, thrown by David Jenkins and "handled, finished and decorated" by Elliott. Wares designed by him are shown in 64 and 65.

References: A&CXS 1889, 1890, 1893; Lewis, J. M., *The Ewenny Potteries* (National Museum of Wales, Cardiff, 1982); *MBD*.

Elton, Sir Edmund Harry
1846–1920
Sunflower Pottery, Clevedon, Somerset
1884–1922

His mother having died in childbirth and his father, an artist, living in Italy, Sir Edmund was brought up by an aunt and uncle. He read chemistry at Jesus College, Cambridge, and later at Cirencester Agricultural College, where he heard the lectures of Professor Church, who had a particular interest in ceramic chemistry. These studies in chemistry were to prove essential to Sir Edmund and his pottery. Professor Church had formed an enormous collection of early English pottery, the examination of which doubtless influenced Sir Edmund. Sir Edmund was also an accomplished watercolourist and wood carver, and an inventor, all of which were skills that would serve him in his new career. Sir Edmund inherited his baronetcy in 1883, which title had passed to him from his uncle.

Opposite, left, **66** Sir Edmund Harry Elton's Elton Ware gold *craquelé* jug, painted mark "Elton", h. 34 cm.

Opposite, right, **67** Sir Edmund Harry Elton's Elton Ware vase, with gold *craquelé* over green glaze, marked "Elton", h. 27.5 cm.

In 1879 he decided to make mural mosaics. As his first attempts to fire these in his greenhouse furnace were unsuccessful, he subsequently had his mosaics fired at Pountney & Co. (Ltd)* in Bristol. Soon he had a local bricklayer build him a kiln modelled on one used by Pountney's, to whose works he had been given free access. He purchased clay, colour and glazes from Pountney's as well.

Sir Edmund was nevertheless determined to learn the potter's art by himself. "It was very clearly in his mind at this time that as the Pre-Raphaelites had discarded modern teaching in painting and all modern schools, he might do the same in pottery . . ." (Quentin). Sir Edmund's many experiments are recorded in his notebooks and have been verified by William Fishley Holland*, who studied fragments of pottery found in the orchard. His first efforts were apparently with the local clay, which was too coarse. Attempts with pure white ball clay were similarly unsuccessful. He eventually introduced parings from one of the Staffordshire potteries to the local clay to produce a heavy body, with which he was satisfied. Commercial colours were brought in from Staffordshire; mixed with the red clay, they produced the muted tones now associated with Elton ware. By 1881 a marketable ware had been produced. Elton ware was shown at Howell & James's* exhibition in 1883.

George Masters, who held the lowly position of "boots" at Clevedon Court, was fascinated by Sir Edmund's pottery. Masters was to become his "right hand in everything". Quentin reported: "His interest in the work was intense from the first, he has a strong feeling for art industry, and so thoroughly enters into Sir Edmund's methods that the latter says often that without George Masters he would be inclined to give up Elton ware." There was usually a second assistant at the pottery. Three, Charlie Neads, Jack Flowers and Henry Isgar, are known.

The estate carpenter and local blacksmith constructed a primitive wheel and Sir Edmund hired a local flower-pot thrower. "It was found that the flower-pot man could not be raised much above the ordinary red flower-pot level, and so he had to be discarded" (Church). Although Sir Edmund had learned to throw, it seems that thereafter most of the throwing was done by George Masters. They never learned to pull handles, but rather modelled them and stuck them on with slip.

Sir Edmund experimented constantly with recipes for bodies and glazes, never being content merely to reproduce his past successes. Every piece is unique, intentional pairs excepted. His shapes were original and highly distinctive, influenced by Inca, Aztec, Mediterranean and Far Eastern ceramics, as well as by early English pottery. The wares were mostly jugs and vases, although he also made tygs, plaques and ecclesiastical pieces.

The reddish brown earthenware body was covered in slip, and decorated with coloured slips. The bold relief decoration of stylized roses, tulips, poinsettias and, most especially, sunflowers was built up with coloured slips – what Fishley Holland called "a sort of heavy *pâte-sur-pâte*". This was then coated with a very glossy glaze (68). The pots were always fired on three pieces of clay (instead of stilts) which left distinctive marks on the base of the pots.

Opposite, **68** Sir Edmund Harry Elton's Elton Ware. *Left to right:* vase with gold *craquelé* over olive glaze, painted mark "Elton", h. 20.5 cm; jug in pink, sky and navy blue glazes, painted mark "Elton", h. 14.3 cm; three-handled jug in black, yellow, green and rust glazes, painted mark "Elton", h. 18.3 cm.

These wares met with approbation. The press, enchanted with the idea of a potter-baronet and the romance of struggles for perfection, gave frequent notice of his work. Professor Church emphasized: "No ordinary potter's workman is employed, nor, indeed anyone who has before worked in a pottery." Thus the art of Sir Edmund avoided the taint of industry. Nevertheless, then as now, the quality of the pots themselves was the final arbiter. Professor Church explained: "Elton ware

has achieved a decided and original success by virtue of the thorough soundness, extreme hardness of its fabric, the freshness and temperance of its forms, the appropriateness of its decoration and the rich qualities of its colour."

Apparently, Sir Edmund was strongly influenced by the ceramics shown at the Paris International Exhibition of 1900, where he displayed some Elton Ware. Within the next few years he introduced two new wares, which were similar to those shown at the exhibition. Double-walled pierced wares were introduced in 1901. Sir Edmund began to develop his metallic crackle glazes in 1902. These crackle, or *craquelé*, glazes were obtained by coating the wares with liquid platinum and gold. The metal was mixed with tar oil and painted on glazed pots. The glazes are usually the only decoration on these wares, as any relief would interfere with the effect. When the pot was fired to the low temperature of 750 degrees centigrade, the tar oil burned off, leaving a skin of metal on the pot. As the metal expanded less than the glaze beneath, the metallic coating crackled, revealing that coloured glaze (66 and 67). These wares were a great success at the Louisiana Purchase Exhibition, St Louis, in 1904, and were sold by Tiffany & Co.*, New York.

Sir Edmund won twelve gold medals and two silver medals at international exhibitions between 1885 and 1913. He also displayed his works regularly at the Arts and Crafts Exhibitions of 1889 to 1916. In every case George Masters was given credit for throwing, "working in the rough" or executing the pots. In 1889 Henry Isgar was also given credit for assisting with those tasks. The lustre and crackle glazes displayed in 1916 included: lustre crackle, platinum crackle, coffee lustre, platinum and gold crackle, copper lustre, platinum lustre, lustre with pink reflections and bronze iridescent.

For two years after Sir Edmund's death in 1920, his son Ambrose attempted to keep the pottery going. In 1921, after George Masters's death, Ambrose brought in William Fishley Holland*, who recalled in his memoirs: "Between us we turned out several very nice pots and I introduced some new shapes, especially in bowls, of which they seemed to have made few previously. The fashion for ornate things, heavy furniture, and Victorian design was rapidly dying, therefore the demand for Elton ware was falling off." Ambrose reluctantly closed down the pottery and allowed Fishley Holland to purchase a piece of land from the estate on which to build a pottery of his own.

Marks: "Elton" painted, or more rarely, impressed; "G.F.M." for George Masters. A very few pieces are dated. An "X" was added to the mark on pots made after Sir Edmund's death.

References: A&CXS 1889–1916; Bartlett, John A., "Elton Ware Rediscovered", *The Antique Collector*, July 1985, pp. 50–55; Bartlett, John A., "Elton Ware: the Genius of Sir Edmund Elton, Potter-Baronet", *Antique Collecting*, vol. 21, no. 9, February 1987, pp. 11–14; Blacker; *British Official Catalogue, Paris Exhibition 1900*; Church, A. H., "Elton Ware", *The Portfolio*, 1882, pp. 212–14; Elton, Arthur and Margaret Ann, *Clevedon Court* (The National Trust, Clevedon, 1990); Elton, Sir Edmund, "Elton Ware", *Proceedings of the Somersetshire Archaeological and Natural History Society*, vol. LVI, 1910, pt. II, pp. 31–37 (reprinted in Haslam 1975); Elton, Julia, "Eltonware at Clevedon Court", *National Trust*, autumn 1980; Haslam 1975; Haslam, Malcolm, *Elton Ware* (Richard Dennis, 1989); Holland, W. Fishley, "*Fifty years a Potter*" (Pottery Quarterly, Tring, 1958); Monkhouse, Cosmo, "Elton Ware", *MA*, 1883, vol. VI, pp. 228–33 (reprinted in Haslam 1975); "Paintings on China

Opposite, **69** Ewenny Pottery wares. *Left to right*: vase with streaky grey and brown glazes, inscribed "Ewenny Wales", h. 13 cm; vase with rich mottled brown and green glazes, inscribed "Ewenny Pottery", 11 cm; jug with streaky reddish brown, cream, green and yellow glazes, inscribed "Ewenny Pottery", 12 cm; vase in bright blue and green mottled glazes, inscribed "Ewenny Pottery", 13 cm; basket, with rich mottled brown and green glazes, inscribed "Ewenny Pottery", l. 24 cm.

by Lady Amateurs and Artists," *Artist*, June 1883, pp. 183–84; *PG*; Quentin, Charles, "Elton Ware", *AJ*, 1901, pp. 374–76; Ruck, Pamela, "A Victorian Squire and his Eccentric Pottery", *Art & Antiques*, March 27, 1976; "The Story of 'Elton' Ware", *PG>R*, September 1920, pp. 1206–07; Thomas 1975.

Elton, J. F. & Co.
Archer Works, Stoke-on-Trent, Staffordshire
1901–10

This firm's advertisement in *The Pottery Gazette* of March 1904 reads: "*Speciality: Art Ware*". In February 1905 the same journal commended the Spencer Edge Pottery made by Elton. Spencer Edge was a designer and illustrator in the Potteries; he designed advertisements and trade catalogues, as well as pottery in the Art Nouveau style.

Marks: "J. F. E. Co. LTD. BURSLEM" or "JFE" monogram used on a variety of marks.

References: Godden 1964; Rhead; *PG*.

Essex Art Pottery

See Castle Hedingham Art Pottery.

Evans & Co.

See Watcombe Terra-Cotta Co. (Ltd)

Ewenny Pottery
near Bridgend, Dyfed,
South Wales
c.1820 to the present day

The Ewenny area has been the site of a pottery industry since the early eighteenth century. There were several potteries in Ewenny; the one actually named Ewenny Pottery has been owned by the Jenkins family since *c.*1820. Evan Jenkins ran the pottery until his death in 1856, when his sons, David and John, continued. David sold his interest to John, although he continued to work there until his death in 1905. John died in 1888, leaving the pottery to his son, Edwin. On Edwin's death in 1919, his son, Edwin John, ran the pottery for only three years before handing it

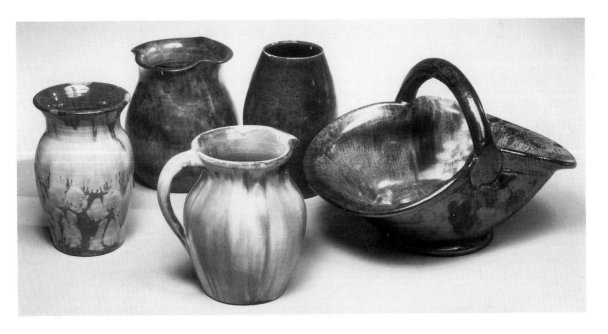

over to his cousin, David John. David John and his five sons continued the pottery until 1939. After the Second World War the two youngest sons, David and Thomas Arthur, resumed operations. In 1970 Arthur's son, Alun, joined the pottery, which he was running on his own by the 1980s.

This was a country pottery making traditional wares, when it was first visited by Horace Elliott*. Initially content with retailing their rustic pottery in his Bloomsbury shop, he soon began to spend several weeks or months at Ewenny annually. The Jenkins executed his highly original designs, some of which were displayed at the Arts and Crafts Exhibitions of 1889 and 1893. Although Ewenny continued to make domestic wares until the Second World War, the pottery also produced a variety of decorative wares. Ewenny's red-bodied wares were usually dipped in white slip, into which mottos or designs were incised. Reserved leaf decoration was also popular. Since the beginning of this century a wide variety of mottled or running-glaze effects have been successfully employed. *See* 64, 65 and 69.

Marks: "EWENNY", incised, sometimes with a date or one of the Jenkins' names; a *fleur-de-lys* on pieces designed by Horace Elliott, sometimes with "*ELLIOTT*" beneath; a number of Elliott's pots have his name incised, sometimes with "Welsh Pottery" or "South Wales Pottery" and a date.

References: A&CXS 1889, 1893; Evans, Lieutenant Colonel Frederic, "The Ewenny Potteries", *P&G*, July 1953, pp. 208–09; Lewis, J. M., *The Ewenny Potteries* (National Museum of Wales, Cardiff, 1982); Smith, Alan, "The Ewenny Potteries", *NCS*, no. 48, pp. 12–14.

Exeter Art Pottery

See Cole & Trelease.

Eyre, John
1847–1927

A Staffordshire-born designer, decorator and painter, trained at the South Kensington School of Art. He worked for Minton's Art Pottery Studio* *c.*1872–73 as a designer, painter, general foreman and kiln superintendent. When W. S. Coleman left, relations between Eyre and Coleman's replacement, Matthew Elden, were strained, and he left to superintend the Art Pottery Studio established by Phillips*, the china dealers. R. Mawley reported: "Some plates painted either by him or under him were shown to me. The modes of treatment I thought novel, but the effect was not so good as it might have been." Apparently Eyre was not impressed with his new situation either, for he did not stay with Phillips for very long.

He moved to Staffordshire, where he worked as a designer for W. T. Copeland (& Sons Ltd). He then returned to London, working at Doulton & Co. (Ltd) Lambeth* *c.*1884–97. A pair of enormous vases painted by Eyre with scenes from the legends of Perseus, Ariadne and Andromeda, and eight panels designed by him and illustrating Agriculture, Commerce, Columbus's Life and so on, were shown at the Chicago World's Fair of 1893. His ceramic work was also shown at the Paris Universal Exhibition of 1889, and the Arts and Crafts Exhibition of 1890. His paintings were shown at the Royal Academy (1877–1919) and the Royal Society of British Artists (1906–18), of which he was a member.

References A&CXS 1890; Atterbury, Paul, and Batkin, Maureen, *The Dictionary of*

Minton (Antique Collectors' Club, Woodbridge, 1990); Barnard; Cameron; Godden 1961; Graves; Johnson; [Mawley, R.], *Pottery & Porcelain in 1876* (Field & Tuer, 1877); Rhead & Rhead; Royal.

Farnham Pottery

See A. Harris (& Sons).

Fife Pottery
Kirkcaldy, Scotland
1827–1930

The Gallatoun Pottery, manufacturer of creamware, was purchased by John Methven (sometimes spelled Methuen) in 1827, who traded under the style Fife Pottery. When Methven died in 1837, he left the pottery to his daughter and son-in-law, Mary and Robert Heron. In 1882, their son, Robert Methven Heron, who had been a partner since 1870, brought in some Bohemian artists, most notably Karel Nekola, and Wemyss wares were introduced. Wemyss ware was named after Wemyss Castle. The first Wemyss wares were self-coloured wares with red, yellow, green and orange glazes. Soon Wemyss wares were decorated with brightly painted flowers on a white ground, a style which was already practised in the region. Best known are the roses and shamrocks, but Canterbury bells, irises, carnations, violets, sweet peas and fruit such as apples, citrus fruits, cherries, plums, strawberries and red currants were also painted (Colour XVIII). Another popular line featured barnyard fowl (70). Chinoiserie designs were also used. Davis and Rankine list and illustrate the wide range of designs employed. The rims of these wares were usually painted with green or red lines. Cats, pigs and other animals were also produced. These wares were retailed by T. Goode & Co. in London and enjoyed the great popularity associated with Scottish themes that stemmed from Queen Victoria's love of Scotland. The ware was made from Cornish clay.

The earlier Wemyss wares were mostly large pieces such as toilet sets and umbrella stands. From 1900 smaller items were introduced, including commemorative pieces for the Diamond Jubilee of 1897 and the coronations of Edward VII and George V. Earlshall wares were introduced in 1914. These wares were made to be sold at charity fairs given at Earlshall Castle. The designs were most often rooks or features from the Castle and its furnishings.

Robert Methven Heron and his sister Jessie (d. 1895) inherited the pottery in 1887. Upon Robert's death in 1906, his friend, William Williamson, inherited the firm. Karel Nekola died in 1915 and in 1916 Edwin Sandland, from Stoke-on-Trent, became chief decorator, introducing a more impressionistic style and underglaze colours. Black or dark backgrounds were also characteristic of these

70 Fife pottery Wemyss Ware mug. *c.*1900, impressed "WEMYSS WARE, R. H. & S.", printed retailer's mark "T. Goode & Co.", h. 14 cm.

later wares. After Sandland's death in 1928, the firm continued for only two more years. Joseph Nekola approached the Bovey Tracey Pottery Co. (owned by Pountney & Co. (Ltd)*), who purchased the reproduction rights to Wemyss patterns and brought Nekola to Bovey Tracey as an artist. The Bovey Tracey wares were distributed by Jan Plichta, whose backstamp they bear. These wares may also be marked "Wemyss Made in England". Nekola remained at Bovey Tracey until his death in 1951. The Bovey Tracey Pottery closed in 1956 but Brian Adams and Esther Weeks now make Essex Wemyss Wares. These are clearly marked "Wemyss Ware, Exon" to prevent any confusion.

Pountney & Co. (Ltd) hired two painters, David Grinton and George Stewart, from the Fife Pottery apparently after Robert Heron's death in 1906. Wemyss-style wares were also made at Guest & Dewsberry (Ltd)* and by Villeroy & Boch in Luxembourg.

Wemyss ware artists

JAMES ADAMSON worked at Fife sporadically from the 1890s to the 1920s.

JOHN BROWN was trained by Karel Nekola. He worked at Fife from the 1880s to the 1890s, also decorating Abbotsford ware for David Methven & Sons*.

DAVID GRINTON worked at Fife from 1882. He worked for Pountney & Co. Ltd*, painting Bristol Art Ware in the Wemyss style *c.*1907.

CHRISTINE "TEENY" MCKINNON was Hugh McKinnon's sister, probably working *c.*1898–*c.*1925.

HUGH MCKINNON (*c.*1870–1943) was working at Fife before 1890, leaving by 1916.

CARL NEKOLA (b. 1891), son of Karel Nekola, worked 1919–24. Mark: "CK".

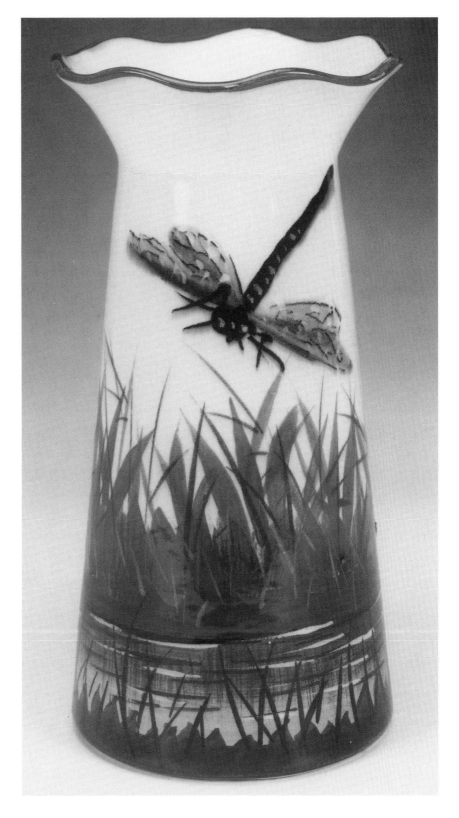

71 Fife Pottery Wemyss Ware vase, probably painted by Edwin Sandland, marked "WEMYSS" in script, h. 20.5 cm.

JOSEPH NEKOLA, son of Karel Nekola, painted Wemyss ware for Bovey Tracey Pottery 1930–52. Mark: "JK".

KAREL NEKOLA, a Bohemian artist brought to Fife in 1882, worked for the pottery for thirty years. He trained many of the other Fife artists, including his sons, Carl and Joseph. When his health began to fail in 1910, a workshop was set up at his home, where he continued to decorate wares until his death in 1915. Mark: "KN".

EDWIN SANDLAND (1878–1928) trained at an art school in Staffordshire. His father was the proprietor of Sandlands Ltd, a manufacturer of earthenwares and china tea sets. He worked at Fife 1916–28. *See* 71.

JAMES SHARP (*c*.1868–1943) worked at Fife *c*.1882–1919. He also painted Abbotsford ware for David Methven & Sons*.

GEORGE STEWART trained at J. Wedgwood (& Sons Ltd)*. He later worked for Pountney & Co. (Ltd)*.

Marks: "Wemyss" or "WEMYSS", painted, printed or impressed; "RH&S"; "Robert Heron & Sons" surmounted by a thistle, after 1920; "Earlshall", painted.

References: Adams, Brian, David Thorn and Esther Weeks, *Wemyss Ware Pottery, The Devonshire Years* (B. & T. Thorn & Son, Budleigh Salterton); Cameron; Coysh; Cruickshank; Davis, Peter and Robert Rankine, *Wemyss Ware* (Scottish Academic Press, Edinburgh, 1986); Godden 1964; Levitt, Sarah, *Pountneys, The Bristol Pottery at Fishponds 1905–1969* (Redcliffe, Bristol, 1990); McVeigh, Patrick, *Scottish East Coast Potteries 1750–1840* (John Donald Publishers Ltd, Edinburgh, 1979).

Fishley family

See Fremington Pottery.

Flaxman Art Tile Works

See J.W. Wade & Co.

Foley Art Pottery

See Wileman & Co.

Forester, Thomas (& Sons Ltd)‡

1877–1959
Blythe Works, Newtown Pottery, High Street, Longton, Staffordshire
1877–1959
Phoenix Works
1879–1959
Church Street, Longton; Imperial Works, Longton
1890–1959

Thomas Forester was born in Stoke-on-Trent in 1832. His father was head of the throwers, turners and handlers at Mintons*. Young Thomas served his apprenticeship as a presser at Mintons. In 1856 he became manager of the Victoria Works of Lockett, Baggaley & Cooper. "After this, some extraordinary circumstance or other impelled him to enter upon the manufacture of artificial teeth but, finding apparently that the process was neither auriferous nor congenial, he returned to his old love, and joined Mrs Wardle, of Sun Street, Hanley, in the making of majolica on the death of her husband" (*PG*, September 1905). He then spent two years in Tournai, Belgium, working for Peterinck & Co., where he established a majolica department.

Forester started his first business at the Blythe Works (Newtown Pottery), High Street, Longton, in 1877. He soon took additional premises in Church Street. These he promptly demolished to make way for the new Phoenix Works, completed in 1879. He then purchased the adjoining china factory – a truly extraordinary

expansion in a period of only six years. In 1883 Thomas Forester took his two sons into the business under the style Thomas Forester and Sons Ltd. Herbert Forester eventually managed the Phoenix Works and Victor Forester, the Blythe Works. In 1887, Forester purchased the majolica works of Samuel Lear in Hanley. The Hanley address is not mentioned in any subsequent advertisements or documents, however, so it is not certain whether he occupied the works. Forester acquired the Imperial Works from the trustees of Green & Clay in March 1890 (PG, May 1890). As Forester had long been grinding ash and bone for sale to china manufacturers, it was not surprising when in 1902 the Imperial Works began production of bone china. By 1907 the works had nine ovens, and was "probably the largest china manufactory in Longton (PG, July 1907).

Forester was a very aggressive businessman, who made a special effort to capture the American market. He advertised "artistic and useful majolica" extensively in the American trade publication, *The Crockery and Glass Journal*, during the 1880s. In January 1883, *The Pottery Gazette* reported: "Mr Forestor [sic] in his 'American' style of business, seems to be rushing in where others fear to tread. His productions are being planted in every State in America, and his premises are filled with busy hands working early and late, to keep down his increasing trade. Others are keenly competing for the American favors, and it will be interesting to watch the struggle for supremacy."

From its inception, the firm specialized in majolica, which it continued to produce up to the First World War. Its Barbotine wares were in fact decorated with moulded applied flowers, rather than painted with slip, in the true barbotine manner. On February 1895, *The Pottery Gazette* observed: "This firm claims to be the largest in the world for turning out art flower pots, their capacity running to a thousand per week, one machine being able to produce two per minute. When we consider the artistic shape and design of these pots, such an output as this truly marks the development of the age as regards machinery in the application to art."

Despite this most industrial of modes of production, Thomas Forester's firm was listed in *Morris's Business Directory* as an art pottery 1889–1930. Their advertisements in *The Pottery Gazette* first mention art pottery in 1899, although *The Pottery Gazette* noted: "Those who have been acquainted with Forester's goods for the past quarter of a century will have noticed the gradual evolution of high-class artistic pottery, from the simple but useful and immensely popular majolica flowerpot." (PG, November 1909).

Although Forester could be seen today as the engineer of the downfall of art pottery, his contemporaries in the industry saw him as something of a hero:

> It is a matter of history, and not recent history either, that the founder of the present extensive company did more than any other single person to prevent the early invasion of our markets by Continental manufacturers of flower-pots. He did not keep what were called "art pots" of foreign make out of our markets altogether, but by his energy in producing English pots in almost unlimited quantities, and in constantly improving designs and ornamen-tations, he took all the sting out of what might have proved a most formidable foreign competition. There was at that time a sort of belief that British art ware was necessarily expensive, and that for medium-priced art ware we could not compete with manufacturers on the Continent. We do not know that Mr Forester ever took the trouble to write a refutation of what he knew to

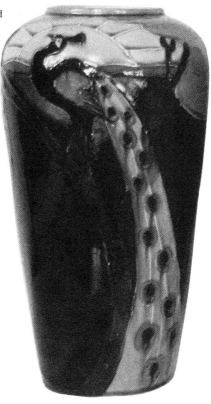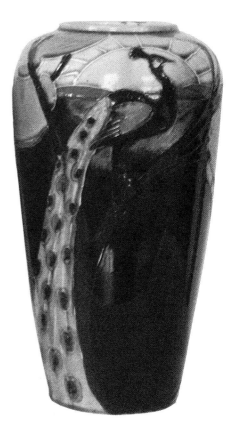

72 Thomas Forester & Sons Ltd vases, signed by A. Dean, printed mark "T. F. & S. LD. ENGLAND" with eagle.

be a fallacy – but we do know that he quietly demonstrated that it was a fallacy, by producing in thousands pots that were artistic in shape and decoration at prices that had previously been unheard of. (*PG*, February 1903)

‡This firm should not be confused with the firm of Thomas Forester and Son, subsequently Forester & Hulme, at the Sutherland Pottery, Fenton.

Forester's art vases

The art wares consisted of flower pots, vases and toilet pieces. These were often hand-painted, but the only known artist was A. Dean (72), whose work was shown at Forester's stand at the Paris International Exhibition of 1900 (*PG*, April 1900). Grotesques were also made.

AZTEC (*PG*, April 1900).

BERRIES, "blackberries in natural colours as the predominating subject, and an embossed leafage on foot and neck in a delicate shade of green" on a white vellum ground. "The general effect is further improved by a fine gold shading, and the pattern being finished off with best burnished gold ..." (*PG*, May 1913).

BOHEMIAN WARE "strives, not unsuccessfully, after a rouge flambé ground, relieved by white slip-painted storks and black lotus leafage, the design being an imposing creation which receives a final embellishment of green and gold." (*PG*, May 1913).

BRIGHTON, "a bright floral decoration on vellum ground" (*PG*, October 1911).

CHESTERFIELD, "a delicate light ground, with panels formed by raised gold and

dark blue ornamentation, with flowers in the panels" (*PG* April 1911).

CHRYSANTHEMUM, "hand-painted flowers on a pleasing celadon ground, the neck and foot of the vases being given a maize relief and a fine gold finish" (*PG*, May 1913).

COLORADO "has an amber ground, shaded from dark at the foot to light amber at the top of the pieces", with the "notorious" Colorado Beetle on the sides (*PG*, November 1909).

DELTA WARE, a combination of coloured clays and added colour effects, on "art shapes". "It is all handwork and each piece unique." These "art shapes" were ordinary vase shapes with wide, asymmetrical, inverted and fluted lips. "There is a remarkable freedom in the treatment of the floral subjects, and the tasteful blending of the colours is very effective" (*PG*, December 1899).

ESSEX, "very pretty rosebuds" (*PG*, October 1911).

GRECIAN, in "Worcester shadings" (*PG*, May 1913).

GREEK (*PG*, November 1909).

GREEN BOUQUET (*PG*, November 1909).

HAWTHORN was decorated with a hand-painted blackbird surrounded by coloured foliage, finished with gold (*PG*, May 1913).

INDIANESQUE, "a beautiful conception on Oriental lines, . . . in charming colours and gold, on soft delicate green shaded ground" (*PG*, November 1909).

LE LENE, delicately shaded with hand-painted leaves on a pure satin ground (*PG*, April 1911).

LOTUS WARE, "has naturally painted lotus flowers on a white vellum ground, with dark leaves traced in platinum and gold, and the flowers shaded at the back with fine gold" (*PG*, October 1911; May 1913).

LOUVRE, "an effective floral decoration on soft shaded grounds . . . bright, striking and inexpensive" (*PG*, November 1909).

MAGNOLIA WARE, " deep jasper blue panels on the neck and foot, the remaining portion consisting of a naturally coloured magnolia flower on a white vellum ground, finished off in best burnished gold" (*PG*, May 1913).

MELROSE (*PG*, November 1909).

MORESQUE, "in shape and modelling this is something after the Rococo, but differently treated" (*PG*, February 1895).

OLD IVORY, "it has a beautiful old ivory tint, with imitation carved pattern deeply cut in; the ornamentation being in gold with just sufficient floral decoration to relieve the richness of the soft subdued tone of the ivory" (*PG*, February 1895).

ORIENT, "a charming female figure ornamentation on light-shaded ground and gilt" (*PG*, November 1909).

PARIS, "large pink roses on an ivory ground, with neck and foot of old gold, relieved with a gold diaper print, the knob and handles of the vase being treated in dull gold . . ." (*PG*, May 1913).

PRIMROSE (*PG*, April 1900).

REMBRANDT WARE, "a purely artistic decoration with gold effects . . . The scheme of it is the introduction of classical heads, subdued in green and other colours, and gold effects. One of the subjects treated is the head of 'Rembrandt' himself." (*PG*, October 1903).

ROYAL ALBERT, in "Worcester shadings" (*PG*, May 1913).

ROYAL WINDSOR "embodies a judicious blending of many different colours" (*PG*, February 1903).

RUBY, "A very bright and uniform ruby is applied to the neck and opening of the vase" (*PG*, October 1911).

SCRIPTURAL SUBJECTS (underglaze paintings). (*PG*, December 1899).

TRENT (*PG*, November 1909).

TROPICAL, decorated with "a rich brown ground, with gold, and with tropical birds in natural plumage as central figures" (*PG*, March 1905).

VANDYKE "is a clever floral treatment applied to vases of many kinds, but all art shapes. The ground is a fine specimen of clever shading from pale fawn to dark brown, with roses in rich colours." (*PG*, March 1905).

VELOUTINO WARE (*PG*, April 1890).

Marks: "T. F. & S." or "T. F. & S. Ld.", sometimes surmounted by an eagle, or with a pattern name; "FORESTER'S ENGLISH FAIENCE". Craven Dunnill* decorated Forester blanks for their art pottery, and so some Craven Dunnill pots bear impressed Forester marks.

References: Austwick; Bergesen; Godden 1964, 1972, 1983; 1988; Meigh; *P&G*; *P&GR*; *PG*; *PG>R*; *PG Diary*; Rhead; "Mr. Thomas Foster, J. P.", *PG*, September 1905, p. 1003; "Thomas Forester, J. P., Obituary", *PG*, July 1907, pp. 811–12.

Forster & Hunt
High Street, Honiton, Devon
*c.*1915–18

This firm made typical Torquay slip-decorated wares, including motto wares, as well as domestic earthenwares. A particular similarity has been noted between the wares of this firm and those of Hart & Moist* of Exeter; no connection has yet been established, however. James Webber* founded the pottery on this site in 1881 and appeared in *Kelly's Devonshire Directory* as late as 1897. It is believed that he was succeeded by Frisk & Hunt, but nothing more is known of this firm. Frisk was presumably Hunt's partner before Forster. The pottery was acquired by Charles Collard* *c.*1918. Forster may later have owned the Barton Pottery in Torquay.

Marks: "FH HONITON", incised, or "Forster & Hunt Honiton", impressed, when marked.

References: Cashmore 1983; *Honiton Pottery Collectors' Society Newsletters*; KPOD *Devonshire*.

Forsyth, Gordon Mitchell
1879–1952

There is no doubt that Forsyth was the single most influential man in twentieth-century British ceramics. After training at the Royal College of Art, he became Art Director of Minton Hollins (& Co.) (Ltd)*, where he designed tiles, architectural faience and mosaics. In 1905 he became the chief artist and later the art director of Pilkingtons Tile & Pottery Co. (Ltd)*. He is credited with bringing vigour to the designs of the other Pilkingtons artists, as well as designing many shapes and patterns himself (Colour XXXV and XXXVI).

In 1920 Forsyth became Superintendent of Art Instruction at the Stoke-on-Trent School of Art, where he remained until his retirement in 1945. He took a great interest in his pupils, continuing to give support and advice after they had graduated and taken up positions in the industry. His conviction that design could resolve the opposition between form and function, and art and industry was borne out by tablewares designed by his former students. These included Clarice Cliff,

Susie Cooper, Harold Holdway (at W. T. Copeland (& Sons Ltd)), Cecil J. Noke (at Doulton & Co. (Ltd), Burslem), Victor Skellern (at J. Wedgwood (& Sons Ltd)), Eric Slater (at Wileman & Co.) and Millicent Taplin (at J. Wedgwood (& Sons Ltd)).

During this period Forsyth designed and decorated tablewares for E. Brain & Co. (Ltd)* and others (73). In 1932 he persuaded Bullers Ltd, manufacturers of electrical porcelains, to open an art pottery studio in which his students could gain practical experience. Although it was never successful financially, the studio's wares gained a wide reputation and the experience it provided was important for the many students who had the opportunity of working there.

Forsyth's paintings were exhibited by the Royal Academy between 1922 and 1948. After his retirement, he continued to work as an artist and a designer of ceramics and stained glass until his death.

References: A&CXS 1910, 1912, 1916; Batkin, Maureen and Paul Atterbury, *Art Among the Insulators, The Bullers Studio, 1932–52* (Gladstone Pottery Museum, Stoke-on-Trent, 1977); Cameron; Cross, FAS 1973; Eatwell, Ann, "Gordon Mitchell Forsyth (1879–1952) – Artist, Designer and Father of Art Education in the Potteries", *Journal of the Decorative Arts Society*, no. 13, pp. 27–32; Forsyth, Gordon, *The Art and Craft of the Potter* (Chapman & Hall, Ltd., 1934); Forsyth, Gordon, *20th-Century Ceramics* (The Studio Ltd., c.1947); Holdcroft, Harold, "Passing of a Great Artist", *PG>R*, February 1953; Lomax; Royal; Spours.

73 Earthenware dish with pale copper lustre, painted by Gordon Forsyth, c.1920–30s, marked with four scythes rebus, d. 36 cm.

Fremington Pottery

Barnstaple

1865–1921

A large seam of fine red clay was discovered at Fremington as early as the seventeenth century. The Fishley family were potters of domestic earthenwares as early as 1800. Four generations of the family ran the Fremington pottery until 1912.

George Fishley (1770–1865) founded the business, producing domestic redwares as well as ornamental pieces such as mantelpiece ornaments and watchstands with ornate moulded and modelled decoration. He also used leaf resists to decorate the wares. His most remarkable achievements were naïve, free-standing figures.

In about 1839 George was succeeded by his sons Edmund (1800–60) and Robert (1808–87) (74). Edmund was particularly adept at making traditional Devon harvest jugs and posset pots, which were decorated with sgrafitto and covered with shiny golden galena glazes. By 1851 the pottery had reached its acme, employing a staff of eight men and four women. When Edmund died in an accident in 1860, his son, Edwin Beer Fishley (1832–1911), inherited the pottery.

74 Fremington Pottery covered jar by Robert Fishley, marked "R. Fishley. Fremington Pottery. June 22nd 1899" and inscribed "r.f. 1844", h. 35.5 cm.

75 Fremington Pottery wares. *Top*, tyg and puzzle jug both marked "EB Fishley/ Fremington/N Devon"; tyg inscribed "Fill me full of liquor sweet For that is food when friends do meet. When friends do meet and liquor plenty Fill me again", and on one handle, "w/κ" "τ" (?) "I.B.M.T.H.", h. 16.5 cm; puzzle jug inscribed "Within this jug there is good liquor/Fit for parson or for Vicar/But how to drink and not to spill/Will try the utmost of yr skill!", h. 16.2 cm. *Bottom, left to right*: plate, marked "E B Fishley/Fremington", d. 24.8. cm; bowl and cover, marked "E B Fishley/Fremington/N Devon", d. 12.8 cm.

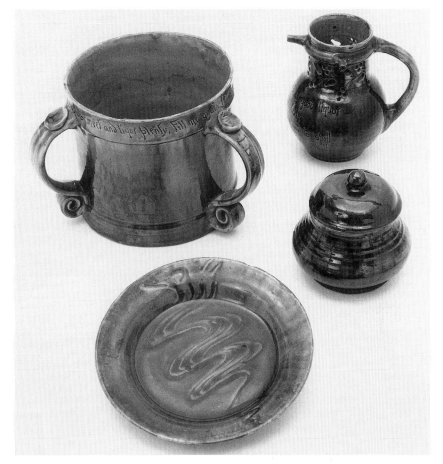

After exhibiting some of his wares at the Barnstaple Show of the Bath and West of England Agricultural Association, Edwin Beer Fishley was taken up by a number of local gentlemen, namely Sir John Walrond, Sir Thomas Acland and Squire Divett of Buller & Divett, Bovey Tracey. Sir John and Mr Ireland, a former master at the Barnstaple School of Art, supplied Edwin with some designs. Edwin made the acquaintance of the Devon historian, J. Phillips, who accompanied him to London to visit the best collections of pottery, including pots excavated by Dr Schliemann at Troy. Edwin won medals at the Plymouth Art and Industrial Exhibition of 1881 and the Newton Abbot Art Exhibition of 1882.

Edwin's sgraffito wares made use of techniques long used for harvest jugs in the area, but he also introduced Etruscan designs and hunting scenes. Strong in 1889 also mentioned Egyptian and Japanese designs, and pots inspired by Dr Schliemann's excavations. Edwin also produced puzzle jugs, Cadogan teapots, fruit-dishes, candlesticks, vases and other small wares (75). These smaller wares, dipped in white slip and simply decorated with blue or green glazes, were popular souvenirs. The glazes, the secret of which was passed on to William Fishley Holland*, were noted for their iridescence, and their mottling with other tints. Occasionally these wares were ornamented with a simple combed pattern.

Edwin's work was already collected by connoisseurs in 1900: "though he still considers the chief business of his life to be the making of pots and pans, while

designing and executing his designs in his native clay is his great delight: this he does from pure love of his work" (Steele). Ten pots made by E. B. Fishley were displayed at the Arts and Crafts Exhibition of 1903.

William Fishley Holland*, Edwin's grandson, joined the pottery in 1902. When Edwin died, William was briefly manager but, much to his chagrin, his uncles sold the pottery to Ed Sadler of John Sadler & Sons (Ltd) of Burslem, in 1912. William went to work at the Braunton Pottery*, refusing Sadler's offer to stay on as manager. *The Pottery Gazette* reporter who visited the pottery late in 1912 said: "I have seen some dilapidated potteries in Staffordshire (before inspection was introduced), but never one quite so antiquated as this one at Fremington." The pottery now made was sgraffito ware, motto ware, fancy jugs, rustic ware, artistic green, matt lustre and other highly glazed art pottery, buttons, hat pins and so on. The shapes, however, were radically different from the Fishley shapes and the wares were decorated with golfers, a monk fishing, Harry Lauder, Dutch scenes and scenes from the novels of Charles Dickens. The task finally proved too much for Sadler and, in 1915, he sold the pottery to C. H. Brannam (Ltd)*. Brannam used it for the production of redware until it was finally demolished in the late 1920s.

Marks: Variations on "G*FISHLEY FREMINGTON", incised; "Edmond Fishley/ Maker, Fremington", incised; "R. Rt. Rob." or "Robert Fishley/Maker/Fremington", incised; "Edwin Fishley ∧ Fremington", or "E B Fishley/maker/Fremington", incised. All of these may appear with dates.

References: A&CXS 1903; *BAPS*; Blacker; Brears 1971, 1974; Cameron; Coysh; Edgeler; Godden 1972; Holland, William Fishley, *Fifty years a Potter* (Pottery Quarterly, Tring, 1958); Leary, Emmeline, "By Potters' Art & Skill: Pottery by the Fishleys of Fremington", *Ceramic Review*, 91, 1985; Leary, Emmeline and Jeremy Parson, *By Potters' Art and Skill: Pottery by the Fishleys of Fremington* (Friends of Exeter Museum and Art Gallery, 1984); Sandon, John, "Slipware: the Tradition Lives on", *Antique Collecting*, vol. 23, no. 1, May 1988, pp. 18–21; "A Short Visit to Some North Devonshire Potteries", *PG*, January 1913, pp. 53–55; Steele, Francesca M., "Fremington Pottery", *AJ*, 1900; Strong, H. W., *Industries of North Devon, 1889* (reprinted, B. D. Hughes, editor, David & Charles, 1971); "A West Country Potter: Some Specimens of his Work", *CM*, vol. XLII, no. 515, 7 August 1909, pp. 171–73; Wondrausch.

Frisk & Hunt *See* Forster & Hunt.

G

Garrard, Frederick
West Ferry Road, Millwall,
London
1881–90

Garrard was listed as an art potter in *Morris's Business Directory* of 1881–90. His tiles were included in the Arts and Crafts Exhibitions of 1888, 1889 and 1890. These were tiles for walls, hearths and so on, in buff clay coloured with transparent glazes and opaque enamels; embossed tiles, stamped by hand with raised patterns and filled in with coloured glazes and enamels; and hand-made tiles, coated with white stanniferous enamel, and painted while still in the raw state. Some of his tiles were executed by John Lewis James, who later fired the work of Alfred and Louise Powell* when they took over what may have been Garrard's studio in Millwall.

References: A&CX 1888–90; Batkin; *MBD*.

Gateshead Art Pottery
East Street, Gateshead,
County Durham
c.1880–c.1887

Although the Gateshead Art Pottery did not appear in local directories until 1883, in a discussion of Vallauris wares in "simple shapes with simple colours", Cosmo Monkhouse noted: "at Gateshead, Leeds, and other places, potteries have added such ware to their staple manufactures" (*MA*, January 1883). We must assume, therefore, that the pottery had been in existence long enough to establish itself and add the new range to its staple wares.

The art pottery studio was in fact an adjunct to the Gateshead Stained Glass Co. located at Sowerby & Co.'s Ellison Works. The only marked pieces recorded seem to have been fireclay chargers and tiles, which were decorated in a variety of contemporary styles, eg. *japonesque* and aesthetic. Perhaps the Vallauris-style wares were unmarked. Art tiles were made by the Gateshead Stained Glass Company until 1887. Among their commissions were the nursery tiles for the Children's Sick Hospital in Finsbury, praised in *The Pottery Gazette* of 1880.

Marks: "GJS" monogram, printed; "Gateshead Art Pottery", painted.

References: Austwick; Barnard; Bell, R. C., *Tyneside Pottery* (Studio Vista, 1971); Cottle, S., *Sowerby: Gateshead Glass* (Tyne & Wear Museums Service, 1986); Coysh; Lockett; Monkhouse, Cosmo, "Vallauris and its Allies", *MA*, vol. VI, 1883, pp. 30–36; Murray, Sheilagh, *The Peacock and the Lions: The Story of Pressed Glass of the North-East of England* (Oriel Press, Stocksfield, 1982).

Gibbons, Francis
1852–1918

After training at South Kensington School of Art for two years, Gibbons became Art Director at Doulton & Co. (Ltd) Lambeth*, "where he designed many of their world-renowned ceramic productions" (*PG*, November 1918). He then worked as an art master at the Edinburgh School of Art, as an artist at the "Devon Ware Factory at Torquay" (which has not been identified) and designer and later as manager of the Salopian Art Pottery*. In 1883, his design for a Salopian majolica vase won a National Gold Medal. In 1885 he established the Gibbons, Hinton & Co. Ltd tile

factory with his brother, Owen Gibbons (who had been designing tiles for Maw & Co. (Ltd)* while Headmaster of the Coalbrookdale School of Art), and his brother-in-law, W. J. Hinton. Francis Gibbons was an innovative and practical potter and ceramic chemist, and, after initial difficulties, the firm succeeded. He was also an accomplished painter in both oils and watercolours, exhibiting at the Royal Academy in 1895.

References: Barnard; Bergesen; Huggins, Kathy, "Owen Gibbons – London to Ironbridge", *GE*, no. 9, spring 1985, pp. 1–2; Lockett; "Mr Francis Gibbons: Obituary", *PG*, November 1918; "Tiles Designed by Owen Gibbons", *GE* summer 1982, p. 8.

Gibson & Sons (Ltd)
Albany Works and Harvey Pottery, Burslem, Staffordshire
1884–1970s

This was a large firm; it employed some 500 hands in 1905 and kept some 15,000 dozen teapots in stock. Primarily a producer of general earthenware, including jet, Rockingham, russet and mosaic-bodied wares, it also produced several art wares. The firm advertised Royal Fiji, Royal Dora and Impasto Art Wares in 1900. In 1905 it introduced its Malacca Art Ware, which was named after the vessel, *Malacca*, seized by the Russians. The ware was slip-decorated with nautical subjects in the "Dutch" style. In 1911 the firm introduced Georgian Art Ware, which had a rich red ground throwing into relief a white narcissus with tinted edges. In 1918 it advertised Silvoe and Windsor Art Wares. These art wares included toilet, tea and coffee sets, vases, jardinières, flower-pots and the like.

Marks: a wide variety of printed marks incorporating "G. & S. Ltd." or "Gibson & Sons Ltd". Also a printed mark "H. P. Co." on a representation of a two-handled vase.

References: Godden 1964; *PG*.

Glastonbury Pottery Co. Ltd
Glastonbury, Somerset
c.1892–1931
Glastonbury Brick, Tile & Pipe Co. Ltd,
1931–39

This pottery was listed as an art pottery manufacturer (1892–96) in *Morris's Business Directory*. In 1902 and 1906 the secretary and manager was John Bishop, a local accountant who held important posts in a number of local businesses, including his own accountancy firm. By 1923 the firm had been taken over by Ernest Brewer. It operated under the style Glastonbury Brick, Tile & Pipe Co. Ltd from 1931 to 1939.

References: *KPOD Somerset*; *MBD*.

Granville Pottery
Jaris Street, Hanley, Staffordshire
c.1894–98

Giovanni Carlo Manzoni* established his art pottery here in 1894. He was a close friend of Conrad Dressler*. After a fire at Granville, Manzoni started the Coleorton Pottery* and later joined the Della Robbia Pottery*. The pottery produced hand-painted decorative wares such as chargers, jugs and vases painted in a maiolica palette of green, yellow and reddish brown. Manzoni's patterns were inspired by maiolica, but he had a distinctive geometric style, which was later to influence greatly the decorators at Della Robbia.

Marks: "CM" monogram, with the digits of the date printed at each corner, and "Hand Drawn and Painted", painted.

References: Godden 1980; Meigh; *PG*; Williamson.

Green, T. G. & Co. (Ltd)

Church Gresley Potteries,
Church Gresley, Burton-on-
Trent, Derbyshire
1864 to the present day

Best known for their good-quality yellow wares and the blue-banded Cornish Kitchen Ware, T. G. Green introduced Ivanhoe Ware in c.1904. The ware included teapots, toilet sets, vases, jardinières and chargers painted with Art Nouveau floral designs. ''The chief beauty of it are the peculiar, yet effective colour schemes employed . . .' (*PG*, April 1904).

Marks: a wide variety of printed marks employing the firm's name or initials, often with a picture of a church.

References: Godden 1964; Green, Kenneth Stanley, *The Story of T.G. Green Ltd.* (T. G. Green & Co. Ltd, Church Gresley, 1972); ''Ivanhoe Ware'', *PG*, April 1904; ''Post-war Progress at Church Gresley'', *PG>R*, December 1951; Rhead; *The Story of Cornish Kitchenware* (T. G. Green & Co., Ltd, Church Gresley, no date); ''A Visit to the Burton-on-Trent Potteries'', *PG*, June 1915.

Grovelands Pottery

See S. & E. Collier.

Guest & Dewsberry (Ltd)

South Wales Pottery,
Llanelly, Carmarthenshire,
South Wales
1877–1922

Formerly Holland & Guest. The South Wales Pottery, built in 1839–40 and beginning production in 1841, experienced several changes of management before its closure in 1875. In 1877, David Guest and his cousin, Richard Dewsberry, reopened the pottery. After David Guest's death in 1892, his son, Richard Guest, continued in partnership with Richard Dewsberry until the latter's sudden death in 1907. Richard Guest's nephew, Gwilym Thomas, managed the pottery during its later years.

Guest & Dewsberry continued to make the transfer-printed earthenwares that had been successful under the firm's previous ownership, but they also introduced hand-painted pottery. The earliest patterns were the Persian Rose (which was painted in blue or polychrome) and cockerels. All the cockerel patterns were painted by Sarah Jane ''Auntie Sal'' Roberts, who was a paintress at the South Wales Pottery for forty years. The birds all face left, probably because the paintress was left-handed. Samuel Shufflebotham* worked here from 1909 to 1915, painting Wemyss-style pottery, with fruits and flowers, especially roses, in imitation of the wares made at the Fife Pottery*. (Hughes and Pugh list and illustrate all known patterns.)

During this period the quality of the wares declined, despite the fine painting, and the glazes tended to craze. The firm became a limited company in 1910. The contraction of the market and the shortage of skilled labour caused by the First World War affected the pottery very badly. *Morris's Business Directory* (1914) listed the firm as an art pottery making ''Useful and ornamental earthenware for sales of work and bazaars''. A pot bearing a paper label reading ''last kiln 1922'' has been recorded, after which date the works became derelict. The works were demolished in 1927, the last year in which they appeared in *The Pottery Gazette Diary*.

Marks: ''SOUTH WALES POTTERY'' or ''S.W.P.'' in the nineteenth century. Most hand-painted wares were unmarked, but ''LLANELLY'', ''Llanelly Pottery'' or ''Llanelly Art Pottery'', painted with a stencil or in free-hand script appears on some pots, possibly only those painted by Samuel Shufflebotham.

References: Cameron; Godden 1964; Hughes, Gareth, and Pugh Robert, *Llanelly*

Pottery (Llanelli Borough Council, Llanelli, 1990)‡; Hughes, Peter, *Welsh China* (National Museum of Wales, Cardiff, 1972); Jenkins, Dilys, *Llanelly Pottery* (DEB Books, Swansea, 1968); Levitt, Sarah, *Pountneys* (Redcliffe Press Ltd, Bristol, 1990); *MBD*; *PG Diary*.

‡This work is the result of exhaustive research and should be taken to supersede all previous accounts.

Hadley, James (& Sons) (Ltd)
Diglis Road, Worcester
1896–1905

After working for a number of years as a modeller for the Worcester Royal Porcelain Co. Ltd, James Hadley (1847–1903) set up an independent studio in 1875. Most of his models were purchased by the Worcester Royal Porcelain Co. Ltd, and he was widely acknowledged as one of the finest modellers of the nineteenth century. In 1896, Hadley became a manufacturer of art porcelains, faience and terracotta. His three sons, Howard, Louis and Frank, joined the business, which employed some former Royal Worcester hands.

"When Mr Hadley commenced manufacturing on his own account, he struck out quite a new line of his own. New forms, new colour schemes, new combined effects of form and colour, characterized his independent work" (*PG*, January 1904). The wares, not surprisingly, are characterized by their extremely fine modelling. The terracottas were often designed as pictures in frames. From 1897 to 1900 glazed faience ornamented with coloured clay mounts was usually decorated in monochrome. After 1900, more realistic polychrome decoration in rich, lustrous colours was used. Subjects included flowers (especially roses), birds, fish and yachts. After 1902, some figures and figure groups were also produced. The firm was amalgamated with Royal Worcester in 1905.

Marks: "J&HS" monogram, printed or impressed, sometimes with a ribbon reading "FAIENCE" and "HADLEYS WORCESTER ENGLAND"; "Hadleys" in script surmounting a ribbon reading "WORCESTER ENGLAND". Terracotta may be marked "James Hadley & Sons, Art Pottery" or "Hadley's Fine Art Terracottas," both impressed. Additional written marks indicate the colours of the clay mounts, the subjects and the shapes. A full list of these can be found in Sandon.

References: Godden 1964, 1980, 1988; Godden, Geoffrey, *Victorian Porcelain* (Herbert Jenkins, 1961); "Mr Hadley's Pottery", *MA*, October 1898, vol. XXII, pp. 672–75; "James Hadley, Obituary", *PG*, January 1904; *PG*; Sandon, Henry, *Royal Worcester Porcelain* (Barrie & Jenkins, third edition, 1978).

Hale & Lotinga

Cauldon Art Pottery, Shelton,
Staffordshire
c.1911.

In December 1911, *The Pottery Gazette* reported that this firm, which had not very long been established, was "devoting [its] attention to the production of art vases and flower pots, . . . There are many familiar forms, but some original designs are tastefully decorated and gilt. The colours employed are striking and effective – especially the pretty shade of blue applied to vases and other art forms."

Hancock, Sampson (& Sons)

Bridge Pottery, Shelton,
Staffordshire
1881–91
Gordon Works, Wolfe Street,
Shelton
1892–1920
Gordon Pottery, Old Burton
Place Works, off New Street,
Hanley
1920–30
Corona Pottery
1923–37

This firm was established in 1857 by Benjamin and Sampson Hancock (1838–1900) under the style B. & S. Hancock. This partnership was dissolved on 31 December 1881, Sampson continuing alone. The firm principally manufactured a better class of cream-coloured wares, vitreous hotel wares and ivory and semi-porcelain toilet and dinner wares.

In 1906 it first advertised "Art Toilet Wares" and "Art Trinket Wares". These were decorated with art glazes, lithographic transfers and shaded grounds. The firm introduced Morris Ware, named after William Morris*, at the British Industries Fair of 1918. These wares were designed by George Cartlidge* and each piece bore his facsimile signature. The patterns were usually highly stylized florals, tube-lined and coloured with rich glazes (76). In 1919 the firm introduced two new Morris Ware patterns, one incorporating fishes and the other tulips. F. X. Abraham, the firm's art director in 1925, had been art director at W. T. Copeland (& Sons Ltd).

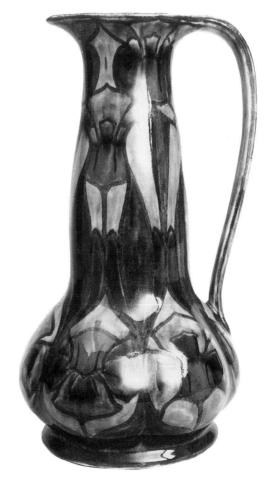

76 S. Hancock & Sons Morris Ware ewer, designed by George Cartlidge, with painted decoration in blue, purple, yellow and green. Marked "Geo. Cartlidge July 1919 MORRIS WARE S. HANCOCK & SONS, STOKE-ON-TRENT, ENGLAND", h. 22.5 cm.

Marks: "ROYAL CORONA WARE" over a crown with a ribbon reading "S. HANCOCK & SONS" beneath, "STOKE-ON-TRENT ENGLAND", printed. Morris Wares also bear George Cartlidge's signature, printed.

References: *Cox's Potteries Annual & Year Book*, 1925; Godden 1964; *LG*, 6 January 1882; no. 25056; Meigh; *PG*; *P&GR*; "Mr Sampson Hancock, Obituary", *PG*, June 1900; Watson, Pat, "Happily taken over by Hancock: Collecting Pottery by S. Hancock & Sons", *Antique & Collectors' Fayre*, October 1989.

Hants Art Tile & Pottery Co.
Totton, Hampshire
c.1908

The Pottery Gazette of June 1908 announced the dissolution of partnership of the "Hants Art Tile & Pottery Co. (David Clough Broadhead, Edwin Page Turner and Jno. Arnold Robt. de Clermont), Totton, art tile and pottery makers. May 12, as regards D. C. Broadhead. Debts by E. P. Turner and J. A. R. de Clermont (May 15)."

A. Harris (& Sons)
Farnham Pottery,
Wrecclesham, Surrey
1872 to the present day

Absolom Harris established this pottery in 1872, making horticultural and domestic pottery, a few pieces of which were decorated with yellow or brown glazes. These pieces were typical of the country pottery of the region and period.

Around 1880, Absolom received a commission from the artist Myles Birket Foster to copy a French green-glazed garden vase. After many months of experimentation, the green glaze was successfully replicated. This led to a commission for copies of a collection of sixteenth-century green-glazed wares, which were soon being marketed as Farnham Green-ware.

These Farnham Green-wares were made until the First World War. Some of the Green-wares were copied from Tudor originals; others (for example, rustic fern pots and Rebecca pitchers) were designed by W. H. Allen, who was appointed Art Master at Farnham School of Art in 1889. Allen first visited the pottery in 1890, when he tried his hand at casting and mould-making. Allen's students were encouraged to design and decorate pots which were then fired at the pottery. The potters at Farnham were also encouraged to take courses in art and design. Although Allen retired from the School of Art in 1927, he continued his association with the pottery until his death in 1943.

Farnham Green-wares were first exhibited at Farnham School of Art on 2 December 1890. Many orders resulted, and the pottery entered a period of rapid expansion. By 1892, the wares were being supplied to The Rural Industries Society, Heal & Son Ltd and Liberty & Co.*. Absolom displayed five pieces of green and yellow pottery at the Arts & Crafts Exhibition of 1893. In a period which was seeing a great decline in country potteries, Farnham's metamorphosis into an art pottery was well timed. As transport improved, the local country potters were finding it hard to compete with the wares produced in the major pottery centres, most especially the Staffordshire Potteries. The popularity of the Green-wares (some of which were similar to wares being made in Barnstaple) spread to the traditional country pottery made at Farnham, and this side of the business expanded as well. At one point the pottery employed twenty workmen.

Absolom was succeeded at the pottery by four of his six children. His daughters, Gertrude and Nellie, were modellers, decorators and designers. Gertrude made the pottery archway surmounted by an owl's head which still graces the pottery's

courtyard (77). It was quite unusual for women to be modellers, for their traditional role as paintresses led more naturally to the design of surface patterns.

In 1905, the Farnham Pottery was producing horticultural wares, garden ornaments, vases, hearth and mantel tiles, table and toilet wares and sgraffito art wares. Like all potteries, it experienced difficulties during the First World War but, after 1914, it expanded steadily and produced art wares in bright blue, green, orange, brown and pale yellow lead glazes. Sgraffito-decorated pots and tiles were made up until the 1920s. Owl jugs were made until the 1950s, and have recently been revived. Since the 1920s, the pottery has concentrated on large terracotta horticultural wares.

Marks: "F. S. P."; "HARRIS HAND MADE FARNHAM, SURREY ENGLAND" in a square, impressed or incised.

References: A&CXS 1893; Bergesen, Victoria, "Farnham Pottery", *GE*, no. 21, winter 1990., pp. 7–8; Bergesen, Victoria, "Classics in Clay", *Traditional Homes*, March 1991, pp. 65–66; Brears, C. D., *Farnham Potteries* (Phillimore, 1971); Brears 1971, 1974; "Farnham Greenware", *Surrey & Hants News*, 3 June 1948; Harris, A. & Sons, various catalogues and brochures; Penfold, Alastair, *W. H. Allen* (Hampshire County Council, Winchester, 1989).

77 A. B. Harris & Sons' pottery yard, Wrecclesham, *c.*1920.

Hart & Moist

St Thomas, Exeter, Devon
Devon Art Pottery
1897–1904
Royal Devon Art Pottery
1904–1935

This pottery was established in 1894 by William E. Hart and Alfred Moist. They were joined by Alfred's younger brother, Joseph, in 1895. Alfred Moist (1862–1910), apprenticed at the Bovey Tracey Pottery, completed his apprenticeship with John Dimmock & Co.* in Hanley. He then went on to work for J. Wedgwood (& Sons Ltd)* and for Bullers (Ltd). A thrower by trade, he was acquainted with art pottery in nearly all its stages. William Hart was a decorator trained at the Aller Vale (Art) Pottery*. The two men worked together for Cole and Trelease* at their Exeter Art Pottery. When that firm failed in 1896, Hart and Moist set up on their own, probably buying the Exeter Art Pottery's undecorated stock, equipment and goodwill. Pots bearing the marks of both the Exeter Art Pottery and Hart & Moist are occasionally found.

The wares were made with clay from the Exeter Brick and Clay Co., which gave a brown rather than a red body. The body is coarse and contains distinctive black and white flecks. The bases are recessed and glazed. It is therefore fairly easy to recognize the many pots which are unmarked. The quality of the wares, excepting the pieces decorated by Charles Collard*, is not very high. The early wares included flowers and scrolls painted in slip on brown, blue, lime green or bottle green grounds. Hart & Moist continued to produce the Exeter Pottery's "ancient wares", principally motto-ware tygs. A sgraffito-decorated vase with a green glaze, which appears to be more in the style of the North Devon potteries, was illustrated in *TPCS Magazine*, April 1988.

As Hart & Moist advertised regularly in *The Pottery Gazette*, there is a good deal of information about their twentieth-century wares. The patterns on the slip-decorated wares illustrated in 1904 all consisted of highly stylized foliage or flowers. The Persian pattern, known as A1 at the Aller Vale Pottery, was briefly used. These high-quality pieces seem to have been decorated by Charles Collard during the several months that he worked for Hart and Moist in 1903 and 1904. They also advertised motto wares and grotesques. The Hart & Moist motto wares are noted for their backward-sloping script. The grotesques included mice and a primitive seated woman. The recorded examples are about $4\frac{1}{2}$ inches high.

The cockerels and motto wares which appeared in advertisements in 1905 look quite undistinguished. For the most part, Hart & Moist copied the successful shapes, patterns and mottos used by other Torquay firms. Their daisy pattern, however, is believed to be unique. The Cashmores describe it as "a cream band on a dark green ground on which daisy heads in pale blue with brown eyes are painted in slip with their stems sweeping downwards through the green ground to cream coloured leaves". In 1906 they introduced some mottled effects and shadings.

After Alfred Moist's death in 1910, the firm continued under the same style. In 1912 its Marine decoration had been greatly improved. Excel ware was introduced, with "its pretty colour combination, in which various shades of green are introduced" (*PG*, December 1912). The firm issued a new catalogue in 1913, showing the various shapes and decoration of its popular art ware. Illustrations of pieces available in 1920 show the same motto wares as those made fifteen years before (*PG>R*, February 1920).

When Hart retired in 1921, Joseph Moist became the sole proprietor. The pottery experienced financial difficulties in the 1930s and was forced to close in 1935.

Marks: Wares are usually unmarked but the following were sometimes used: "H M EXETER", impressed; "H.M. Exon", incised; "The Royal Devon Art Pottery," printed in black, on later wares.

References: Brisco, Virginia, "Hart and Moist", *TPCS Magazine*, April 1989, pp. 12–15; Cashmore 1983; Jones; Patrick; *MBD*; *PG*; *PG>R*; Thomas 1974, 1978; *TPCS Magazines*; *TPCS*, 1986; *TPCS*, 1989.

Hawley-Webberley & Co.

Garfield Works (opposite the church), High Street, Longton, Staffordshire
1895–1902

Thomas Henry Hawley in partnership with H. J. Colclough worked this pottery under the style Colclough & Co.*. Upon the dissolution of that partnership in December 1894, he formed Hawley, Webberley & Co., with John Lewis Webberley, in 1895. This partnership was dissolved 19 June 1899, though Webberley continued under the same style. This majolica manufacturer, whose speciality was jugs and flower pots, advertised "Earthenware, Art Ware, Majolica &c . . . See our toilet ware in art pottery. It is very effective." (*PG*, July 1899).

Marks: "H&W" monogram, printed.

References: Bergesen; Godden 1964; *LG*, 23 June 1899, no. 27092; Meigh; *PG*.

Heath, Thomas

Park Hall Street, Longton, Staffordshire
1882–89
Baltimore Works, off High Street, Longton
1887–1913
Albion Works, off High Street, Longton
1890–1913

Although in his advertisements Thomas Heath claimed to have established his firm in 1864, it is not certain at what address or under what style he ran the business at that time. In 1890 the business was thriving sufficiently for Heath to purchase the Albion Works, adjoining his Baltimore Works. Both premises were then improved. In October 1893, he dissolved the partnership with Esther Annie Beswick which had existed "for some time past", and continued alone. During the 1890s Heath was joined at the works by his two sons, Thomas Junior and Edward James. Thomas Junior was active in the works as late as 1908, but he predeceased his brother, who died in 1911 at the age of thirty-five. Thomas Heath senior successfully underwent a cataract operation in 1911, but the firm shut down in 1913.

Primarily a majolica producer, advertising "Majolica Art Ware", Heath advertised "Earthenware, Art Ware and Majolica" in later years. By 1908, *The Pottery Gazette* reporter noted: "Art ware and majolica today are very different from what they were a quarter of a century ago" (*PG*, December 1908). Grotesques and "uglies" were made for the export market. In 1909 an article in *The Pottery Gazette* reported: "Flower-pots, vases, and jugs are made by machinery – indeed without his special mechanical arrangements he would not be able to produce some of his lines fast enough . . . One branch of his works is devoted entirely to the 6½ d. bazaar trade." Wares mentioned include clock sets and figures with moving heads. Another article, of April 1911, illustrated "face" jugs and bird jugs.

References: Bergesen; *LG*, 27 October 1893, no. 26453; *PG*.

Hexter, Humpherson & Co. (Ltd).

Newton Abbot, Devon
c.1890–1958+

This firm first appears in local directories in 1890 as earthenware manufacturers of Kingsteignton Road, Newton Abbot, Devon. In October 1894, *The Pottery Gazette* reported a fire at the works, which had been established "four or five years ago": "Kiln after kiln fell prey to the flames, which eventually reached the main building, and the roof of this fell in within half an hour. The damage is estimated at £50,000" (a staggering sum at the time). In a few years, however, the business had grown sufficiently to employ nearly 250 hands. When Hexter, Humpherson & Co. (Ltd) went into the art pottery business, it was quite a departure from their manufacture

of bricks, tiles and sanitary goods. In 1897 they acquired the Aller Vale (Art) Pottery Co.* and, in 1901, the Watcombe Terra-Cotta Co. (Ltd)* and the Castle Hedingham Art Pottery*.

The Castle Hedingham acquisition was a failure. Edward W. Bingham, who had been retained as manager, did not get on with the new owners. In 1905, when he emigrated to the United States, the pottery appears to have closed. Hexter, Humpherson & Co. (Ltd) were left with large stocks of wares, which they continued to advertise as late as 1917.

Although many employees of the Aller Vale (Art) Pottery were alienated by the new management and departed to other local potteries, the acquisition was a business success. In 1901 Hexter, Humpherson & Co. (Ltd) amalgamated Aller Vale and Watcombe to form the Royal Aller Vale and Watcombe Pottery Co. (Ltd)*. The firm closed Aller Vale in 1924, continuing production, chiefly of motto wares, at Watcombe until 1962. In the late 1950s, the ownership of the pottery was transferred to the Mid-Devon Trading Co., which also acquired and reopened the Longpark Pottery Co. (Ltd)*.

References: Cashmore 1983; Godden 1964; *PG*; *PG>R*; Thomas 1978.

Holland, William Fishley
1889–1969

William Fishley Holland, Edwin Beer Fishley's grandson, joined the Fremington Pottery* in 1902. When Edwin died, William was briefly manager but, much to his chagrin, his uncles sold the pottery in 1912. Refusing an offer to stay on as manager, William went to Braunton, where he built the Braunton Pottery* for Mr Hooper, a solicitor.

As manager, Holland had a free hand and produced some interesting wares. He developed a clear green glaze which was to become a trademark of his (Colour XIX).

78 William Fishley Holland candelabrum, marked "W F. Holland", h. 26.5 cm; and jug, incised "W F Holland/MEND" and impressed "MADE IN ENGLAND", h. 19 cm.

Despite the pottery's success, Hooper went bankrupt in 1921, and the pottery was sold. Disappointed in his efforts to purchase the Braunton Pottery himself, Holland and his assistant, George Manley, moved to Clevedon, where Sir Edmund Elton's* son, Ambrose, was attempting to keep the Sunflower Pottery in business. After two or so years, Ambrose reluctantly closed the pottery and allowed Holland to purchase a piece of land from the estate on which to build a pottery of his own. Here he made tablewares and ornamental wares (78). This is still operated today by Holland's grandson, as the Clevedon Pottery.

Marks: "W Holland Fremington N. Devon"; "WFH" monogram, incised; "F H", incised; "WHolland", signature, incised; "Fishley Holland"; "W. FISHLEY HOLLAND, CLEVEDON, SOM," impressed.

References: A&CXS 1916; Blacker; Brears 1971, 1974; Cameron; Coysh; Edgeler; Godden 1964; Holland, William Fishley, *Fifty years a Potter* (Pottery Quarterly, Tring, 1958); Leary, Emmeline and Jeremy Parson, *By Potters' Art and Skill: Pottery by the Fishleys of Fremington* (Friends of Exeter Museum and Art Gallery, 1984); Robinson, John, "William Fishley Holland at Clevedon", *BAPS*, October 1990, pp. 19–24 and January 1991, pp. 26–28.

Hollinshead & Griffiths
Chelsea Works, Moorland Road, Burslem, Staffordshire
1890–1909

This firm made Chelsea Art Pottery.

Marks: "CHELSEA ART POTTERY, H&G BURSLEM ENGLAND", round a crest with a lion standing on a crown, printed.

References: Godden 1964; Rhead.

Holt, John, W.
Chadwick Street, Longton, Staffordshire
1898–99
Clarence Works, High Street, Longton
1900–01

John Holt was listed as an art potter in *Morris's Business Directory*, 1898–1901.

Holyrood Art Pottery

See Wyse & Isles.

Howell & James (& Co.) (Ltd)
5–9 Regent Street, London
1810–1922

After the closure of Minton's Art Pottery Studio in 1875, Howell & James, retailers of home furnishings, held annual china-painting exhibitions. The first display was a disappointment to R. Mawley, author of *Pottery and Porcelain in 1876*: "The exhibition generally presented a very fair average, but nothing more. A great many of the paintings were amateurish, but the quality of the work was in several instances very respectable." See 79 and 80. None the less, these exhibitions became major events of the London season. Initially, the shows were dominated by the work of Doulton & Co. (Ltd)* and the Lambeth School of Art; soon, though, prizes were eagerly sought both by professionals and amateurs, who included not a few titled ladies. *The Magazine of Art* reported; "The influence of Lambeth teaching is

strongly felt in many of the best works; and this is as it should be, for it is to this school that we owe in a great measure the revival of a love of the natural and simple artistic decoration of some of the lower qualities of ceramic ware." In 1879 *The Art Journal* noted:

> The educated classes at large seemed to jump at the idea; their Art instincts were aroused, and when they really discovered that these could find adequate expression in more tangible and concrete form than on paper and canvas, that prizes were offered to encourage their efforts, and a ready market for whatever they might do almost assured to them, the enthusiasm for ceramic Art, whether in modelling or painting, reached such a pitch that Messrs Howell and James had to build new galleries, and the works now on show equal in number those of the kindred arts exhibited at the Royal Academy.

The exhibitions were eagerly reviewed by the leading periodicals of the day.

Although artistic instincts may have been satisfied, the competitions did not encourage creativity. The prospectus of Howell & James Fifth Annual Exhibition was quoted in *The Artist* in 1880:

> It is particularly recommended that dark-coloured grounds be adopted – sage greens, bronze browns, blues, &c., in graduated tints; that when flowers are

79 Charger decorated by Joseph Longmore and exhibited at Howell & James, impressed "J. Holdcroft", printed paper label "Howell & James Art Pottery Exhibition 1879", and inscribed "Joseph Longmore". d. 47.9 cm.

80 Howell & James earthenware plate hand-painted over the glaze, printed mark "HOWELL & JAMES, SPECIAL MAKE", and "E.M.S." painted.

painted they be confined to one sort, and all designs arranged so as to cover the whole plaque as far as possible. It is important that all subjects should be well and faithfully drawn (from nature where possible), and broadly and artistically treated. Plates or plaques of from twelve to fifteen inches are found to be the most saleable; pretty rural scenes with children – after the style of Birket Foster; landscapes on square or oblong slabs, and long panels of tall-growing flowering plants or flowers and tinted backgrounds, are also much in request . . .

Indeed, nearly all the prize-winners in 1880 had painted flowers with such titles as *Primrosing*, *White Azaleas*, *Marsh Marigolds*, *Horse Chestnut Branch*, *Poppies and Tiger Lilies* and so on.

At a time when the employment of gentlewomen had become a serious social problem, china-painting offered a solution. The ladies could carry on this artistic occupation in their own homes without loss of social face. Howell & James sold blanks for decoration and would fire the amateurs' efforts in their enamelling kilns. In 1880, they established a school for china-painting under the tuition of Florence Judd. In 1887, the principal was Mary Salisbury.

Howell & James commissioned designs from various eminent designers, for example the sunflower clocks from Lewis F. Day*, and R. Phené Spiers and Walter Crane*. The firm also retailed the work of various art potteries, including Doulton & Co. (Ltd)*, Sir Edmund Elton's* Sunflower Pottery, Mintons*, C. H. Brannam (Ltd)*, Henry Tooth & Co. (Ltd)* and Burmantofts Pottery*. At the Universal Exhibition in Paris in 1878, these wares were exhibited alongside the best of the china-painting from the annual shows.

Marks: "HOWELL & JAMES ART-POTTERY EXHIBITION" on paper labels may still be found on the reverse of items which were included in the exhibitions. These

labels also include the exhibitor's name, the title of the work, whether it was an original or a copy, the price and whether the executor was a professional or amateur.

References: Aslin, Elizabeth, *The Aesthetic Movement: Prelude to Art Nouveau* (Ferndale Editions, 1981); Callen, Anthea, *Women in the Arts and Crafts Movement, 1870–1914* (Astragal Books, 1979); Cameron; "China Painting", *Artist*, 15 January 1880, p. 19; Coysh; "The Exhibition of Paintings on China", *MA*, vol. I, 1878, p. 176; "The Fourth Annual Exhibition of Paintings on China", *MA*, vol. II, 1879, p. 269 (reprinted in Haslam 1975); Haslam 1975; [Mawley, R.], *Pottery and Porcelain in 1876* (Field & Tuer, 1877); "Painting on China by Lady Amateurs and Artists", *AJ*, 1879, vol. 18, p. 164.

Hunsletesque Co. *See* Leeds Art Pottery (& Tile Co.) Ltd.

I

Iceni Pottery

Letchworth, Hertfordshire

c.1907–c.1914

When the architect William Harrison Cowlishaw (1870–1957) built The Cloisters school of psychology for the wealthy philanthropist Miss Annie Lawrence, he was intrigued by the pottery included on the premises. The students learned weaving and country dancing as well as potting. Cowlishaw thus became the designer of pots which were made by the students and sold locally. He gave up his architectural practice and worked full time at the pottery until the First World War.

A member of the Art Workers Guild*, Cowlishaw designed needlework and illuminated manuscripts. His interest in calligraphy is evident in the few painted pots made at Iceni. Ford Maddox Hueffer wrote: "In short he is a master of many materials, a handcraftsman of a kind much needed today, a designer whose work will stand much testing." Cowlishaw worked for the Graves Registration Department and the Imperial War Graves Commission in France until 1931. He then worked for the architectural firm of Adams, Holden & Pearson until his retirement.

The Iceni Pottery exhibited leadless glazed stoneware designed by W. H. Cowlishaw and an earthenware vase by G. A. Hodgkinson at the Arts and Crafts Exhibition of 1910. At the next exhibition, in 1912, it exhibited more than fifty items, all designed by Cowlishaw. These included pierced bowls (one decorated with wind-blown leaves), vases with raised briar rose decoration, a bowl with dandelion and grass decoration, a vase entitled *A Misty Morning*, sweetmeat and

card dishes, pot-pourri and jam pots. Many of Iceni's pots are decorated in monochrome lustres, including pale blue, blue, buff and yellow.

Marks: "ICENI WARE", impressed within a circle; "ICENI" or "Iceni", impressed; "ICENI LETCHWORTH LEADLESS", impressed.

References: A&CXS 1910, 1912; Brighton 1984; Godden 1964; Hueffer, Ford Maddox, "The Work of William Harrison Cowlishaw", *Artist*, vol. XX, 1897, pp. 432–36; *Lustre Ceramics from British Art Potteries* (Wolverhampton Art Gallery and Museum, 1980).

J

Jacob, Eleanor

"Six pieces of pottery decorated with coloured slips and sgraffito" designed and executed by Miss Jacob were shown at the Arts and Crafts Exhibition of 1889. She exhibited sgraffito vases at the 1893 exhibition.

References: A&CXS 1889 and 1893.

Jeffries, William
*Oldham Pottery, Trent Walk,
Leek New Road, Joiners'
Square, Hanley, Staffordshire*
1889–91
*Anchor Works, Brewery
Street, off Hope Street*
1891

In 1890, William Jeffries advertised in *The Pottery Gazette* as a "manufacturer of Art Ware (Vases, Claret Jugs, &c.). Adapted for all markets".

References: Meigh; *PG*.

Jervis, W. Percival
*Stoke-on-Trent, Staffordshire
c.1882*

Jervis advertised "Printed and art tiles, Art Pottery &c." in *Decoration* during 1882. Barnard lists the firm as tile decorators with a small production during the 1880s. Jervis emigrated to the United States *c.*1892, where he managed the Avon Faïence Co. (1902–03) and worked at the Craven Art Pottery. He was involved in several other pottery ventures, including the Jervis Pottery, which he established in New York with F. H. Rhead*.

References: Barnard; Cameron; *Decoration*; Evans, Paul, *Art Pottery of the United States*. (Feingold & Lewis Publishing Corporation, New York, second edition, 1987); Jervis, W. P.; Jervis, W. Percival, *A Book of Pottery Marks* (Wright, Tyndale & van Roden, Philadelphia, 1897).

Jones, Evan

Claypits Pottery, Ewenny,
Clwyd, North Wales
1884–1912

Perhaps inspired by the work of Horace Elliott* at the neighbouring Ewenny Pottery*, or by William Doel* at Bridgend, Jones made reproductions of mediaeval and other early British pottery. The wares included baskets, jugs, puzzle jugs, tygs and loving cups bearing incised mottoes. The red body of the wares was dipped in white slip and thick lead glazes were then applied in blue, yellow, green or brown. Sgraffito, slip trailed and leaf-resist decoration were used (81). Jones also reproduced traditional Ewenny wassail bowls.

Jones's ability as a potter was not greatly respected locally. He employed local and Bristol journeymen to help with the potting; it is thought that he may have drawn ideas for his art pottery from one of these journeymen.

Marks: A variety of incised or impressed marks incorporating "Jones Bridgend, Claypit" or "Jones Eweni Penybont-ar-Ogwy".

References: Lewis, J. M., *The Ewenny Potteries* (National Museum of Wales, Cardiff, 1982).

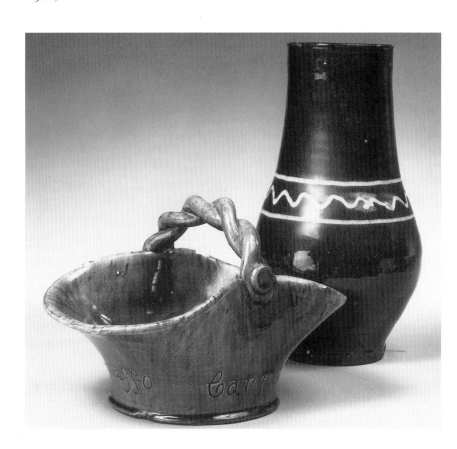

81 Evan Jones green-glazed basket with inscribed motto, impressed "JONES", l. 18 cm; vase with dark blue glaze, impressed "CLAYPITS EWENNY", h. 20 cm.

Kensington Fine Art Pottery Co.
Kensington Works, Jervis Street, Hanley, Staffordshire
1892–99

In *The Pottery Gazette* of July 1899, under "Extracts from Deeds of Arrangement", George and Arthur John Bevington, of Hanley, trading as the Kensington Fine Art Pottery Co., were listed as earthenware manufacturers. The following month the firm was reported to be undergoing bankruptcy proceedings. In November, it was listed under "Notices under Assignment, &c.", with claims to be addressed to Charles E. Bullock, of Hanley, chartered accountant and trustee. William Hines, late of Hines Bros, took over the works. In January 1904, *The Pottery Gazette* announced Arthur Bevington's death of a heart attack at the age of forty-three. He had recently been engaged in travelling. George and Arthur John were the sons of John Bevington, who had previously made porcelain at these works.

Marks: "K. F. A. P Co" surmounted by a crown, printed or impressed.

References: Godden 1964, 1988; Meigh; *PG*; Rhead.

Kerswell Art Pottery
King's Kerswell, Newton Abbot, Devon
c.1887–89

J. G. Skinner is listed as manager of this firm in *Kelly's Post Office Directory, Devonshire* of 1889. Skinner, a modeller, was one of the original workmen who came down from Staffordshire to work for the Watcombe Terra-Cotta Co. (Ltd)*. He may have started the Kerswell Art Pottery when Watcombe temporarily closed in 1883–84. The only recorded piece is a small slip-cast terracotta bust of Joseph Chamberlain with "J.G.S. 87" moulded into the side.

Marks: Published by the "Kerswell Art Pottery, King's Kerswell, South Devon".

References: *KPOD Devonshire*, 1889; Thomas 1974.

Kettle, Edgar
Putney Pottery, London
c.1879

Kettle was an engraver who also decorated pottery for the Martin Brothers* and C. J. C. Bailey & Co.* (1874–75). He made his own pottery at Putney *c.*1879, firing his wares in a kiln in his garden. These were salt-glazed stonewares with applied modelled decoration, as well as incised decoration of the type that he had used at Bailey's.

Marks: "EK" monogram; kettle rebus on Fulham Pottery wares. A"?", incised on Putney Pottery wares.

References: Cameron; Drew, David, "Artist Potters working in Fulham and Chelsea 1870–1930, *The Antique Collector*, January 1979, pp. 78–81; Haslam, Malcolm, *The Martin Brothers* (Richard Dennis, 1978).

Kirkby Lonsdale Pottery

Mill Brow, Kirkby Lonsdale, Cumbria

1892–1904

John Thomas Firth attended art school, becoming interested in painting, modelling and, finally, pottery. He used red clay from Burton mixed with white china clay, which he obtained from Wenger's along with his pigments and glazes. Later he used a creamy-white body. He accidentally discovered how to make an unglazed vitreous black ware. He initially sent his pots to be fired at Burton but later used a kiln that he built in his basement. He was assisted with the throwing by his son, Sydney, and his daughter, Ellen, decorated the wares with sgraffito patterns.

The Kirkby Lonsdale Pottery was very active in the Home Arts and Industries Association. In 1898, *The Artist* noted: "Kirkby Lonsdale also sent up some good specimens of pottery, wood-carving and leather, the frame being designed by Mrs Harris and executed by Susan Firth. The pottery was executed by J. Firth and his family, the father and sons 'throwing' the vases, and the daughter ornamenting them." *The Art Journal* illustrated some vases, jugs and oil lamps with shapes that could loosely be called Roman, labelled "Pottery by Mr Firth, Kirkby Lonsdale, under Mr. Harris". In the accompanying article, Lewis F. Day* surmised: "The forms of the Kirkby Lonsdale pottery were obviously set before the potter by Mr Harris." Mr and Mrs Harris designed a number of Kirkby Lonsdale items which were exhibited by the Home Arts and Industries Association. In 1900, *The Studio* reported: "In another part of the hall was a very pleasing little group of vases in many ingenious and picturesque shapes, sent by John, Sidney and Ellen Firth, of Kirkby Lonsdale – the only surviving family of potters in the district."

The Firth family were friendly with William Burton* and, before Pilkingtons Tile and Pottery Co. (Ltd)* began making its own pots, Pilkingtons decorated Kirkby Lonsdale blanks.

Marks: "JTF", "SF" or "EF" over "KL", incised.

References: Cameron; Day, Lewis F. "Art for Winter Evenings", *AJ*, 1898; "Home Arts & Industries", *Studio*, vol. XX, 1900, pp. 86–87; "Home Arts & Industries Association", *Artist*, vol. XXII, 1898, p. 152; Lomax.

Kirkcaldy Pottery

See Methven & Sons.

L

Lamb, J. & Sons, Art Pottery Co.
Buckley Old Pottery, Buckley, Chester, Cheshire
c.1905–20+

Listed in *The Pottery Gazette Diary's* Directory of Manufacturers and in *Morris's Business Directory* of 1905–08 as art pottery manufacturers. *The Pottery Gazette and Glass Trade Review* commented in 1920: "Why this pottery should now be described as an art pottery is a trifle difficult to understand, seeing nothing but very prosaic brown ware is manufactured here."

References: *MBD*, *PG Diary*; "Some Flintshire Coarseware Potteries", *PG>R*, February 1920, pp. 227–31.

Lauder, Alexander
The Royal Devon Art Pottery, Pottington Pottery, near Barnstaple, Devon
c.1889–1921

Alexander Lauder (1836–1921), an architect and artist, was headmaster of the Barnstaple School of Art, where he taught C. H. Brannam*. In 1876, Lauder and William Otter Smith, his brother-in-law, established Lauder & Smith*. Lauder became the sole proprietor c.1889. Soon afterwards, when Jeffery Ludlam, proprietor of the Marland Brick & Clay Works*, was declared bankrupt, Lauder purchased the works. With this new source of clay, he was able to find a body suitable for his art pottery. In 1890, the firm was patronized by the Duke of Edinburgh and restyled the Royal Devon Art Pottery.

Throughout the 1890s the firm continued to experiment with the new greyish body that it had developed. The style and techniques employed at Lauder's Pottery are very similar to those used at Brannams; however, they are more naturalistic and the colours tend to the pastel, by contrast to Brannam's strong rich shades. Although sgraffito and slip decoration were commonly used, the most distinctive form of decoration was the marbled finish. By 1895, the firm had developed sgraffito designs of flowers, fish or birds which either covered the entire surface of a pot or were contained in panels. The background was often cross-hatched. Slips were sometimes applied in stripes of colours. Modelled flowers, dragons and snakes were applied to handles and vases. Figural bird vases, frog mugs, toby jugs and miniature animals were also made.

It has been said that, in 1914, a number of the pottery's skilled workers joined the armed services and that this was probably instrumental in the decision to close. However, Lauder's Devon Art Pottery, Bridge Buildings was listed as a manufacturer of art pottery in *Morris's Business Directory* of 1910–21. In 1922 the Barnstaple Art Pottery is listed at the Bridge Buildings address.

Marks: A variety of marks incorporating "Alex Lauder", "Lauder Barum", or "DEVON ART POTTERY", incised, usually with a pattern or shape number, these reaching as high as 2,000.

References: Cameron; Coysh; Edgeler; Edgeler, Audrey, "Lauder's Villas", *BAPS*, January 1991, pp. 19–22; Godden 1964; Haslam 1975; *MBD*; Strong, Hugh, *Industries of North Devon 1889* (North Devon Journal 1888–9; reprinted David & Charles, 1971); Thomas 1974.

Lauder & Smith

*Pottington Pottery, near
Barnstaple, Devon
c.1876–c.1889*

In 1876 Alexander Lauder* and William Otter Smith, his brother-in-law, leased clay deposits at Pottington, west of Barnstaple, and established a pottery to manufacture bricks, tiles and architectural terracotta. The clay proved difficult to work and the pottery traded at a loss for some years. Throughout the 1880s Lauder & Smith experimented with Devon Art Pottery. As the clay was found to be unsuitable for colouring and glazing, the early efforts were confined to terracotta flowerpots, vases and plaques. By 1888 they had opened showrooms at 71 High Street, Barnstaple. Lauder became the sole proprietor c.1889, although some later directory entries still mention Lauder & Smith after that date.

Marks: A variety of marks incorporating "Lauder Barum", or "Lauder & Smith", or "LAUDER & SMITH", or "DEVON ART POTTERY", incised, usually with a pattern or shape number.

References: Cameron; Coysh; Edgeler; Godden 1964; *MBD*; Strong, Hugh, *Industries of North Devon 1889* (North Devon Journal 1888–89; reprinted David & Charles, 1971); Thomas 1974.

Lea & Boulton (Lea of Tunstall)

*High Street, Burslem,
Staffordshire
1897–98
The Art Tileries, 91 High
Street, Tunstall
1897–1923
Church Street, Tunstall
1912–13*

The Pottery Gazette of October 1896 described this firm as "manufacturers of every description of art tiles, porcelain floors, geometrical and mosaic wall and dado tiles". Recorded examples are decorated with transfer prints or majolica glazes. In March 1901, the partnership between James Hewitt Lea and Frank Dunning Boulton was dissolved. Boulton continued the firm with Henry Lawton under the same style. Frank Dunning Boulton was the son of William Boulton, a well-known engineer, who patented twenty-three inventions associated with ceramic manufacture.

Marks: "L&BT" or "L.T., ENGLAND", impressed.

References: Austwick; Barnard; *LG*, 14 June 1901, no. 27323; Lockett; Meigh; *PG*; Stuart, "Tiles for Use and Ornament", *PG*, October 1896, pp. 803–06.

Leeds Art Pottery (& Tile Co.) Ltd

*Leathley Road, Hunslet,
Leeds, Yorkshire
c.1892–1908
Formerly Browne, Leach &
Senior
1890–c.1892
Hunsletesque Company
c.1890.*

Reuben North established a pottery in Leathley Road in 1824. Throughout their history the works underwent numerous changes of ownership and style.

In January 1890, The Hunsletesque Company advertised art pottery, panel tiles and other wares. By March, Browne, Leach & Senior, "Successors to the Hunsletesque Company", advertised "Fine Art Pottery, Painted Tiles, Plaques & Ware for mounting &c". When the partners fell out, James W. Senior left to start the Woodlesford Art Pottery*. By 1895 the firm was styled the Leeds Art Pottery and it was advertising "Specialities in Leeds Faience, Pedestals, Flower Pots, Vases, Grass & Palm Stands, Centrepieces, etc., Cameo, Rococo, Baroque, Pâte-sur-Pâte, and Plain Faience in the latest designs and beautiful New Colours" as well as "Decorative and Constructive Faience, Tiles for Walls, Ceilings Hearths &c.". By 1899, the style had changed to Leeds Art Pottery & Tile Co. The firm continued to be listed in *Morris's Business Directory* under this style from 1899 to 1908.

The wares made by the pottery's successive owners in the 1890s seem to have changed little. They concentrated on large items such as flowerpots and pedestals, most often with relief-moulded scroll-work or floral decoration, covered with thick majolica glazes (82 and Colour XXI). As Rowland Browne and Harold Leach had

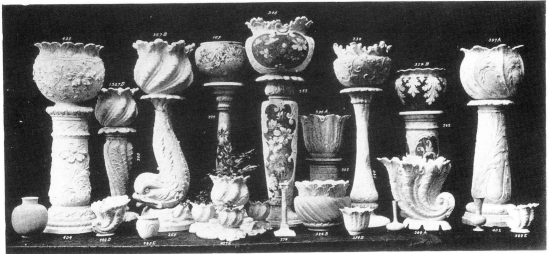

The Leeds Art Pottery and Tile Co. Ltd.,
~ LEEDS, ENGLAND. ~

London Showrooms: 13, CHARTERHOUSE STREET, HOLBORN CIRCUS, E.C.

Scale 1 inch 1 foot. Echelle au 1.12. Maassstab 1 : 12. Escala de 1 A 12. Registered Designs

Entirely new Shapes and most artistic Color Treatments are now ready for the Season.

Leeds Art Pottery continues to hold a leading position for the better-class trade on account of its artistic merit, high quality, unique effect, and moderate cost. As a decorative feature for Show purposes it has no rival.

82 Leeds Art Pottery (& Tile Co.) Ltd, advertised in *The Pottery Gazette*, 1899.

formerly worked for Burmantofts Pottery*, it is not surprising that Leeds' wares are very similar to those of Burmantofts. Shape numbers given in advertisements range from 100 to 407.

Marks: name or initials of Leeds Art Pottery, printed; shape numbers, impressed.

References: Cameron; Godden 1964; Hurst; Lawrence; *MBD*; *PG*.

Leeds Fireclay Co. Ltd

See Burmantofts Pottery.

Lemon & Crute
Teignmouth Road, St Mary Church, Torquay, Devon
c.1914–26

Harry Edmunds Crute and Thomas William "Tom" Lemon bought The Tor Vale Pottery* in 1914. Some blank pots marked "Tor Vale" were purchased with the pottery and decorated by Lemon & Crute. Tom Lemon had worked at C. H. Brannam (Ltd)* as a thrower. Harry Crute, formerly at Royal Aller Vale and Watcombe Pottery Co. (Ltd)*, was the decorator, assisted by Henry Birbeck and a Mr Hunt. In April 1916 *The Pottery Gazette*'s report on the British Industries Fair announced: "Lemon & Crute, Torquay, showed their Devonshire art pottery in plain, coloured, mottled and lustred glazes in flowerpots, vases, toilet ware, &c., and a selection of useful table articles." The partnership was dissolved on 7 July 1926, Harry Crute continuing as H. E. Crute & Co. (Torquay Ltd), Daison Art Pottery,

until *c.*1930. Tom Lemon went on to establish the Westsuma Pottery at Weston-super-Mare with his son.

Lemon & Crute products were typical of Torquay wares of the period, except that they included no motto wares. One distinctive group of wares has a streaky mauve ground upon which butterflies and flowers are painted (83). Birds – flying sea-gulls, blue-tits, flamingoes, kingfishers and peacocks – seem to have been favourite subjects of Harry Crute's. He is credited with introducing the eventually ubiquitous seagull motif to Torquay. Lemon & Crute wares of the 1920s often have pale blue grounds.

Marks: "Lemon & Crute Torquay" or "L&C", incised; "LEMON & CRUTE", impressed on unglazed bases; "Lemon & Crute Torquay" in a semi-circle, stamped in black; "DAISON POTTERY, TORQUAY" in a semi-circle, printed. Early wares may have incised shape numbers of up to three digits, underlined.

References: Cameron; Edgeler, Audrey, "Tom Lemon, Thrower", *BAPS*, July 1990, pp. 15–16; *KPOD Devonshire*; Patrick; Paull, Keith, "Where was Tor Vale Pottery?"; *TPCS Magazine*, October 1981, pp. 12–13; *PG*; *PG>R*; Thomas 1974; *TPCS Magazines*.

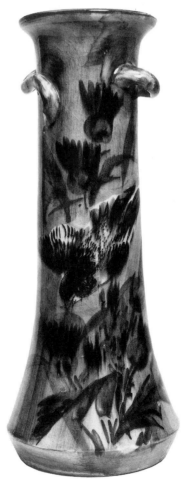

83 Lemon & Crute vase, red earthenware with painted birds and flowers on streaky mauve ground, incised "268 Lemon & Crute Torquay", h. 35.5 cm.

Liberty & Co.
London
1875 to the present day

The role of the retailer Arthur Liberty in establishing the art pottery movement cannot be underestimated. Liberty was at the forefront of several movements in the decorative arts: *japonisme*, Aestheticism, the Arts and Crafts Movement and Art Nouveau. Liberty started business as an importer of Japanese goods but was soon selling a wide range of goods made both in Britain and abroad. The access to the London market given by Liberty to provincial art potters was in many cases crucial to their success. Art pottery firms whose pots were retailed by Liberty included the Aller Vale (Art) Pottery*, William Ault & Co.*, Burmantofts Pottery*, C. H. Brannam (Ltd)*, Compton Art Potters' Guild*, Della Robbia Pottery*, Doulton & Co. (Ltd)*, A. Harris (& Sons).*, Linthorpe Pottery*, William Moorcroft Ltd*, Pilkingtons Tile & Pottery Co. (Ltd)*, William Howson Taylor's* Ruskin Pottery, Henry Tooth & Co. Ltd* and Wardle & Co. (Ltd)*. Additionally, Liberty entered into a partnership with William Moorcroft*, after James Macintyre & Co.* had announced their decision to cease art pottery production.

Marks: Some wares may be marked "Made for Liberty & Co.", or "Liberty's", instead of or in addition to the normal factory mark.

References: Aslin, Elizabeth, *The Aesthetic Movement* (Ferndale Editions, 1981); Atterbury, Paul, *Moorcroft*, (Richard Dennis and Hugh Edwards, Shepton Beauchamp, revised edition, 1990); Cameron; Levy; Morris.

Linthorpe Pottery
Middlesbrough, Cleveland
1879–1889

John Harrison established an art pottery at his brickworks at the suggestion of Christopher Dresser*, whom he had invited to lecture locally in 1878. Henry Tooth*, who had no potting experience at the time, was brought in as manager and Dresser was appointed Art Director. Tooth spent a short period training at T. G. Green & Co. (Ltd)*, before coming to Middlesbrough.

Mostly because of Dresser's involvement, the enterprise received much favourable notice in the press, from its inception. In 1880 *The Art Journal* described the wares: "The body is of a rich red, thrown into forms more or less elegant, and sometimes original; they are also decorated with incised ornaments, all worked by hand, then coloured in glazes, and tinted with oxides, producing rich mottled and semi-translucent enamelled effects." (84). In 1883, Cosmo Monkhouse observed:

> a striking display of the more recent productions of the Linthorpe factory, mainly Oriental in character . . . the Linthorpe colouring did not err on the side of sobriety or amenity. The ware, however, presented many novel effects and rich combinations . . . Vases large and curious in shape, and some of great beauty, come from these works, and the experiments being made there – in splashing vases with glazes of different colours – seem likely to produce enduring results . . . In many of the Linthorpe vessels the contrasts of colours are too strong, and the drip of the liquid is too apparent.

The firm advertised in *The Pottery Gazette* during the 1880s: "Whilst possessing all the Charm and Brilliancy of Eastern Colouring, the Ware is adapted in form and treatment to Western ideas and requirements. Of the various objects produced, many are of a useful character, and all are moderate in price." *Decoration* noted that immense progress had been made by 1888:

> The predominant style of decoration – if such it can be termed – in the fictile work under notice is that of richly coloured flooring glazes, managed with

84 Linthorpe Pottery vases with aubergine and turquoise glazes, impressed "Linthorpe, 477", h. 36.2 cm.

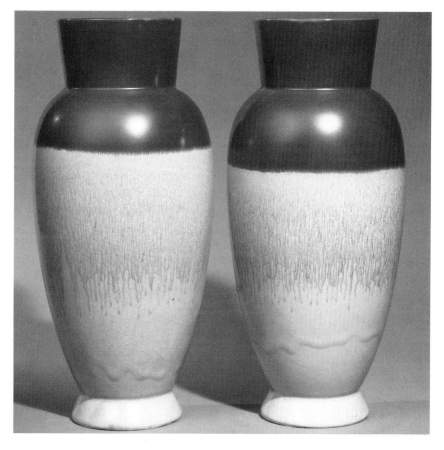

consummate art, although some decided successes have been obtained in other processes of decoration, such as sgraffito, perforated, carving, bas relief, impasto, monochrome and under and over glaze; and while the greater number of designs were floral, yet very many were geometric, while some recalled the taste which prevailed during the fifteenth and sixteenth centuries.

The firm's tiles were also recommended.

Henry Tooth is credited with the development of the famous glazes. In 1915, *The Pottery Gazette* observed:

To many the idea that an artist totally ignorant of potting could, and did, succeed in producing some of the most beautiful colours and combination of colours ever seen on ware may seem so strange as to be incredible. Yet Mr Tooth's unacquaintance with the ordinary potter's ideas as to the use and application of colours and glaze had a certain advantage. He had no preconceived ideas, no traditions.

In fact, Tooth initially purchased all the colours and glazes. He then hired Henry Venables as head of workmen. Venables was in possession of a number of recipes for coloured glazes which were thus at Tooth's disposal.

Crackle ware was Tooth's solution to the potters' *bête noire*, crazing. The crazed pots were dipped into a second glaze which clung to the body left bare by crazing

85 Linthorpe Pottery vase with streaky green glazes, designed by Christopher Dresser, impressed signature "Chr. Dresser, 254", h. 22.5 cm.

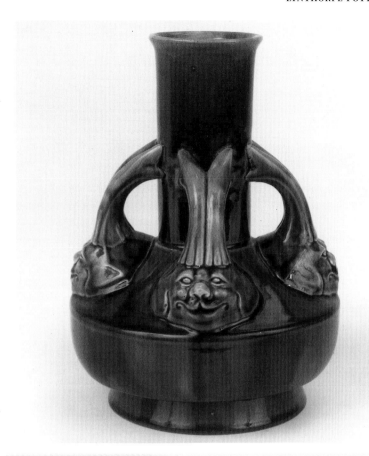

86 Pottery designed by Christopher Dresser. *Left to right*: Linthorpe Pottery vase streaked with khaki glaze, impressed "Ch. Dresser, 810", h. 17.5 cm; stoneware vase with mustard yellow glaze, moulded signature "Chr. Dresser", h. 21.5 cm; Linthorpe Pottery vessel with thick brown and streaky jade glazes, impressed "Linthorpe 312, Chr. Dresser"; Linthorpe Pottery Seal, d. 17.7 cm.

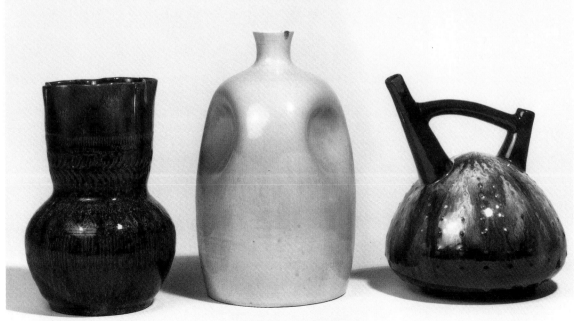

but slid off the glazed areas. Linthorpe was credited with inventing the technique of spraying colours, although this technique had been used by Minton's Art Pottery Studio*. Tooth also designed some of the shapes: "In one case, noticing a failure by a thrower – the piece collapsing under the thrower's hand – he stopped the thrower, and told him to try to reproduce the failure. The thrower did so, and in a little time a vase was elaborated which had a curious fluted rim suggestive of a cowrie shell." (*PG*, August 1915). This is of interest, as such shapes are usually automatically attributed to Christopher Dresser.

There has been a certain amount of confusion about Dresser's connection with the pottery, which may partly stem from a highly inaccurate account by Arthur Moreland. It seems quite certain that Dresser was the instigator of the venture and that Henry Tooth was installed at his suggestion. Apart from that, Dresser acted as an agent for the pottery's wares and contributed many designs as a freelance. He may never even have visited the pottery. Harrison dispensed with Dresser's services in 1882, although the shapes designed by him continued to be used. These were described as "borrowed from every school and style. In the majority of cases his designs were copies of museum exhibits; Moorish water bottles, cinerary urns, Aztec double tube bottles, Greek vases, Chinese bowls, Japanese gourds, Hindoo jars and designs of his own which tried to be original by being eccentric." (*PG*, August 1915). *See* 61, 85 and 86.

When Tooth left in 1882, Richard William Patey, whom Tooth had brought with him from the Isle of Wight, took over as art director. Tooth was briefly a partner in the Bretby Art Pottery with William Ault*, whom he had met during his training period at T. G. Green & Co. (Ltd)*, under the style Tooth & Ault*. Ault left the partnership and Tooth carried on alone as Henry Tooth & Co. (Ltd)*.

John Harrison died in 1889, after a brief illness, and the pottery, which had never been profitable, was closed. A brief attempt to revive it in 1890 failed, and it was sold at auction. Many of the moulds were purchased by William Ault, Henry Tooth and the Torquay Terra Cotta Co. Ltd*; some of them were in use as late as the 1920s.

Perhaps because of its brief existence, Linthorpe pottery was considered collectable from the firm's demise. The Dorman Museum published a catalogue of the Loan Collection of Linthorpe Art Ware as early as 1906. In 1915, *The Pottery Gazette* published a history of the firm written by a special contributor who had known John Harrison and Henry Tooth, as he had worked at the pottery from a few months of its opening until its closure (and he plainly had little use for Dresser). This history was reprinted in an expanded form in 1922, when the popularity of most Victorian wares had nearly reached its nadir. Along with the restoration of Victorian art wares to respectability, the enormous interest in the work of Christopher Dresser over the past twenty years has resulted in the particular popularity of Linthorpe wares.

Marks: "Linthorpe", impressed; "HT" monogram, impressed on pieces made during Henry Tooth's management; Christopher Dresser's signature moulded on wares which he designed. Painted artist's marks are listed in Hart. Hart has recorded a fairly consistent run of shape numbers from 1 to 2350, although pots marked 2588 and 4196 have been recorded. These shape numbers were part of the moulds.

References: Blacker; Bracegirdle, Cyril, "Linthorpe, The Lost Pottery", *Country Life*,

29 April 1971, vol. CLXIX, pp. 1022–25 (reprinted in *Collectors' Fayre*, vol. 2, no. 2, August 1987, pp. 6–7); Brighton 1983; Cameron; *Christopher Dresser 1834–1904* (Fine Art Society and Haslam & Whiteway Ltd, 1990); *Christopher Dresser 1834–1904* (Fine Art Society, 1972); *CM*; Collins, Michael, *Christopher Dresser 1834–1904* (Camden Arts Centre, 1979); Coysh; Godden 1964, 1972; Halén, Widar, *Christopher Dresser* (Phaidon, Oxford, 1990); "Mr John Harrison", *Decoration – The Arts Trade Review Supplement*, May 1888, pp. 4–5; Hart, Clive W., *Linthorpe Art Pottery* (Aisling Publications, Cleveland, no date); LeVine, Jonathan, *Linthorpe Pottery, an Interim Report* (Teesside Museums and Art Galleries Service, 1970); "Linthorpe Art Pottery", *PG*, August 1915, pp. 849–53; "Linthorpe Art Pottery", *CM*, March 1883, pp. 165–66; "Linthorpe Art Pottery", *Artist*, vol. IV, 1883, pp. 181–82; "Linthorpe Pottery", *AJ*, vol. XIX, 1880, p. 53; "Linthorpe Pottery", *PG>R*, September 1922, pp. 1387–89; Lawrence; Monkhouse, Cosmo, "Vallauris and its Allies", *MA*, vol. VI, 1883, pp. 30–36; Moreland, Arthur, "Linthorpe: A Forgotten English Pottery", *The Connoisseur*, vol. XXXIX, 1914, pp. 85–88 (NB very inaccurate); Pinkham; *PG*; Thomas 1974; Wade, Hilary, "Christopher Dresser and the Linthorpe Pottery", *The Antique Collector*, February 1984.

Little, C. P.

A review of the Inventors' Exhibition in *Decoration*, May 1885, reported that Little showed "a number of painted tiles, faience &c. the designs of which are very good, the florals and grotesques especially so, but the colouring adopted seems rather muddy".

Llanelly Pottery

See Guest & Dewsberry (Ltd).

Llynion Tile & Pottery Works

See I. & W. Powell.

Longpark Pottery Co. (Ltd)
*c.*1903–07;
Royal Longpark Potteries Ltd.
1908–18
Longpark Pottery Co. Ltd.
1923–57
Shiphay, Collaton, Cockington, Torquay

The pottery was acquired from Brewer Bros* by a group of Aller Vale (Art) Pottery* employees disgruntled with Hexter Humpherson & Co. (Ltd)*, possibly in 1903. The firm was registered in February 1905 with a capital of £1,400 in £1 shares, with the object of taking over "the business of art potters and decorators carried on by G. W. Bond, G. H. Causey, F. H. Blackler, W. J. Skinner, R. H. Skinner and H. E. Bulley*' (*PG* April 1905). They appeared as the "Longpark Fine Art Terra Cotta Co., Newton Rd., St. Mary Church" in *The Pottery Gazette Diary*'s Directory of Manufacturers, 1907. Herbert Edward Bulley was secretary from 1906 to 1913, followed by Robert H. Skinner from 1913 to 1926 and Frederick H. Blackler from 1926 to 1943.

The wares produced by Longpark were, not surprisingly, quite similar to those produced at Aller Vale. In some cases even the same pattern numbers were used. Nevertheless, some good-quality original designs were produced and there are a number of distinctive features of Longpark wares (87). The lettering on Longpark motto wares is particularly thick. Some Longpark motto wares with coloured grounds have slip-trailed writing. Thomas has noted that the colours often look

87 Longpark Pottery Co. Ltd wares, all with printed mark "LONGPARK TORQUAY". *Left to right*: Wild Rose pin tray with streaky purple glaze, d. 9 cm; Kingfisher bowl, painted mark "198", d. 8 cm; vase with butterflies on streaky mauve ground; Scandy pattern bowl, painted mark "96MI", d. 11 cm.

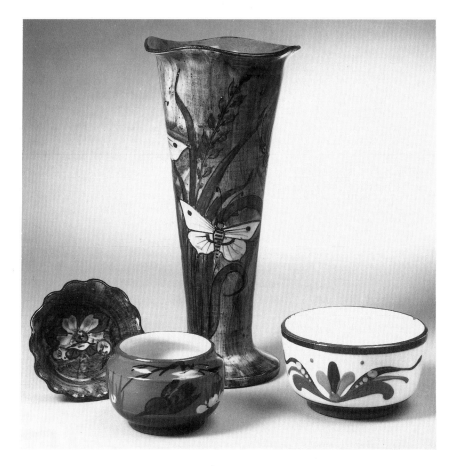

colder and greyer than on wares from other Torquay potteries, and that this was possibly due to a higher firing temperature. In 1904 Longpark featured green-glazed ware and colour treatments such as a combination of blue, green and orange (*PG*, February 1904). They exhibited slip-decorated pottery at the Louisiana Purchase Exhibition in St Louis that year. Charles Collard* worked here briefly in 1904–05. Some very odd chanticleer and mallard grotesques with human faces have also been recorded (*TPCS Magazine*, July 1989).

Pots marked Tormohun were made from 1907 to 1913. The Royal Tormohun Pottery Co. Ltd seems to have been an art studio within Longpark rather than a separate pottery, although it did appear as such in some directories. The 1914 directories show two Longpark firms – The Royal Longpark Pottery and the Longpark (Art) Pottery – operating on the same premises. The wares of the Royal Longpark Co. are similar to the North Devon wares produced by C. H. Brannam, and it is believed that one of the North Devon decorators may have been in charge of this production line.

A catalogue of Longpark Pottery Co. Ltd wares issued in the 1930s shows a wide variety of motto wares, including Conventional (usually known as Scandy), Coloured Cock, Black Cock, Thistle (Scottish mottoes), Shamrock (Irish mottoes) and ships. Also listed were Daffodil Ware, New Butterfly and Rosebud Ware, and Kingfisher Ware, along with plain brown, yellow, blue, olive green and dark blue wares. The crocus pattern was also very popular in the 1930s. The shapes appear

to have changed very little during the thirty-odd years of the firm's operation. Rustic ware, imitating tree trunks and branches, was the speciality of George Bond in the 1930s.

The pottery closed in 1943, after which it was acquired by Hexter, Humpherson & Co. (Ltd)'s* Mid-Devon Trading Co. The works were managed by Arthur Cole, from the Watcombe Pottery (which was also owned by Mid-Devon Trading Co.). Wares were mostly motto wares in Scandy, Black Cockerel and cottage patterns, and daffodil wares. Production ceased in 1956, and Arthur Cole returned to manage Watcombe. Longpark wares are among the motto wares most commonly found today, probably because of the firm's long existence.

Marks: "LONGPARK TORQUAY", incised, impressed or stamped in black. Pattern numbers, some of which are identical to those used at Aller Vale, may be found; shape numbers less often. A variety of marks incorporating "Tormohun" are found on some wares.

References: Cashmore 1983; Jones; Longpark Pottery Co. Ltd, *Illustrated Catalogue and Revised Price List* (Torquay, *c.*1930s, reprinted *TPCS*); Mayo, Leonard W., "'Men of Longpark' A Personal Recollection", *TPCS Magazine*, January 1978, pp. 8–10; *MBD*; *KPOD Devonshire*; Patrick; *PG Diary*; Thomas 1978; TPCS 1989; *TPCS Magazines*.

Longpark Terra Cotta (China) Works
Newton Road, St Mary Church, Torquay, Devon
1883–95

Messrs Ridley and Taylor established this pottery as a terracotta works in 1883. The two were among the Staffordshire potters employed by the Watcombe Terra-Cotta Co. (Ltd)* who were laid off when Watcombe closed in 1883–84. The wares manufactured were of the Watcombe type. The partners were Taylor and Crutchlow, 1889–93, and Taylor and Willot, 1893–95. From 1895 Ralph Willott was in partnership with William and James Brewer, under the style Brewer Bros*.

Marks: "LONGPARK TORQUAY", encircled by "TERRA COTTA WORKS".

References: Thomas 1978; *TPCS Magazines*.

Lovatt & Lovatt (Ltd)
The Pottery (Langley Art Pottery), Langley Mill, near Heanor, Nottinghamshire
1895–1931
Lovatt's Potteries Ltd
1931–67
Langley Potteries Ltd
1967–82

Formerly Calvert & Lovatt*, this firm was run by Albert and John Lovatt, who worked in partnership. In 1895 Albert's sons, L. H. and A. E. "Bert" Lovatt, joined the partnership. L. H. Lovatt died in 1900. In 1913, after Albert's death in November 1912, the firm was registered as a limited company with a capital of £70,000; the first directors were John Lovatt and A. E. Lovatt (*PG*, June 1913). By this time the firm employed more than four hundred hands. In 1931 the firm was acquired by James Oakes & Co. (Riddings) Ltd, manufacturers of saltglaze stoneware, sanitary pipes, and fittings, bricks and so forth, and the style was changed to Lovatt's Potteries Ltd. The pottery was purchased by J. Bourne & Son (Ltd)*, in 1960, continuing to operate until December 1982.

Although it was a stoneware pottery which specialized in fireproof and domestic wares using only leadless glazes, Lovatt's had produced Langley Art Ware from the mid-1880s. Because the firm was a regular advertiser in *The Pottery Gazette*, its wares are quite well documented. In 1903 it introduced its Princess ware:

Its main scheme is a neat combination of coloured grounds – the upper portion of the pieces being blue, and the lower section a pretty neutral or grey tint. The blue portion is decorated with pansies in natural colours, and the lower portion with a white blossom. In this new art pottery they are showing teapots and pot stands, coffee-jugs, coffee-pots, "Toby jugs", tankard jugs, mounted and unmounted, sugar basins, and flower vases and flower-pots. (*PG*, February 1903)

In the same year the firm introduced another new art ware: "This consists still of "Langley" pottery, but with flowers hand-painted on dull grounds, and on glazed grounds, variously tinted. This fully justifies its description as art pottery. There are vases of all sizes and in multitudinous shapes, all graceful and artistic." (*PG* July,

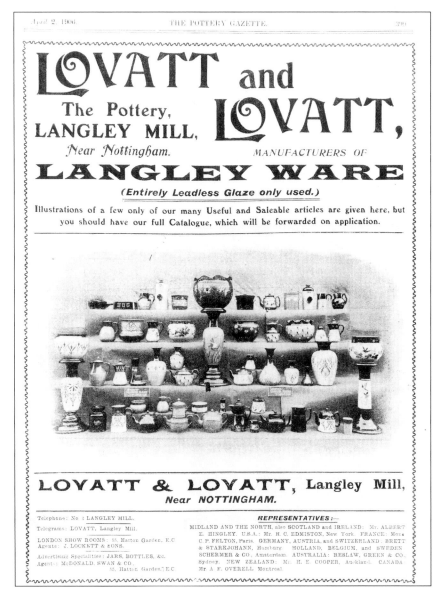

88 Lovatt & Lovatt (Ltd)'s Langley Ware, advertised in *The Pottery Gazette*, April 1906.

1903) The vases illustrated in the advertisement are painted with flowers and birds.

In 1905 Lovatt & Lovatt introduced wares with a "green ground and light band, on which there is pretty green foliage" (*PG*, December 1905). In 1906 the firm developed the "production of pedestals and pots in Langley ware with considerable success" and introduced gilt Myrtle ware, which had "all the brightness and freshness of the evergreen shrub from which it takes its name" (*PG*, September 1906) (88). In 1907 it showed "some good slip decorations" and specimens of threaded work, "coloured thread on light ground" (*PG*, September 1907). The pots illustrated were decorated with Art Nouveau scroll-work and flowers.

The year 1908 saw "an artistic introduction of lace-like effects on light ground: indeed, the lace pattern is part of the ground scheme, and on it are pretty conventional designs in darker colour. The soft delicate matt surface has a very pretty effect, and this can be enhanced and varied at will by varying the ornamentations put on it." (*PG*, March 1908) In 1909 Lovatt & Lovatt introduced Osborne ware: "The upper parts of the pieces are in a beautiful dark blue (either with or without gold). The body has a matt surface – light blue-grey in colour – with a conventional design in a judicious colour combination of white, salmon, and blue green." (*PG*, February 1909)

At the Brussels International Exhibition of 1910, Lovatt & Lovatt showed "a tall vase with a serpent coiling round it from top to bottom" (*PG*, August 1910). Old Roman ware was introduced in 1911: "in antique shapes, which bear a strong resemblance to hammered bronze and copper work. Some have a solid dull green glaze, and even the weight of them makes the imitation of the metal originals more striking." The pottery also featured its Lizard decoration: "Jugs, vases, flower pots, &c. have each a 'lizard' crawling up the side. It is a good imitation of the living reptile, and as there is only one on each piece the illusion is more complete than it would be if there were more." (*PG*, February 1911).

The art pottery closed during the First World War, and the entire works were devoted to strictly useful lines for the Admiralty and the War Office. Art-ware production resumed after the war; a photograph of the pottery in late 1919 shows a warehouse full of art pottery (*PG*, December 1919).

Marks: "LANGLEY WARE"; later marks incorporated "LANGLEY".

References: Cameron; Coysh; Godden 1964; Niblett; "Obituary. Albert Lovatt", *PG*, January 1913; *PG*; *PG>R*; "Stoneware from Langley Mill", *PG>R*, November 1954; "A Visit to the Langley Pottery", *PG>R*, December 1919, pp. 1329–32.

J. R. Lovegrove
Clevedon Art Pottery,
Hill Road, Clevedon, Avon
*c.*1894–95

This firm was listed as an art pottery manufacturer in *Morris's Business Directory* of 1894–95.

Macintyre, James & Co. Ltd

Washington China Works, Burslem, Staffordshire
*c.*1852–1940

James Macintyre (1803–68) supervised his family's Anderton Carrying Co. from 1848 to 1852; this was a major carrier of clay, flint and other ceramic materials, as well as finished wares. He then joined his brother-in-law, William Sadler Kennedy, who had been managing Anderton's pottery business, manufacturing artists' equipment since 1838 and house numbers and door furniture since a move to the Washington Works in 1847. Two bodies were used: a cream-coloured Ivory China and a black ware which was actually a red body with a cobalt glaze. In 1854 Macintyre became the sole proprietor. In 1863 he patented methods for turning non-circular shapes on a lathe. After Macintyre's death in 1868, the firm was continued by his son-in-law, James Woodall (1832–1901), and former manager, Thomas Hulme (1830–1905). Hulme retired in 1880, and William Woodall was succeeded by his brother, Corbett, in 1893.

Although this large firm always devoted the vast majority of its production to industrial or trade porcelains, such as pestles and mortars for chemists, the production of tablewares and ornaments increased during the 1880s. The first mentions of art pottery appear in the American trade periodical, *The Crockery & Glass Journal*, in April 1882:

> Messrs Macintyre & Co., Burslem, are producing some exquisite specimens of art decoration on lamp bodies. Their enamelled [*sic*] patterns, blue and red, on ivory bodies, are not to be excelled. In high-class fittings for cabinet makers', upholsterers' and builders' furniture, they do a large business. Mr Woodall, MP, one of the firm, will shortly visit the United States as a member of the Parliamentary Commission on technical education.

A distinct art pottery department was not set up until 1893, however. The first wares produced were Washington Faience with sprigged ornaments designed by Mr Wildig, and Taluf Ware, with carved slip decoration.

In 1895, Harry Barnard*, then at Doulton & Co. (Ltd) Lambeth*, was engaged to supervise the development of a new slip-decorated art ware. This was Gesso Faience, a variety of *pâte-sur-pâte*, adapted by Barnard for factory production, the slip being applied free-hand over a stencilled pattern. Over one hundred of his designs for shapes were put into production, some of them continuing in use for many years. His surface patterns were a combination of revived rococo and Art Nouveau which was refined under William Moorcroft*. Barnard was also responsible for establishing the art studio and training the girls in his new technique.

Barnard left to work for J. Wedgwood (& Sons Ltd)*. William Moorcroft, who had been working as a designer of printed patterns, then took over as designer in 1897 and Manager of Ornamental Ware in 1898. Although he inherited Barnard's department, techniques and patterns, he soon developed his own individual style. His first efforts were Florian Ware and Aurelian Ware (89–91; Colour XXII and XXIII). In keeping with the name, most Florian Ware patterns were floral designs,

89 James Macintyre & Co. Ltd vase, *c.*1907, printed Macintyre mark signed "W. Moorcroft" in green, impressed "160", with "M1862W" in script, h. 20 cm.

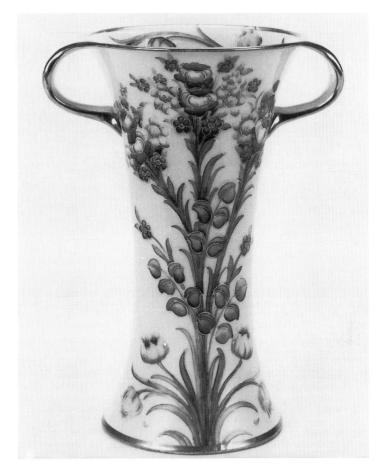

90 James Macintyre & Co. Ltd Florian Ware part dessert service, *c.*1902, each piece signed "W. Moorcroft des." in green.

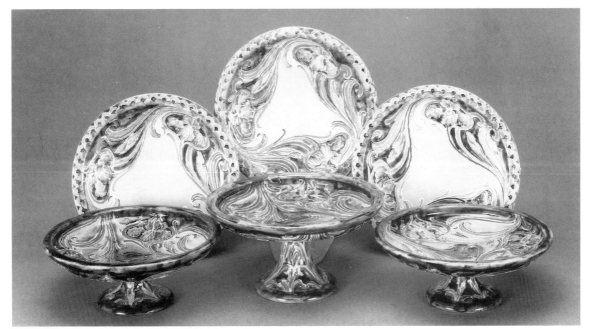

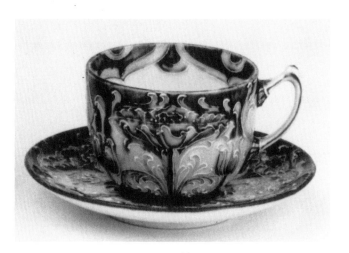

91 James Macintyre & Co. Ltd
Florian Ware teacup and
saucer, c.1900.

but butterflies, fish, peacock feathers and other patterns were also devised. A
contemporary article on Florian Ware described the making in detail. The pot was
thrown, turned on the lathe and dipped in slip, usually coloured yellow, blue, green
or brown. The pot was then tube-lined with white slip, biscuit fired, glazed and glost
fired. Moorcroft's management was also described:

> All the designs are the work of W. R. Moorcroft; every piece is examined by
> him at each stage, and is revised and corrected as much as is necessary before
> being passed into the oven. The decorative work is executed by girls – who
> have previously to go through a course of training at the Burslem Art Schools
> – and, while the design of Mr. Moorcroft is followed as closely as possible, any
> individual touches of the operators are seldom interfered with if they tend
> to improvement. It thus happens that no two pieces are precisely alike.
> (MA, 1898)

Moorcroft said that he had been inspired by the pottery of the East and "the
freedom and individuality that characterizes their work". He told Fred Miller in
1903:

> It was after long dreaming of what was possible in this direction, that in 1898
> I was first able to express my own feeling in clay. Perhaps no other material is
> so responsive to the spirit of the worker as is the clay of the potter, and my
> efforts and those of my assistants are directed to an endeavour to produce
> beautiful forms on the thrower's wheel, the added ornamentation of which is
> applied by hand directly upon the moist clay. This, I feel, imparts to the
> pottery the spirit of the art-worker, and spontaneously gives the pieces all the
> individual charm and beauty that is possible, a result never attained by
> mechanical means.

Florian Ware and the other art wares to follow were characterized by the
earthenware body that was adapted from Macintyre's industrial porcelain. The
highly vitrified glazes were achieved by firing to 1100 degrees centigrade. Initially,
this high temperature limited the choice of colours to blue, green, pink and yellow,
but Moorcroft soon developed additional colours which could withstand the heat.

Aurelian Ware was transfer-printed outside of the art pottery department. The
printed pattern was sometimes highlighted with tube-lining and "richly embel-

lished in burnished gold". Like Florian Ware it bears Moorcroft's signature. Although the designs are today considered to be Art Nouveau, a reporter in 1906 insisted: "This simplicity in outline and in added ornament is exactly antithetic to what is called the 'New Art'." (*PG*, March, 1906)

Hesperian Wares were made as early as 1902 or 1903, and were advertised as late as 1909. These were similar to Florian Wares but featured aquatic motifs, typically highlighted with mauve. Dura Ware was a decorated version of the firm's Tinted Faience tablewares. Although made in Moorcroft's department, it did not carry his signature.

Macintyre displayed "Fifty-seven pieces of beautiful pottery designed by and executed under the direction of W. Moorcroft" at the Louisiana Purchase Exhibition at St Louis, 1904. These won Moorcroft's first gold medal, and perhaps more importantly his pots were now retailed by Tiffany & Co.* in New York, alongside the work of many other distinguished art potters.

Moorcroft was an enthusiastic chemist; his Flamminian Ware in red and green glazes was introduced in 1905. In 1907 *The Pottery Gazette* reported that the firm was concentrating on glaze effects, although the earlier wares were still being produced. The Pompeian shapes introduced in 1900 lent themselves to this treatment particularly well, and continued in use as late as 1935. The shapes' earlier combination with tube-lined decoration had been criticized: "We doubt, however, whether his applications of renaissance and modern ornament to these simple classic forms is altogether to be commended" (*MA*, 1901). Ruby Lustre was applied to tube-lined patterns such as Hazeldene (landscape) and Claremont (mushrooms) from 1907. Yellow lustre was also used. These were commercial lustres, probably purchased from an outside firm, as opposed to the reduction-fired lustres of William De Morgan*.

Tube-lined wares continued to be produced in many new designs. Eighteenth Century Wares, which were ivory-bodied wares with Adams-inspired tube-lined garland patterns, were introduced in 1905. John Service commended these wares: "Simplicity is the characteristic feature of these productions, features equally apparent in the subjects of the decorative schemes and in the forms upon which they are applied, and in combination there is a fitness about them, a repose, a restraint, and restfulness which is quite refreshing." Florian, Gesso and Aurelian Wares were shown at the Brussels International Exhibition of 1910; for them Moorcroft again won a gold medal. Pomegranate, possibly Moorcroft's best known design, was introduced in 1910.

During the early years of the century, the firm had enormously increased its business in electrical porcelains. In 1913, it was decided that the pottery should devote itself entirely to this new industry. The art wares were manufactured continuously until Moorcroft, in partnership with Liberty & Co.*, had built his own pottery in Cobridge, where he continued their manufacture on his own account under the style W. Moorcroft Ltd*. In March 1914, Macintyre offered an "Unique Opportunity of obtaining a nice selection of Distinctive Art Pottery . . . at reduced prices" (*PG*, March 1914). Thereafter the firm's advertisements were confined to their "porcelain specialities for every trade in which porcelain parts are used".

An excellent collection of Macintyre and Moorcroft wares may be seen in the museum at the Moorcroft Pottery, Sandbach Road, Burslem, Stoke-on-Trent, ST6 2DQ, Telephone (0782) 214323. The Moorcroft Collectors' Club may be contacted through the Secretary, Gill Moorcroft, at the same address.

Marks: "Gesso Faience" surrounded by "James Macintyre & Co. Ltd./Burslem England", printed in script. This mark was originally used on Gesso Faience developed by Barnard *c.*1895, but was used haphazardly on other wares into the twentieth century. "FLORIAN WARE/JAS. MACINTYRE & CO. LTD./BURS-LEM/ENGLAND", printed 1898–*c.*1905. "JM&Co." monogram in circle surrounded by "MACINTYRE/BURSLEM/ENGLAND", printed, *c.*1903–13. "W. Moorcroft" signature or "W.M." painted or incised. Retailer's marks are also found, especially Liberty & Co.'s*. Many shapes and patterns were registered designs, and registration numbers may be printed on the bottom of these pots.

References: Atterbury, Paul, *Moorcroft* (Richard Dennis & Hugh Edwards, Shepton Beauchamp, revised edition, 1990)‡; Atterbury, Paul, *William and Walter Moorcroft, 1897–1950* (Fine Art Society, 1973)‡; Cameron; *The Crockery & Glass Journal*; "Florian Ware", *MA*, vol. XXIII, 1898–99, p. 232; Godden 1988; Jewitt; Levy; *MA*, 1901, pp. 87–88; Miller, Fred, "The Art Pottery of Mr. W. Moorcroft", *AJ*, 1903, pp. 57–58; *Moorcroft Collectors' Club Newsletters* 1989–90; Morris; Pemberton; *PG*; Rhead; Rix; Service, John, "British Pottery", 3 pts, *AJ*, 1908, pp. 53–57; 129–37; 237–44; Stuart.
‡ Paul Atterbury's book was first published in 1987. The revised edition contains a great deal of new material concerning the history of both the Macintyre and Moorcroft firms. It also supersedes the 1973 Fine Art Society catalogue.

Mansfield Bros Ltd
Art Pottery Works, Woodville and Church Gresley, near Burton-on-Trent, Derbyshire
1890–1957

The firm advertised "Artistic Pottery & Tiles: Toilet Ware, Pedestals, Plant Pots, Umbrella Stands, Vases &c." (*PG*, January 1903). This Mansfield Ware was relief-moulded and decorated with majolica glazes, some with very attractive polychrome shadings. *The Pottery Gazette* of January 1905 illustrated a plant pot and pedestal with applied modelled cherubs. Jewelled Art Ware was another speciality: "This consists of new art-shaped pots with rows of 'jewels' round the bowls. There are beautifully realistic turquoise, amber, ruby, and diamond. These scintillate very effectively from the self colours in which they are set." (*PG*, January 1905). Also mentioned were the fancy and grotesque pieces in mottled ware. The Woodville works closed in 1957, but the firm continued at Paisley, Strathclyde, Scotland, where their products were mainly utilitarian.

Marks: "M. B." on a cross-hatched diamond impressed or moulded.

References: Godden 1964; Greene, John, "Mansfield Brothers", *GE* autumn/winter 1981, p. 7; Mansfield Brothers' *Catalogue*, no date (held at Ironbridge Gorge Museum Trust Library); *PG*.

Manzoni, Carlo
1855–1910

Manzoni was a talented artist, modeller, designer, decorator and sculptor. He operated the Granville Pottery* on his own account from 1894 to 1898. After a fire at Granville, he ran the Coleorton Pottery*, where he remained less than a year. In 1898–9 he was placed in charge of the architectural side of the Della Robbia Pottery*, where he remained until its closure in 1906.

References: Godden 1964, 1980; Meigh; Williamson.

Marland Brick & Clay Works
Torrington, Devon
1879–89

These works produced tiles, pipes, coloured clays and 100,000 bricks a week. They also apparently produced pottery. In *The Artist* of October 1882, Thomas Carder, manager of these works, reported his discovery of a black pottery glaze:

> This discovery of mine made about three weeks since, was the result of investigation on combining certain portions of clays, fluxes and other materials, with the object of securing a particular colour, when to my great surprise and delight one of the most brilliant and indescribably deep blacks, equal to, if not eclipsing the ancient Egyptian black, was the result. The vase so treated by me contains a group of flowers raised upon its surface, namely roses, leaves, stems &c.: the flowers &c. are a beautiful bright blue and this raised upon the brilliant black is most striking, and has gained the admiration of all who have seen it. I can now reproduce it and shall be prepared to exhibit "specimens".

Jeffery Ludlam, proprietor of the works, went bankrupt c.1889, and Alexander Lauder* purchased the works. The clay from these beds did much to improve the Lauder body and hence the quality of his art wares.

References: *Artist*, October 1882, p. 311; Edgeler.

Marsden Tile Co. (Ltd)
Dale Street, Burslem, Staffordshire
c.1890–1919

George Anthony Marsden's decorative technique was registered as Wedgwood Patent Impressed, after he had sold the invention to J. Wedgwood (& Sons Ltd)*, and managed a department producing these tiles. The technique gave the appearance of hand-decorated barbotine or *pâte-sur-pâte* work (92). In 1888, finding the product unprofitable, Wedgwood cancelled the contract, and Marsden established his own firm. Marsden's Patent technique has also been found on tiles with Doulton & Co. (Ltd), Lambeth* marks, probably because Marsden decorated Doulton blanks until he had obtained the equipment to manufacture his own tiles.

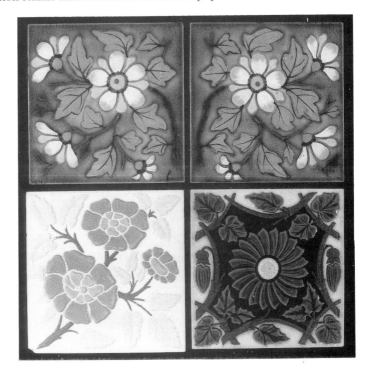

92 Marsden Tile Co. (Ltd) tiles. *Above*: pair of Marsden Patent tiles with "Mechanical Barbotine" decoration, polychrome decoration on white dust-pressed blanks, with clear and olive green glazes, c.1893–95, incised "M85", 15 cm sq. *Below*: Marsden Patent tiles with moulded decoration in coloured clays, on light cane body, c.1893–95, moulded marks "PATENTED", 15 cm sq.

The firm's tiles, as described in *The Pottery Gazette* of October 1896, included printed, floral and geometrical patterns and a patented "rainbow" glaze effect. Marsden also advertised majolica and Marsden Velouté tiles (*PG*, October 1896). Beside tiles, the firm also produced a range of sgraffito-decorated art wares designed by Harold Moorcroft, brother of William Moorcroft*.

References: Atterbury, Paul, *Moorcroft* (Richard Dennis and Hugh Edwards, Shepton Beauchamp, revised edition, 1990); Batkin; Clegg, Peter and Diana, "Back Chat 2", *GE*, no. 6, spring 1984, p. 6; Clegg, Peter and Diana, "Back Chat 5 and Chat Back 2: Marsden's Patent", *GE*, no. 10, summer 1985, pp. 4–5; Lockett; *PG*.

Martin, R. W. & Brothers

Fulham, London
1873–77
Southall, London
1877–1915; 1928–c.1937

In January 1873, Robert Wallace Martin* leased Pomona House, which was to serve as a residence for his parents and siblings, and house his pottery as well. The second kitchen became his laboratory, and the stables his studio. He was soon joined in the business by his brothers, Walter Fraser*, Edwin* and Charles. For the first eighteen months, their wares were fired by C. J. C. Bailey & Co.*, Wallace's former employer. John Patterson, an employee of Bailey's who was later to become Walter Martin's father-in-law, retrieved an old wheel from Bailey's yard and built the Martins' first pug mill.

In the early years, the mainstay of the firm was architectural work, supplied by architects whom Wallace had met in his previous employment or to whom he boldly introduced himself. These included J. P. Seddon (whose commissions Wallace had carried out while with C. J. C. Bailey), Frederick Pepys Cockerell and George T. Robinson. The brothers also made clock cases for Lund and Blockley of Pall Mall. *The Art Journal* commended their work in 1874: "The specimens of stoneware vases, of a similar character and origin to those of Messrs Doulton, by Mr. R. W. Martin of Fulham, and a fruit plate in stoneware by Mr. W. F. Martin are all of a sound character, and present admirable variations of treatment of detail to the Lambeth stoneware. Trained in the same school with those who execute Messrs Doulton's productions, a certain identity of thought is to be expected, but it never takes the form of mere imitation, still less of any attempt at reproduction."

In December of 1874 the brothers broke off their relationship with Bailey, who was charging exorbitant prices for firing their wares. They briefly used the kilns at Ruel Bros' Crucible Works, but in 1876 resorted to Bailey's kilns again. In 1877 they moved to Southall and, with the finance of several patrons, most notably the ironmonger Frederick Nettlefold, they set up their own pottery.

The brothers' early work was influenced by the Gothic revival, but conventional ornament as proposed by Christopher Dresser* was also used. As the 1880s progressed, they developed what Charles Beard called the Canal Bank style. Malcolm Haslam has shown that, while the brothers may have been inspired by the flora and fauna of their rural Southall situation, many of their designs were taken from eighteenth-century botanical and zoological illustrations. Their execution of these designs was strongly influenced by the *japonisme* of the period. The use of a few powerful lines to convey the essence of a flower, bird or fish was well suited to the stoneware medium. After H. F. Fawcett had given Edwin Martin and the brothers' assistant W. E. Willy drawing lessons, they decorated some wares in a painterly fashion which was enhanced by new colours developed by Walter. This new palette gave a richness to the wares not seen before in stoneware. Renaissance designs, inspired by maiolica, were a speciality of Willy and Fawcett, although

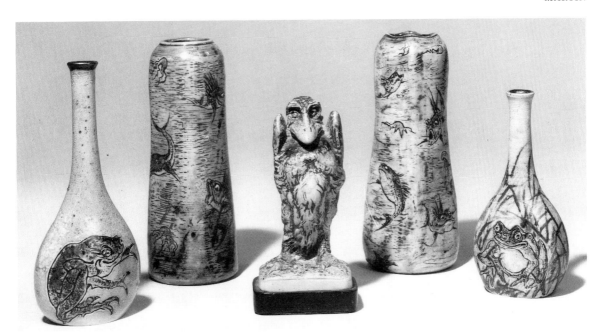

93 Martin Brothers stonewares. *Left to right*: Vase, incised "Martin Bros. London & Southall 4-1913", h. 12.4 cm; vase, incised "Martin Bros. London & Southall 8055 6-1913", h. 12.8 cm; "Wally Bird", incised "R. W. Martin & Bro., London & Southall 18.6.1913", h. 10 cm; vase, incised "Martin Bros. London & Southall 4-1913", h. 12.7 cm; vase incised "Martin Bros. London & Southall 4-1913", h. 10.2 cm.

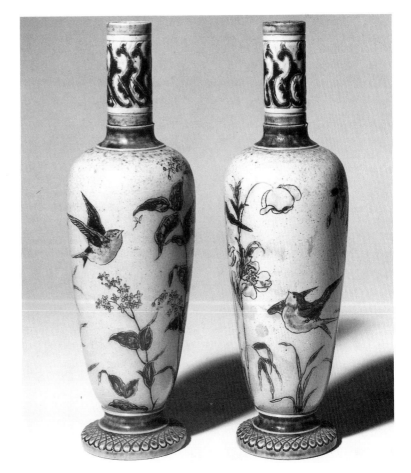

94 Martin Brothers stoneware vases, incised "R. W. Martin & Bros., London & Southall, 31.7.8 3" (only partially legible), h. 25.4 cm.

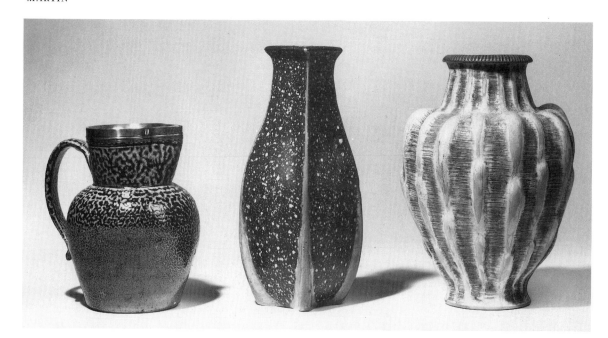

95 Martin Brothers
stonewares. *Left to right*: jug
with white-metal-mounted rim,
impressed "R. W. Martin,
Southall", h. 18.6 cm; vase,
incised "Martin Bros. London &
Southall 4-1901", h. 27 cm;
vase, incised "Martin Bros.
London & Southall 3-1900",
h. 25.7 cm.

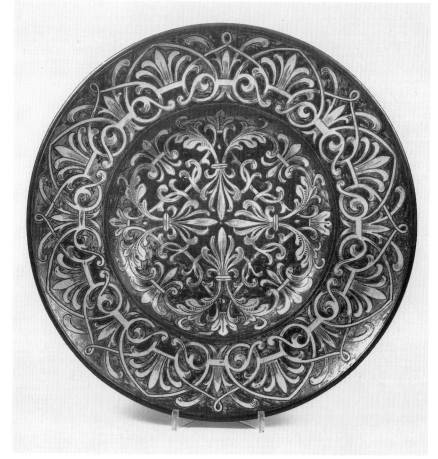

96 Martin Brothers charger,
incised "Martin & Bros,
Southall 12-1895". 37 cm.

97 Martin Brothers wares.

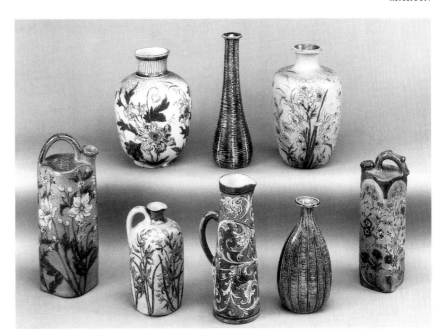

some were executed by Edwin Martin. As Edwin Martin and W. E. Willy developed their decorating skills, Wallace increasingly devoted himself to modelling. Although he is most admired today for his grotesques and "Wally" birds (Colour XXV), he modelled a wide range of figures and conventional portrait plaques and busts. *See* 93–97 and Colour XXIV.

The Martin Brothers, celebrated as they were, never achieved a wide popularity. Although Martin Wares were appreciated by connoisseurs, they were an acquired taste. After a visit to the Brownlow Street gallery, Edward Spence commented;

> I do not say that all pieces of their ware are beautiful, or that any of it is *pretty* but every piece possesses individuality of character, so that even those which are downright ugly have the fascinating interest similar to that which is to be found in the face of a plain but intellectual-looking man. Indeed, at first sight, every one is disappointed by this sombre coloured, severely shaped, salt-glazed ware: after a time, however, the disappointment wears off and interest takes its place, then the latent beauties disclose themselves and at last, the fact that no hands save only those of the artist have touched it produces a subtle charm, and leaves the spectator in a state of delight.

The brothers experimented with earthenware from 1896 to 1898. Since there were only two partially successful earthenware firings in a new kiln, these pots are extremely rare. Perhaps inspired by ceramics seen at the Paris International Exhibition of 1900, Walter experimented with lustre and crystalline glazes, but he was largely unsuccessful.

The twentieth century brought increasing recognition to Edwin. He had for several years been making small pots to fill the spaces in the kilns. These were simply decorated with abstract patterns sometimes inspired by animal or vegetable forms. This new style was encouraged by Edwin's friend, Sidney Greenslade, who also provided sketches. Edward Spencer, who was later to become involved with the Upchurch Pottery*, sold these wares through his Artificers' Guild.

R. W. Martin & Bros are listed in *Morris's Business Directory* 1880–1914 as having their showroom at 16 Brownlow Street, Holbourne [Holborn], but they probably had used these premises for some time before that. After their move to Southall, this London retail outlet was vital; it was skilfully run by Charles Martin, who managed the finances of the firm as well. Charles's contribution and the degree to which he dominated his brothers is usually underestimated. Apart from managing the business, which took some doing in precarious years, he cultivated connoisseur patrons and frequently sent his own designs for execution at Southall. When the showroom caught fire in 1903, causing the death of three people living above, as well as the loss of a large stock of Martin Ware, Charles suffered a breakdown from which he never recovered. He died, from tuberculosis, insane, seven years later. This was the first of many severe blows to the firm.

After Charles's breakdown in 1903, marketing became uncertain and the brothers lacked the direction that he had provided. Despite the success of Edwin's new wares, the brothers were consumed by internal squabbles and firings became less and less frequent. Wallace's son, Clement, had joined the firm *c.*1900, and Edwin and Walter feared that he would succeed to the business. Walter died in 1912, and with him went many of his ceramic formulae. Edwin continued by firing in a small muffle kiln, but he suffered cruelly from cancer of the jaw and his output before his death in 1915 was small. Wallace modelled sporadically, but the pottery was fired, presumably in Edwin's muffle kiln, only twice more before his death in 1923.

In 1921, *The Pottery Gazette and Glass Trade Review* reported that there were "over a thousand pieces still in clay on the pottery, but no kiln has been fired since Walter's death in 1912, and although offers have been made by practical men to undertake the firing of it in their own kilns, arrangements to do so are still pending, and it is quite possible that a different effect would result without the guiding and experienced presence of Walter". The arrangements to have the wares fired elsewhere failed and, in 1928, Clement tried to revive the pottery with a certain Captain H. Butterfield, who had worked at the pottery as a boy. They fired at least some of the wares decorated by Walter and Edwin, but these can be recognized by their poor colouring. The quality of the new wares was inferior, and they found few customers in the Jazz Age. Nevertheless, the revived business continued until at least 1937.

Artists, decorators and designers

Although the Martin Brothers are often described as prototypes of modern studio potters, they did in fact employy others as and when they could.

H. F. FAWCETT, who had previously worked as a decorator for William De Morgan*, spent about two years with the Martins. He gave W. E. Willy and Edwin Martin drawing lessons, and his own designs continued to be used throughout the 1880s.

SIDNEY GREENSLADE met Edwin in 1898. He became Edwin's mainstay in all the family disputes during the following years. From the surviving correspondence, it is apparent that he sent many sketches to Edwin, and some of these were executed. Greenslade was an architect with many connections in the world of the arts, exhibiting at the Royal Academy from 1893 to 1899. He took it upon himself to preserve the Martin Brothers' fame after Edwin's death.

MARK V. MARSHALL met Wallace at the Lambeth School of Art. They became re-

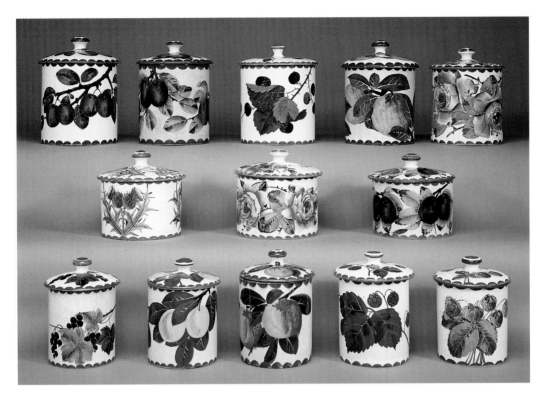

XVIII Fife Pottery Wemyss Ware, *c.*1900 (*bottom row, fourth from left*, 1925–30). *Top, left to right*, preserve jars and covers: impressed "WEMYSS WARE, R H & S", h. 15.5 cm; impressed "WEMYSS WARE, R H & S", h. 16 cm; "Wemyss" in green script, h. 14.5 cm; impressed "WEMYSS WARE, R H & S", h. 15.5 cm; impressed "WEMYSS", with "Wemyss" in yellow script and "T. GOODE & CO. LONDON" in script, h. 14.5 cm. *Centre, left to right*, biscuit barrels and covers: impressed "WEMYSS", with "Wemyss, T. Goode & Co." in green script, h. 11 cm; impressed "WEMYSS", with "Wemyss, T. Goode & Co." in green script, h. 12.5 cm; impressed "WEMYSS", with "Wemyss" in script, h. 12.5 cm. *Bottom, left to right*, four preserve jars and covers and a jam pot and cover: "Wemyss" in green script, h. 11.5 cm; impressed "WEMYSS", with "Wemyss" in yellow script, h. 11.5 cm; "WEMYSS" in green script, h. 12.5 cm; *c.*1925–30, "Wemyss" in green script, h. 12 cm; impressed "WEMYSS", with "Wemyss" in green script, h. 11.5 cm.

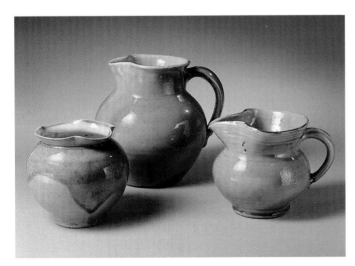

XIX William Fishley Holland and Braunton Pottery green-glazed wares. *Left to right*: vase, printed "BRAUNTON POTTERY DEVON", h. 9 cm; jug, impressed "W. FISHLEY HOLLAND CLEVEDON, SOM.", h. 13 cm; jug, inscribed "WFH", h. 9.5 cm.

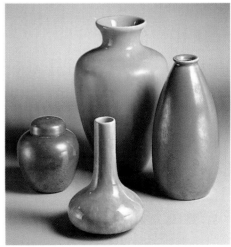

XX Glaze effects. *Left to right*: orange lustre ginger jar, impressed "RUSKIN 1912", h. 8 cm; blue and pink vases, printed circular mark "MINTON, HOLLINS & CO. STOKE-ON-TRENT, ASTRA WARE", h. 18 cm and 11 cm; purple lustre vase, impressed "Aultcliff, MADE IN ENGLAND", h. 15 cm.

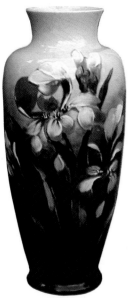

XXI Leeds Art
Pottery vase
impressed "LEEDS
ART POTTERY
ENGLAND, 105.
12351".

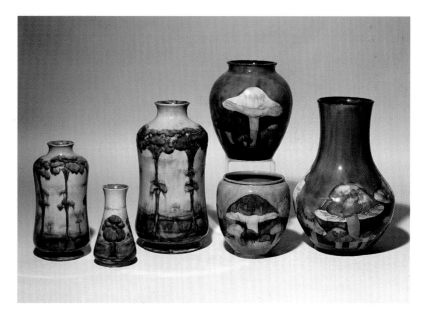

XXII Wares designed by William Moorcroft and executed by J. Macintyre & Co. and W.
Moorcroft Ltd. *Top*: Moorcroft Claremont pattern vase, *c.*1916, impressed "Moorcroft,
Burslem, England", "W. Moorcroft" facsimile signature in green, h. 21 cm. *Bottom, left
to right*: Macintyre Landscape pattern vase, *c.*1903, "W. Moorcroft" facsimile signature
in green, h. 23.5 cm; Macintyre Landscape pattern vase, *c.*1910, "W. Moorcroft"
facsimile signature in green, and "Made for Liberty & Co.", h. 15.5 cm; Macintyre
Landscape pattern vase, *c.*1903, "W. Moorcroft" facsimile signature in green and
"Made for Liberty & Co.", h. 31 cm; Moorcroft Claremont vase, *c.*1916, impressed
"Moorcroft, Burslem, England", "W. Moorcroft" facsimile signature in green, h. 21 cm;
Moorcroft Claremont vase *c.*1916, impressed "Moorcroft, Burslem, England", "W.
Moorcroft" facsimile signature in green.

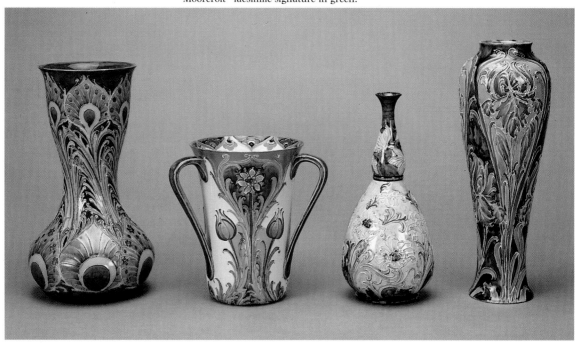

XXIII Macintyre Florian Ware. *Left to right*: vase, painted Florian Ware mark, registration
number 347807, signed "W. Moorcroft des", in green, h. 27.5 cm; tyg, printed Macintyre
mark, h. 18.5 cm; vase, printed brown Florian Ware mark, impressed "2", signed "WM des" in
green, h. 24 cm; Iris vase, signed "W. Moorcroft des" in green, h. 30 cm.

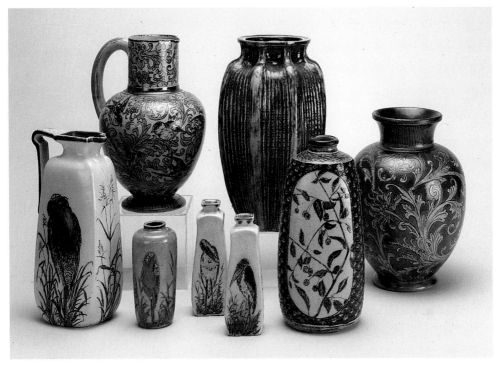

XXIV Martin Brothers stonewares. *Back, left to right*: jug, incised "R. W. Martin & Bros., London and Southall", h. 22.5 cm; Organic vase, incised "Martin & Bros., London and Southall, 2.1898", h. 25.5 cm. *Front, left to right*: jug incised "Martin & Bros., London and Southall, 5.1901", h. 23 cm; vase incised "Martin Bros London and Southall, 8/1903", h. 12 cm; pair of vases, incised "Martin & Bros., London & Southall, 3-1904", h. 14 cm; vase incised "R. W. Martin & Bros., London and Southall, 9-84", h. 23 cm; vase incised "Martin Bro's London and Southall, 3.1983", h. 23.5 cm.

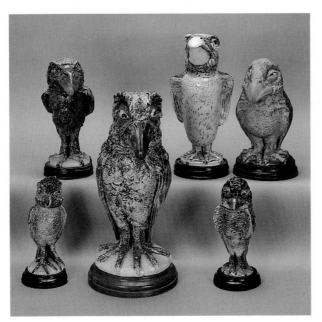

XXV Martin Brothers "Wally Birds". *Back, left to right*: incised "9.2.1907", h. 21 cm; incised "3-1902", 26.5 cm; incised "1-1898", h. 20.5 cm. *Front, left to right*: incised "1.1891", h. 17 cm; incised "9-1898", h. 33 cm; incised "12.1891", h. 18 cm.

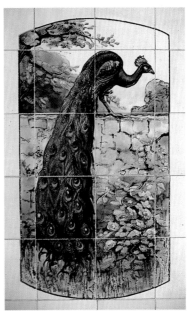

XXVI Maw & Co. panel, tube-lined and hand-painted.

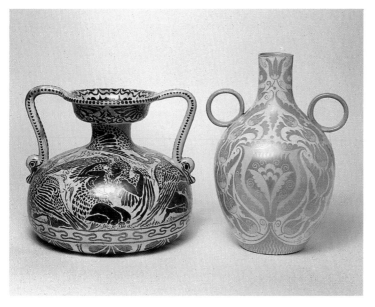

XXVIII Middleton Pottery
ashtray, impressed
"MIDDLETON LEEDS".

XXVII *Left*: Maw & Co. lustre vase, *The Six Swans*, designed
by Walter Crane, dated 1890, enamelled monogram,
h. 26.7 cm. *Right*: William de Morgan vase decorated by
Joe Juster, impressed with Sands End Pottery seal (1888–
97), enamelled initials "J. J." and "17", h. 33.4 cm.

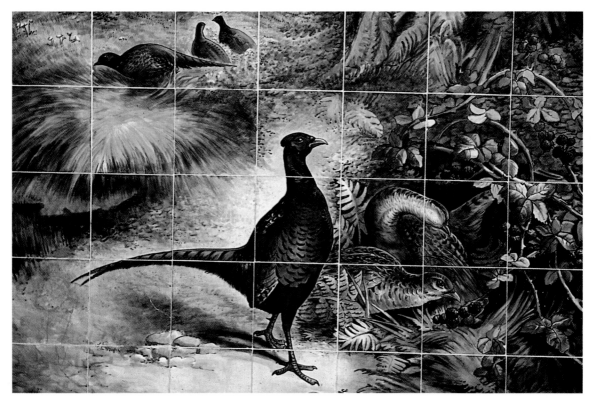

XXIX Minton Hollins tile panel, painted by Albert Slater, *c.* 1880. Used in the Grand
Hotel, Colmore Row, Birmingham.

XXX Minton's Art Pottery Studio plaque,
painted by William Wise.

XXXI Minton's Art Pottery Studio plaque, painted by
W.S. Coleman, printed circular mark "Minton's Art
Pottery Studio, Kensington Gore", numbered 320, d.
58 cm.

XXXII Minton's Art Pottery Studio plaque.

XXXIII Minton's Art Pottery Studio porcelain plaque, *The Seven Ages of Man*, printed mark
"Minton's Art Pottery Studio, Kensington Gore", inscribed "H. Stacey Marks", 44.6 cm by
72.8 cm. From a series designed by Marks for the Duke of Westminster's dining hall at Eaton
Hall, Cheshire.

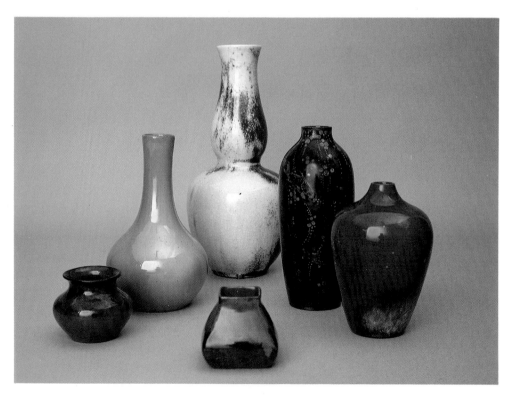

XXXIV Vases decorated by Bernard Moore. *Left to right*: *rouge flambé* vase, incised "BERNARD
MOORE 1904", h. 11 cm; vase with lustrous blue glaze and painted fish, painted mark
"BERNARD MOORE", 14.5 cm; *sang-de-bœuf* vase, painted mark "BERNARD MOORE", h. 21.4 cm;
peach bloom vase, marked "BERNARD MOORE", h. 14 cm; *rouge flambé* vase, incised "BERNARD
MOORE 1904", h. 4.7 cm. *Foreground*: *rouge flambé* vase, incised "BERNARD MOORE 1904", h.
4.6 cm.

XXXV Pilkingtons wares: *Left to right*: Royal Lancastrian vase painted by Richard Joyce, impressed Pilkington mark, painted artist's mark, h. 28.5 cm; Lancastrian covered jar, painted by Gordon Forsyth, inscribed, "W. Burton & H. Read 1910", impressed Pilkington mark, painted artist's mark, h. 29 cm, (presented to Sir Charles Hercules Read by William Burton in 1910); Royal Lancastrian vase, painted by William S. Mycock, impressed Pilkington mark, painted artist's mark, dated 1923, h. 28 cm.

XXXVI Pilkingtons Tile & Pottery Co. (Ltd) Royal Lancastrian Lustre vases. *Back, left to right*: decorated by William S. Mycock, impressed marks, painted monogram, dated 1921, h. 42 cm; decorated by William S. Mycock, impressed marks, artist's monogram, date code for 1929, h. 23 cm; decorated by William S. Mycock, impressed marks, painted monogram, year mark for 1913, h. 31 cm; decorated by Gordon Forsyth, impressed marks, monogram, date code for 1908, h. 32.5 cm. *Front, left to right*: decorated by Richard Joyce, impressed marks, date code for 1915, painted monogram, h. 21.5 cm; decorated by Richard Joyce, impressed marks, date code for 1919, artist's monogram, h. 20 cm; decorated by Richard Joyce, impressed marks, artist's monogram, h. 14 cm; decorated by William S. Mycock, impressed marks, painted monogram, year mark for 1913, h. 31 cm; decorated by Richard Joyce, impressed marks, artist's monogram, h. 20.5 cm.

XXXVII Porcelain vase painted by Alfred Powell, underglaze blue monogram and "1015", h. 33.5 cm.

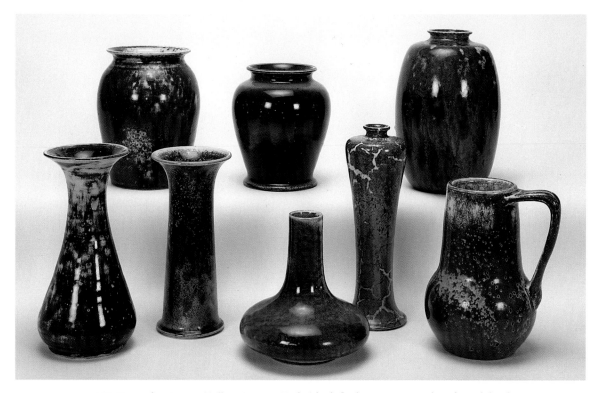

XXXVIII Ruskin Pottery (William Howson Taylor) high-fired vases, impressed marks and dated. *Back, left to right*: 1925, h. 21 cm; 1910, h. 18 cm; 1933, h. 22 cm. *Front, left to right*: 1933, h. 23 cm; 1909, h. 24 cm; 1922, h. 17.7 cm; 1909, h. 27.3 cm; 1924, h. 24 cm.

XXXIX Woodlesford Art Pottery vase, marked "WOODLESFORD ART POTTERY NR. LEEDS 234".

XL Wortley Art Pottery lustre vase, impressed "WORTLEY".

acquainted during Wallace's work for the Farmer and Brindley masonry yard. Marshall came to work with the Martin Brothers for a brief period. He wanted to be taken on as a partner but left when this proved unworkable and eventually became one of Doulton & Co. (Ltd)'s* most prominent designer-decorators. After Cosmo Monkhouse's article had appeared in *The Magazine of Art* in 1882, Marshall wrote to the editor complaining that some of the pieces illustrated were his work, although they were not acknowledged as such.

ALICE MARTIN worked as a colourist for her brothers in the early years. When she married, she left their employ, and her place was taken by her brother, Edwin.

WALTER EDWARD WILLY, known as Edward to avoid confusion, worked for the Martin Brothers for twenty-six years. He had been employed by Wallace's brother-in-law in the grocery business, but was dismissed and imprisoned in Wandsworth Gaol for theft. Although he was initially employed by the brothers as an unskilled labourer to draw the kilns, he soon showed an aptitude for carving and became responsible for the decoration of many of their pots. He was dismissed with only one week's notice in 1899, ostensibly for failing eyesight; such callousness seems uncharacteristic of the brothers, however, and there may have been some other cause. Sidney Greenslade encountered Edward, nearly blind and terribly bitter, in 1906, but he refused to speak about his tenure with the firm without a payment of £5 (a considerable sum at the time), which Greenslade refused to pay.

Marks: Martinware is almost always marked and usually dated. As the marks were usually incised, they vary considerably, but most often read "R. W. Martin" or "Martin Brothers". Tiles have moulded marks reading, "MARTIN BROTHERS LONDON". Two impressed marks were used on commercial wares: "SOUTHALL POTTERIES" and "R.W.MARTIN SOUTHALL". Clement's revival pieces can be identified by the dates that they bear, when these appear. A rare signature mark, "C. R. T. Martin", has also been recorded. Clement also marked some pieces "Martinware", which does not appear to have been used during the brothers' lifetimes.

References: A&CXS 1916; Armstrong, Walter, "The Year's Advance in Art Manufactures, No. VI. – Stoneware, Fayence, Etc.", *AJ*, 1883, pp. 221–23; "Art Handiwork and Manufacture", *AJ*, 1905, pp. 307–10; *Artist*, 1885, p. 122; *AJ* 1868, p. 123, and 1869, p. 116; Battie, David "A Martin Bird", *Antique Collecting*, December 1988, vol. 23, no. 7, p. 9; Beard, Charles R., *A Catalogue of the Collection of Martinware formed by Mr. John Nettlefold. Together with a short history of the firm of R. W. Martin & Bros. of Southall* (Waterton & Sons Ltd, 1936); Blacker; *Boobies, Boojams & Snarks. The Ceramic Curiosities of the Martin Brothers 1880–1914* (Jordan & Volpe, USA, 1981); Cameron; Coysh; "Edwin B. Martin, Obituary", *PG*, May 1915, p. 536; "An Exhibition of Martin Stoneware", *PG>R*, September 1921, pp. 1360–62; Godden 1964, 1972; Haslam 1975; Haslam, Malcolm, *The Martin Brothers, Potters* (Richard Dennis, 1978); "International Exhibition", *AJ*, 1874, p. 241; "The Late Robert Wallace Martin", *PG>R*, September 1923, pp. 1472–75; Lockett; "Martin Birds Still Flying High", *Christie's Rostrum*, February/March 1987; Martin, R. W., *The Woodland Spring* (engraving of a bas-relief), *AJ*, 1875; *MBD*; Miller, Fred, "Art Workers at Home", *AJ*, 1895, pp. 311–14; "Minor Topics", *AJ*, vol. XVIII, 1879, p. 277; Monkhouse, Cosmo, "Some Original Ceramists", *MA*, vol. V, 1882, pp. 443–50 (reprinted in Haslam 1975);

"Some Recent Developments in the Pottery Ware of the Martin Brothers", *Studio*, vol. 42, 1908, pp. 109–15, (reprinted in Haslam 1975); Spence, Edward F., "Martin-Ware Pottery", *Artist*, December 1887, pp. 327–28, "Stoneware of the Martin Brothers", *PG>R*, July 1954, pp. 1022–29; Summerfield, Angela, "Pottery by the Martin Brothers", *The Antique Collector*, November 1987, pp. 92–97; Thomas 1974.

Many of the events and dates given in the works listed above are erroneous, although they contain interesting comments or illustrations. Malcolm Haslam's account, which relies heavily on primary sources, is the most reliable published work, and where other accounts conflict this author has followed his interpretation.

Edwin Martin
1860–1915

In 1873, when Walter Martin's* accident prevented his continuing work at Doulton & Co. (Ltd)*, Edwin was invited to take his place. After this he joined Barry & Hayward, the wholesale stationers who employed his father, until his older brothers were well enough established in their enterprise, R. W. Martin & Brothers*, to take him in.

Having trained at the Lambeth School of Art from 1872, Edwin was largely responsible for decorating pots. His skill was later enhanced by the tutelage of H. F. Fawcett. As the youngest of the brothers, he was also given many menial tasks, and it was not until the late 1890s, when he became friendly with the architect Sidney Greenslade, that his own particular genius was recognized. His talent for abstract decoration brought the firm's pottery into the twentieth century but, if critics appreciated his work, his brothers did not, and the last years of his life were spent in constant battles with them. After his brother Walter's death, he took over responsibility for throwing and firing, but most of these firings were unsuccessful and he was never able to develop his talent to its full extent. He died of cancer of the jaw after a long and painful struggle.

References: *See* R. W. Martin & Bros.

Robert Wallace Martin
1843–1923

At the age of thirteen, Martin had shown sufficient aptitude to be hired as a stone carver's assistant by John Birnie Philip, one of the contractors working on the new Houses of Parliament. Wallace then spent seven years as an assistant to the sculptor Alexander Munro. During this time he studied at the Lambeth School of Art, where he became friendly with George Tinworth (*see* Doulton & Co. (Ltd)). In 1863 he exhibited at the Royal Academy for the first time, and the following year he and Tinworth began to study art there.

Although Wallace had planned to become a sculptor, he was soon inflamed by the fervour of the Doulton experiments. For several years he modelled terracotta which was fired for him by various firms, although none of these schemes was lucrative. In May 1871, after a period working in the Farmer and Brindley masonry yard, he went to Torquay, where one of his brothers was convalescing. There he worked briefly for the Watcombe Terra-Cotta Co. (Ltd)*, where he modelled large garden vases, masks for jugs and a statuette. In October he returned to London and soon began to work for C. J. C. Bailey & Co.*. He designed and modelled for Bailey, who allowed him to carry out and fire his own commissions in the kilns as well. At

Bailey's he met Jean-Charles Cazin*, the sculptor and potter, who was teaching at the Lambeth School of Art.

In 1873, Wallace finally set up on his own at Pomona House, eventually taking his brothers into the business under the style R. W. Martin and Bros.*. His eccentricities in clay were delightful, but his brothers found it difficult to work with him. He became increasingly isolated and, by the time of Walter Martin's death in 1912, work had nearly come to a standstill. He worked only sporadically until his death in 1923.

References: *See* R. W. Martin & Bros.

Walter Frazer Martin
1859–1912

In 1873, at the suggestion of George Tinworth, Walter Martin joined Doulton & Co. (Ltd)'s* art studio as a colourist and attended the Lambeth School of Art. At the time, Doulton had only perfected cobalt blue and cherry colours. After only nine months in their employ, he fell from a ladder and his job was taken by his younger brother, Edwin*. Later, while working with his brothers under the style R. W. Martin & Brothers*, Walter perfected the use of the wheel and threw most of their pots. He was also in charge of their firings, and his many experiments resulted in a wider range of colours than had previously been achieved by any stoneware potter. Although his notes survived, they were too cryptic to be of much use, and his secrets died with him.

References: *See* R. W. Martin & Bros.

Maw & Co. (Ltd)
Worcester
1850–52
Broseley, Shropshire
1852–83
Benthall Works, Jackfield, Shropshire
1883–1960

In 1850, George and Arthur Maw bought a declining tile business run by Mr Barr and Fleming St John. It was located at the Worcester Royal Porcelain Co. Ltd's former premises, which had previously been occupied by Messrs Flight, Barr & Barr. As transporting clay from Ironbridge Gorge to Worcester was expensive, moving the business to Broseley, Ironbridge, was a logical step. By 1883, Maw & Co. was the largest tile producer in the world and, having outgrown the Broseley works, it opened the new Benthall Works. The firm was registered as a limited company in December 1888 with a capital of £100,000. The first managing directors were Arthur Maw, George H. Maw, A. J. Maw and B. Stuart.

Although it is not certain when Maw's began manufacturing pottery, this was well established by 1874, when Professor Archer commented:

> Some of the designs, as in that of a *jardinière* in Louis Quatorze style and in a number of vases formed after Indian, Moorish and classic models, are works which would do credit to the oldest-established potteries, whilst some of the colour-effects displayed upon them have a richness that has never been surpassed. For these articles a white clay is used, and they may be classed as semi-porcelain with a very firm, hard texture.

These early pots were covered with the majolica glazes which had been developed for tiles.

Maw's introduced lustrewares inspired by William De Morgan* at the Paris Universal Exhibition of 1878. Stirling tells how an indignant friend informed De Morgan that a London shop was selling Maw's lustrewares as his own work. When she demanded why he was unperturbed by this, he replied: "Imitation is the

98 Maw & Co. (Ltd)
lustrewares designed by Walter
Crane and displayed at the
1890 Art & Crafts Exhibition,
illustrated in *The Journal of
Decorative Art*.

sincerest form of pottery.'' It is generally taken for granted that Maw's lustres were
inferior to those produced by De Morgan, even though an article in *The Journal of
Decorative Art* of September 1887 insisted that Maw's lustres were, in fact, superior.
Although ruby and d'oro (gold) lustres predominated, light and dark blue, yellow,
green and opal lustres were also used. *See* 99 and Colour XXVII.

Maw's also imitated De Morgan's Anglo-Persian tiles. The early majolica pottery
was followed by barbotine and oiron ware. At the Ecclesiastical Art Exhibition, held
in Wolverhampton in 1887, Maw's showed lustre candlesticks which were

commended by *Decoration* (November 1887). The firm participated in the Arts and Crafts Exhibitions of 1888, 1889, 1890 and 1893, showing tiles, panels, friezes and pottery. *See* 98 and Colour XXVI.

It is rarely appreciated that Maw's continued to produce these art wares well into the twentieth century. *The Pottery Gazette and Glass Trade Review* of May 1924 reported that the firm was still producing "lustre-painted and enamelled tiles for hall decoration and fire places, pottery, majolica, Persian and lustre ware". In 1960, the Campbell Tile Co. (Ltd) purchased Maw & Co. (Ltd) and in 1964 there followed a group merger with Richards Tiles. Then in 1968 Richards-Campbell merged with H. & R. Johnson Ltd to form H. & R. Johnson-Richards. In 1970 the Benthall Works was closed and production moved to Staffordshire.

The Jackfield Tile Works now houses a museum showing Maw's and other local art wares and tiles. This is part of the Ironbridge Gorge Museum complex. Maw's art pottery can also be seen at the Clive House Museum, Shrewsbury, Shropshire.

Designers and artists

J. BRADBURN designed tiles shown at the Arts and Crafts Exhibition of 1888.

A. CHILDE painted tiles shown at the Arts and Crafts Exhibition of 1888 and designed tiles shown there in 1890.

WALTER CRANE* first designed picture tiles for Maw's in 1874 or 1875. He designed tiles shown at the Arts and Crafts Exhibitions of 1888 and 1889. His *Seed Time* panel was exhibited there in 1890. He also designed "a set of vases for lustre ware, giving the sections for the thrower, and painting on the biscuit the designs, which were copied on duplicate vases in lustre" (Crane). Mark: his monogram.

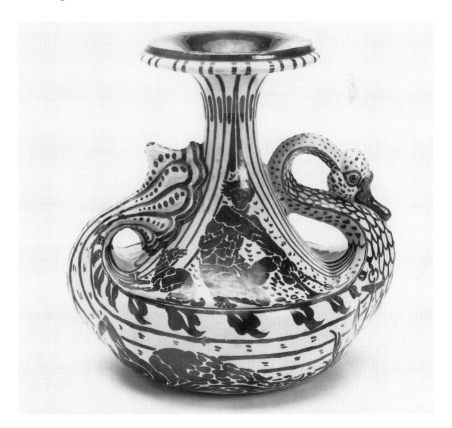

99 Maw & Co. Ltd. Swan vase, designed by Walter Crane, Painted cipher, h. 23.5 cm.

LEWIS F. DAY* designed tiles and pottery shown at the Manchester Jubilee Exhibition of 1887, and the Arts and Crafts Exhibitions of 1888, 1889 and 1890. His arabesque frieze and dragon panel were illustrated in *The Art Journal* in 1889.

F. R. EARLES designed tiles and pottery shown at the Arts and Crafts Exhibition of 1890.

W. EVANS painted tiles shown at the Arts and Crafts Exhibition of 1888 and designed tiles shown there in 1890.

H. B. GARLING designed encaustic tiles.

OWEN GIBBONS designed transfer-printed and painted tiles while Head Master of the Coalbrookdale School of Art. In 1885 he founded Gibbons, Hinton & Co. with his brother, Francis Gibbons*, and his brother-in-law, W. J. Hinton.

GEORGE GOLDIE designed encaustic tiles. He was an architect whose work was exhibited at the Royal Academy from 1854 to 1892.

HENRY HOLLIDAY designed the lustre and ceramic tesserae for *Christ in Majesty*, which was shown at the Arts and Crafts Exhibition of 1890. He was primarily a designer of stained glass and was probably introduced to Maw's by Lewis F. Day, as they were both members of the Fifteen, which was to form the nucleus of the Art Workers Guild*.

C. GROVE JOHNSON designed tiles and pottery shown at the Arts and Crafts Exhibitions of 1888 and 1889.

OWEN JONES (1809–74), who had produced books of designs for mosaics and encaustic tiles, designed some tiles for Maw's.

W. LODGE designed tiles shown at the Arts and Crafts Exhibition of 1888.

GEORGE MAW was a scholar who toured Europe and the Middle East, studying tiles. He also raised and wrote about crocuses, and his geological and ceramic interests led him to study clay samples from all over Britain. He collected tiles and pottery from the Middle East, which often inspired his own tile designs.

W. E. MOORE designed and painted tiles shown at the Arts and Crafts Exhibitions of 1888 and 1890.

CHARLES OLIVER MURRAY designed tiles for Maw's, and is also known to have designed *The Spirit of the Flowers* series for Mintons*. His etchings were shown at the Royal Academy from 1880 to 1904.

ROWORTH designed tiles shown at the Arts and Crafts Exhibition of 1888.

W. J. RUTH designed tiles shown at the Arts and Crafts Exhibition of 1890.

L. A. SHUFFREY designed tiles shown at the Arts and Crafts Exhibition of 1890.

GEORGE STEVENS executed the lustre and ceramic tesserae for *Christ in Majesty*, which was shown at the Arts and Crafts Exhibition of 1890.

C. H. TEMPLE* designed and painted tiles shown at the Arts and Crafts Exhibitions of 1888, 1889, 1890 and 1893. He worked at Maw's as an in-house designer from 1887 to 1906. His prodigious output reduced the need for the many freelance designers previously employed by Maw's. He was largely responsible for Maw's spectacular success at the Chicago World's Fair of 1893. He designed many portrait tiles and invented a process of photographic transfer. Temple left Maw's in 1906 to establish his own decorating studio, where he continued to use Maw's blanks. Mark: "C. H. TEMPLE" or "C. H. T.", painted.

C. F. A. VOYSEY* designed and painted tiles shown at the Arts and Crafts Exhibitions of 1888 and 1889.

A. C. Weatherston designed tiles shown at the Arts and Crafts Exhibitions of 1888 and 1890.

Francis Derwent Wood (1871–1926) designed lustre tiles and majolica pots. He was a teacher and sculptor, and a member of the Art Workers Guild* from 1901 to 1909 and of the Royal Academy from 1920.

Sir Matthew Digby Wyatt (1820–77) trained as an architect and designed tiles for Maw's from 1850. His fireplace was shown at the London International Exhibition in 1862. Many of his designs for Maw's are illustrated in his *Specimens of Geometrical Mosaics* (1862). He exhibited at the Royal Academy from 1853 to 1874.

Marks: impressed or printed, incorporating "MAW" or "MAW & CO". with "BROSELEY", and sometimes "SALOP" or "SALOPIA". Many pieces also bear the round impressed trademark reading "FLOREAT/MAW/SALOPIA".

References: Archer, Professor, "Decorative Tiles – Messrs. Maw, of Broseley", *AJ*, vol. XIII, 1874, pp. 333–34; Atterbury, Paul and Maureen Batkin *The Dictionary of Minton* (Antique Collectors' Club, Woodbridge, 1990); Austwick; Barnard; Bergesen; Blacker; Clegg, Peter and Diana, "Maws Again", *GE*, no. 21, winter 1990; Clegg, Peter and Diana, "More Maws", *GE*, no. 20, spring 1990; *CM*; Coysh; Crane, Walter, "The Work of Walter Crane", *AJ Easter Annual*, 1898, pp. 1–32; Day, Lewis F., "Tiles", *AJ*, 1895, pp. 343–48; *Decoration*; Godden 1972, 1980; Graves; Herbert; Huggins, Kathy, "Owen Gibbons – London to Ironbridge", *GE*, no. 9, spring 1985, pp. 1–2; Jervis; "Messrs. Maw & Co., Ironbridge", *The Journal of Decorative Art*, September 1887, pp. 135–42; Lockett; [The Manchester Jubilee Exhibition], *CM*, vol. VIII, July 1887; Messenger; Messenger, Michael, "Spring of Inspiration, The Tile Designs of Maw and Company", *Country Life*, 6 July 1978, pp. 28–29; Myers, Richard J., "Lustres from Lesser Mortals . . . and Maw's "Anglo-Persian", *GE*, no. 10, summer 1985, pp. 6–8; Stirling, A. M. W., *William De Morgan and His Wife* (Thornton Butterworth, 1922); Tilbrook; "Tiles & Tiling", *AJ Supplement*, 1889, pp. 7–8; "Tiles Designed by Owen Gibbons", *GE*, summer 1982, p. 8.

Medmenham Pottery
Great Marlow,
Buckinghamshire
1897–1907

Robert W. Hudson of Sunlight Soaps established the Medmenham Pottery in a brick and tile works which had been operated by T. B. Butler since 1895. Hudson hired Conrad Dressler* as director. Dressler had recently left the Della Robbia Pottery*, where he had been unhappy because of moves away from a strict arts and crafts tradition, that is, the employment of Staffordshire-trained potters and use of imported clay.

A Medmenham catalogue clearly sets out the firm's intent:

The Medmenham Pottery was founded with the object of producing architectural pottery and tiles possessing individuality in design and execution.

We have felt that in order to reach this aim we must place ourselves in conditions approximating those of the old potteries whose ware delighted and inspired us. We therefore established our pottery right away in the country. We use our Marlow materials as much as possible and employ village workpeople. These elements are allowed to influence our work to the fullest possible extent.

100 Medmenham Pottery tile
with polychrome majolica
glazes, c.1905, moulded dust-
pressed body, moulded marks
"Medmenham Tiles" and
"тм", 15 cm sq.

Our tiles are made in two ways, either in plastic clay, entirely by hand, or pressed in a more mechanical fashion. In both cases, however, the same patterns and the same methods of colouring by hand are used.

One of the first major commissions given to the pottery was providing tiles for Hudson's new home, Danesfield House. The firm's tiles have been located in numerous buildings in the Marlow area as well as in London. Many of the designs were Islamic-inspired, with blue, green, yellow and red tube-lined designs on white grounds. The variable quality of these is testimony to the firm's employment of unskilled workers. The tile in Figure 100 is one of the better examples. The pottery also made sundials and other garden statuary.

The firm exhibited at the International Exhibition in Paris in 1900. At the Arts and Crafts Exhibition of 1903, Dressler was credited with the design of tiles, medallions, a plaque with a lion medallion and a praying angel in enamel earthenware. However, only the "Panel of slabbed Medmenham Painted Tiles" is actually attributed to Medmenham. Spielman noted in 1902: "a good deal of elaborate work has been modelled and fired, including twelve panels representing the months, and two great friezes each seventy-five feet long, divided into sixteen panels, with high relief statues between, representing various agricultural and domestic pursuits."

The pottery encountered difficulties in adhering to these ideals, however, and in January 1903 The Pottery Gazette announced:

We are advised that the closing of this pottery at the end of November was final and not a mere temporary closing as was at first supposed. The pottery was founded some five or six years ago more with a view to encourage good artistic work locally than as a commercial venture. Every assistance and facility was given for the young people of the district to learn the artistic work of the potter, but those whom it was intended to benefit did not take advantage of the offer, and there was no alternative but to close the works. It is a matter of regret in the locality.

There is some evidence that the pottery did re-open, at least briefly, after this. According to the *Victoria County History*, the firm moved to Staffordshire in "the present year", which could have been 1907 or 1908. A footnote states that this information was supplied by Conrad Dressler. By 1906, Dressler was exhibiting the work of his Art Pavements and Decorations Co.*. Kate Hillesch, who had painted Medmenham tiles exhibited in 1903, is again listed as a decorator. It is not certain whether Dressler had taken Miss Hillesch with him to London or whether his new firm was serving as a retail outlet for the Medmenham Pottery, which may or may not have been in production at the time.

Marks: a bird with "Medmenham Tiles" in script, impressed.

References: A&CXS 1903, 1906, "Bucks Tiles Survive", *GE*, summer 1982, p. 2; Cartin, Terence, "Sunlight Chambers Dublin", *GE*, no. 15, winter 1987, p. 3; Chase, J. W., "The Medmenham Pottery 2", *GE*, no. 6, spring 1984, p. 3; Herbert, Tony, "More on Medmenham", *GE*, nos. 7/8, summer/autumn 1984, p. 8; Herbert, Tony, "More on Medmenham", *GE*, no. 11, winter 1985, p. 4; *A History of Medmenham* (privately printed, 1926); *Medmenham Pottery Catalogue*, c.1905; Myers, Richard, "The Medmenham Pottery 1", *GE*, spring 1984, pp. 1–3; *PG*; *Victoria Histories of the Counties of England, Buckinghamshire*, vol. II, 1909; Spielman, M. H., *British Sculpture and Sculptors To-Day* (Cassell & Co. Ltd, 1901); Walker, Robert, "Medmenham Pottery and Conrad Dressler", *GE*, no. 12, summer 1986, pp. 8–10.

Methven, David & Sons
Kirkcaldy Pottery, Kirkcaldy, Fife, Scotland
1847–1930

The Links or Linktown Pottery was originally a brick and tile works established in 1714. John Methven (or Methuen) established a pottery adjacent to the tile works c.1809. Upon his death in 1837, Linktown and the Fife Pottery* passed to Robert and Mary Heron. They sold Linktown to George Methven, who on his death in 1847 left it to his son, David Methven III. At this time the pottery was producing brown wares.

In 1887, James Methven took the works manager, Andrew Ramsay Young, into partnership and traded under the style The Kirkcaldy Pottery. Young introduced a finer class of white ware made from Devonshire and Cornish clays. He is credited with devising a method of sponge decoration, using the roots of sponges in conjunction with underglaze colours. The firm also made dipped and mocha wares, and their first blue-printed pattern, Verona, was very successful.

Abbotsford art ware was also introduced; this was initially decorated with a wide variety of self colours in imitation of wares made at the Dunmore Pottery* and Fife Pottery*. Later, Abbotsford ware was painted in bright colours with flowers, fruit and cockerels in imitation of the Fife Pottery's Wemyss wares. These are more coarsely potted than the Wemyss wares, and the painting relatively stiff. John

Brown, from the Fife Pottery, is known to have decorated much of this ware, and pieces painted by Fife's James Sharp, another Fife Pottery artist, have also been documented.

In 1892, Young, with his sons Andrew and William, purchased the pottery, continuing under the Methven style. When Andrew senior died in 1915, his sons continued the firm, which reverted to specializing in brown wares. In the early 1920s, the book illustrator Jessie M. King was employed for underglaze decorations. The pottery finally closed in 1930.

Marks: "D. M. & S."; "METHVEN"; "D. METHVEN & SONS"; "ABBOTSFORD".

References: Cameron; Coysh; Davis, Peter and Robert Rankine, *Wemyss Ware* (Scottish Academic Press, Edinburgh, 1986); Fleming; Godden 1964; Jewitt; McVeigh. Patrick, *Scottish East Coast Potteries 1750–1840* (John Donald Publishers Ltd, Edinburgh, 1979).

Middleton Fireclay Company
Middleton, Leeds, Yorkshire
late nineteenth century

This firm made small decorative art wares such as ashtrays, vases and plaques with monochrome glazes (Colour XXVIII).

Marks: "MIDDLETON LEEDS", impressed.

References: Lawrence.

Minton Hollins & Co. (Ltd)
Stoke-on-Trent, Staffordshire
1845–1968

In 1845, the production of Minton's* encaustic tiles was taken over by Minton Hollins & Co., a partnership between Herbert Minton and his nephew, Michael Daintry Hollins (1815–98), who ran the firm. Hollins continued in partnership with his cousin, Colin Minton Campbell, after Herbert Minton's death in 1858. In 1863, he was joined by Robert Minton Taylor, but Taylor left to establish his own tile works in Fenton in 1868. That same year, Hollins's partnership with Colin Minton Campbell was dissolved.

In 1870 Hollins received £30,000 in compensation and built a new factory, which produced all types of tiles. In 1898 Hollins's daughter, Jessie Constance Hollins, and J. B. Ashwell became executors. On Ashwell's death in 1912, Jessie became the sole executor, and as such took an active interest in the factory until her death in 1926. From 1913 until his death in 1927, John Henry Marlow was the general manager of the firm. He was the inventor of the Marlow tunnel oven, which was first introduced at Minton Hollins and subsequently at several factories abroad. With the deaths of Jessie Hollins and John Marlow, the Hollins family sold the pottery to A. E. Crapnell for £27,000. In 1927, the firm was registered as a limited liability company with a registered capital of £60,000, and its first directors were A. E. Crapnell and A. D. Gee. The firm was absorbed by H. & R. Johnson-Richards Tiles Ltd in 1968.

In the 1870s the firm produced art tiles in the painterly style practised at Minton's Art Pottery Studio*. The Judges of the Philadelphia Centennial Exhibition of 1876 (Colour XXIX) commented: "Painted panels of birds, flowers etc., by Dixon, are brilliant in color and effective. An ambitious piece, on a large scale, in sepia monochrome, of the 'Young Mother', painted by W. P. Simpson, as are some clever paintings of dogs' head from life and of various other animals spiritedly drawn . . . Among the artists employed are W. P. Simpson and Arthur Simpson, Buxton for flowers, etc., Dixon for birds, etc." William Page Simpson (b. 1845) exhibited for

101 Mintons vase with matt bright blue glaze, c.1905 printed mark "MINTONS LTD" with peacock, h. 20 cm.

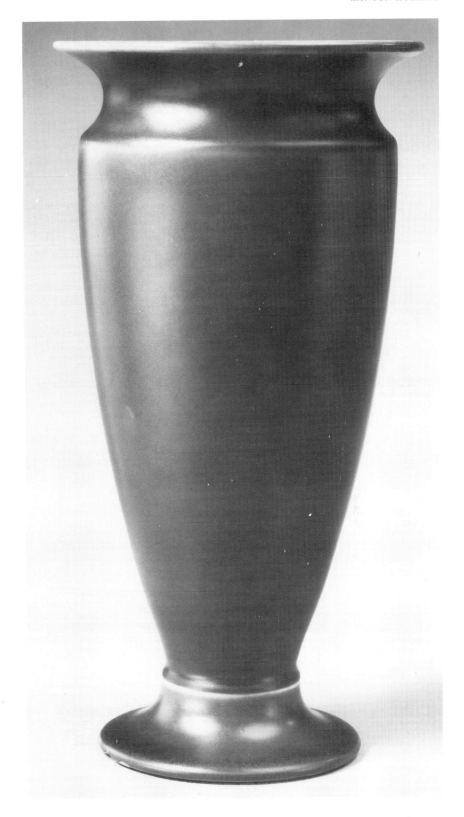

the first time at the Royal Academy in 1859. He joined Minton Hollins in 1871, remaining with the firm for the rest of his life. A certain John Buxton painted floral subjects for Minton's in the 1850s to 1880s, and he may well have done some work for both firms.

As the century progressed, Minton Hollins concentrated its efforts on the mass-production of wall tiles. For the most part, the better-quality art-work was left to the Minton China Works to execute. Minton Hollins did use the designs of J. Moyr Smith for series of transfer-printed tiles, for example, *Shakespeare's Songs*, *Nursery Rhyme Tiles*, *The Poets*, *Pilgrim's Progress* and a *Historical Series*. None the less, in 1895 Lewis F. Day* complained: "it is strange to find such pioneers as Messrs. Minton Hollins & Co. . . . lagging rather behind in the matter of art. In every mechanical excellence of manufacture they have gone on progressing . . . but . . . they do not point the way to better things in colour, taste, and design."

Perhaps Day's criticism was taken to heart, for, in 1903, the firm exhibited tiles designed by R. Anning Bell* at the Arts and Crafts Exhibition. The same year, Gordon Forsyth* was appointed art director. Although he only remained until 1905, it is believed that he had considerable influence on the direction of the firm's designs. Reginald R. Tomlinson, later with Bernard Moore*, served his three-year apprenticeship under Forsyth.

The firm's foray into art pottery production during the First World War was thus explained:

> In a large tile works such as this house controls, there is always an opportunity for developing a number of interesting sidelines. This is rendered possible principally by reason of the fact that economy in firing demands that every available portion of the ovens and kilns shall be profitably utilised, and secondly because of the fact that the workpeople, of necessity, possess the true artistic spirit, and welcome any opportunities which are afforded them of developing their propensies in this direction. (*PG>R*, July 1919)

It was also observed:

> It is no secret in North Staffordshire that one of the departments of the pottery trade to suffer the quickest and the most acutely on the outbreak of the war was the tile trade. But a factory of the standing of that of Minton Hollins & Co. would never be allowed to retrocede, and consequently the situation that was created by the dearth of orders that resulted from the war had to be faced in some way. A progressive management sought a solution of the problem by instituting "Astra" ware as a sideline. The success which attended the move was phenomenal, and a new market was tapped which has since fed the factory with a bulk of orders such as has warranted the provision at the factory of a separate warehouse to deal with these orders specifically. (*PG>R*, June 1920)

Astra ware, sometimes advertised as "reproduced from the antique", was produced in simple classical shapes decorated with glaze effects, which were admired for their beauty and restraint (102 and Colour XX). At the British Industries Fair of 1918 the firm exhibited

> a Grecian cup, dull surface, with matt glazes, the colour being mainly dull red with a medley of pinks, purples and greens. Their crystalline vases, too, with red on black were notable. Of their specimens in their well known Astra Ware

which embodied skill in shaping, a new effect was produced in silver grey-green tone with red glazes. (*P&GR*, February 1918)

In the following year, the firm exhibited "a series of medallions suitable for mounting as brooches, and an interesting line of pottery buttons" (*PG*, April 1919). It also introduced a grotesque novelty match stand, *The Mun Pierced Hallow*: "Surely this is commemorative pottery depicting a rich sense of humour and novelty, and even the most stolid-minded man can hardly fail to be amused by it, interested in it, and desirous of possessing a sample of it to show to his friends." (*PG>R*, July 1919)

The 1919 range was described in detail thus:

> the colours in which the ware can be supplied seem to embrace the whole spectrum, though the alternating rainbow effects achieved on some of the pieces, whilst not departing from the main style, are as variable as they are delightful. There are greens veined with rich brown, reds with markings of golden yellow, greys beautifully variegated with a remarkably rich purple, and marblings and combings grading from a beautiful goldstone effect to the much soberer granite. The shapes, mostly thrown and turned, include many formations, ranging from pieces suitable for the china cabinet to some of fairly noble proportions capable of occupying an important place in a furnishing scheme. (*PG>R*, July 1919)

The firm continued to produce Astra ware until the late 1920s.

Marks: "MINTON HOLLINS & CO. STOKE-ON-TRENT" in a circle around "ASTRA WARE", printed. Tiles are marked "M. H. & Co.", or "MINTON HOLLINS & CO.", printed, impressed or moulded.

References: A&CXS 1903; Barnard; Bergesen; Cameron; Dawson, Aileen, *Bernard Moore* (Richard Dennis, 1982); Day, Lewis F., "Tiles", *AJ*, 1895, pp. 343–48; *Decoration*; Lockett, Godden 1964; Godden, Geoffrey, "The Simpsons – Ceramic Artists and Enamellers", *Apollo*, February 1962; "Jessie Constance Hollins, obituary", *PG>R*, March 1926; "John Henry Marlow, obituary", *PG>R*, March 1927; "J. Moyr Smith", *GE*, no. 9, spring 1985, pp. 10–11 (reprinted from *The Biographer*, 15 October 1894); Jewitt; Lockett; "Moyr Smith Discovery", *GE*, no. 6, spring 1984, p. 1; *PG*; *P&GR*; *PG>R*; "Sheffield's Butcher Shop Rescued", *GE*, no. 11, winter 1985, p. 1; Skinner, D. S. and Hans Van Lemmen, editors, *Minton Tiles 1835–1935* (Stoke-on-Trent City Museum and Art Gallery, 1984); Stuart; "Victorian Delft", *GE*, spring 1983, p. 3.; Van Lemmen, Hans, *Minton Hollins Picture Tiles – A Catalogue Raisonné* (Hans van Lemmen/Gladstone Pottery Museum, 1984).

Minton(s)

Stoke-on-Trent, Staffordshire
1793 to the present day

Under the guidance of Herbert Minton, this firm was in the avant-garde of the most important ceramic developments of the nineteenth century: encaustic floor and glazed wall tiles, Parian, majolica and *pâte-sur-pâte*. Some of the majolica, with hand-painted panels, and the Henri Deux ware, made with inlaid coloured clays, produced from the 1850s, could be considered art pottery, although it was not so called at the time. After Herbert's death in 1858, his nephew, Colin Minton Campbell, continued to lead the firm from strength to strength. However, after his unprofitable experiment at Minton's Art Pottery Studio* at Kensington Gore,

Campbell showed little interest in producing art pottery. The greatest talents of the firm were concentrated on producing fine-quality porcelains, either decorated in a Sèvres style or with *pâte-sur-pâte*. Although a few of the designs used by the Art Pottery Studio salvaged after the fire in 1875 were put into production at the Stoke factory, the experiment was largely written off. Mintons did participate in the Arts and Crafts Exhibition of 1888, but most of the pieces shown were Parian or china.

The barbotine technique of painting with coloured slips was introduced by French artists, including Edouard Rischgitz and Emile Lessore, who came to Minton in the 1850s. The slip was painted in a manner which had the appearance of oil painting. Specimens of these wares painted by William Mussill were included in the London International Exhibition of 1871 and the Vienna Universal Exhibition of 1873. Richard Pilsbury senior and J. E. Dean were also well known for their barbotine painting. This technique was soon used by Doulton & Co. (Ltd), Lambeth* and other art potteries.

Under the influence of Léon Victor Solon (1872–1935), Mintons' interest in art pottery was renewed at the turn of the century. Léon was the son of Louis Marc Solon, the *pâte-sur-pâte* pioneer, and grandson of Léon Arnoux. Léon Solon's pottery panels were exhibited at the Arts and Crafts Exhibitions of 1896, 1899 and 1903. These were widely reviewed and highly commended, although many critics felt Solon's style to be too pictorial to lend itself successfully to his materials. Strangely, while Léon was employed by Mintons 1896–1905, the panels were exhibited by him, rather than Mintons. In 1899 *The Studio* described his technique:

> The first colours used on the slab when in the plastic condition are oxides mixed with liquid clay. All the broad masses of colour are mapped out and then painted on to the thickness of from one-sixteenth to one-eighth of an inch, in order to prevent the ground showing through when reduced by the fire. The slab is then very carefully dried for several days and fired to the "biscuit" state and afterwards glazed and fired again. Next the outline and fine detail are added on the glaze with another kind of colour and again fired. When gold also is used another firing is necessary, for each colour and the gold requires a different intensity of heat. In some panels, Mr Solon has etched away the glaze in lines or patterns, and has achieved good decorative results by rubbing colour into the sunken parts and leaving flakes of white glaze standing out upon the shaded ground.

Pottery panels by Léon V. Solon

AFTER THE SHOWER, exhibited at the Arts and Crafts Exhibition of 1900.

AVE MARIS STELLA, exhibited at the Arts and Crafts Exhibition of 1900; illustrated in *The Studio*, 1900, and *The Magazine of Art*, 1900.

QUEEN ELIZABETH, exhibited at the Arts and Crafts Exhibition of 1903; illustrated in *The Art Journal*, 1903.

THE BLACK CAT, exhibited at the Arts and Crafts Exhibition of 1900; illustrated in *The Studio*, 1900.

THE DAUGHTERS OF PINDARUS, exhibited at the Arts and Crafts Exhibition of 1903; illustrated in *The Magazine of Art*, 1903.

THE HENCHMAN, exhibited at the Arts and Crafts Exhibition of 1900; illustrated in *The Studio*, 1900.

LE PRINTEMPS, exhibited at the Arts and Crafts Exhibition of 1899; illustrated in *The Studio*, 1899.

RAISING THE STORM, exhibited at the Arts and Crafts Exhibition of 1903; illustrated in *The Magazine of Art*, 1903.

RESTING, exhibited at the Arts and Crafts Exhibition of 1899, illustrated in *The Studio*, 1899.

Léon Solon's best-known contribution to Minton's was Secessionist Ware. Solon had been applying the techniques used for his panels to tiles, plates and hollow wares for some time; these were marketed as Anglosia Ware. John W. Wadsworth, trained at the Royal College of Art, joined the firm as Solon's assistant in 1900. By 1902, the two had designed a range of wares most notable for their slip-trailed Art Nouveau designs, now called Secessionist Ware. Sometimes dismissed as a cheap imitation of the Moorcroft* pottery produced at that time by James Macintyre & Co.*, these rich majolica glazes and bold Art Nouveau designs stand on their own merits.

The name is derived from the Viennese Secession movement. In 1897, a group of Viennese artists and architects seceded from the Viennese *Akademie der bilbenden Kunste* in protest against the *Akademie's* conservatism. They formed the *Wiener Sezession*, which was highly influential in Austrian decorative arts until the 1920s. Charles Rennie Mackintosh exhibited with the Secession; the Austrian variant of Art Nouveau, like Mackintosh's, is more spare and angular than the florid French and Belgian style. Secessionist Ware, unlike most English Art Nouveau ceramics, is in the more restrained style.

The outlines were slip-trailed, or relief-moulded to appear slip-trailed (an economy measure). Some pieces were also black-printed. Majolica glazes in art colours were used: mustard, pink, olive green, purple, red, inky blue, pale lime and copper brown (103–105). The Secessionist Ware Catalogue of 1902 is reproduced in full in *The Dictionary of Minton* (*see* References). In 1905 when Solon left Mintons,

102 Minton, Hollins & Co. "Astra Ware with Fine Glaze Effects", illustrated in *The Pottery Gazette*, July 1919.

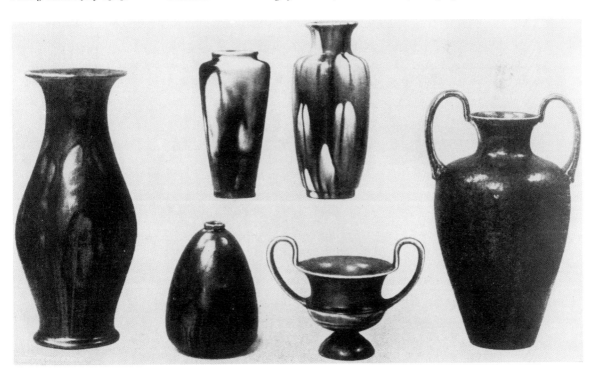

103 Mintons Secessionist Ware jardinières and stands in red, green, ochre and cream glazes, printed "Mintons Ltd", h. 89 cm.

Below, **104** Mintons Secessionist Ware vase, *c*.1904, designed by Léon Solon and John Wadsworth.

Below right, **105** Mintons Secessionist Ware vases, *c*.1904. designed by Léon Solon and John Wadsworth.

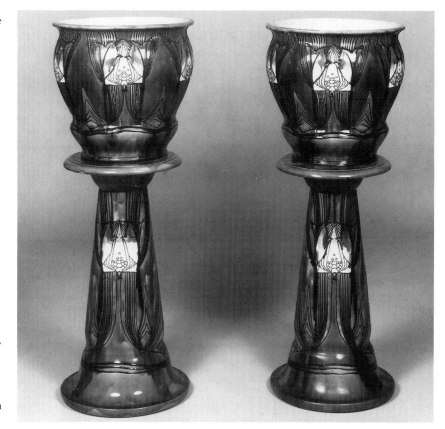

emigrating to the United States in 1909, Wadsworth became the firm's art director. He continued to design Secessionist Ware until it was discontinued in 1914.

Mintons also made some experiments with glaze techniques. The little-known Byzantine Ware was commended by Frederick Rhead for its "rich suave velvety glazes, with gleams of gold showing dimly here in the depths, and sparkling there on the surface". The pieces illustrated are mostly in simple shapes to complement the glazes, two of them with shapes reminiscent of Christopher Dresser*'s Linthorpe Pottery* designs. A recently discovered price list for Byzantine Wares in the Minton Archive (manuscript number 3936) includes pin, comb, pen and ash trays, baskets, jugs, vases, bottles and candlesticks.

A collection of Secessionist and other Mintons wares may be seen at the Minton Museum, Minton House, London Road, Stoke-on-Trent.

Marks: Most wares after 1873 are marked "Mintons", with "England" after 1891 and "Made in England" after 1910. Impressed date ciphers were usually employed. Secessionist wares had a special backstamp, "Mintons Ltd.", often accompanied by a stamped shape number. A previously unrecorded, printed mark, "Mintons Ltd", with a picture of a peacock, occurs on the vase in Figure 101.

References: "The Art Movement. The Arts and Crafts in 1899", *MA*, vol. 24, 1900, pp. 86–91; *A&CXS 1888, 1893, 1896, 1899, 1903*; "The Arts and Crafts", *Studio*, vol. XVIII, 1900, pp. 126–31; "The Arts and Crafts", *Studio*, 1899, p. 268–71; "The Arts and Crafts Exhibition", *AJ*, 1903, p. 92; Aslin, Elizabeth and Paul Atterbury, *Minton 1798–1910* (Victoria & Albert Museum, Thomas Goode & Co. Ltd., 1976); Atterbury, Paul and Maureen Batkin, *The Dictionary of Minton* (Antique Collector's Club, Woodbridge, 1990); "British Arts and Crafts in 1903", *MA*, New Series vol. I, 1903, pp. 220–21; *Decoration*; Muter, Grant, "Léon Solon and John Wadsworth: Joint Designers of Minton's Secessionist Ware", *Journal of the Decorative Arts Society*, 9, pp. 41–49; Muter, Grant, "Minton Secessionist Ware", *The Connoisseur*, August 1980, pp. 256–63; *PG*; Rhead, Frederick, "Pottery Decoration", *Artist*, vol. XIX, 1897, pp. 281–87; "Studio-Talk", *Studio*, vol. XVI, 1899, pp. 50–53.

Minton's Art Pottery Studio
Kensington Gore, London
1871–75

Sir Edward John Poynter designed a tiled scheme for the Grill Room of the South Kensington Museum which was executed between 1867 and 1870 by the women students of the National Art Training School. The success of this venture led the authorities to consider the organization of an art pottery studio to employ the graduates of the school. As Mintons had long had a close relationship with the Museum and the School, it was quite logical that the proposal for this should have been made to Colin Minton Campbell.

The studio, designed by Gilbert R. Redgrave, was built upon ground owned by the Commissioners for the Great Exhibition of 1851, near the Royal Albert Hall, which was let for a nominal ground rent of £136 13s 4d for seven years. The location was considered to be ideal, *The Art Journal* enthused in 1872:

> From the facilities at hand for studying floral forms in their richest manifestation, in the Royal Horticultural Gardens and its periodical flower-shows, and also some of the finest examples of Keramic Art of the best periods, the South Kensington Museum, together with the instruction

obtainable in the Schools of Art, we have a combination of means to a given end which cannot well be over-estimated.

W. S. Coleman, already an established artist, carried out his first experiments in ceramic decoration at W. T. Copeland (& Sons Ltd). He was unhappy there, and approached Colin Minton Campbell, who "received him, so to speak, with open arms, and gave him the use of a commodious studio at the end of the china works overlooking the town of Stoke" (Rhead and Rhead). His work was commended in *The Art Journal* in 1870: "the artist indulges a free fancy, and is graceful in all the compositions he thus presents to us; sometimes, indeed, he reaches high Art, and is never other than pleasing." The Rheads described his work as ". . . a series of plaques, bowls, fireplace-slabs, etc., so charmingly fresh in character, so entirely different in treatment from anything previously seen in the Potteries, that they at once made a deep impression even amongst the workers . . .". This early work was in underglaze colours only, but Coleman's preference for bright colours led him eventually to abandon underglaze altogether, except for outlines. In 1872 *The Art Journal* applauded Coleman's appointment as director of the Studio: "This gentleman is the first English artist of reputation who has cared to devote attention to the production of original works on pottery by his own pencil."

The staff of the pottery consisted of a nucleus of male artists, mostly imported from Stoke, and a larger number of young women from the school. The "small corps of young artists which form the male portion of the staff" were housed separately from the female artists, as decorum demanded. "There are from twenty to twenty-five educated women, of good social position, employed without loss of dignity, and in an agreeable and profitable manner." (*AJ*, 1872)

The wares were mostly plaques, tiles, chargers, vases and bottles, particularly moon flasks, which offered flat surfaces most suitable to the style of painting employed (Colour XXXII). The pottery blanks were shipped in biscuit state from Stoke and, after painting, were fired in the Studio's two kilns. Although the Studio was commonly referred to as employed in china-painting, the blanks were, in fact, earthenware specially produced for the Studio. The ware was usually cream-coloured or white, but a deep red-tinted body was occasionally used.

Despite the many styles employed by the artists at the Studio, much of the Studio's work is easily recognizable, because of the method used, which also limited the palette. In 1872, *The Art Journal* described their method in detail:

> The design being settled in the form of a cartoon or drawing, the outline is traced upon the ware, and the artist begins according to the subject, either by painting in the outline first, or working up certain masses of colour, to be afterwards correctly or more rigidly defined by the addition of a boundary line. The ground, being absorbent, necessitates a manipulation accordingly, but a little practice gives confidence, and great freedom of touch is soon attained by the more skilful; in fact, it is this very freedom of handling which gives such charm to the highest class of subjects . . . The colours are, of course, all chemically adapted to the purpose, and are vitreous in character. They may be divided into two series of "palettes", the "under-glaze" and the "over-glaze". The chromatic range of the "under-glaze", or those colours which are employed to paint direct upon the biscuit is very much more limited than that of the "over-glaze". Practically there is no bright red, and although the blues, yellows, greens, olives, and browns are rich and effective,

still the absence of a brilliant red is a serious drawback to the fulness of the scale. This, however, as we shall see, is compensated for in due course by the introduction of reds of varied tints, by an "over-glaze" process, in which the colours ordinarily used to produce the brilliant and tender effects seen in porcelain-painting are made available.

The "first painting", then, or "laying-in" of the work, to speak technically, is direct upon the unglazed surface of the pottery, and the artist carries his subject as far as the treatment by "under-glaze" colours will permit. Masses of white enamel are "loaded" upon the surface in accordance with the character of the details, with a view to further treatment by "over-glaze" tints, and the various colours available in the "under-glaze" palette are utilised according to the skill and experience of the artist.

After firing, the overglaze colours were added, requiring as many as four further firings, depending on the number of colours employed.

There were 1487 tile designs assigned S (for Studio) pattern numbers during the Studio's brief life. The art-work for a number of these survives in the Minton Archive, and some continued in production at the Stoke factory after the Studio closed. Tiles with S pattern numbers from 1488 were produced by Mintons after the Studio closed. It is possible that the tiles listed below were already in production at Stoke before 1875; no records at the Studio survived the fire that destroyed it that year.

Minton's Art Pottery Studio tile designs
(Compiled from surviving art-work in the Minton Archive)
Names with capital letters are titles given on the drawings; other names are those given by this author.

S1059, *Zodiac Panel*; *The Prophet*. This was designed by H. S. Marks as a fireplace slab for Eaton Hall, Cheshire, the seat of the Duke of Westminster. Several replicas were made.

S1210–19: *Mediaeval Musicians*.

S1303: cupid, urn.

S1304: boar hunt.

S1304[A]: putti hunting and fishing.

S1304[B]: fairies and birds (there are three drawings labelled S1304).

S1306: rose and ribbon; bird and strawberries; Girl's Head.

S1306: daisies in urn, two versions.

S1307: prunus in vase.

S1328: girl with a basket of apples; girl picking apples.

S1332: seasons, semicircular with babies.

S1344: girl's head with stylized flowers and foliage.

S1346: putti hunting and fishing (variation on S1304).

S1350: girl with a rake; girl with a jug; girl with a basket; Pruning.

S1376: putti hunting.

S1377: Sunflowers.

S1379: ladies on horsback, "after an engraving".

S1385: girl scattering petals.

S1394: eating apples; fishing; watching birds

S1395: girl with a ring; girl painting. Signed "F. Vanhale esq.".

S1397: catching butterflies; stringing beads; boy with a fish; girl with a bird.

S1401: putti in oak tree.

S1432: affectionate girl and cherub.

S1459: girl and cupid.

Despite a good press, an injection of some of Stoke's best artists, the ideal location and the high prices (from £50 to £70 for some of Coleman's slabs), the Studio did not prosper. The principal reason seems to have been lack of leadership and direction. Coleman was always more interested in pursuing his own interests than developing the talents of others. When John Eyre arrived to relieve him of some of the responsibilities of management, Coleman spent more and more time working on his own projects. Coleman finally resigned at the end of 1873, and Matthew Elden was brought in as his replacement.

Unfortunately, we have only the Rheads' account of Elden's abilities. They acknowledged his talent, but proceeded with a scathing denunciation: "His work at Minton's Studio may be summed up in the one word *failure*. He was forever experimenting: inventing devices for this and 'dodges' for that . . . If he happened upon occasion to achieve any measure of success, he couldn't rest, apparently, until he had spoiled it." Elden stayed for less than two years, having driven away Eyre.

Mintons now made an arrangement with Colonel Stuart-Wortley, an amateur photographer who took portraits in fancy costume, which were then copied onto plaques. While these were good imitations, quality declined. The use of Elden's experimental technique of spraying ground colour brought further deterioration.

A fire in 1875 put an end to the Studio. It has generally been assumed that Mintons did not want to rebuild, as the venture had been far from profitable. Mintons' year-end account for 1874 lists the loss from the Studio as £1846 6s 9d. However, according to R. Mawley "After the fire, the authorities at South Kensington would not give permission for the studio to be rebuilt."

The influence of the Studio was disproportionate to its brief life. It played a large part in the mania for china painting which soon swept the nation. On the one hand, this resulted in a great deal of very poor-quality amateur work, but the movement was an important step forward for women in the arts. Many women achieved a degree of financial independence which would not otherwise have been possible. Furthermore, their achievements were not confined to the decorative arts. Through their china painting, they developed the skill, confidence and reputation to exhibit paintings and sculpture at the Royal Academy and other important exhibitions. As observed by Mawley "Several of the artists – as Mr Eyre and Miss Black – opened studios at some of the leading china shops, where they now paint and give lessons."

The work of the Studio also influenced the ceramic industry at large. Its style of painting was much imitated and, as evidenced by the biographies below, many of its artists went on to positions of importance within the industry. Secondly, as Terence Lockett has pointed out, its work was the key to the inception of pictorial tiles, which were first made by Mintons and which soon swept the burgeoning tile industry.

Artists, designers and principal personnel

As all records of the Studio were destroyed in the fire of 1875, there is no comprehensive list of Studio artists. The following have been identified through

signed works, or through contemporary press notices. Several of the artists below are listed in *The Dictionary of Minton* as possibly or probably having worked at the Studio; they are included below in the hope that more definite information may be forthcoming. In some cases working dates may be clarified by the date codes on recorded pots, but it should be remembered that the codes were applied at the time of the biscuit firing in Stoke, and that it may have been many months before the pieces reached the Studio and were decorated.

THOMAS ALLEN (1831–1915) studied at the Stoke School of Design while apprenticed to Mintons, where he painted china, majolica and tiles. He studied on a scholarship to the School of Design at Somerset House for two years, returning to Mintons until 1875. He then went to J. Wedgwood (& Sons Ltd)*, being appointed art director in 1878. It is thought that he may have worked for the Studio because he does not appear on salary lists for Mintons in Stoke between 1871 and 1875.

HANNAH BOLTON BARLOW worked at the Studio during 1871, before settling at Doulton & Co. (Ltd), Lambeth*.

BATEMAN. Several designs by this artist, at least one of which was produced, are in the Minton Archive.

LUCIEN BESCHE trained as a figure painter in Paris before coming to England. He was probably working at the Studio before he came to Mintons in Stoke. He also worked for W. T. Copeland (& Sons Ltd), and was Frederick Rhead's* brother-in-law.

MISS BLACK worked at the Studio throughout its short existence. After the fire she became the director of Mortlock Ltd's* studio in London, where she gave china-painting lessons.

JOHN BROOKE trained at the Sheffield School of Design, eventually becoming headmaster. He then worked as a draughtsman for iron founders until he won a National Art Scholarship. He next worked as an assistant to William Morris*, as a painter of stained glass. He seems to have worked at the Studio throughout its short life.

HELEN CORDELIA COLEMAN (1847–84), sister of W. S. Coleman, specialized in flower subjects. She was mostly self-taught, with assistance from her brother. She continued as a professional decorator after the closure of the Studio. She painted fruit, flowers and birds in the style of Hunt, Clare and Cruikshank, and was regarded by William Hunt as his successor. In 1875 Helen married the amateur artist John Angell. She was appointed Flower Painter in Ordinary to Queen Victoria in 1879. In 1876 Clayton noted: "Her most recent pictures have created a marked sensation among critics and connoisseurs. For their intrinsic beauty, technical excellence and perfect originality, her drawings take high rank."

She exhibited regularly at the Dudley Gallery (from 1866), the Institute of Painters in Water Colours (of which she was made a member in 1875), Royal Society of Painters in Water Colours (of which she became an associate in 1879), the Royal Academy (1876–78) and elsewhere.

REBECCA COLEMAN (1847–84), another of W. S. Coleman's sisters, studied at Heatherley's Art School, London, and in Germany, and was noted for her studies of heads (106). Her *Dora* was shown at the Howell & James* exhibition in 1884. She continued as a professional decorator after the closure of the Studio. She was mourned by Cosmo Monkhouse: "The loss which this branch of china-painting

106 Minton's Art Pottery Studio charger painted by Rebecca Coleman, signed, with printed mark "Minton's Art Pottery Studio, Kensington Gore", and impressed Minton factory marks and "657" in script, d. 42 cm.

has sustained . . . is not easily overestimated. In skill of handling, in the bright purity of her tint, she was unequalled. The last work of hers which I have seen was like a rainbow." (*MA*, 1884). She designed a set of twenty-five girls' heads which were used by Mintons for dessert plates and other tableware. She exhibited at the Royal Academy (1872), The Society of Women Artists, the Dudley Art Gallery and elsewhere.

WILLIAM STEPHEN COLEMAN (1829–1904), designer, illustrator, author and watercolourist, worked briefly for W. T. Copeland (& Sons Ltd) before joining Mintons in 1869. He was one of the most prolific of Victorian greetings card designers, specializing in paintings of nude and scantily clad pubescent girls. After he left the Studio in 1873, he continued to send his work there for firing, but concentrated on his paintings and illustrations. He is listed as a debtor for the amount of £140 to the Studio in the accounts for 1874, perhaps for monies received under an unfulfilled contract agreement. He was also a trained naturalist and wrote several works on natural history. *See* 112 and Colour XXXI.

Coleman's work was discussed at length by R. Mawley:

> . . . I examined some large designs by Coleman, an artist whose drawings I seem to remember appearing at the Dudley Gallery. In addition to a large and well designed piece of his, consisting of birds, flowers and foliage, there were figure subjects of children, fanciful and pretty in treatment, but

without anything that could be called "great" in them. They were circular plaques framed as pictures, and one was valued at one hundred pounds. I believe Mr Coleman some time since abandoned painting on china for water-colours and oils.

Mawley goes on to describe a watercolour drawing by Coleman: "A young girl puting a feather into a globe of gold fish, was pretty in treatment. The figure was perhaps too nude, but so good in drawing, and so innocently rendered, it could scarcely fail to please."

ANDREW B. DONALDSON (1840–1919), a watercolourist whose range included historical, religious and landscape subjects. He exhibited at the Royal Academy.

CHRISTOPHER DRESSER*. Many of Dresser's designs for the Studio were featured at the London International Exhibition of 1871, including *seaux* with grotesque ornaments, cylindrical vases and dinner plates. Many of these designs incorporated animals, especially frogs and cats.

MATTHEW ELDEN trained at the Stoke School of Design and won a scholarship to the National Art Training School. He worked as painter and modeller for J. Wedgwood (& Sons Ltd)* (designing the modelled decorations for the façade of the Wedgwood Institute, Burslem) and then succeeded W. S. Coleman as director of the Studio in 1873. The Rheads clearly disliked Elden; their scathing account (see above) has until recently been Elden's only testimonial. Atterbury and Batkin have, however, recently uncovered a more friendly account in an issue of *The Pottery Gazette* of 1908: "He was, in his special style, one of the cleverest men I have had the pleasure of knowing." After the Studio's closure, Elden worked with the tile-decorating firm of W. B. Simpson & Son (Ltd). According to the Rheads, "The poor distracted soul ended his days in an asylum . . .".

JOHN EYRE* worked at the Studio *c*.1872–73 as a designer, painter, general foreman and kiln superintendent. According to the Rheads, he did not get on with Matthew Elden and left soon after his directorship began.

HERBERT WILSON FOSTER (1848–1929) trained at the Hanley and South Kensington Schools of Art, and joined the Studio in 1872. After the fire, he continued working for Mintons in Stoke until 1893, when he left to teach at Nottingham School of Art. He was an accomplished artist who exhibited at the Royal Academy and in Europe. He is best known as a portrait painter, but also painted bird and animal subjects, and Persian designs both on porcelain and earthenware. He designed a series of printed picture tiles with mediaeval subjects. His panel for the South Kensington Museum, *The Triumph of Truth and Justice over Ignorance, Superstition and Crime* was mentioned in *The Art Journal* in 1877. He executed the *Euphrosyne* panel exhibited at the Universal Exhibition, Paris, in 1878.

L. H. was an unidentified painter of plaques dated 1872–74, which were included in the Minton Exhibition at the Victoria & Albert Museum 1976 (catalogue number J6–12).

EDWARD HAMMOND was a designer and artist who painted tiles and panels for the Studio, including a series of mediaeval musicians together with Matthew Elden. He later worked for Burmantofts Pottery* and may have worked for W. T. Copeland (& Sons Ltd).

CHARLES HINLEY was a designer at the Studio. He collaborated with A. Boullemier on the design of a booklet, *Monsieur Cupidon*, and later worked for J. Wedgwood (& Sons Ltd)*.

Opposite, **107** Minton's Art
Pottery Studio porcelain
plaque, *The Seven Ages of Man*,
designed by Henry Stacey
Marks, RA, printed mark
"Minton's Art Pottery Studio,
Kensington Gore", impressed
"MINTONS", with painted
marks "248 297".

FLORENCE JUDD taught china painting at Howell & James* after the Studio closed. She won a prize at the Howell & James Exhibition of 1880.

HENRY STACEY MARKS was a freelance artist and designer best known for his mediaeval designs in the aesthetic style. His work also included Shakespearean and animal subjects. His work for the Studio included the design of their business card, mural plaques including *The Seasons* and the *Zodiac* panel (S1059); and *The Seven Ages of Man*, a series of tiles (107–111 and Colour XXXIII). Many of his original designs survive in the Minton Archive. He exhibited regularly at the Royal Academy and elsewhere 1853–97.

HUGH MCNEILE MINTON was the son of the Reverend Samuel Minton, son of Herbert Minton's elder brother, the Reverend Thomas Webb Minton. He worked at Mintons' Walbrook depot before coming to the Studio as manager in 1871. According to the accounts for the Studio, he received a regular share of the profits.

WALTER JENKS MORGAN was a painter. His signature has been recorded on a moon flask dated 1872.

RICHARD PILSBURY SENIOR (1830–97) was one of Mintons's finest artists, specializing in flower painting. He was apprenticed with Samuel Alcock & Co., won twelve National Medals, and taught at the National School of Design, Marlborough House. He returned to Staffordshire and began to work for Mintons c.1866. He is thought to have been attached to the Studio at some time during its existence. He then returned to Mintons until 1890. From 1892 he was art director at Moore Bros.

EDMOND G. REUTER (1845–1912+). Born in Geneva, Reuter studied floral design in Paris before coming to London to study at the South Kensington School of Art. According to the Rheads, his talent was wasted at the Studio. After the Studio closed, he worked for Mintons in Stoke until 1895. By 1886 he had become an assistant designer under Léon Arnoux. He specialized in floral and figure subjects. In 1895 he returned to Switzerland, where he worked as an illuminator, calligrapher and watercolourist, sometimes being employed as such by William Morris*.

GEORGE WOOLISCROFT RHEAD JUNIOR* (1855–1920) was apprenticed to Mintons in 1868. He worked under W. S. Coleman from 1869 and moved to the Studio with Coleman in 1871. At the Studio he specialized in adapting subjects from Japanese paintings. He remained at the Studio until it closed. *Staffordshire Pots and Potters*, which he wrote with F. A. Rhead, contains a full account of the Studio.

J. D. ROCHFORT was an amateur who worked with the Studio, also decorating blanks from J. Wedgwood (& Sons Ltd)*.

AARON SIMPSON was a gilder engaged by Mintons in the 1860s. He is thought to have transferred to the Studio, returning to Stoke by 1876. He had left Mintons by 1882. He won a medal at the Vienna Universal Exhibition in 1873.

HENRY SIMPSON began work as a gilder and painter at Mintons in 1871, probably working at the Studio from 1872 to 1875. He then returned to Mintons, remaining until at least 1882.

THOMAS SIMPSON was a painter specializing in fruit and flowers who probably transferred to the Studio from Mintons. His vases painted with flowers were shown at the Vienna Universal Exhibition in 1873. He did not return to Mintons after the Studio closed, but is recorded as having worked at Coalport.

108 Minton's Art Pottery Studio porcelain plaque, *The Seven Ages of Man*, designed by Henry Stacey Marks, RA, printed mark "Minton's Art Pottery Studio, Kensington Gore", impressed "MINTONS", with date cypher for 1873 and painted mark "5807".

CHARLOTTE SPIERS was an exceptional artist who continued to work freelance after the Studio closed, in partnership with Ellen Welby. In 1879 she won the Howell & James* first prizes for "Heads and Landscapes" with her *Diana Verona* and for "Ornaments, Birds and Flowers" with her *Chrysanthemums* and *Hollyhocks*. She won the Howell & James prize for women professionals with her *Poppies and Tiger Lilies* and *Placida* in 1880. In 1884, Cosmo Monkhouse commended her work as "thoughly English and pure, and masterly also if such an epithet can be applied to designs which are feminine in the best sense of the word". She may have been a relative of René Spiers of Spiers & Pond, who designed some sunflower-dial clocks for Howell & James, and who asked the

Top, **109** Minton's Art Pottery Studio porcelain plaque, *The Seven Ages of Man,* designed by Henry Stacey Marks, RA, printed mark "Minton's Art Pottery Studio, Kensington Gore", impressed "MINTONS", with date cypher for 1873 and painted mark "5807".

Studio to decorate the Criterion Restaurant; according to the Rheads, the commission was lost because of Coleman's indolence.

Charlotte Spiers exhibited regularly at the Society of Women Artists, New Gallery, Royal Academy, Royal Society of British Artist's Royal Institute of Painters in Water Colours, Royal Society of Artists and others.

ELIZA JAMESON STRUTT painted figure subjects. She decorated a plaque date-coded 1873 with a portrait of a girl, which was included in the Minton Exhibition at the Victoria & Albert Museum in 1976 (catalogue number J5).

ROSA JAMESON STRUTT painted landscapes. Her panel *Spring,* shown at Howell & James*, was illustrated in *The Magazine of Art* in 1884.

111 Minton's Art Pottery Studio porcelain plaque, *The Seven Ages of Man*, designed by Henry Stacey Marks, RA, signed ''H. S. Marks'', with printed mark ''Minton's Art Pottery Studio, Kensington Gore'' and date cypher for 1872, 25.9 cm by 52.5 cm.

Opposite, 110 Minton's Art Pottery Studio porcelain plaque, *The Seven Ages of Man*, designed by Henry Stacey Marks, RA, printed mark ''Minton's Art Pottery Studio, Kensington Gore'', impressed ''MINTONS'', with painted marks ''248 297'', 25.3 cm by 50.6 cm.

112 Minton's Art Pottery Studio plaque, painted by W. S. Coleman.

KATHERINE STURGEON worked at Doulton & Co. (Ltd), Lambeth* after the Studio closed. She was a fine artist who exhibited her genre watercolours regularly.

ELIZABETH GERTRUDE THOMSON designed tiles for J. Wedgwood (& Sons Ltd)* and may have been attached to the Studio.

F. VANHALE designed tile S1395.

ELLEN WELBY was a paintress who continued to paint china after the Studio closed, in partnership with Charlotte Spiers. In 1879 she won Howell & James*'s second prize for "Heads and Landscapes" with her *Head with Apple Blossoms*. She also won a prize at their Fifth Exhibition in 1880. She exhibited at the Royal Academy, Royal Society of British Artists, Royal Institute of Oil Painters, Society of Women Artists and others.

WILLIAM WISE (c.1831–89) was born in London and trained at an art school there. He was a painter, designer, etcher and engraver who also worked with stained glass. When the Studio closed, Wise worked for Mintons in Stoke. *See* Colour XXX.

Marks: The wares are impressed "MINTONS" with an impressed date cipher. A printed mark in an oval, reading "MINTON'S ART POTTERY STUDIO KENSINGTON GORE, S. W.", was added at the time of decoration.

References: *AJ*, vol. IX, 1870, p. 195; Aslin, Elizabeth, *The Aesthetic Movement: Prelude to Art Nouveau* (Ferndale Editions, 1981); Aslin, Elizabeth and Paul Atterbury, *Minton 1798–1910* (Victoria & Albert Museum, Thomas Goode & Co. Ltd, 1976); Atterbury, Paul and Maureen Batkin, *The Dictionary of Minton* (Antique Collectors' Club, Woodbridge, 1990); Atterbury, Paul and Terence Lockett, "The Work of William Wise", *The Antique Dealer & Collector's Guide*, July 1978, p. 59; Austwick; Barnard; Batkin; Bergesen; Buckley; Callen, Anthea, *Women in the Arts and Crafts Movement* (Astragal Books, 1979); Cameron; Clayton; Coysh; "The Fourth Annual Exhibition of Paintings on China", *MA*, vol. II, 1879, p. 269 (reprinted in Haslam 1975); Godden, Geoffrey, *Victorian Porcelain* (Herbert Jenkins, 1961); Godden 1964; Graves; Halén, Widar, *Christopher Dresser* (Phaidon, Oxford, 1990); Haslam 1975; "Howell and James Fifth Exhibition", *Artist*, vol. I, 1880, pp. 167–68; "John Brooke, Obituary", *PG*, January 1906; Lockett; [Mawley, R.], *Pottery & Porcelain in 1876* (Field & Tuer, 1877); Minton Archive materials; "Minton's Art-Pottery Studio, South Kensington", *AJ*, vol. XI, 1872, pp. 100–01; Monkhouse, Cosmo, "The Royal Academy of China-Painting", *MA*, vol. VII, 1884, pp. 245–50; Ovenden, Graham, *Nymphets & Fairies: Three Victorian Children's Illustrators* (Academy Editions, 1976); "Painting on China by Lady Amateurs and Artists", *AJ*, 1879, vol. 18, p. 164; "Paintings on China by Lady Amateurs and Artists", *Artist*, June 1883, pp. 183–84; Petteys; Rhead & Rhead; Thunder, Moire, "William Wise", *Antique Collecting*, vol. 19, no. 4, pp. 64–67.

Moorcroft, William
1872–1945

William Moorcroft's father, Thomas, was a painter, specializing in flower subjects, at E. J. D. Bodley's Hill Pottery, Burslem. At the age of twelve, William began to study art at the Wedgwood Institute, Burslem, going on to the National Art Training School in South Kensington. Although he was given an Art Master's Certificate, he decided on a career in pottery, and accepted a job as a designer of printed patterns with James Macintyre & Co. Ltd*. When the Art Director, Harry

Above left, **113** Moorcroft Pansy vase, impressed "1200", signed "W. Moorcroft" in green and dated 1913, h. 31 cm.

Above right, **114** Moorcroft Landscape pattern vase, *c.*1916, printed marks "Made for Liberty & Co", and "W. Moorcroft' painted signature in green.

Right, **115** Moorcroft wares. *Left and right*: candlesticks, painted signature "W. Moorcroft" and printed mark "Made for Liberty & Co.", h. 15.2 cm. *Centre*: vase, painted signature "W. Moorcroft", and printed registration number 360676.

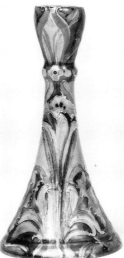

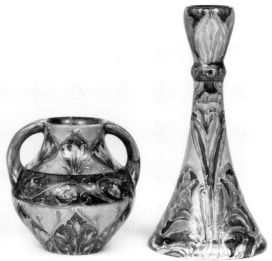

Barnard*, left Macintyre's in 1897, Moorcroft took over as designer, becoming Manager of Ornamental Ware in 1898.

From the first, the art wares designed by Moorcroft were recognized by the press as his unique creation. He carefully supervised the workshops and signed each satisfactory piece himself. In 1912 Macintyre's decided to discontinue tableware (also designed by Moorcroft) and art ware production to concentrate on their industrial porcelains. Moorcroft was able to secure the rights to all his designs and by 1913 had set up his own firm in Cobridge, under the style W. Moorcroft Ltd*.

With the help of Moorcroft's unfailing genius as a chemist and designer and aided by his insistence on the production of quality wares, the firm flourished. On his death in 1945, the firm was taken over by his son, Walter Moorcroft. *See* 89–91 and 113–115; Colour XXII.

References: *See* James Macintyre & Co. Ltd; W. Moorcroft Ltd (PLC).

Moorcroft, W., Ltd, (PLC)

Sandbach Road, Cobridge, Staffordshire

1913 to the present day

In 1912, James Macintyre & Co. Ltd* informed William Moorcroft* that it was to discontinue production of art pottery and tablewares in order to develop further its industrial porcelain production. After protracted negotiations (described in detail in Paul Atterbury's book), Moorcroft entered into a partnership with Liberty & Co.* (who was also the largest client). This was to last until 1961. The first directors were William Moorcroft and Alwyn Lasenby. Moorcroft obtained the designs which he had produced for Macintyre over the previous sixteen years, and many of his former employees at Macintyre's moved to the new firm with him.

The art wares were manufactured continuously at Macintyre's until Moorcroft built his own pottery in Cobridge, where he continued their manufacture on his own account. Moorcroft's first wife, Florence Lovibond, played an active role in the planning of this new factory. She had been a factory inspector in the district, and the couple were determined to provide the best possible working conditions. Reginald T. Longden, a local architect, provided drawings of the new pottery, which pioneered the single storey plan, since adopted by many other firms.

Moorcroft concentrated on art pottery wares which were usually thrown on the wheel, slip-trailed and decorated with the rich glossy glazes achieved by high-temperature firing and for which Moorcroft wares are still recognized today. *The Pottery Gazette* noted that ". . . he is an artist as well as a manufacturer, and that whilst he realises that it is necessary to live he regards it even more important to live beautifully, and for this reason he has set himself to the production of articles of utility which have a corresponding artistic value". (*PG*, July 1916). Another observer commented on the firm: ". . . it clings to all that is best in the very oldest of potting principles, and it seems to stand as a plea for the recognition of the dignity of human craftsmanship . . ." (*PG>R*, November 1921)

The pottery flourished and, despite some difficulties during the First World War the premises expanded in 1919–20. On William's death in 1945, his son Walter, who had joined the firm in 1935 (serving in the army 1939–45), took over the concern, which he maintained on the same lines. After his semi-retirement in 1987, he continued to design some Moorcroft wares until his recent full retirement. His half-brother, William John Moorcroft, who joined the firm in 1962, became Managing Director in 1984. At that time the Moorcroft family sold a large block of shares to Michael, Stephen and Andrew Roper, owners of the Churchill Group. This interest was sold to the Dennis and Edwards families, major collectors and

Moorcroft enthusiasts, in 1986. Since Walter Moorcroft's retirement Sally Tuffin (wife of Richard Dennis) has been the firm's chief designer, bringing out many new and boldly original designs. The firm became a public limited company in February 1990.

A number of new wares were introduced during the period 1913–20, with which this account must be chiefly concerned. Atterbury lists the following patterns as being in production in 1915: green Flamminian, Pansy (113), Pansy celadon, cornflower, Spanish Claremont, Hazeldene, pomegranate, blue and white panel, Persian, wisteria, toadstool, tree, Red Persian and 2170. *See* 114, 115 and Colour XXII. Several of these were patterns produced in the Macintyre period, or variations upon them. The Persian patterns were, however, an entirely new production. Moorcroft also introduced blue and white panels, which used powder blue slip: ". . . a new floral decoration with an egg-shell blue background, and cobalt blue sprays and white panels . . ." (*PG*, June 1915). A similar ware was produced with an olive-green ground. In 1918 he introduced a new pansy border and an orchid decoration.

Moorcroft continued his experiments with glazes, including lustres and flambés. At the British Industries Fair of 1915, he displayed ". . . a gold-coloured glaze of peculiar lustrousness, another a purple glaze of a rich and unique order, and a third . . . a matt green effect which could hardly be excelled". At the British Industries Fair of 1918 many lustrewares were shown. A critic reported: "The colours acquire an unrivalled depth of hue, seeming to carry the light far back into the body of the ware, and to give it back with renewed brilliance imbued with their own tints, yet merging imperceptibly into the kindred sections of the prismatic scale." Celadon Crackle was introduced in 1919.

Useful wares were also manufactured, for advertisements in *The Pottery Gazette* of the period 1916–18 offered: vases, bowls, jardinières, tea, coffee and dessert sets, early morning sets, coquetiers, mufineers, inkstands, pen trays, candlesticks, toilet table accessories, children's mugs, dress buttons, brooches and hat pins. The Powder Blue, also known as Blue Porcelain or Moorcroft Blue, tablewares were introduced soon after the establishment of the new factory. Despite being the firm's "bread and butter" line, each piece was thrown on the wheel and dipped in blue slip. This ware continued in production until 1963, save for a brief period during the Second World War.

An excellent collection of Macintyre and Moorcroft wares may be seen in the museum at the Moorcroft Pottery, Sandbach Road, Burslem, Stoke-on-Trent ST6 2DQ, telephone (0782) 214323. The Moorcroft Collectors' Club may be contacted through the Secretary, Gill Moorcroft, at the same address.

Marks: Most art wares bear the Moorcroft signatures of William, Walter or William John, along with various other marks. Minor decorated ornamental wares and useful wares, such as Powder Blue tableware, are impressed "MOORCROFT".

References: Atterbury, Paul, *Moorcroft* (Richard Dennis & Hugh Edwards, Shepton Beauchamp, revised edition, 1990)‡; Atterbury, Paul, *William and Walter Moorcroft, 1897–1950* (Fine Art Society, 1973)‡; Bunt; Cameron; "Florian Ware", *MA*, vol. XXIII, 1898–9, p. 232; Jewitt; Levy; Miller, Fred, "The Art Pottery of Mr. W. Moorcroft", *AJ*, 1903, pp. 57–58; *Moorcroft Collectors' Club News Letters* 1989–90; "The Moorcroft Pottery", *PG>R*, November 1921, pp. 1664–66; Moorcroft, Beatrice, "Growing Up in Burslem: William Moorcroft's Childhood

and Education'', *Moorcroft Collectors' Club News Letter*, No. 2, 1989, p. 15–17; Moorcroft, Walter, "Moorcroft Blue Tableware", *Moorcroft Collectors' Club News Letter*, No. 3, 1990; Morris; Pemberton; *PG*; *PG>R*; Rhead; Service, John, "British Pottery", 3 pts, *AJ*, 1908, pp. 53–57; 129–37; 237–44; Stuart; "Tradition in half a century, Moorcroft Achievements, Past and Present", *PG>R*, May 1954, pp. 719–25.

‡ Paul Atterbury's book was first published in 1987. The revised edition contains a great deal of new material concerning the history of both the Macintyre and Moorcroft firms, and covers the firm's production in the 1986–90 period. It also supersedes the 1973 Fine Art Society catalogue.

Moore, Bernard

1850–1935
Wolfe Street (later known as Kingsway), Stoke-on-Trent, Staffordshire
1905–15

Although the vast majority of Moore's productions employed a porcelain body, a few were produced on earthenware blanks. His work is of great importance in that it inspired high-temperature-glaze experiments by several other potteries, both small and large. Furthermore, as a consultant and author of technical papers, Moore played a significant part in the development of the ceramic industry as a whole.

The Mount Pleasant Works, Longton, were established in 1830 and continued until 1859 by Hamilton & Moore. In 1859 Samuel Moore and his eldest son, Joseph, became sole proprietors, operating under the style Moore & Son. Joseph died in 1861, but the firm prospered, constructing a new works, the St Mary's Works across the road in 1862. Upon Samuel's death in 1867, his son, Bernard Moore, took over. In 1870 Bernard's younger brother, Samuel Vincent Moore junior, joined the firm, which still traded under the style Moore Bros. Samuel Vincent controlled the business side and Bernard the firm's production. They were soon noted for their good-quality majolica and fine bone chinas, which won many international awards.

Samuel Vincent Moore died in 1890 and, possibly due to poor financial management or investment, Bernard was constrained to sell the St Mary's Works in 1905. He set up a consultancy and art pottery in Stoke, employing his nephew, Reginald Moore, to handle the business side. His son, Bernard Joseph Moore, joined the business in 1906. Moore had been experimenting with *sang-de-bœuf* and *rouge flambé* glazes for some years. Jewitt noted that the "... Chinese ruby glaze has been cleverly imitated; it is rich and full of colour". This was not a high-fired flambé glaze, but Moore had certainly perfected this technique by 1902, when he presented some examples to the British Museum. Examples of these were sold to the Victoria & Albert Museum and the Hanley, Stoke and Burslem Museums in 1905 (*PG*, June 1905). Moore was employed by Doulton & Co. (Ltd), Burslem* to aid them in the development of their flambé glaze.

Moore was soon producing remarkable pots at his new pottery. These were produced on porcelain blanks acquired from a number of Staffordshire firms, including Mintons* and J. Wedgwood (& Sons Ltd)*. Some fifty designs believed to have been manufactured solely for Moore's use have been discovered in the Minton Archive, although he also used many shapes which were part of Mintons' regular production. A porcelain body was nearly always employed, as earthenware could not stand the high temperatures (1300–1400 degrees centigrade) used for his glaze effects. Of some 263 pieces exhibited at the Victoria & Albert Museum in 1983, only eighteen were earthenware and five "probably earthenware". Stoneware and bone china were also very occasionally employed.

The wares were largely ornamental, including vases, bottles, bowls, plates, jardinières and figures. Although the glaze is the most important decoration, Moore employed a number of decorators whose work was complemented by lustre or flambé (117 and Colour XXXIV). In July 1906 Moore opened an exhibition at Stoke which included *rouge flambé*, *sang-de-bœuf*, lustre and crystalline jade wares. On these, William Burton* commented:

> . . . the glazes now produced by Mr Moore are as perfect, their tones as varied, and in some cases, their colour more brilliant than any that have come from China; but owing to the difficulties of manufacture, the pieces can never be produced wholesale, and "from the nature of the process every piece is practically an individual specimen, bearing on it the mark of the master, and worthy, therefore, of its place in the finest collections of ancient and modern pottery. (*PG*, August 1906)

In 1908 the Duchess of Sutherland gave an "At Home" at which samples of Moore's pottery including copper, red and *rouge flambé*, and green crystalline wares were shown.

To the International Exhibition in Brussels of 1910 Moore sent "the finest collection of his wonderful *sang-de-bœuf*, peach blow, haricot, *rouge flambé*, transmutation glazes, lustre, hispano-moresque, gold flambé and crystalline ware that has ever been got together." (*PG* August 1910). He also exhibited a vase commemorating the disastrous fire at that exhibition: "On one side is a picture of the burnt-out façade of the Exhibition, while on the other a picture of a potter's oven. Round the edge reads a Latin motto, 'What the fire gave, the fire has taken away'." (*PG*, November 1910). As further testimony to his own losses at that exhibition, Moore exhibited in 1911 a "little lustre vase, burnt and battered, with its surface encrusted with molten glass from the roof – a transmutation glaze of a very undesirable nature". (*PG*, August 1911)

At the Arts and Crafts Exhibition of 1910, he exhibited two *Night Scene* vases

116 Bernard Moore's wares, shown at the International Exhibition in Brussels and illustrated in *The Pottery Gazette*, November 1910

117 Bernard Moore porcelain
vase with turquoise-coloured
glaze and Viking longship
painted in gold, marked
"BERNARD MOORE", h. 24 cm.

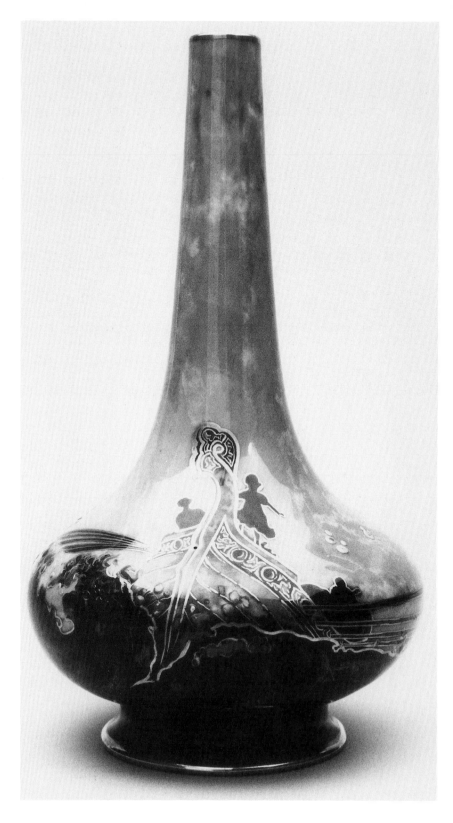

executed with Reginald Tomlinson, a flambé jardinière executed with John Adams and a piece of gold flambé. He won the Grand Prix at the Imperial International Exhibition, London, in 1909, and at the International Exhibition in Brussels in 1910 (116), the Hors Concours Medal at the International Exhibition in Turin in 1911 (where he was a member of the Jury of Awards), and an Hors Concours Medal at the Universal Exhibition in Ghent in 1913 (where he was elected President of the Jury of Awards for the British Section). He was visited at his showrooms by Their Majesties King George V and Queen Mary in 1913.

Despite these successes, the pottery's profitability is doubtful. Moore had to earn his living by his work as a consultant. This work seems to have suited him. He enjoyed solving complex problems and from all accounts he was a genuinely kind man who was glad to be able to assist fellow potters. From an incomplete set of notebooks, Aileen Dawson has compiled a long list of his clients. Among them were Pilkingtons Tile and Pottery Co. (Ltd)*, Doulton & Co. (Ltd), Burslem*, whom he aided in the development of their *rouge flambé* glaze, and J. Wedgwood (& Sons Ltd)*, whom he aided in the development of their powder-blue glaze. Major Frank H. Wedgwood recalled how he used to visit Moore in his "little red shed":

> ... usually when he got there, he found two gentlemen – there were always two – Dr Mellor and Mr Bernard Moore – sitting round a horrible pot stove. The atmosphere was always thick, the place always chock-a-block with all sorts of machines, and these two gentlemen – continually lighting their pipes, or rather matches – reminded one of the witches of "Macbeth". There they sat, plotting unknown things. (*PG>R*, December 1924)

Moore's consultations were not confined to Britain; he travelled to the United States, Spain, Switzerland and France. These journeys seemed to have been plagued with mishaps. He is said to have been in San Francisco during the 1906 earthquake, he "narrowly escaped being included among the victims of the recent gas explosion near Geneva" (*PG*, September 1909), and he suffered a severe blow to the head in a cab accident in London (*PG*, April 1909).

His work on the Lead Commission in 1910 with William Burton led to an improvement in working conditions which the manufacturers found financially acceptable. His papers entitled "The Cause and Prevention of the Red Stain in China Bodies in the Enamel Kiln" (1905) and "Spit Out" (1909) were also invaluable to manufacturers. It was estimated that staining had caused some £50,000 worth of losses to manufacturers and that spit out cost them some £15,000 a year (*PG*, December 1905; April 1909).

By the 1920s, Moore was the grand old man of the industry. At a presentation dinner in 1924, he was toasted as "the greatest and most significant personality in the pottery world of to-day ... there was no man who had ever lived who possessed such deep and wide knowledge of pottery, in its many branches and its varied ramifications ... and not only was his knowledge so intimate and so profound, but he seemed to have an uncanny, intuitive understanding and insight into the many difficult problems a potter had to tackle." His obituary noted: "He was kind-hearted to a fault, and always willing to be of service to any young enthusiast who sought his advice and help."

Moore's son, Major Frank Moore, was general manager at J. Wedgwood (& Sons Ltd)* from 1913 to 1927, after which he became general manager and director of the Worcester Royal Porcelain Co. Ltd.

Artists and decorators

JOHN ADAMS (1882–1953) worked for Moore during his vacations, while attending the National Art Training School at South Kensington. He entered a sgraffito dish into the National Competition of Schools of Art of 1908, which was commended by *The Studio*. His work was exhibited by Moore at the Arts and Crafts Exhibition of 1910. He went on to become one of the principals of Carter, Stabler and Adams (Ltd) (formerly Carter & Co.*). Marks: "JA" monogram.

EVELYN HOPE BEARDMORE (c.1886–1972) worked for Josiah Wedgwood (& Sons Ltd)* before coming to Wolfe Street during the First World War. Her favourite motifs were fish with seaweed and birds with waves. Mark: "HB" monogram.

DORA M. BILLINGTON (1890–1968) trained at Stoke School of Art, then worked for Moore for two years before going on to the National Art Training School at South Kensington. She was for some years Chairman of the Arts and Crafts Exhibition Society, in whose exhibitions she participated regularly. As Instructor in Pottery at the Central School of Arts and Crafts, she greatly influenced an entire generation of studio potters. Mark: "DMB" monogram.

HILDA CARTER (b. 1895) trained at Hanley School of Art, joining Moore by 1913. She left in 1916, and designed tiles until she married. Her designs often included birds and fish. Mark: "HC" monogram.

CICELY H. JACKSON, paintress. Mark: "CJ" or "CHJ" monogram.

HILDA LINDOP, paintress. Mark: "HL" monogram.

ANNIE OLLIER (1878–1951) had worked for Moore at St Mary's Works. She was a capable decorator but, more importantly, served as Moore's laboratory assistant. Her pots were most often decorated with stylised fish, birds, butterflies and grasses. Marks: "AO" monogram.

R. R. TOMLINSON (1885–1978) served a three-year apprenticeship at Minton Hollins & Co. (Ltd)* under Gordon Forsyth*. He then worked at Wolfe Street from 1906 to 1909, thereafter continuing to work during vacations while studying at the National Art Training School. His work was exhibited by Moore at the Arts and Crafts Exhibition of 1910. He was Art Director of the Crown Staffordshire Porcelain Co. Ltd from 1913 to 1919. He was later Senior Inspector of Art to the London County Council from 1925 to 1951 and Principal of the Central School of Arts and Crafts from 1935 to 1936 and 1939 to 1946. Mark: "RTR" monogram.

E. R. WILKES (1861–1953) had worked for Moore at St Mary's Works. He left Moore in 1912 to help Richard Howson, a cousin of William Howson Taylor*, develop his own flambé glazes at Howson's Pottery. Wilkes has been much maligned, both as a painter and a chemist. Some of the results that he achieved at Howson's are admirable.

Marks: "B.M." painted; "BERNARD MOORE", painted, incised or printed, occasionally dated. Various impressed marks from the firms who manufactured the blanks, e.g. "MINTONS", may also be found. Various Moore Bros marks do not necessarily indicate pre-1905 production, as Moore used Moore Bros blanks after the St Mary's Church Works had been sold.

References: Atterbury, Paul, "A Forgotten Art Pottery", *Country Life*, May 6, 1976, p. 200; "Bernard Moore, Obituary", *PG>R*, May 1935; Blacker; *Cox's Potteries Annual and Year Book*, 1925, p. 153; Cameron; Coysh; Dawson, Aileen, *Bernard Moore Master Potter 1850–1935* (Victoria & Albert Museum, 1983); Dawson,

Aileen, *Bernard Moore Master Potter 1850–1935* (Richard Dennis, 1982); Godden 1972, 1988; Hampson, Rodney, *Longton Potteries 1700–1865*, Journal of Ceramic History vol.14 (City Museum & Art Gallery, Stoke-on-Trent, 1991); Jewitt; Lukins, Jocelyn, *Doulton Flambé Animals* (M. P. E., Yelverton, no date); "The National Competition of Schools of Art, 1908", *Studio*, vol. 44, p. 275; *PG*; *PG>R*; "Presentation Portrait of Mr Bernard Moore", *PG>R*, January 1925; "Presentation to Mr Bernard Moore", *PG>R*, December 1924, pp. 1993–96; Rhead and Rhead; Rix; Stuart.

Morris, William
1834–96

Morris was educated at Oxford, where he became fast friends with Edward Burne-Jones* and through him became associated with the members of the Pre-Raphaelite circle. In 1861 he was the driving force in the establishment of Morris, Marshall, Faulkner & Co., for which he also put up most of the money. By 1875, the partnership had proved unworkable and Morris bought out the rest of the partners, after which the firm was known as Morris & Co.*. Apart from his work in the decorative arts, Morris was a prolific poet and essayist and, in his later years, a dedicated socialist.

Morris's output was so varied and enormous that, in retrospect, he has become all things to all people. He is routinely described as the founder of the Arts and Crafts Movement, a precursor of Art Nouveau, a pioneer of modernism and an élitist reactionary. None of these epithets is strictly true, although there is certain justification for all these judgments. What can be said unequivocally is that he had an enormous influence on the decorative arts of the nineteenth and twentieth centuries. Morris himself was greatly influenced by the writings of John Ruskin and by the beliefs of George Edmund Street, to whom he had been articled as an architect. In Henderson's words, "Street believed that an architect should not be just a builder, but a blacksmith, a painter, a fabric worker and a designer of stained glass".

Surprisingly, ceramics is the one field in which Morris did not take an active interest, with the exception of tiles (*see* Morris & Co. below). He designed and painted stained glass, designed and executed embroideries and tapestries, designed, dyed and wove his own fabrics and carpets, designed and printed wallpapers, and designed, printed and illuminated books, but never sat down to the potter's wheel. He did, however, have some very distinct ideas about what pottery should be: "Articles should not be moulded if they can be made on the wheel, or in some other way by hand. Pottery should not be finished by turning on a lathe. Excessive neatness is undesirable, especially in cheap wares. Pottery should not be decorated by printing, and painted decoration should be confined to what can only be done on pottery." These strictures were taken to heart and in some cases followed slavishly by many art potters and the twentieth-century studio potters who followed them.

Morris excelled in flat pattern design, and so his ceramic designs were confined to tiles. According to William De Morgan*, he only executed three of Morris's designs, two of which were Trellis & Tulip and Poppy. However, the Myers have pointed out the large number of designs common to both firms, and suggest that De Morgan may have made some of these designs for Morris during the 1860s and later used them himself.

Morris became a member of the Art Workers Guild* in 1888, some four years after its establishment. Although he did attend some meetings, he was at this point almost entirely absorbed in his political activities, and in the establishment of the

Kelmscott Press. He became Master of the Guild in 1892, but seems to have been more of a celebrity figurehead than one of the active shapers of the Guild's precepts, although many of the Guild's ideas were based on his writings of the 1870s.

References: Brighton 1984; Cameron; *Catalogue of the Morris Collection*, (William Morris Gallery, Walthamstow, second edition, 1969); Day, Lewis F., "Of William Morris and his Work", *AJ, Easter Annual*, 1899; Fitzgerald, Penelope, *Edward Burne-Jones* (Hamish Hamilton, 1989, originally published in 1975); Gillow, Norah, *William Morris: Designs and Patterns* (Bracken Books, 1988); Henderson, Philip, *William Morris: His Life, Work and Friends* (Thames & Hudson Ltd, 1967); Marsh, Jan, *Jane and May Morris: A Biographical Story 1839–1938* (Pandora, 1986); Myers, Richard and Hilary, "Morris and Company Ceramic Tiles", *Journal of the Tiles and Architectural Ceramics Society*, vol. I, 1982, p. 17–22; Myers, Richard and Hilary, "William Morris Tile Survey", *GE*, summer 1981, p. 2; Naylor, Gillian, editor, *William Morris by Himself* (Macdonald Orbis, 1989); Pinkham, Roger, "A Morris and De Morgan Tile Panel", *Victoria & Albert Museum Masterpieces*, 13 (Victoria & Albert Museum, 1977); Stokes, Susan M., *William Morris*, Bibliographies No. 5 (Fine Arts Department, Birmingham Public Libraries Reference Library, 1977); Tames, Richard, *William Morris* (Shire Publications Ltd, Aylesbury, 1972); Tilbrook; Vallance, Aymer, *The Life and Work of William Morris* (George Bell & Sons, 1897, reprinted Studio Editions, 1986); Van Lemmen, Hans, *Decorative Tiles Throughout the Ages* (Bracken Books, 1988); Wright, Meg, "The Multi Faceted William Morris", *Collectors' Fayre*, April 1990, pp. 6–7.

Morris & Co.

8 Red Lion Square, London
1861–65
26 Queen Square,
Bloomsbury, London
1865–81
Merton Abbey, Surrey
1882–1940

Unable to find suitable furnishings for The Red House, his new home, William Morris enlisted the aid of his many Pre-Raphaelite friends to design and execute furniture, tapestries and murals with which to decorate it. The group soon decided that offering their services as decorators might be a useful supplement to their erratic earnings. Morris, Marshall, Faulkner & Co. was established in March 1861 as a partnership between Ford Madox Brown, Charles Faulkner, Edward Burne-Jones*, P. P. Marshall, Dante Gabriel Rossetti, Philip Webb and William Morris. Morris's mother lent £100 as capital and the other partners contributed single shares of £1. Although Morris was paid a salary of £150 for management of the firm, he soon felt that the others were doing far less than they should. In 1875, after much acrimonious dispute, Morris bought out his partners and the firm was restyled Morris & Co. Edward Burne-Jones, a very close friend of Morris, continued to supply the firm with designs.

Initially, the firm contracted the execution of most of their designs out to other manufacturers, but Morris was dissatisfied with the standard of the work and ideologically opposed to the mode of production. He soon began to experiment with the production of textiles, carpets and wallpapers. By the late 1870s, Morris needed to find larger premises and, after a very long search, he settled at Merton Abbey.

The first prospectus of the firm did not mention any form of ceramics, but it is worth quoting at length, as the precepts set forth were to be repeated by various art potters in the ensuing years:

> The growth of Decorative Art in this country, owing to the efforts of English Architects, has now reached a point at which it seems desirable that Artists of reputation should devote their time to it. Although no doubt particular instances of success may be cited, still it must be generally felt that attempts of

this kind hitherto have been crude and fragmentary. Up to this time, the want of that artistic supervision, which can alone bring about harmony between the various parts of a successful work, has been increased by the necessarily excessive outlay, consequent on taking one individual artist from his pictorial labours . . . These artists having for many years been deeply attached to the study of the Decorative Arts of all times and countries, have felt more than most people the want of some one place where they could either obtain or get produced work of a genuine and beautiful character.

The only art pottery known to have been retailed by the firm were those of Morris's dear friend William De Morgan* and the Della Robbia Pottery*. Morris combined business with pleasure whenever he travelled, frequently acquiring peasant pottery for sale in London. In Florence in 1873, he bought "a lot of queer pots they use for hand-warmers, 'scaldini' of leaded glazed ware" and flasks in wicker holders. Morris wrote: "Ned [Edward Burne-Jones] complains of me that I seem to pay more attention to an olive tree or a pot than I do to a picture . . . I understand more of pots than of pictures . . ."

It is amusing to learn that, despite Morris's disapproval of printed pottery (see page 213), the Pre-Raphaelites all adored Willow pattern crockery. According to Fitzgerald, they believed it to be the "only honest pattern available". Elizabeth Siddal, wife of Dante Gabriel Rossetti, signed one of her letters to Georgina Burne-Jones: "a willow pattern dish full of love to you and Ned." Rossetti, Burne-Jones, J. M. Whistler and G. P. Boyce brought Willow pattern dishes to the poet Algernon Swinburne as housewarming gifts. Various accounts of meals at the Morris homes and that of Ford Maddox Brown mention that Willow pattern dishes were used. One cannot help but surmise that, if the group had not been enamoured of Willow, they might have been interested in making their own tablewares.

The early tiles decorated by Morris & Co. were imported from Holland, as Morris was unable to locate a native source of hand-made, rather than dust-pressed, blank tiles. Despite Morris's abhorrence of machine-made tiles, a few examples of Morris & Co. decoration on such tiles have been recorded. The decorated tiles were fired in the stained-glass kiln. Edward Burne-Jones and Morris designed most of these but Albert Moore, William de Morgan, Dante Gabriel Rossetti, Ford Madox Brown, Philip Webb and Simeon Solomon also designed stained glass and tiles occasionally. Stained glass, tapestry and wallpaper designs were often adapted to tiles. It seems that all the tile designers occasionally executed their own designs, but most of the tiles were painted by Charles Faulkner's sisters, Kate and Lucy Faulkner, often assisted by Georgina Burne-Jones. George Campfield, a stained glass painter who was foreman of the firm for many years, is also known to have painted some tiles. The tiles were most often blue and white, or blue, yellow and white (118). At the International Exhibition in London of 1862, the firms' great debut, tiles painted by Dante Gabriel Rossetti, Edward Burne-Jones, Philip Webb and William Morris were exhibited.

In its 1881 catalogue the firm claimed to have successfully revived the art of tile-making "similar in manner to the ancient majolica: of these we keep in stock several sets of figures with appropriate diapers and borders suitable for the decoration of fireplaces in private houses . . .". Compared to the usually more fragile wallpapers and textiles, surprisingly few Morris tiles have survived. The decoration deteriorated relatively quickly, especially when exposed to the heat of fireplaces. Morris later relied on William De Morgan to supply his colours, with somewhat

118 Tiles designed by William Morris. *Above left*: Artichoke pattern hand painted over the glaze by Morris & Co. *c*.1870, on Dutch blank, 15 cm sq. *Above right*: Colombine pattern, hand-painted over the glaze by Morris & Co., *c*.1870, on Dutch blank, 15 cm sq. *Below left*: Scroll pattern stencilled and hand-painted in-glaze in bright blue on white ground, *c*.1895, produced in Holland, probably by Ravesteyn Utrecht. *Below right*: Daisy pattern, hand-painted in-glaze in polychrome on white ground, *c*.1875, produced in Holland, probably by Tjallingi Utrecht.

better results. There were no kilns at Merton Abbey, and so Morris had tiles and stained glass fired elsewhere. Some of the firm's designs at this time were executed entirely in Holland. A number of unauthorized reproductions of Morris & Co.'s tiles were also made there.

Marks: Morris & Co. tiles were not usually marked, although some marked "F/A" are recorded. Some panels which were repurchased by Morris & Co. in later years may bear a paper label with the address of the firm's Oxford Street showrooms.

References: *See* William Morris.

Morris, Marshall, Faulkner & Co.

See Morris & Co.

Mortlake Pottery

See George Cox.

J. Mortlock or Mortlocks Ltd
Oxford Street and other addresses in London
1746 or 1796–*c*.1930

Mortlock was a leading china retailer who dealt in some of the better-quality wares, for example, Coalport, Derby, Worcester and Mintons*. Miss Black established a china painting studio under the auspices of Mortlocks at Orchard Street after the closure of Minton's Art Pottery Studio*. R. Mawley reprinted several of Mortlock's advertisements, most notably:

MORTLOCK'S POTTERY STUDIO – LESSONS in CHINA PAINTING are given daily at this Studio, or at private residence if required, by the principal leading artists who were employed at Minton's Studio, South Kensington, before the late fire. Colours, bisques or glazed pottery, paint boxes, and all necessary materials supplied. Paintings fired twice weekly. Sole Addresses, the Pottery Galleries, 203 & 204 Oxford-street, and 31, Orchard-street, Portman-square.

Marks: "MORTLOCK'S STUDIO LONDON".

References: Godden 1964, 1988; [Mawley, R.], *Pottery and Porcelain in 1876* (Field & Tuer, 1877).

Myatt Pottery Co.
Bilston, Staffordshire
1845–c.1894

The Pottery Gazette Dairy of 1884 carried this advertisement: "Myatt Pottery Co., Bilston, Staffs., Fine Art Potters, Flower Vases, Plaques in Terra-Cotta, Ornamental Glazed Wares, Bristol Stoneware etc.".

Marks: "MYATT" in a rectangle, impressed.

References: Godden 1964; *PG Diary* 1884.

Newsham Pottery
near Blythe, Northumberland
1911–c.1914
Blythe Pottery Co.
1920–22
Newsham Pottery Co. Ltd
1922–?

The following appeared in *The Pottery Gazette* of April 1911:

As a result of the initiative of Lord Ridley, an art pottery factory is to be established at Newsham, near Blythe. A considerable area of fine clay exists in the district, and Mr George Skee has had all the necessary buildings and plant for an extensive business erected. There will be a considerable output of useful and fancy crockery, and almost every description of builders' decorative casts will also be supplied. Mr Skee proposes at the first burning, which is to take place shortly, to introduce a model of a mongrel dog to be known as the "Newsham Terrier".

The pottery closed down during the First World War, to be reopened by the Blyth Pottery Co., once again under the management of George Skee, who was described as a local artist. It was hoped that there would be "a steady output of utensils which are in daily use in the home." (*PG>R*, December 1920)

In 1922 the Newsham Pottery Co. Ltd was registered as a limited company with capital of £6,000, with the object of acquiring the business carried on by Mary

Egerton and J. Philipps under the style Newsham Pottery Co. The firm manufactured bricks, tiles, terracotta and stoneware. (*PG>R*, January 1922)

References: *PG*; *PG>R*.

**North Walian Art
Pottery**

See I. & W. Powell.

Omega Workshops Ltd
Bloomsbury, London
1913–19

Roger Fry (1866–1934) was a painter, art historian and critic and one-time director of the Metropolitan Museum of Art in New York (1905–10). He established the Omega Workshops to sell fabrics, furniture, pottery and entire decorative schemes executed by young English Post-Impressionist artists. A number of artists worked briefly with the group, but the mainstays were his co-directors, the painters Duncan Grant (1885–1978) and Vanessa Bell (1879–1961), sister of Virginia Woolf. Their designs were very much influenced by the Fauvist and Cubist movements, which Fry championed.

A leaflet advertising their objects showed that Fry's approach to the decorative arts was influenced by John Ruskin and William Morris*:

> The Omega Workshops Limited is a group of artists who are working with the object of allowing free play to the delight in creation in the making of objects for common life. They refuse to spoil the expressive quality of their work by sandpapering it down to a shop finish, in the belief that the public has at last seen through the humbug of the machine-made imitation works of art. They endeavour to satisfy practical necessities in a workmanlike manner, but not to flatter by the pretentious elegance of the machine-made article. They try to keep the spontaneous freshness of primitive or peasant work, while satisfying the needs and expressing the feelings of the modern cultivated man.

Fry's beliefs about pottery harked back to Morris and Ruskin and looked forward to the perception of ceramics as sculpture as proposed by the studio potters, most especially William Staite Murray:

> . . . of all the crafts none has suffered more than pottery from the application of scientific commercialism. We now use almost entirely articles which have lost all direct expressiveness of surface modelling. Our cups and saucers are

reduced by machine turning to a dead mechanical exactitude and uniformity. Pottery is essentially a form of sculpture, and its surface should express directly the artist's sensibility both of proportion and surface. The Omega pottery is made on the wheel by artists and is not merely executed to their design. It therefore represents, as scarcely any modern pottery does, this expressive character.

Initially, Fry obtained pottery blanks for decoration from George Schenk* at Mitcham, in Surrey. Fry wrote to Duncan Grant in 1914:

> Vanessa and I have been potting all day . . . We went when the potter wasn't there and got the man to turn the wheel. It was fearfully exciting at first; the clay was too stiff and Vanessa very nearly bust with the effort to control its wobbleness [sic] – and in vain; then we got softer clay and both of us turned out some quite nice things – little ones mostly, but they'll make quite nice little bowls and pots. It's fearfully exciting when you get it centred and the stuff begins to come up between your fingers.

When the Mitcham pottery closed down in 1914, Fry's friend Winifred Gill recommended Carter & Co.*. Soon, Fry was spending long periods at Poole, learning to throw, glaze and decorate his own pots, many of which were decorated with only a "white tin glaze analogous to that of the Old Delft" or a black, dark blue or turquoise glaze. With the outbreak of the First World War, tin was needed for munitions, and the tin glaze was replaced with white slip. Despite Fry's purist attitude towards pottery, he made a prototype for a dinner service, tea and coffee sets, from which moulds were made. Phyllis Keyes slip-cast the wares and Angelica Bell decorated many of the pots. The firm advertised ashtrays, inkstands, letter-weights, jam pots, cruet stands, salad bowls, tiles, tea sets, vases, bowls, large jars and jugs. They also made figures of polar bears, cats and the Madonna and Child.

It is hard to find anything positive to say about the pots produced by Omega. The pots made by Fry are thick and clumsy. The decoration, even if it appeals, has not withstood time and is often scaling. Nevertheless, some important developments came from Omega's efforts. Angelica Bell, daughter of Vanessa Bell and Duncan Grant, was to design plates for E. Brain & Co. Ltd* in 1935. Her half-brother Quentin Bell, son of Vanessa and Clive Bell, has become a potter much influenced by the Omega style, though technically proficient. His designs from original moulds by Roger Fry were produced by J. Wedgwood (& Sons Ltd)* in 1936. Both Duncan Grant and Vanessa Bell designed for Brain & Co. Ltd* and Clarice Cliff's Bizarre range, of 1932–34, at A. J. Wilkinson Ltd*. They also painted on J. Wedgwood (& Sons Ltd)* blanks and painted some trial pieces at Etruria during the 1930s. To some extent, it is believed that Fry's influence can be seen in the productions of Carter, Stabler and Adams (Ltd), who took over Carter & Co. in 1921. Most certainly, the pottery imitating North African wares that was sold at Omega served as a direct inspiration for some of Carter & Co.'s late designs.

It is more difficult to assess Omega's influence on the development of ceramic design in the twentieth century. Although it was ignored during its brief life, Quentin Bell claimed in 1964: "It is a prototype of the ceramics of our century. From it a generation has learned to avoid fussiness and indecision and yet it also has a sensual quality . . . It is a useful reminder that simplicity need not be dull."

The short career of the workshop was tumultuous, with many artistic disputes

splitting the members. The workshop dwindled away during 1918–19, finally closing down and selling off the remaining stock, in June 1919.

Marks: Ω, painted or impressed.

References: Anscombe, Isabelle, *Omega and After: Bloomsbury and the Decorative Arts* (Thames & Hudson, 1981); Batkin; Bell, Quentin, "The Omega revisited", *The Listener*, 30 January 1964, pp. 200–01; Cameron; Diamand, Paula, *Some Recollections and Reflections about the Omega* (unpublished manuscript, c.1968); Haslam, Malcolm, "Some Vorticist Pottery," *The Connoisseur*, October 1975, vol. 190, pp. 98–101; Hawkins, Jennifer, *The Poole Potteries* (Barrie & Jenkins, 1980); Jervis; Murray, Peter and Linda, *Dictionary of Art and Artists* (Penguin Books, revised edition, 1989); Naylor, Gillian, editor, *Bloomsbury: The Artist, Authors and Designers by Themselves* (The Octopus Group, 1990); *The Omega Workshop, Alliance and Enmity in English Art, 1911–20* (Anthony d'Offay Gallery, 1984); Omega Workshop Ltd, *Catalogue* (no date); *Twentieth-Century Art* (Whitechapel Art Gallery, May–June 1914).

Palissy Pottery Co.
Linton, Swadlincote, Derbyshire
c.1892–c.1897

This firm advertised in *Morris's Business Directory* of 1892–97 as an "Art Pottery Manufacturer" and "Sole Manufacturers of Palissy art pottery".

Passenger, Charles and Fred

Charles and Fred Passenger began to work for William De Morgan* in 1877 and 1879, respectively (119 and Colour XII and XIV). They were De Morgan's partners during the period 1898–1907 at Sands End, Fulham, London. During the period 1907–11, after De Morgan's retirement (which had actually begun in 1905), the brothers continued to decorate pottery after De Morgan's old designs, at Brompton Road, London. From 1923 to 1933 Fred continued to decorate pots with De Morgan-inspired designs at the Bushey Heath Pottery*. Charles's work was exhibited at the Arts and Crafts Exhibitions of 1888, 1889, 1890, 1893, 1896 and 1899. Fred's work was exhibited at the Arts and Crafts Exhibitions of 1888, 1889, 1890, 1893, 1896, 1899 (with De Morgan), and 1923 and 1926 (with Ida Perrin of Bushey Heath Pottery).

Marks: "CP" or "FP", painted.

References: A&CXS 1888, 1889, 1890, 1893, 1896, 1899, 1923, 1926; Cameron; *See* references for Bushey Heath Pottery and William De Morgan.

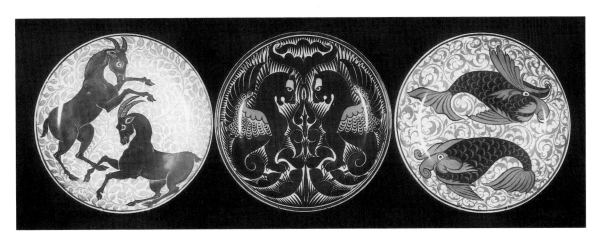

119 William De Morgan ruby lustre chargers. *Left and right*: *c*.1888–95. *Centre*: by Fred Passenger, with initials "FP", impressed "17". Each d. 36 cm.

Pembury Pottery

See Philip Peters & Co.

Peters, Philip & Co.
Pembury Pottery, Pembury, Kent
c.1886–*c*.1938

Philip Peters, the landlord of the Royal Oak public house, discovered clay at the bottom of his garden and established the Pembury Pottery. He first appears in the local directory in 1886 as proprietor of the Royal Oak and as a brick and pottery manufacturer. In 1889 he is listed as a manufacturer of "fine art pottery". He had become a retailer of china and glass by 1892. By 1916, Peters's executors were running the brickworks and pottery. The firm last appears in the local directory of 1938.

This pottery made principally domestic redware in the rustic style. Decorative pieces such as candlesticks were made to resemble tree trunks or branches. These wares were all consistent with the country pottery produced in Kent and Sussex at the time. However, some very successful glaze experiments seem to have been made; a very large redware vase with a wonderful green and yellow mottled glaze marked "PEMBURY WARE" and with the monogram "TH" is in the Maidstone Museum.

The two bottle kilns were fired with the scraps of chestnut wood left over from the manufacture of hop poles. The small output of the pottery may be judged by the fact that it took the two or three throwers about five months to fill the kilns. The pottery also made bricks, which were apparently used as saggars to shield the pottery from the wood ash. When the local farmers began to train their hops up strings, Peters tried unsuccessfully to fire the kilns with coal. It appears that this was the end of art pottery production at Pembury.

Some examples of Pembury rustic ware may be found at the Tunbridge Wells Museum. A marvellous green and yellow glaze effect vase can be seen at the Maidstone Museum.

Marks: "PEMBURY WARE", impressed, and "TH" monogram, incised.

References: *KPOD Tunbridge Wells*, 1886–1938; Standen, E. J., *Just One Village, 1910–60* (1974); Standen, M. E., *A History of Pembury* (privately published, 1984).

Phillips Art Pottery Studio

357–359 Oxford Street,
London
1876–?

Phillips was a London china-retailer operating c.1799–1929. They were based at the Oxford Street address c.1858–97. After the fire at Minton's Art Pottery Studio* in 1875, Phillips engaged John Eyre* to set up a china-painting studio. R. Mawley reprints the following advertisement: "ART POTTERY STUDIO – Messrs. PHILLIPS have now completed their building, and having engaged Mr Eyre (of Minton's late studio, South Kensington) as Superintendent, are prepared to give LESSONS in PAINTING on POTTERY. Materials supplied. Special designs executed at the studio. Entrance 357, 358, 359 Oxford-street, W." Mawley goes on to say: "Some plates painted either by him [Eyre] or under him were shown to me. The mode of treatment I thought novel, but the effect was not so good as it might have been . . . Two circular *plaques* painted at the studio in Oxford-street, under Mr Eyre's direction, took my fancy, and not being expensive, I bought them."

Marks: various printed marks incorporating "Phillips".

References: Godden 1964; [Mawley, R.], *Pottery and Porcelain in 1876* (Field & Tuer, 1877).

Pilkingtons Tile and Pottery Co. (Ltd)

Clifton Junction,
near Manchester
1892–1938
Pilkington's Tiles Ltd,
1938 to the present day

An unsuccessful attempt to drive a new mine shaft at the Clifton Colliery led to the discovery of red marl clay. The Pilkington family, who owned the colliery, sent samples to William Burton*, then a chemist at J. Wedgwood (& Sons Ltd)*, asking his opinion as to whether it would produce satisfactory bricks. Burton, in fact, recommended that they produce decorative tiles, and the Pilkingtons soon secured the services of William and his brother Joseph as Manager and Assistant Manager. William was given a free hand to design the efficient and modern works, which began production in January 1893.

The firm soon established a wide reputation for these tiles. In an article on tiles in *The Art Journal* in 1895, Lewis F. Day* described their efforts:

> . . . Messrs' Pilkington's "sun-stone" glaze, a less positive kind of "aventurine" surface, applied to tiles. This is quite unlike anything that has been done before; both it and the imitation of agate by the same firm, though not to be commended in so far as they simulate natural stones, are intrinsically of very great beauty . . . The most striking of the firm's new departures is a kind of cloisonné enamel, in which a fine raised earthenware outline separates the cells of variously coloured deep rich glaze . . . They appear to have carried colour printing, if not farther than anyone else, at least as far as it has yet been carried.

An article about the works noted that, unlike the majority of tile manufacturers, "the company do a larger business in artistic tiles than in plain ones. Their productions include all descriptions of decorated tiles, including particularly printed, embossed, painted, enamelled and mosaic, and small pieces used for fine artistic mosaics, made from plastic clay of different colours." (*PG*, 1909) G. W. Rhead* stated, in 1910, that they were "probably the largest manufactory of decorative tiles in this country".

The Burton brothers soon decided that the Sunstone glaze (developed by Joseph in 1893), which had small gold flecks in a green, yellow or brown glaze, would be seen to better advantage on hollow wares than it was on the flat surface of tiles. William Burton's lecture to the Society of Arts in 1896, entitled "The Palette of the

Potter", illustrates that he already had extensive experience in working to achieve a wide range of glaze effects, including lustre, although these were not to be perfected and exhibited for some years to come.

Pilkingtons produced two lines of pottery. Lancastrian – simple classical shapes designed by Lewis F. Day and decorated only with the Burton brothers' magnificent glaze effects – was introduced at the Graves Gallery, London, in June 1904. The Burtons had actually been experimenting with this ware for some ten years in limited quantities, but had held it back until they had enough to put on what was universally described as a stunning show. In fact, Burton had displayed a case of these wares at the Manchester Arts and Crafts Exhibition of 1899. This ware ". . . represented all that has been done in this branch of handicraft, and was chiefly interesting as showing experiments in coloured glazing. The method was said to be 'after the manner of the Chinese', and the colours obtained were certainly very pleasing. Some of the greens were especially pure and translucent, and the shapes of the vases were simple and good." (*Studio*, 1899) The early experiments were made upon pots supplied by the Kirkby Lonsdale Pottery*. The glaze effects exhibited in 1904 included orange peel, egg-shell, metallic, transmutation and fruit-skin glazes. Lewis F. Day also mentions that flambé wares were being produced at this time.

Arthur Veel Rose of Tiffany & Co. divided these glaze effects into several categories: opalescent, crystalline and texture. The opalescent glazes

> in which throughout the substance of the glaze, and giving to it an appearance of marvellous depth, we have veinings, striations, or cloudiness, sometimes showing themselves only as lighter or darker variations of the ground colour, but at other times taking on a distinct hue of their own . . . These effects run through the whole gamut of colors from the palest ivory tones or delicate bluish greys, through pale blue or green to full-bodied yellows, blues, greens, or rich browns.

Apart from the Sunstone glaze, Rose singled out the Fiery Crystalline: ". . . while the glaze itself is of a rich copper hue, beautiful red crystals, almost like splinters of garnet, display themselves upon its surface, producing an effect of the utmost richness." The Texture glazes were those in which

> . . . the surface is no longer brilliant and glossy, but resembles in gloss and feel rather the surface of egg shell or old vellum . . . Beautiful soft shades of yellow, brown, and green are to be found among these glazes, while perhaps most noteworthy of all is a vivid and intense blue such as has never been seen in pottery before. In another variety of this texture glaze, the color and often the surface of the glaze itself are broken and varied just as we would expect to find the skin of a ripe pear or some similar fruit.

These latter were, of course, the fruit-skin glazes. The metallic glazes included a gold glaze which had the appearance of lacquer. At the Universal Exhibition in Liège in 1905, Pilkingtons introduced their *sang-de-bœuf* glaze.

By 1905, Lancastrian wares were being retailed by Tiffany & Co.* in New York. Arthur Veel Rose, of Tiffany, wrote a pamphlet about the pottery published that year. In 1907, Sir Casper Purdon Clarke acquired, through Tiffany & Co., a collection of Lancastrian Lustre for New York's Metropolitan Museum of Art.

In January 1906, Pilkingtons was advertising: "The latest development in

artistic glazes . . . superb effects in lustre, crystalline, opalescent, flambé, transmutation and texture glazes . . ." The brothers continued to experiment, frequently improving upon or adding to the range available.

Their Lancastrian Lustre wares were introduced shortly after the debut of the Lancastrian wares. These were "true lustre", that is, reduction lustres with a smoky iridescence, as opposed to what William Burton referred to as "metallised" or "plated" wares in an address to the Northern Art Workers Guild at the Manchester School of Art in 1908. In this address he also mentioned that: "They had found it possible to produce excellent lustres on glazes of every type – leadless glazes, lead glazes, and glazes with or without oxide of tin." (PG, January 1908). Burton also pointed out that, having mastered the technical side of lustre production, they then set about gathering the finest collection of young artists from the art schools that they could find, also employing the established talent of Walter Crane* and Lewis F. Day. In 1907, The Pottery Gazette commented:

> All the pieces are painted by different artists, for it is one of the merits of this Lancastrian lustre ware that no two pieces are decorated alike. All the artists are left free to treat each vase, plate or dish on its merits, and while there is a unity of purpose through the works as a whole, there is endless variety in detail and treatment.

This is not entirely true, for there certainly were set designs which were carried out to order by whichever artist happened to be available. Cross, for example, illustrates three vases in Walter Crane's Sea Maiden pattern, two of which were painted by Richard Joyce and one by William S. Mycock. In reference to this very issue William Burton stated: "In cases where they have been fortunate enough to obtain designs from distinguished decorative artists like Mr Walter Crane no two pieces were reproduced in the same way." (PG, January 1908) However, while an expert might distinguish between the copy by Joyce and that by Mycock, to the untutored eye the vases certainly appear identical, or as identical as hand-painting allows. In fact, designs were pounced onto the pots by means of tissue paper tracings of the designer's original drawing, which necessarily limited the creativity of the painter. Nevertheless, there is no doubt that the artists were strongly encouraged to develop their own ideas, within the stylistic canon of Walter Crane's, and later Gordon Forsyth*'s, work.

Pilkingtons stand at the Franco-British Exhibition of 1908, designed by Manchester architects Edgar Wood and J. H. Sellars, was deemed a great success. The exterior was covered in Parian faience tiles (especially designed to withstand weather and pollution) arranged in a chevron pattern of white and sage green, with bands of blue, black and white unglazed pottery for relief. The interior was truly exotic, with a flattened Byzantine dome incrusted with a mosaic of turquoise tiles, relieved with bands of silver lustre. The upper part of the walls was covered with Lewis F. Day's Persian tiles and, below the dado, with mottled green tiles. The floor was a black and white mosaic. As if that were not enough to give one vertigo, the fireplace was of marble inlaid with lustre tiles. Within there were, of course, numerous cases filled with the Lancastrian and Lancastrian Lustre wares.

All the ware sent by the firm to the Venice International Exhibition of 1908 was purchased by Italian museums. It won a Grand Prix at the International Exhibition in Brussels in 1910, for its wares, which included a bowl by Gordon Forsyth. commemorating the disastrous fire at that exhibition. Of their display at the International Exhibition in Turin in 1911, The Pottery Gazette noted:

The smaller cases are chiefly occupied by specimens of lustre and transmutation glazes now so much in vogue. In the discovery of these Messrs Pilkington were among the pioneers, and though it is a case of "all can grow the flower now that all have got the seed", and makers of such glazes are springing up on every side, this firm still keep easily in the front ranks. (*PG*, August 1911)

The year 1913 saw the issue of a Royal Warrant, and the firm's productions were thereafter known as Royal Lancastrian.

This was really the peak of the Lancastrian wares' fame. In 1915, William Burton retired, leaving Joseph as manager. Although Joseph Burton's talent and competence were beyond doubt, he does not seem to have possessed the innovative flair of his brother. The pottery further suffered from the loss of several of its principal artists, who were serving in the armed forces. Most crippling was the loss of Gordon Forsyth, who only returned briefly after the war.

All tile manufacturers suffered a severe drop in demand during the First World War but afterwards the tile side of Pilkingtons's output increasingly dominated the firm. In 1928 Lapis Ware was introduced, being first exhibited at the British Industries Fair in 1929. This was decorated on the biscuit ware "in underglaze colours of special composition, which change in the firing and soften and merge to a certain extent with the glaze . . .'. (*PG>R*, March 1934) The pottery side of the business slowly wound down; a decision to cease pottery production was taken in 1937, the last firing taking place in 1938.

In 1948 William Barnes set up a pottery studio which made attractive decorative wares in the Contemporary style of the 1950s. This studio closed in 1957. In December 1964 the firm merged with Poole Pottery Ltd and in 1971 the amalgamated firm was taken over by the Thomas Tilling Group. There was another revival of pottery production in 1972–75. Although these wares were sometimes taken from Carter & Co. and Pilkingtons originals, the glaze effects, being commercially supplied, were entirely different. The colours most often used were green, orange and blue. In March 1983 Thomas Tilling was bought by the finance group British Tyre and Rubber. The firm continues as a tile manufacturer to this day.

Artists, designers and other important figures

Dates refer to periods at which individuals are known to have worked at Pilkingtons. Dates in brackets are those of birth and death.

ALBERT E. BARLOW, 1903–14, studied at the Salford School of Art and later at the Manchester School of Art, winning several prizes in the National Art School competitions. His tiles for a wall fountain submitted to the National Competition in 1910 was illustrated in *The Studio*. An illustration in *The Pottery Gazette* of October 1909 shows him painting lustre tiles in "Persian and other Oriental designs . . .". In 1914, Barlow left to study at the Royal College of Art, afterwards becoming a designer and calligrapher.

MISS BARLOW painted tiles shown at the Arts and Crafts Exhibition of 1903.

EMME BOULTON painted tiles shown at the Arts and Crafts Exhibition of 1896.

MISS M. BRADLEY painted tiles shown at the Arts and Crafts Exhibitions of 1896, 1899 and 1903.

KATE BRIGGS was a paintress of tiles who left the firm on her marriage to John Chambers.

ANNIE BURTON, working until 1916, was the niece of Joseph and William Burton. She designed and painted Lancastrian Pottery exhibited at the Arts and Crafts Exhibitions of 1910 and 1912. She specialized in florals.

DAVID BURTON, the son of Joseph Burton, worked closely with his father in developing glazes (*PG>R*, December 1927). On his father's death in 1934, he succeeded him as Manager.

JOSEPH BURTON (1868–1934) was a skilled ceramic chemist like his brother William. He was Assistant Manager 1892–15, and Manager 1915–34. After the departure of Gordon Forsyth, Burton took over the artistic direction of the firm as well. Although long in the shadow of his eminent brother, Joseph was a talented and widely respected figure in the pottery industry.

WILLIAM BURTON*, 1892–1915, was the firm's Manager from its establishment in 1892, until 1915. He engineered the firm's early success, and, after his departure, Pilkingtons' pottery aspect declined. His career is largely described in the main text of this entry and that under his own name.

JOHN CHAMBERS, early 1890s–1938, had worked as a freelance designer for J. Wedgwood (& Sons Ltd)* and Doulton & Co. (Ltd), Burslem*. He was chief designer of tiles and the first head of the architectural faience department and also painted some pottery. His tiles were among those exhibited at the Manchester Arts and Crafts Exhibition of 1895, the Arts and Crafts Exhibition, London, of 1896, and the International Exhibition, Paris, of 1900. Lancastrian Pottery and Lancastrian Lustre Pottery designed by Chambers was included in the Arts and Crafts Exhibition of 1906.

JAMES ROBERT COOPER was an active designer before the establishment of Pilkingtons. At the Manchester Arts and Crafts Exhibition of 1891, he displayed decorative friezes and figures. Glazed Pilkingtons tiles designed by Cooper were shown at the Arts and Crafts Exhibition of 1899, the Glasgow International Exhibition of 1901 and the Paris International Exhibition of 1900. He was mentioned as an important tile designer in *The Pottery Gazette* of October 1909.

WALTER CRANE*. Crane's work for Pilkingtons is of importance not only for his actual designs, but because his style had a great influence on Pilkingtons in its formative period. His style of illustration was much influenced by Japanese woodcuts as well as by classical Greek decorative art. Another motif which appeared frequently in his work was a mounted knight which he had used originally in his illustrations for Spenser's *Faerie Queene*. Two vases with raised figures in slip under the glaze designed by Crane for Pilkingtons were exhibited at the Arts and Crafts Exhibition of 1906. Lancastrian Pottery designed by Crane was shown there in 1910, 1912 (when some pots were also painted by Crane) and 1916. His work shown at the Franco-British Exhibition of 1908 was illustrated in *The Studio* that year. His *Valkyrie Vase*, in silver and ruby lustre on a sapphire ground, and his *Saint George for England*, a vase with a powder-blue ground and modelled design, also with silver and ruby lustre, were singled out for mention by *The Pottery Gazette* (July 1908). Crane was also mentioned as an important tile designer at Pilkingtons in *The Pottery Gazette* of October 1909. His tiles were among those shown at the Paris International Exhibition of 1900.

CHARLES CUNDALL, 1907–14; 1917, studied at the Manchester School of Art and Levenshulme Evening School. His punch bowl and two vases in silver and ruby lustre were awarded the chief honours at the National Competition of Schools of Art 1908: "They were the work of a very young student, but there was no sign of

120 Pilkingtons Tile & Pottery Co. (Ltd) Lancastrian Wares, impressed bee marks, date codes 1907 and painted artists' monograms. Small vase painted by Charles Cundall, h. 15.4 cm. Large vase painted by Richard Joyce, h. 27 cm.

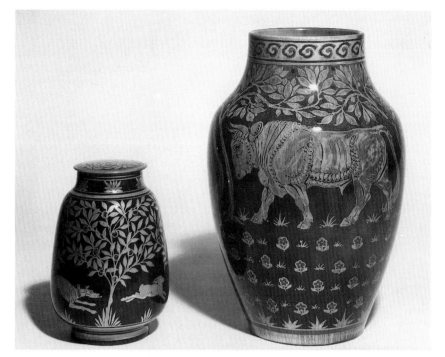

121 Pilkingtons Tile & Pottery Co. (Ltd) Royal Lancastrian charger, painted by William S. Mycock, impressed rosette mark, painted artist's monogram and date code for 1934, h. 47.4 cm.

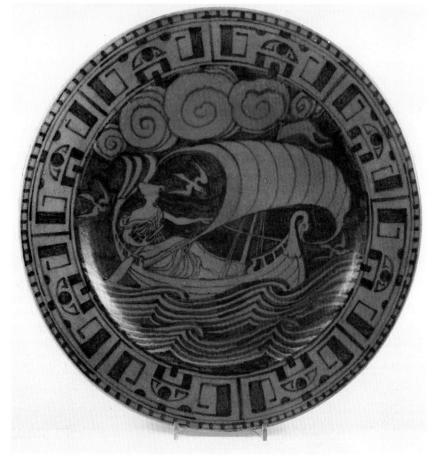

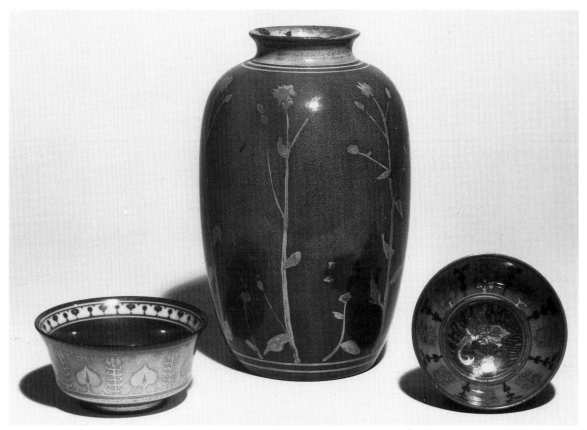

122 Pilkingtons Tile & Pottery Co. (Ltd) Lancastrian Ware, with impressed bee marks. *Left to right:* bowl, lime green glaze decorated with lustre, painted artist's mark and date code for 1908, h. 9.7 cm; vase, blue glaze with ruby lustre decoration, date code for 1908, h. 19.5 cm; bowl painted by Jesse Jones, ruby and blue glazes with lustre decoration, artist's monogram, h. 8.7 cm.

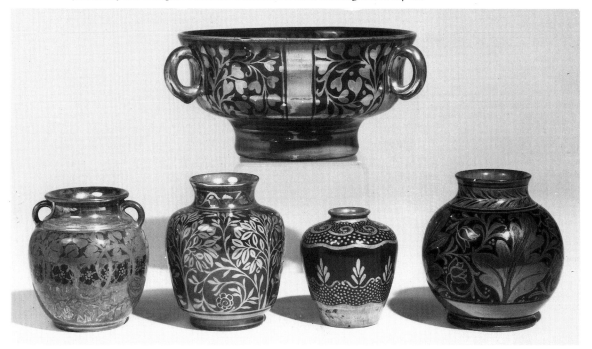

immaturity in their design or execution." (*Studio*, 1908, illustrated) Lancastrian Pottery designed and painted by Cundall was shown at the Arts and Crafts Exhibitions of 1910 and 1912. He is probably the youth mentioned in *The Pottery Gazette* of October 1909:

> I was greatly interested in the work of the youth seen seated at the first table. I do not know his name or I would give it. Mr Burton addressed him as Charlie, and asked him to complete a section of some work on which he was engaged in order that I might see it done. "Charlie" proceeded to portray a leafage design. He works with his left hand, and displays considerable artistic ability (he would not be there if he did not!). More will be hear of Mr Charles – in the not distant future.

In his early years, Cundall mostly painted the designs of the other artists, but developed his own style, particularly in animal painting. According to Lomax, Cundall left the firm in 1914 to serve in the First World War. He is then said to have returned briefly in 1917, before attending the Royal College of Art. However, his work was shown by Pilkingtons at the British Industrial Art Exhibition in 1920. Cundall became a professional artist and was elected to the Royal Academy, where he exhibited regularly, in 1937. He was an official war artist during the Second World War. *See* 120 and 123.

DOROTHY DACRE was a designer and decorator. Lancastrian Pottery designed by Dacre was shown at the Arts and Crafts Exhibition of 1910 and the Franco-British Exhibition of 1908.

LEWIS F. DAY* was a freelance designer for many media, especially tiles. From 1899, Pilkingtons put him under contract to design tiles exclusively for them. Tiles designed by Day for Pilkingtons were exhibited at the Arts and Crafts Exhibitions in Manchester (1895) and London (in 1896 and 1903) and at the Paris International Exhibition in 1900. His tiles shown at the exhibition of 1903 were illustrated and praised: ". . . the tiles and pottery panels exhibited by Mr Lewis F. Day were richly floreated and lavish of colour in a great variety of designs." (*Studio*, 1903) His tiles were among those exhibited at the Paris International Exhibition in 1900. Day was responsible for the simple, classic shapes of the Lancastrian Pottery (glaze effects) first exhibited at Graves Gallery in 1904. He designed some Lancastrian Pottery and Lancastrian Lustre Pottery which was exhibited there in 1906.

T. F. EVANS, 1894–1935, was an artist whose painted tiles were shown at the Arts and Crafts Exhibition of 1903, and Lancastrian Lustre Pottery shown in 1906. An illustration in *The Pottery Gazette* of October 1909 shows him painting lustre tiles in "Persian and other Oriental designs . . .". He is thought to have been responsible for the tile panels made for the Maypole Dairies in Lancashire.

MISS T. EVANS-BELL designed tiles shown at the Manchester Arts and Crafts Exhibition of 1895.

J. FISHER's painting on Lancastrian Lustre Pottery was shown at the Arts and Crafts Exhibition of 1906. He was listed as J. Fish.

GORDON MITCHELL FORSYTH*, 1905–16 and 1919–20, was introduced to William Burton by Bernard Moore. He joined Pilkingtons in 1905 as chief artist. By 1915 he had become art director. He left in 1916 to serve in the First World War, returning briefly in 1919–20, before becoming Superintendent of Art Instruction of the Stoke-on-Trent School of Art.

Opposite, **123** Pilkingtons Tile & Pottery Co. (Ltd) Royal Lancastrian Ware. *Above*: large bowl painted by W. S. Mycock, impressed Pilkingtons mark, underglaze artist's mark and date code for 1910, d. 19.3 cm. *Below, left to right*: vase painted by Charles Cundall, impressed Pilkingtons mark, underglaze artist's mark and date code for 1912; vase painted by W. S. Mycock, impressed Pilkingtons mark, underglaze artist's mark, dated 1925, h. 11.3 cm; vase, bee mark, date code for 1905, h. 9 cm; vase painted by W. S. Mycock, impressed Pilkingtons mark, underglaze artist's mark, dated 1924.

Forsyth's energy infused the work of all the painters who worked under him, as it was later to inspire his students at Stoke. He was responsible for many of the themes used by the other Pilkingtons artists: armorials, lions rampant, sailing ships and quotations in Gothic lettering. Forsyth designed lustre tiles and Lancastrian Pottery exhibited at the Arts and Crafts Exhibition of 1910; Lancastrian Lustre Ware, which he had designed and painted, in 1912; and his *Cock and Boy* and a vase in 1916. His work shown at the Franco-British Exhibition of 1908 was illustrated in *The Studio* that year, and his work was frequently illustrated in *The Pottery Gazette*. He was a medallist at the Franco-British Exhibition (1908) and at the International Exhibitions in Venice (1909), Brussels (1910) and Turin (1911). *See* Colour XXXV and XXXVI.

ALBERT HALL (1887–1934). An illustration in *The Pottery Gazette* of October 1909 shows him painting lustre tiles in "Persian and other Oriental designs . . .". Hall designed and decorated a panel of tiles shown in the Arts and Crafts Exhibition of 1910. He was the son of Lawrence Hall (see below).

LAWRENCE HALL was an artist who worked for Mintons* (from 1869) before coming to Pilkingtons in 1894. He painted a panel of tiles shown at the Arts and Crafts Exhibition of 1896 and tiles shown there in 1903.

JESSIE JONES studied at the Manchester School of Art, her lustre plaque and bowl (illustrated in *The Studio*) winning prizes at the National Competition of Schools of Art 1908. Her work was shown at the Franco-British Exhibition of 1908. She left Pilkingtons around 1909 to teach in India and South Africa. *See* 122.

RICHARD JOYCE (1873–1931), 1903–31, won the Queen Victoria Prize for Art while studying at Swadlincote School of Art. He then taught at Burton-on-Trent School of Art, and worked for Henry Tooth & Co. (Ltd)*. He was next engaged as an artist by Moore Bros. Bernard Moore* introduced him to William Burton, who induced him to move to Pilkingtons. Joyce designed and painted Lancastrian Pottery exhibited at the Arts and Crafts Exhibition Society in 1910, 1912 and 1916, and at the Franco-British Exhibition of 1908. An illustration in *The Pottery Gazette* of October 1909 shows him painting vases. He specialized in animal painting with a Japanese influence. He spent much time in Manchester's Zoological Gardens, making studies for these. He often moulded his designs in low relief before glazing. In the late 1920s he designed and executed a series of shapes with modelled and carved decoration, covered with subtly coloured eggshell glazes. *See* 120 and Colour XXXVI.

EDMUND KENT, 1910–39, had formerly worked for J. Wedgwood (& Sons Ltd)*, where he had known William Burton. Most of his designs were for commercial, rather than art, production but he produced many fine tube-lined designs. At the time of his death in 1939, he was the head of the tile-design section.

A. JOSEPH KWIATKOWSKI was a freelance designer and modeller who had worked for Josiah Wedgwood (& Sons Ltd)* and Pilkingtons. At Pilkingtons he modelled both tiles and architectural faience. Tiles modelled by Kwiatkowski were shown at the Arts and Crafts Exhibition of 1903.

ABRAHAM LOMAX, 1896–1911, worked as an assistant chemist to Joseph Burton but he is best remembered for his book about the pottery, published in 1957.

ALPHONSE MUCHA (1869–1930), a Czech, is best remembered today as an Art Nouveau illustrator and graphic designer. He also designed textiles, jewellery, carpets, furniture, cutlery and tiles. William Burton apparently became acquainted with Mucha at the Paris International Exhibition of 1900, and

correspondence reveals that he produced some twenty designs each year, although it is not known how many of these were actually put into production. Four tile panels made to his design were shown at the Glasgow International Exhibition of 1901. He was mentioned as an important Pilkingtons tile designer in *The Pottery Gazette* of October 1909.

WILLIAM SALTER MYCOCK (b. 1872), 1894–1938, worked for some years at J. Wedgwood (& Sons Ltd)*, attending evening art classes at the same time. He then worked as a jobbing artist for a number of small firms. Originally a tile painter, Mycock had moved to Pilkingtons pottery department by 1906. He favoured Gothic and floral designs although he also made many heraldic, bird and ship designs, occasionally with mottoes in Gothic lettering. He painted Lancastrian Lustre Pottery shown at the Arts and Crafts Exhibition in 1906. He is listed as a potter in the exhibition catalogue of 1910, and as a designer and painter in 1912 and 1916. His work shown at the Franco-British Exhibition was illustrated in *The Studio* in 1908. An illustration in *The Pottery Gazette* of October 1909 shows him painting vases. *See* 121, 123 and 126; Colour XXXV and XXVI.

MARGARET PILKINGTON, a director of the company and a founder of the Red Rose Guild of Handicrafts, designed a set of nursery tiles.

EDWARD THOMAS RADFORD* worked as a potter at Pilkingtons from 1903 to 1936. His Lancastrian and Lancastrian Lustre Pottery was shown at the Arts and Crafts Exhibition of 1906. An illustration in *The Pottery Gazette* of October 1909 shows him throwing: "Mr Radford is a prince among craftsmen in the most ancient and most beautiful of all arts. He must have been born with a gift for potting." Dissatisfied with throwing pots only to the designers' specifications, Radford eventually began to design his own shapes. Some of his later works were incised "E. T. R." *See* 126.

GLADYS M. ROGERS, 1907–38, studied at the Levenshulme Evening School, her bowl in silver and ruby lustre (illustrated in *The Studio*) winning a prize at the National Competition of Schools of Art in 1908. Lancastrian Pottery designed and painted by Rogers was shown at the Arts and Crafts Exhibitions of 1910, 1912 and 1916. Her work was shown at the Franco-British Exhibition of 1908, and she was a Gold Medallist at the International Exhibition in Paris in 1925. She painted lustrewares mostly with floral or geometric designs until 1928, when she began to decorate the new Lapis Ware.

COSMO ROWE designed tiles shown at the Manchester Arts and Crafts Exhibition of 1895.

J. H. RUDD was a designer.

FREDERICK SHIELDS was a Manchester artist on the fringes of the Pre-Raphaelite circle. After seeing their work in Manchester in 1857, he became friendly with Dante Gabriel Rossetti and F. Madox Brown. He was primarily a watercolourist but also painted murals. His tiles were among those exhibited at the Manchester Arts and Crafts Exhibition of 1895 and at the Paris International Exhibition of 1900.

MISS SIMPSON was a designer.

FLORENCE A. STEELE was a sculptor, metalworker and designer. Her tiles were among those exhibited at the International Exhibition in Paris in 1900.

ROBERT TUNNICLIFFE, 1898–c.1908, was a thrower formerly employed at Mintons. His Lancastrian and Lancastrian Lustre Pottery were shown at the Arts and Crafts Exhibition of 1906.

Ruth Tyldesley was an artist who painted tiles shown at the Arts and Crafts Exhibition of 1903.

C. F. A. Voysey* designed tiles that were shown at the Arts and Crafts Exhibitions of 1896 and 1903; at the Glasgow International Exhibition of 1901; and at the Paris International Exhibition in 1900. He was mentioned as an important tile designer in *The Pottery Gazette* of October 1909. His known tile designs were Vine and Bird, Bird and Lemon and Fish and Leaf, but there were probably many more. He also designed a *Lemon Tree* panel and two friezes, *The Viking Ships* and *Tulip Pattern*.

Annie Yates was an artist who painted tiles shown at the Arts and Crafts Exhibition of 1903.

Marks: "Every piece is authenticated by the stamp of the factory impressed in the clay, and by the monogram or cipher of the artist responsible for the design or its execution" (*PG*, October 1907). The earliest pottery was marked with an incised or impressed "P". From 1903 to 1914 a "P" with two bees was printed and later impressed. From 1914 to 1938 the mark was "ROYAL LANCASTRIAN", impressed and surmounted by an elaborate rose. A very much simplified rose was used for the pottery from 1948 to 1957. The 1970s ware bears a stamped mark with a rose surrounded by "LANCASTRIAN POTTERY ENGLAND". The hand-painted wares bear elaborate artists' monograms, and the date cyphers of the particular artist. (See Cross for a full listing of these.) A variety of marks was used for tiles, many bearing the full name and address of the pottery. A single-letter date-code system was also used (also to be found in Cross).

References: A&CXS 1896, 1899, 1903, 1906, 1910, 1912 and 1916; "The Arts and Crafts Exhibition", *Studio*, vol. XXVIII, 1903, pp. 181–83; "Arts and Crafts at Manchester", *Studio*, vol. XV, pp. 121–24; *A Catalogue of the Lancastrian Pottery at Manchester City Art Galleries* (no date); Austwick; Barnard; *British Official Catalogue, Paris International Exhibition 1900*; Burton, William, "Crystalline Glazes and their Application to the Decoration of Pottery", *Journal of the Society of Arts*, 25 May 1904, pp. 595–601; Burton, William, "Lustre Pottery", *Journal of the Society of Arts*, 7 June 1907, pp. 756–70; Burton William, "Material & Design in Pottery", *Journal of the Society of Arts*, 8 October 1897, pp. 1127–32; Burton, William, "The Palette of the Potter", *Journal of the Society of Arts*, 28 February 1896, pp. 319–35; Cameron; Coysh; Cross, A. J., *Pilkington's Royal Lancastrian Pottery and Tiles* (Richard Dennis, 1980); Day, Lewis F., "Tiles", *AJ*, 1895, pp. 343–48; Day, Lewis F. "The New Lancastrian Pottery", *AJ*, 1904, pp. 201–04; Godden 1964; Godden, Geoffrey. "Pilkington's Royal Lancastrian Pottery", *Apollo*, October 1961, pp. 97–99; Gray, Richard, "The Pilkington Tile and Pottery Company: Some Early Designs", *English Ceramic Circle Transactions*, 11, 1983, pp. 173–85; Jervis; Knowles, Eric, "Pilkington's Royal Lancastrian", *The Antique Collector*, August 1979, pp. 56–59; "Lancastrian 'Lustred' Pottery", *American Pottery Gazette*, vol. V, no. 4, June 1905, p. 28; "Lancastrian Pottery", *PG*, July, 1904, pp. 755–56 and August, pp. 904–05; Lockett; Lomax, Abraham, *Royal Lancastrian Pottery, 1900–38* (Abraham Lomax, Bolton, 1957); Marillier, H. C., *Pilkington's Tiles & Pottery* (Chatto & Windus, 1908); "The National Competition of Schools of Art, 1908", *Studio*, vol. 44, 1908, pp. 272–75; Niblett; *PG; PG>R;* Rhead; Rix; Rose, Arthur Veel, *Lancastrian Pottery* (New York, 1905); Service, John, "British Pottery", *AJ*, 1908, 3 parts., pp. 53–57, 129–37, 237–44; "Studio Talk", *Studio*, vol. 33, 1904,

pp. 68–73 and vol. 44, 1908, p. 292–93; *Royal Lancastrian Pottery 1900–1938* (Manchester City Art Galleries, no date); Thomas 1974; Thornton, Lynne, "Pilkington's Royal Lancastrian Lustre Pottery", *The Connoisseur*, May 1970, vol. 174, pp. 10–14; "True Lustred Pottery", *PG*, January 1908, p. 57; "A Visit to Pilkington's Tile & Pottery Works", *PG*, October 1909, pp. 1154–57; Wood, Christopher, *The Pre-Raphaelites* (Weidenfield & Nicolson, 1981).

Plant, James & Son

Brook Street, Tile Works, Hanley, Staffordshire
c.1914–1920
James Plant & Sons Art Pottery, Brook Street Art Pottery, Hanley
c.1920–1933
James Plant & Son Ltd, 1934–37

This tile manufacturer began to make art pottery after the First World War. *The Pottery Gazette and Glass Trade Review* announced in August 1919 that James Plant & Son were manufacturing "... a range of art wares of a type that is quite unique so far as English wares go ...".

F. Plant, the junior member of the firm, is credited with developing "... lines which are decidedly off the beaten track, and of a class that one might have expected to have discovered being manufactured outside rather than inside the Staffordshire Potteries, at some remote art pottery, where aestheticism is allowed to exert itself to the full, regardless of what may be the prevailing vogue". The wares were a "soberer" imitation of the Dutch Gouda wares, whose importation by Liberty & Co.* had been disrupted by the war. They were designed by a Mr Thorley. Unlike the Gouda wares, however, Plant ware, as it was called, seems to have had an earthenware (as opposed to stoneware) body (124).

The firm also made miniature vases and statuettes in art glazes, including mottlings, marblings and imitation flambé. There were some 120 different shapes, which were sold in boxed sets of twelve. After 1934, the firm apparently devoted its entire production to tiles.

References: *PG Diary*; *PG>R*.

124 James Plant & Son's Plant Ware advertised in *The Pottery Gazette*, November 1920.

Plant, R. H. & S. L. (Ltd)
Tuscan Works, Longton, Staffordshire
1898 to the present day

Best known for its Tuscan China, this firm produced some art earthenwares after the First World War. Its Ploverine ware was decorated with ". . . an all-over treatment reminiscent of veined and figured marble, over which hangs a delicate sheen of purple lustre. No two pieces are identical . . ." (*PG>R*, May 1919) The pieces illustrated have simple, Chinese-inspired shapes. The firm became a part of the Wedgwood Group in 1966.

Marks: Various marks incorporating the firm's name or initials. The firm's many marks incorporating "Tuscan China" may not have been used on earthenwares.

References: Andrews, Sandy, *Crested China* (Springwood Books, 1980); Bunt; Cameron; Godden 1964, 1988; *PG>R*.

Port Dundas Pottery Co. (Ltd)
66 Bishop Street, Port Dundas, Glasgow, Scotland

This manufacturer of salt-glazed stonewares was established *c*.1816. After many changes of ownership, the pottery was acquired by James Miller, trading as James Miller & Co. and later under the style The Port Dundas Pottery Co. The firm's principal wares were salt-glazed stoneware, Bristol glazed ware and, later, electrical insulators. Frank and Stanley Miller succeeded their father James. Cruikshank illustrates a stoneware art vase with impasto decoration of tulips, peacocks and butterflies.

Marks: various impressed or painted marks incorporating the firm's name.

References: Cameron; Cruikshank; Fleming; Godden 1964, 1972, 1980; *PG*.

Pountney & Co. (Ltd)
Bristol Pottery, Fishponds, Bristol, Avon
1905–69

Pountney's frequently cited 1652 as their date of establishment. There certainly were delftware potteries in Bristol at that time, and a tortuous line of descent brings one to the point at which Pountney's, under T. B. Johnston, established the Fishponds Pottery in 1905. This was a state-of-the-art factory whose principal products were tablewares and sanitary wares.

Johnston reintroduced hand-painted wares to the firm, and he hired, among others, two painters (David Grinton and George Stewart) from the Fife Pottery*, in Scotland, best known for its Wemyss ware. In February 1907, *The Pottery Gazette* described Bristol Art Ware: "Roses, shamrocks, tulips, and many other flowers are nicely painted in natural colours on all descriptions of domestic pottery. There is a full range of each of these bright-looking stock patterns. One of the most cheerful stock decorations in 'Bristol Art Ware' is the 'Iris' in natural colours applied all round." Other designs included barnyard fowls. A range of cat-and-dog decorations was designed by the artist Louis Wain. Samuel Shufflebotham*, who also worked for Guest & Dewsberry* at the South Wales Pottery, Llanelly, was also an accomplished imitator of the Wemyss-ware style. He designed a range of Puritan-type heads, sometimes on a ground painted to resemble leaded glass, with painted mottoes. Pountney's also produced a range of art pottery in imitation of Sir Edmund Elton's* wares, including metallic crackle glazes.

Marks: As Sarah Levitt has explained, a number of deceptive back stamps were used for Bristol Art Pottery. These were meant to give the impression that the wares had been made in smaller art potteries, rather than at the giant factory at Fishponds. Names include: The Bristol Cock & Hen Pottery, The Bristol Fiscal

Pottery, The Bristol Cat & Dog Pottery, The Bristol Leaded Lights Pottery. A gold crackle vase illustrated in Levitt is marked "Bristol Gold Crackle".

References: "The Bristol Story", *PG>R*, October 1953; Cameron; Davis, Peter and Robert Rankine, *Wemyss Ware* (Scottish Academic Press, Edinburgh, 1986); Godden 1964; Levitt, Sarah, *Pountneys, The Bristol Pottery at Fishponds 1905–1969* (Redcliffe, Bristol, 1990); *PG*; *PG>R*.

Powell, Alfred Hoare
1865–1960

Powell was an architect, designer and pottery painter who, with his wife, Louise Powell*, is largely credited with the revival of hand-painted pottery after the First World War. Powell first submitted designs to J. Wedgwood (& Sons Ltd)* in 1903, and the potential of these was immediately recognized. The Powells worked closely with Wedgwood for the next forty years. In 1906 Wedgwood helped Powell set up a London studio where he, his wife and their assistants would paint biscuit ware shipped from Etruria, which was then fired in London by J. L. James. Batkin reprints Frank Wedgwood's correspondence with Powell on this subject.

Some 190 pieces of the Powells' work were exhibited at William B. Paterson's Galleries in Old Bond Street, London, in 1905. These included wares painted under the glaze with enamels and lustres in floral, foliage, animal and abstract designs. A number of these were illustrated in *The Art Journal* of 1905:

> If he had long been in collaboration with Wedgwoods this variety of styles might be disconcerting. Admirable examples of design and facture like the crested pot of blue and lustre illustrated, or genuine discoveries of effects in the material such as the wheel-ribbed surface of the clay, giving variety and interest to the colour effect of the green and blue hyacinth pot, or the black-blue vine jar, are side by side with pots where what is added to a traditional style that perplexes the effect, or with little things not exquisitely done ... Mr Powell's progress has already taken him so far on the road to realisation of splendour and interest in big things, and of a fresh simplicity in smaller ones, that one looks for examples of Powell-Wedgwood ware finer than those which are remarkable in this exhibition ...

An exhibition at the Powells' studio at Red Lion Square, in London, was praised by *The Pottery Gazette*: "The two hundred examples of pottery are not trade lines; most of them are unique productions of the artist and are interesting to the lover of ceramics almost as much on that account as on account of their merit ..." (July 1907) The Powells' work increasingly dominated the ceramics shown at the Arts and Crafts Exhibitions of 1906 to 1926. Afterwards, the exhibitions were dominated by Bernard Leach and other stoneware studio potters, but the Powells continued to exhibit from 1928 until 1935. Alfred Powell was a member of the Art Workers Guild from 1916 to 1941, rejoining in 1943. *See* Colour XXXVII.

Marks: A heart-shaped leaf with "AP" monogram. Also "WEDGWOOD", impressed.

References: A&CXS 1906, 1910, 1912, 1916, 1923, 1926, 1928, 1931 and 1935; "Art Handiwork and Manufacture", *AJ*, 1905; Batkin; Brighton 1984; Buckley; Cameron; *Catalogue of Earthenware and China by Josiah Wedgwood & Sons Ltd., designed and painted for them by Mr. Alfred H. Powell* (William B. Paterson

Galleries, 1905); *PG*; "Powell-Wedgwood Pottery", *AJ*, 1908, pp. 10–12; *The Studio* yearbook, 1919.

Powell, I. & W.

Ewloe Pottery, Buckley,
near Chester, Cheshire
1871–1929
Llynenion Tile & Pottery
Works, Ruabon, North Wales
1889–1920+

Buckley, with its abundant deposits of clay and open-cast coal mines, had been the site of potteries from mediaeval times. By the 1780s a strong pottery- and brick-making industry had been established. The port of Chester had a lively coastal trade with other Welsh ports and with Ireland. The Ewloe Pottery was far from new when Isaac and William Powell took it over from their uncle in 1871.

Originally a country pottery, I. & W. (sometimes given as J. & W.) Powell first advertised as art potters at the Ewloe Pottery in *Morris's Business Directory* in the early 1880s. In 1915 they advertised in *The Pottery Gazette*: "I. & W. Powell, North Walian Art Pottery, Buckley, near Chester. Also Proprietors of the Llynenion Tile & Pottery Works, Ruabon, N. Wales. Manufacturers of Real Welsh Motto Ware. Useful and Ornamental Art Ware, In various shapes, colours and designs, also Reproductions of the 17th Century Slip Decorated Ware."

By 1895 the Powells dominated the local movement towards producing rustic art and novelty wares, their pottery being the only one in the region to be partly mechanised. Many of the wares, particularly the motto wares, were copied from those produced in Torquay. As noted in their advertisement, seventeenth-century slipwares were also reproduced. Solon noted: "At the present time, indeed, at Buckley, a few miles from Chester, they have not discontinued the practice of the oldest style, and are turning out slip pieces which, with a little scratching and chipping, might be mistaken for the work of 200 years ago."

In 1920 *The Pottery Gazette* illustrated a wide range of the firm's pre-war wares, including sgraffito animals after the manner of Hannah Barlow, streaky glaze effects, Satsuma-style vases and tube-lined Art Nouveau patterns. These art wares were discontinued during the First World War because of a shortage of suitable labour. Despite unusually aggressive marketing, the firm could not ultimately compete with the Torquay potteries, and the business was sold in 1929. Flower pots and slip-decorated kitchen wares continued to be produced up until the Second World War.

References: Davey, Peter, *Buckley Pottery* (Buckley Clay Industries Research Committee, Chester, 1975); Hartley, Dorothy, *Made in England* (Century 1939, reprinted 1987); Jones; Lewis, J. M., *The Ewenny Potteries* (National Museum of Wales, Cardiff, 1982); *MBD*; Mostyn Art Gallery, *Buckley Pottery* (Gwynned, 1983); *PG*; "Some Flintshire Coarseware Potteries", *PG>R*, February 1920, pp. 227–31; Solon, Léon, *Art of the English Potter* (second edition, revised 1885).

Powell, Ada Louise Lessore

1882–1956

Louise Powell, as she was generally known, was the granddaugher of Émile Lessore, famous for his painting of Wedgwood pottery, and the daughter of Jules A. Lessore, a well-known painter of marine and landscape scenes. She studied calligraphy and illumination at the Central School of Art. After her marriage to Alfred Powell* in 1906, the pair worked together in their decorating studio. She excelled at armorials and foliate designs derived from Islamic and Renaissance sources. She was a member of the Society of Scribes and Illuminators and her work was exhibited at the Arts and Crafts Exhibitions of 1910 to 1935. *See* 125.

Marks: A heart-shaped leaf with "LP" monogram. Also "WEDGWOOD", impressed.

125 Covered jar painted by Louise Powell, painted monogram "LP", "3182", h. 94 cm.

References: A&CXS, 1910, 1912, 1916, 1923, 1926, 1928, 1931 and 1935; Batkin; Buckley; Cameron. *See also*, Alfred Powell.

Putney Pottery *See* Edward Kettle.

R

Radford, Edward Thomas

*c.*1860–1937

Among the potters listed in this encyclopaedia, Radford is, unfortunately, the only man who dedicated himself to the throwing of pots. This is not because few others are worthy of notice, but because he is the only one who achieved a wide reputation. *The Pottery Gazette* wrote of him: "Mr. Radford is a prince among craftsmen in the most ancient and most beautiful of all arts. He must have been born with a gift for potting." Radford began his career as an apprentice at Josiah Wedgwood (& Sons Ltd)* (1873–80). On completing his apprenticeship, he went to the Linthorpe Pottery* (1880–86), where he developed his abilities as a "big ware" thrower. He then went on to Burmantofts Pottery* and Doulton & Co. (Ltd), Lambeth*. Wedgwood then invited Radford to return, and it was here that William

126 Pilkingtons Tile & Pottery Co. (Ltd) Lancastrian vase, potted by E. T. Radford and painted by W. S. Mycock, impressed factory mark "Royal Lancastrian England", potter's initials, artist's monogram and date code for 1929, h. 39.9 cm.

Burton* first observed his great skill. Burton brought him to Pilkingtons Tile & Pottery Co. (Ltd)* in 1903. According to Lomax, he had spent some years "off the wheel" in other work at the time that he joined Pilkingtons. His Lancastrian and Lancastrian Lustre Pottery were included in the Arts and Crafts Exhibition of 1906. Dissatisfied with throwing pots only to the designers' specifications, Radford eventually began to design his own shapes (126). He remained with Pilkingtons until his retirement in 1936.

Marks: Some of his later works were incised "E. T. R.".

References: A&CXS 1906; Cameron; Godden 1980; Hart, Clive, W., *Linthorpe Pottery* (Aisling Publications, Cleveland, 1988); Lomax; "A Visit to Pilkington's Tile and Pottery Works", *PG*, October 1909, pp. 1154–57.

Ravenscourt Pottery
Ravenscourt Park, London
1916–25

Dora Lunn (1881–c.1961) was the daughter of Professor Richard Lunn, who was a ceramics instructor at the Camberwell School of Art and the Royal College of Art. Formerly art director of Royal Crown Derby, Lunn published two pioneering works on practical pottery which undoubtedly influenced his daughter: "Notwithstanding all this [the application of machinery to the manufacture of pottery], to the student, who can acquire the knowledge and skill to make the shapes he has designed, and to decorate and fire them, there still remain endless untrodden paths, which may be explored and turned to his advantage, away from the rush and noise of the modern factory." Dora's association with the "Chelsea set" further reinforced the precepts of the Arts and Crafts Movement. She studied pottery at the Camberwell School of Arts and Crafts, but was frustrated by the system of segregation there, under which men made the pottery and women decorated it. She received her Board of Education Art Class Teaching Certificate in 1907 and became an Associate of the Royal College of Art in 1908.

In 1916 Lunn founded Ravenscourt Pottery. Initially she hired a thrower from Doulton & Co. (Ltd), Lambeth*, but soon became proficient herself. The pottery was an all-woman enterprise, Lunn hiring unskilled girls and training them herself. Throwing was considered too heavy a job for a woman, and so Lunn designed and patented the lightweight Ravenscourt wheel. She took a particular interest in glazes, making many experiments, which again was extraordinary for a woman at the time. She later designed the "Vyse" gas-fired kiln, and published blueprints of kiln designs for studio potters, once again venturing into an area previously the exclusive province of men.

The Ravenscourt Pottery's first appearance at the British Industries Fair in 1917 was enormously successful. Although *The Pottery Gazette* considered her display "not of a large commercial importance", Lunn was accorded a lengthy review – perhaps because both Queen Mary and Queen Alexandra purchased examples of her pottery. The earthenware exhibited included vases, bowls, plant pots and small figures. The shapes were simple, but the glazes "some of which are homemade" were remarkable. The turquoise glaze was singled out for special mention. "Her figures of birds and children had a quaintness which was altogether charming." (*PG*, April 1917)

Having met with such success, Lunn acquired a larger kiln. The glazes exhibited at the British Industries Fair in 1918 included a yellow glaze, a "splendid" green frosted glaze, and two shades of Moonlight blue. The glaze effects included mottling,

127 The Ravenscroft Pottery's stand at the British Industries Fair, illustrated in *The Pottery Gazette*, April 1919.

RAVENSCOURT POTTERY

crackle, "treacling", and "peacocking". Her new penguin figures were purchased by Queen Alexandra. A goose was also added to her range of figures. Utilitarian wares were also displayed: jugs, honey and jam jars, and egg cups (*PG*, April 1918). Some of the wares had checked patterns. "One of the most beautiful colour effects in the pottery section was a turquoise green with black designs, it was strong yet delicate." (*P&GR*, February 1918)

In 1919 Ravenscourt's stand (127), where the glazes were shown off to good effect against a black background, was illustrated in *The Pottery Gazette*. Several new glazes and glaze effects were introduced: lemon yellow, cream and yellow, a Mediterranean blue and grey. The following year *The Pottery & Glass Record* observed: "Miss Lunn and her co-workers thoroughly understand the use of colour, strong, yet subservient to the texture and shape of the hand-thrown

pottery." (March 1920) Dora Lunn and her assistants displayed vases at the Arts and Crafts Exhibitions of 1923 and 1926. A more commercial range of wares designed by Lunn was made at the Fulham Pottery under the name Fulraven. It seems that Lunn's pottery was unsuited to the Jazz Age and in 1925 the pottery closed down. In the following years Lunn devoted herself to pottery education, writing *Pottery in the Making*, which was an influential guide for teachers. Lunn later worked from a studio in Shepherd's Bush (1943–55).

References: A&CXS 1923, 1926; Cameron; Godden 1964; "A London Lady's Pottery Exhibition", *PG>R*, January 1923; Lunn, Dora, *Pottery in the Making* (Dryad Press, 1948); Lunn, Richard, *Pottery: A Hand-Book of Practical Pottery for Art Teachers and Students* (Chapman & Hall Ltd, 1903; vol. II, 1910); McLaren, Graham, "A Complete Potteress – The life and work of Dora Lunn", *The Journal of the Decorative Arts Society*, no. 12, pp. 33–38; *PG*; *P&GR.*; *The Studio Yearbook*, 1919.

Rhead family

The Rhead family had lived in North Staffordshire for some four centuries when George Wooliscroft Rhead (1832–1908) rose to prominence. Four of his eleven children were to manifest his artistic abilities: George Wooliscroft Rhead*, Frederick Alfred Rhead*, Louis John Rhead (who became a famous illustrator and poster designer in the United States) and Fanny Wooliscroft Rhead (who designed ceramics on a freelance basis, when she could find time away from her eleven children).

Frederick Alfred Rhead married the daughter of the famous Copeland flower painter C. F. Hürten. Four of their six children were to become involved in the pottery industry: Frederick Hürten Rhead*, Harry Rhead (who served briefly as art director at Wardle & Co. (Ltd)* before emigrating to the United States), Charlotte Rhead* and Adolphine "Dolly" Rhead (who worked as a tube-line decorator and enameller with her sister at Wardle & Co. (Ltd)*, Keeling & Co. (Ltd), F.H. Barker & Rhead Ltd* and Birks, Rawlins & Co. Ltd, before becoming a midwife). (*See* individual biographies below.)

George Wolliscroft Rhead senior was an artist at Mintons, eventually rising to the high position of heraldic gilder. He was also an unusually talented art teacher. In his obituary, *The Pottery Gazette* surmised: "There must be many skilled workers, and probably not a few employers, who received their early training in art under Mr Rhead's tuition, so that the fruit of his labour is still ripening." The family is particularly associated with tube-lined decoration, Frederick Alfred, Frederick Hürten, Charlotte and Adolphine all being particularly adept at designing and executing in this medium. *Pâte-sur-pâte* was another medium in which the family excelled. Frederick Alfred had learned to decorate in this mode under Louis Marc Solon, and he introduced the technique to Wardle & Co. (Ltd)*, where it was practised by his daughter Charlotte.

References: Bumpus; Bumpus, Bernard, "The Rheads as Art Educators", *The Journal of the Decorative Arts Society*, no. 13, pp. 3–8; Bumpus, Bernard, "Tube-line Variations", *The Antique Collector*, December 1985, pp. 59–61; "George Wooliscroft Rhead, Obituary", *PG*, November 1908.

Rhead, Charlotte "Lottie"
1885–1947

Although Charlotte Rhead trained formally at Fenton School of Art, the training that she received at home from her father and elder brothers, who were all employing tube-lining at their respective posts, must have been invaluable. In 1901, she joined the staff of tube-liners at Wardle & Co. (Ltd)*, where her brother, Frederick Hürten Rhead*, was succeeded as art director by her brother, Harry, in 1902. She left Wardle's in 1905, working briefly as an enameller at Keeling & Co. (Ltd). Charlotte was then employed for a couple of years at her father's unsuccessful tile manufactory, F.H. Barker & Rhead Ltd*. When the firm closed in 1910, she worked for various tile manufacturers, including T. & R. Boote Ltd. At the International Exhibition in Turin in 1911, the firm of Birks Rawlins & Co. Ltd* exhibited *Ships*, a pair of *pâte-sur-pâte* bowls by Charlotte and tube-lined porcelain vases decorated by Charlotte and her sister Dollie (*PG*, July 1911). When her father became art director of Wood & Son(s) (Ltd), Charlotte went with him as a tube-liner and *pâte-sur-pâte* artist. She worked for Wood's and their subsidiaries, Bursley Ltd and the Ellgreave Pottery Co. Ltd, until the end of 1926. During the 1920s she had established herself as a designer, and her name began to appear in the backstamp "Lottie Rhead Ware". Charlotte now moved to Burgess & Leigh (Ltd), where she remained until 1931. She next designed wares for A. G. Richardson & Co. Ltd*'s Crown Ducal range. She remained here until 1942, when she moved to H. J. Wood (Ltd), a subsidiary of Wood & Son(s Ltd), for whom she worked until her death, from cancer, in 1947.

References: Buckley; Bumpus; Bumpus, Bernard, "Tube-line Variations", *The Antique Collector*, December 1985, pp. 59–61; *PG*.

Rhead, Frederick Alfred
1857–1933

After serving his apprenticeship at Mintons*, Frederick designed and decorated pottery for J. Wedgwood (& Sons Ltd)* (1878–83) and Pinder, Bourne & Co. He then became art director at a series of potteries: James Gildea, E. J. D. Bodley, the Brownfields Guild Pottery Society Ltd and Wileman & Co.* (where he introduced

128 Wood & Son(s) (Ltd) *pâte-sur-pâte* vase, signed "F. Rhead", h. 26 cm.

the Intarsio line of art pottery). In 1908 he and F. H. Barker formed the F.H. Barker & Rhead Ltd* partnership to operate the Atlas Tile Works. This venture was unsuccessful and was sold in 1910.

After a brief stay in the United States, Frederick returned to work for his friend, Lawrence Birks, who had been a fellow apprentice under Louis Marc Solon at Mintons. He then became art director at Wood & Son(s Ltd) (1912–29) (128) and afterwards at the Cauldon Potteries Ltd. He wrote *Staffordshire Pots and Potters* with G.W. Rhead junior*.

References: Bumpus; "A Pottery Designer's Views on Art", *PG>R*, January 1922, pp. 83–84.

Rhead, Frederick Hürten
1880–1942

On leaving school, Frederick was apprenticed to his father, then art director of the Brownfields Pottery Guild Society Ltd. He studied in the evenings at the Wedgwood Institute, Burslem, and at the Schools of Art in Stoke, Hanley and Fenton. When his father became art director of Wileman & Co.*, Frederick joined him there. In 1899 Frederick was appointed art director at Wardle & Co. (Ltd)* (although he continued to work for Wileman & Co.) and was an instructor at the Longton School of Art. In June 1902, Frederick emigrated to the United States, where his distinguished career included work at the Avon Faience Co. in Tiltonville, Ohio; Weller Pottery and Roseville Pottery in Zanesville, Ohio; the Oyster Bay Pottery in New York; School of Ceramic Art at University City, St Louis, Missouri; the Arequipa Pottery; the Rhead Pottery at Santa Barbara, California; the American Encaustic Tiling Co., at Zanesville, Ohio; and the Homer Laughlin China Co. at Newell, West Virginia.

References: Bumpus, Bernard, "America's Greatest Potter?", *The Antique Collector*, April 1986, pp. 38–43.

George Wooliscroft Rhead junior
1855–1920

Rhead was apprenticed to Mintons* at Stoke under W. S. Coleman in 1871. He then moved to Minton's Art Pottery Studio*, where he specialized in adapting subjects from Japanese paintings. When the Studio closed he won a two-year scholarship to the National Art Training School. He worked as a faience artist for Doulton & Co. (Ltd), Lambeth* c.1882. Rhead worked for his brother, F. A. Rhead*, at Wileman & Co. He also designed stained glass and murals, and exhibited his paintings at the Royal Academy from 1882 to 1896. He taught at the Putney School of Art from 1896, and then became director of the Southwark Polytechnic Institute. He was the author of several works on ceramics, including *Staffordshire Pots and Potters*, which he wrote with F. A. Rhead, *Pottery Marks* and *The Earthenware Collector*. This first contains a full account of the Studio.

Rhead was a member of the Art Workers Guild from 1890 to 1915 and a member of the Council of the Arts and Crafts Exhibition Society. His etchings also gained him distinction, and he became a Fellow of the Royal Society of Painter Etchers, with whom he frequently exhibited. He also reproduced the important works of William Holman Hunt, George Frederick Watts, Marcus Stone and Ford Madox Brown. He exhibited regularly at the Royal Academy for forty years, and illustrated many books and periodicals.

References: A&CXS 1890, Brighton 1984; "G. Wolliscroft Rhead, Obituary", *PG*, June 1920; Rhead and Rhead.

Royal Aller Vale and Watcombe Pottery Co. (Ltd)

Newton Abbot, Devon
1901–24
Torquay, Devon
1901–62

The Aller Vale (Art) Pottery* was acquired by Hexter, Humpherson & Co. (Ltd)* in 1897 and the Watcombe Terra-Cotta Co. (Ltd)* in 1900. The two were amalgamated as the Royal Aller Vale and Watcombe Pottery Co. in 1901. Initially, the two potteries continued to develop the wares for which they had become known (129). An article in *The Pottery Gazette* noted:

> They have added largely to their plant, and have greatly increased the number of their specialities. But in addition to this they have also improved the character of them, with the result that they now produce several distinct classes of art pottery . . . The countless number of natty little pieces of art pottery in which the late Mr Phillips took such pride, constantly receive additions, so that that branch of art pottery is fully maintained . . . They supply a good variety of motto ware, and their group of crying dogs, laughing cats, frogs, pigs, owls &c., is most amusing. (August 1903)

The same article mentions several new lines, green [glazed] ware, ornamental wares with raised flower decoration and tall spills in "imitation of oak and other woods".

Iris, a pattern with a blue flower on a cream ground, which was to become one of the staples of the pottery industry in Torquay, was introduced at Aller Vale in 1903; and at Watcombe there was a new terracotta bust of Chamberlain, and the Ishbel pattern, "a bold and free hand treatment of flowers and fruit under the glaze". It was named after the Countess of Aberdeen, who had suggested the design (*PG*, December 1903). 1905 saw the introduction of Crane, Owl and Frog patterns, as well as an Iris pattern with a pale flower on a dark ground. Later in the year the pottery introduced Farm Yard and Moss Rose patterns (*PG*, September 1905).

Green and chocolate ware (130), green-glazed wares with brown interiors and rims, were introduced in 1907 (*PG*, March 1907). The following year saw the introduction of Wild Rose, pansies and daisies with bands of dark green at the top and bottom, and Sunset, consisting of "landscapes, water scenes, windmills, and other buildings in the Dutch style, with sunset effects" (*PG*, August 1908). The Lily pattern, featuring a Calla Lily on a dark green ground, was introduced in 1909, as was the Bird series: "Every kind of bird is shown – one bird on a piece – on a light ground, shaded green at the top and bottom. There are pheasant, partridges, robins, sparrows, peacocks, and practically all familiar birds, while there is the 'merlin' and other less known varieties." (*PG*, December 1909) New Marine Ware was introduced in 1911: "The decoration consists of sea-views with vessels with sails full set. The ground is light shaded colour, and the vessels in dark tints are in bold relief." (*PG*, September 1911) Shamrock ware is mentioned among the old lines still produced. In 1912 the firm brought out New Art Ware: "The ground is dark green blue, picked out with yellow and brown with good effect." (*PG*, May 1912) Also new that year was a series of the Old English cock-fighting; the three scenes were Challenge, Combat and Vanquished. The fact that these were portrayed on teawares perhaps indicates the public's less fastidious taste at that period.

While the pottery must have been affected by the First World War, it continued to bring out new patterns and designs. In 1914, they brought out Alexandra Rose: ". . . which has a marbled and splashed purple background and a bold wild rose design, which is specially suitable to their productions, inasmuch as it is distinctly 'arty'." They also introduced Fuchsia, a modified version of Ship ware, and the

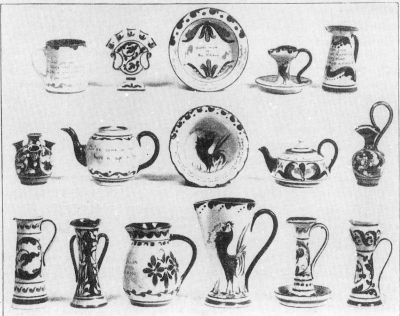

THE ROYAL ALLER VALE AND WATCOMBE ART POTTERIES,
Newton Abbot, Devon,
MANUFACTURERS OF
DECORATED, GROTESQUE, AND MOTTOED WARES.

High-class
ART
WARE.

Richly
Coloured
and Glazed.

Tea Sets,
Pots and
Pedestals,
Vases and
Flower
Pots
IN
GREAT VARIETY.

Also
Proprietors
of
The Royal
Essex
Pottery,
Castle
Hedingham,
(*Patronised by H.M.
Queen Alexandra*).

London Show
Rooms —
BUCHANAN
BUILDINGS,
24, HOLBORN, E.C.
Also at
FETTER LANE.

AGENT —
MR. F. FINDLAY.

129 Royal Aller Vale and Watcombe Art Pottery Co. (Ltd) advertised in *The Pottery Gazette*, July 1904.
130 Royal Aller Vale and Watcombe Pottery Co. (Ltd) green and chocolate glazed wares. *Left to right*: Cream jug, impressed "WATCOMBE TORQUAY" and incised '1476', h. 5 cm; udder vase, unmarked, h. 8.5 cm; sugar bowl, impressed "WATCOMBE TORQUAY" and incised "1476", h. 3.5 cm; basket, unmarked, h. 6 cm.

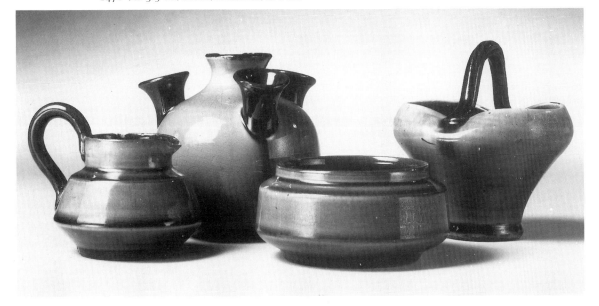

Windmill series. 1915 saw the introduction of "Tudor Rose, a variation on the very successful Alexandra Rose" (*PG*, April 1915).

In 1916 it introduced a new series of Daffodil ware, with rich yellow flowers on a "lustrous, dark chocolate brown". But perhaps the greatest innovation was the introduction of scented pottery: "This series has been introduced to supersede the odoriferous pottery hitherto supplied from certain Continental houses, and it is succeeding admirably in accomplishing its express purpose. The shapes are . . . mostly of antique conception, Roman and Grecian, their severity of form being counteracted by the employment of fancy straw plaited handles and ribbon tie-ups." (*PG*, October 1916) This sort of perfumed pottery was to become a staple of the Torquay industry in the 1920s. Hawthorn branches on streaky blue or purple ground were brought out in 1917.

By the end of the war, the pottery seemed to have lost its direction. Aller Vale closed in 1924 and motto-ware production was brought to Watcombe. Advertisements from the 1920s tend to show the same motto wares and slip-decorated wares as had been brought out five or ten years earlier, although some new patterns were introduced. An article in 1928 mentioned the new patterns – Cherries, Tinted Leaves and Pavor Fruit, as well as self-coloured wares in blue, green and tangerine. It is stressed, however, that the familiar Moorland Cottage, Windmill, Lake and Kingfisher patterns were still available (*PG>R*, September 1928). In the 1930s while continuing with their traditional motto wares, Watcombe produced a number of Art Deco designs and pots decorated with matt streaky glazes. By the 1950s the firm only advertised "Original Devon Motto Ware", mostly in the Moorland Cottage pattern on breakfast wares. The Watcombe Pottery finally closed in 1962.

Marks: a wide variety of marks incorporating "Watcombe, Torquay, Made in England", usually stamped in black but sometimes impressed. "ROYAL ALLER VALE DEVON MOTTO WARE", printed or impressed. Some of the Aller Vale (Art) Pottery pattern codes continued in use. These are listed in Barber.

References: Barber, Pat, "Aller Vale Pattern Codes", *TPCS Magazine*, January 1990, pp. 21–23; Brisco, Virginia, "The Influence of Art Deco on the Torquay Potteries", *TPCS Magazine*, January 1990, pp. 10–14; Godden 1964; Patrick; *PG*; *PG>R*; Thomas 1974, 1978; TPCS 1986; TPCS 1989; *TPCS Magazines*; Wilson, Cyril, "The Watcombe Pottery in 1847", *TPCS Magazine*, July 1989, pp. 22–26.

Royal Art Pottery Co.
Waterloo Works, Stafford Street, Longton, Staffordshire
1896–1922

The partnership between Harry Aynsley, Lucy Helen Forester and John Thomas Fell, trading as majolica manufacturers at the Waterloo Works, Longton, under the style Royal Art Pottery Company, was dissolved by mutual consent on 21 December 1897 (*LG*, 28 December 1897, no. 26923). Harry Aynsley and Thomas Fell continued, by 1921 having changed their style to Aynsley & Fell Ltd. The firm also established the St Louis Fine Art Pottery Co.* in 1905, and had an interest in the Rubian Art Pottery Co. Ltd*.

The firm was listed as an art pottery in *Morris's Business Directory* 1898–1922. However, the vast majority of its output consisted of relief-moulded majolica flowerpots for the lower end of the market. The pottery claimed to be the "Largest makers of flowerpots in England" (*PG*, July 1899). One writer explained:

"Everyone knows, doubtless, that their good[s] appeal to the million, and are intended to be within the reach of all. It is on this basis that the company's huge turnover has been secured; the secret of their success is that they have something to interest the most slender pocket." (*PG*, June 1913)

The Art Nouveau Milk Maid pattern was introduced in 1903 (*PG*, March 1905). In 1906 the firm offered Hawinian ware flower pots with "scenes from ancient Roman history depicted in heavy embossments round the body of the pot" in light green on a black ground. Other new designs were the Gibson Girl, farmyard and rural scenes and Sunset scenes.

In 1907 the firm installed a gas-fired furnace, which was so revolutionary that a demonstration of the process was written up in *The Pottery Gazette* (December 1907). At this time it advertised vases, clock sets, flower pots, pots and pedestals, and majolica flower pots. Its "art pots" were those with a gilt shaded ground. Further gestures towards "art pottery" were made by introducing "art shapes" and "Liberty" colours, such as green and maroon. The firm also made vases with "Dutch" decoration (*PG*, March 1907), and advertised a grotesque winking cat (*PG*, January 1911) and a grotesque dog (*PG>R*, November 1921).

References: Bergesen; LG; *MBD*; Meigh; *PG*; *PG>R*.

Royal Devon Art Pottery	*See* Lauder & Smith; Hart & Moist.
Royal Essex Pottery	*See* Castle Hedingham Art Pottery.
Royal Longpark Potteries Ltd	*See* Longpark Pottery.
Royal Tormohun Pottery Co. Ltd	*See* Longpark Pottery Co. (Ltd).
Royal Torquay Pottery	*See* Torquay Pottery.

Royal Vienna Art Pottery
Fenton, Staffordshire
*c.*1907–34

This firm, established by A. G. Harley Jones, produced ornamental wares frequently decorated with commercial lustre. After 1920 the firm made domestic crockery, heraldic souvenir ware and, later, glazed fireplace tiles.

Marks: the pre-1920 mark has a crown in a wreath surmounted by a crowned lion.

References: Cameron; Godden 1964, *PG*.

Rubian Art Pottery Co. Ltd
Park Works, Fenton,
Staffordshire
1900–33

Formerly Barker & Read, this firm was continued by H. K. Barker as the Rubian Art Pottery (*PG*, April 1900). The Royal Art Pottery Co.* had an interest in Rubian. In 1903 Rubian advertised "Pots & Pedestals, vases, &c., in a great variety of shapes and decorations. Flowerpots, both decorated and in art colours. Toilet Sets in numerous shapes and beautifully decorated." (*PG*, January 1903) They were selling majolica flower pots in "shaded art glazes" into the 1920s.

Marks: "L. S. & G.", printed or impressed; "RUBAY ART WARE", c.1926–33.

References: Godden 1964; Meigh; *PG*; *PG>R*.

Ruskin Pottery

See William Howson Taylor.

Ryan & Co.
43 Ufford Road, Blackfriars Road, London
c.1919–c.1920

This firm, which specialized in fireclay bars for electric heaters, was listed as an art pottery in *Morris's Business Directory* 1919–20.

Rye Pottery.

See Belle Vue Pottery.

S

St Louis Fine Art Pottery Co.,
Argyle Works, Napier Street, Fenton, Staffordshire
1904–1909

In 1904 *The Pottery Gazette* announced that: "The St Louis Fine Art Pottery Company have begun business as manufacturers of fancy goods" (*PG*, August 1904). This maker of "artistic and fancy pottery" was under the management of H. K. Barker, who also managed the Rubian Art Pottery Co. Ltd* (*PG*, September 1904). "The St Louis Fine Art Pottery, though associated with the Royal Art Pottery, make an essentially different class of goods" (*PG*, March 1905). The wares produced, however, were the vases, pots and pedestals and clock sets associated with the Royal Art Pottery Co.* and Rubian Art Pottery Co. Ltd. One speciality was wares with vellum ground, painted flowers and gilt.

References: Meigh; *PG*.

Salopian Art Pottery
Benthall Pottery, Benthall, near Jackfield, Shropshire
1882–c.1912

The Benthall pottery was making utilitarian brown wares, when William Allen (b. 1834) became manager. He employed Francis Gibbons* as chief artist and designer, and students from the Coalbrookdale School of Art, where Owen Gibbons, Francis's brother, was headmaster (*see* Maw & Co. (Ltd)). Allen's son, William Beriah Allen (b. 1875), was later taken into the business. He had a special interest in natural history and botany, particularly mycology. He may have been responsible for some of the sgraffito wares with designs of ferns, grasses and seed heads.

Apart from the continued production of utilitarian wares and "electrical

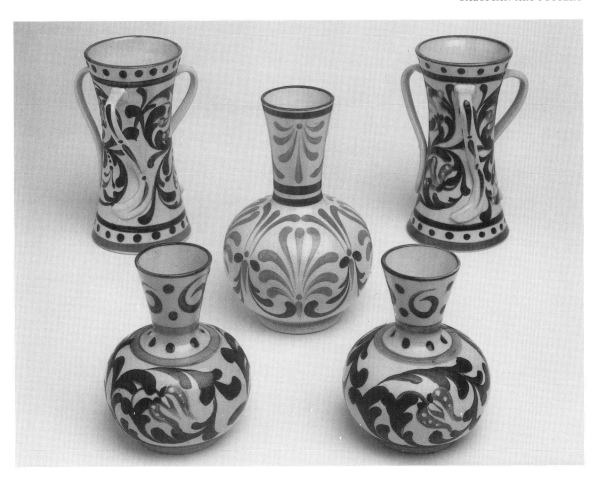

131 Salopian Art Pottery slip-painted wares, impressed "SALOPIAN", h. of tallest vase 16.5 cm.

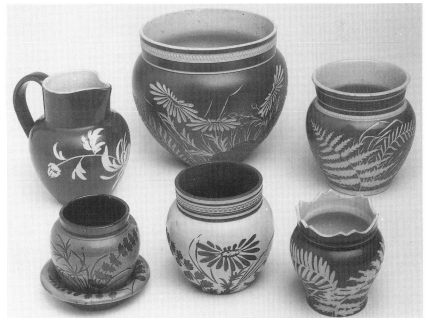

132 Salopian Art Pottery wares, c.1900, red and white bodies with coloured slip and incised decoration, impressed "SALOPIAN", h. of tallest vase 15 cm.

pottery", four major groups of pottery were made: enamel and slip-painted wares (131), sgraffito wares (132), coloured-glazed wares similar to those made at the Linthorpe Pottery*, and majolica wares with elaborately modelled fruit, flowers and reptiles. Gibbons won a National Gold Medal for a Salopian majolica vase (*PG*, January 1884). In 1883 some 300 shapes and thirty colours and effects were being produced (*PG*, January 1884). In 1882, an advertisement described the firm's aims and wares in detail:

> The Art Pottery is made entirely from clays of the Broseley District ... Some of the shapes are reproductions, modifications, or adaptations of Egyptian, Trojan, Greek, and Roman Pottery, the beauty of which has seldom been equalled, and may never be surpassed; others are taken from natural forms, such as Thistle-heads, Poppy-heads, etc., and are likewise beautiful; they are produced in charming Art-colours, such as Peacock-Green, Turquoise-Blue, Crimson, Amber, Yellow, and Olive Green. The very old style of Decoration known as "Flambé" has been most successfully introduced, and many most curious and beautiful effects are shown. The Ware known to Connoisseurs as "Barbotine" has also been very successfully produced here, and the far more difficult, but infinitely more artistic "Slip-Painting" is at the present time the subject of the most careful study and experiments.

Salopian art pottery can be seen at Clive House Museum, Shrewsbury.

Marks: "SALOPIAN", impressed, sometimes within a diamond.

References: Bergesen; Cameron; *Contemporary Biographies* (held at the Ironbridge Gorge Museum Trust Library); Godden 1964, 1972; Haslam 1975; Herbert, Tony, "The Artful Pot", *Traditional Homes*, February 1989, pp. 67–71; Messenger; Randall, John, *The Severn Valley* (1882); Randall, John, "Pottery", *Victoria County History of Shropshire*, vol. 1 (1908).

Sant & Vodrey

Abbey Pottery, Sneyd Green,
Cobridge, Staffordshire
1887–91
Sant & Co.,
1891–93

This partnership between Frederick Vodrey, Samuel Sant and Henry William Sant, who traded under the style Sant & Vodrey, advertised as manufacturers of earthenware and "art ware in crimson, turquoise, bronze, yellow and other colours" (*PG*, January 1890). The partnership was dissolved on 12 May 1891, with the Sant brothers continuing under the style Sant & Co. (*LG*, 19 May 1891, no. 26163).

Marks: "S. & V. COBRIDGE", printed or impressed in a ring.

References: Godden 1964; *LG*; Meigh; *PG*.

Schenk, George

Nursery Road, Mitcham,
Surrey
closed 1914

George Schenk, a Frenchman, exhibited art pottery at the Franco-British Exhibition of 1908: "He shows art pottery in various forms – glazed tiles, plaques, hearths, architectural pottery, panels, busts, pots, &c. He also exhibits tiles and slabs with lustre decorations." (*PG*, August 1908) Schenk supplied the Omega Workshop Ltd* with blanks in 1913–14. The pottery closed when he returned to France to fight in the First World War.

References: *The Omega Workshop, Alliance and Enmity in English Art, 1911–20* (Anthony d'Offay Gallery, 1984); *PG*.

Seaton Art Pottery

King Street, Aberdeen,
Scotland
c.1908

Visiting this pottery in 1908, a reporter for *The Pottery Gazette* remarked: "It is not large for a pottery, but evidently very old, and there are indications of recent additions and improvements." Arthur Mills, who had formerly worked for Joseph Bourne & Son (Ltd)* in Derbyshire, had a few years previously come to Aberdeen to work for Messrs Clark and Smith at the Seaton Pottery. Within a year, the firm failed, whereupon Mills took it over.

To the firm's staple output of brown flower pots, vases, pans, jars and basins, Mills added several new lines: fern stands, butter jars, poultry-raising requisites, glazed terracotta ware, Rebecca jars and fancy pieces in biscuit for amateur painters. He also produced majolica barrels, tobacco jars, flower pots and other fancy lines in mottled or coloured glazes. His work included an elephant-shaped crocus pot, and art pottery with incised decoration and crinkled edges.

References: Fleming; "Some Glass and Pottery Works in Scotland", *PG*, November 1908.

Sherwin & Cotton

Vine Street, Hanley,
Staffordshire
1876–1900
Eastwood Tile Works
1900–c.1930
Waverley Works
c.1907–c.1912

The partnership between James Sherwin, Arthur Sherwin, Edward Wood and Samuel Cotton, trading under the style Sherwin, Wood & Co. was dissolved in April 1876. Edward Wood retired and the firm then operated under the style Sherwin & Cotton (*LG*, 8 August 1876, no. 24352). The partnership between James, Arthur and David Sherwin, and Henry Cotton, trading under the style of Sherwin & Cotton, was dissolved on 31 October 1884, when David Sherwin retired to establish a partnership by the name of Jones, Hopkinson and Sherwin (*LG*, 24 March, 1885, no. 25454; 2 September 1887, no. 25735).

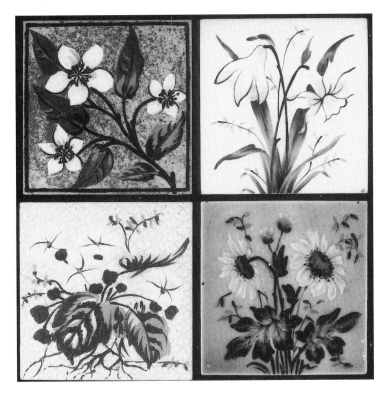

133 Sherwin & Cotton hand-painted barbotine decoration on dust-pressed tiles, *c.*1890. *Above left*: marked with moulded Staffordshire Knot and incised "B2118". *Above right*: moulded mark "Sherwins Patent Lock Back. Trade Mark. ENGLAND". and incised "RMB390". *Below left*: marked with moulded Staffordshire Knot and incised "MR232". *Below right*: marked with moulded Staffordshire Knot, "ENGLAND" and incised "RMB 368 3".

This tile manufacturer advertised "Barbotine Painted Tiles [and] Underglaze Art-Painted Tiles" (*PG Diary*, 1884) (133). They are, however, best known for their relief-moulded tiles with majolica glazes, and transfer-printed tiles. George Cartlidge* worked for this firm for a number of years, developing *émail ombrant* portrait tiles.

In 1900 the firm moved to the Eastwood Tile Works, Hanley, which were new and more spacious premises. By 1907 it was also operating from the Waverley Works. In 1912 the firm, now owned only by James and Arthur Sherwin, was placed under assignment (*PG*, June 1912) but survived this setback, continuing operations until 1930.

Marks: a Staffordshire knot within two triangles, impressed; "SHERWIN & COTTON", impressed or incised.

References: Austwick; Barnard; Bergesen; Cameron; Godden 1964; *LG*; Lockett; *PG*; *PG Diary*; Rhead; "Sherwin and Cotton Mini-Tiles", *GE*, no. 9, spring 1985.

Shufflebotham, Samuel
1875–1940

Shufflebotham was born at Leek, Staffordshire; his early life remains a mystery. He was a talented pottery decorator who worked for Guest & Dewsberry*, at the South Wales Pottery, Llanelly (1908–15), and for Pountney & Co. (Ltd)*, Bristol, (1900–08 and 1915–29).

Shufflebotham specialized in painting fruit and flowers in a style reminiscent of that practised on Wemyss ware at the Fife Pottery*, which he had learned from George Stewart (who had worked at the Fife Pottery and Pountney & Co. (Ltd)). He also developed a range of pottery portraying Puritan-type figures, which appear on Pountney's Leaded Lights Pottery and on wares made at the Crown Dorset Pottery* (where he may have worked c.1904–08) and Tor Vale Art Potteries*. In 1930, Shufflebotham moved to Torquay, where he is known to have worked for the Bovey Tracey Pottery, which was owned by Pountney & Co. (Ltd).

References: Cameron; Hughes, Gareth, and Robert Pugh, *Llanelly Pottery* (Llanelli Borough Council, Llanelli, 1990); Hughes, Peter, *Welsh China* (National Museum of Wales, Cardiff, 1972); Jenkins, Dilys, *Llanelly Pottery* (DEB Books, Swansea, 1968); Levitt, Sarah, *Pountneys, The Bristol Pottery at Fishponds 1905–1969* (Redcliffe, Bristol, 1990); "Who is the Link between Dorset and Pountneys?", *Honiton Pottery Collectors' Newsletter*, no. 4, March 1986.

Smith, Thomas & Co.
72 Princes Street, Lambeth, London
1836–66
Old Kent Road
1867–c.1893
Canal Potteries, Verney Road

Smith made typical Lambeth stonewares, especially flasks, until the 1870s. He then began to make art pottery decorated with coloured slip, sgraffito and stamped or sprigged ornament.

Marks: "T. SMITH & CO. OLD KENT RD. LONDON".

References: Edwards, Rhoda, *Lambeth Stoneware* (Borough of Lambeth, 1973); Godden 1964; *MBD*; Oswald.

Steele & Wood

London Road, Hanley,
Staffordshire
from before 1875 until
1892
Elder Road, Cobridge,
Staffordshire
1887

The partnership between Claude William Steele and Edward Wood, manufacturers of encaustic and geometrical tiles, was dissolved in July 1875. The business was continued by Claude William Steele (*LG*, 6 July 1875, no. 24234). In 1884, Steele & Wood advertised encaustic and decorated art tiles: "Special Patterns suitable for Stoves, Hearths, Fireplaces, Walls, Staircases, Dados, Cabinet Work, etc. Choice Designs in Hand Painted Panels" (*PG Diary*, 1884). The Austwicks illustrate one of the firm's tiles, which is a copy of a design used by Minton's Art Pottery Studio*, and a tile designed by Walter Crane*.

By 1891 the partnership had changed. It now comprised Leonard Broughton Wood, Stuart Wood and James Alison Steele but was dissolved in October of that year. Leonard Broughton Wood and James Alison Steele continued (*LG*, 3 November 1891, no. 26219).

Marks: "STEELE AND WOOD", printed or impressed in a ribbon, around an "S&W" monogram; "STEELE & WOOD STOKE-UPON-TRENT", moulded into a dust-pressed tile.

References: Austwick; Barnard; Godden 1964; *LG*; Lockett; Meigh; *PG Diary*.

Stiff, James (& Sons)

The London Pottery, High
Street, Lambeth, London
1840–1912

James Stiff, formerly a foreman at Doulton & Watts, acquired the London Pottery in 1840. It produced brown stonewares typical of Lambeth at that time. In 1860, the firm was flourishing and some rebuilding took place. From 1863 the firm operated as James Stiff & Sons, and was producing white and brown stoneware.

By 1878, the pottery had fourteen kilns and employed 200 people. It apparently felt prosperous enough to embark upon the prestigious course of its competitors, Doulton & Co. (Ltd), Lambeth*. It was listed as an art pottery in *Morris's Business Directory* 1871–96. In 1878, when it showed Lambeth wares at the Universal Exhibition in Paris, *The Magazine of Art* commented: ". . . Messrs Stiff & Sons are following in the footsteps of Messrs Doulton and show some good 'Lambeth ware', decorated after the manner of the old grès de Flandres." These wares were decorated with coloured slip, sgraffito and stamped or sprigged ornament. Jack Shelton, Stiff's head foreman, had studied at Lambeth School of Art with R. W. Martin*. In 1890 Stiff advertised "Decorated Lambeth Stoneware, Tankards, Salad Bowls, Cruets, Vases, Jugs &c." (*PG*). In 1899 they also advertised terracotta (*PG*).

William Stiff, the senior partner, died in 1899. He was the eldest son of the founder of the business. Under the same style, the firm was continued by his brother, Ebenezer, and his sons Sydney James, James Arthur and William Frederick Stiff (*PG*, August 1899). The partnership was dissolved in 1903, when Ebenezer Stiff retired (*PG*, August 1903). Ebenezer had been a member of the South London Committee on Museums.

In 1910, Rhead described the firm's wares as brown salt-glazed stoneware, white stoneware or "Bristol" ware, buff terracotta and "porous ware". Throughout the previous decades, Doulton & Co. (Ltd), Lambeth had absorbed its Lambeth competitors. By the 1890s, Stiff was the only major competitor to remain independent. The firm finally succumbed to a take-over by Doulton & Co. (Ltd) in December 1912.

Marks: Various impressed marks incorporating "STIFF", "J. STIFF", or "J. STIFF & SONS", sometimes with "LONDON" or "LONDON POTTERY LAMBETH", impressed.

References: Blacker; Cameron; Edwards, Rhoda, *Lambeth Stoneware* (Borough of Lambeth, 1973); Godden 1964; Haslam, Malcolm, *The Martin Brothers, Potters* (Richard Dennis, 1978); Jewitt; *MA*, vol. I, 1878; *MBD*; *Merchant & Manufacturers' Pocket Directory 1868*; *Mercantile Directory London*, 1891; *Official Catalogue of the British Section, Paris Exhibition 1878*; Oswald; *PG*; *PG Diary*; *P&GR*; Rhead.

Sunflower Pottery

See Sir Edmund Elton.

T

Taylor, William Howson

Ruskin Pottery, Smethwick, Birmingham, West Midlands
1898–1933

Edward R. Taylor (1838–1912) was born at Shelton. His father, William Taylor, was an earthenware manufacturer. His mother was Ellen Howson, whose brother George established a firm which was to become G. Howson & Sons (Ltd.), 1865–1966, a major manufacturer of sanitary ware. At an early age, Edward began to work in his father's pottery. In 1853, he became the first pupil to attend the Burslem School of Art. Deciding that he preferred a teaching career to that of a potter, Edward then attended the National Training School for Art Masters at South Kensington, which became the nucleus for the Royal College of Arts. In 1862 he was appointed headmaster of the new Lincoln School of Art, which he organized. He was appointed headmaster of the Birmingham School of Art in 1877. Kate Hall, one of his former pupils, wrote: "Those who had the privilege of welcoming him will never forget his coming – his enthusiasm, his energy, and his marvellous power of inspiring all who came near him with his own spirit." Within two months, "he had won the affection and confidence of every teacher and student . . . He had a wonderful way of making everyone feel the possibility of doing *something.*" Edward Taylor retired in 1904. In 1911 his health was failing and he died in January 1912. Taylor exhibited regularly at the Royal Academy from 1865 to 1896.

Edward married Mary Parr, also from a family of potters, and they had six children. The youngest, William Howson Taylor, was born in 1876. He showed an early interest in pottery and, while studying at the Birmingham School of Art, he experimented with a small kiln in the garden. To increase his practical experience, he then spent some time at Howson's in Hanley.

The beginning of the Taylors' pottery is shrouded in obscurity. *Kelly's Post Office Directory, Birmingham* lists "Taylor Bros., Brick and Tile Manufacturers, 173 Oldbury Rd., West Smethwick" for the first time, in 1899. Edward R. Taylor is listed

134 William Howson Taylor's Ruskin Ware, illustrated in *The Pottery Gazette*, July 1915.

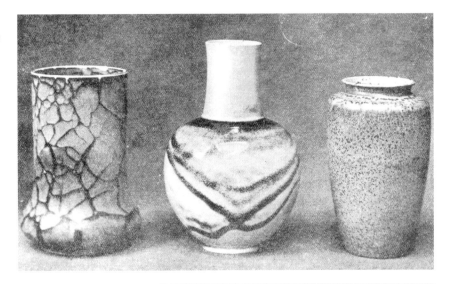

135 William Howson Taylor's Ruskin Ware, presented to Birmingham Art Gallery in memory of Edward R. Taylor, illustrated in *The Pottery Gazette*, May 1926.

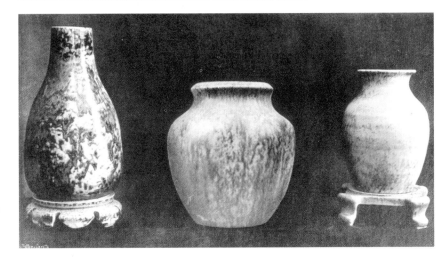

136 William Howson Taylor's transmutation glazes, illustrated in *The Pottery Gazette*, February 1928.

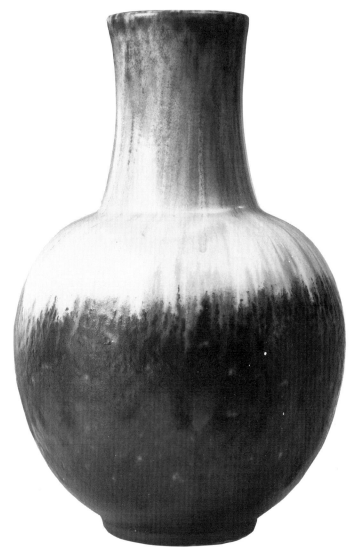

137 William Howson Taylor's Ruskin Pottery high-fired vase, impressed "RUSKIN ENGLAND 1933", with incised signature "W. Howson Taylor", h. 24 cm.

as a "tile maker". The exact nature of the early wares remains uncertain, none yet having been identified. From 1904 to 1933, the listing reads: "W. Howson Taylor, earthenware manufacturer, 173 Oldbury Rd". It is known that Edward Taylor financed the enterprise, and that when its early losses (some £15,000 in the first three years) mounted, he consulted the family before sinking the remainder of their savings into the venture. Very little, however, is known about the degree of practical assistance rendered by Edward Taylor and his other sons to William Howson Taylor. Many contemporary accounts give Edward Taylor the entire credit for the development of the Ruskin Pottery. In his will, Edward left his son William Howson a choice of any *thirty* of his books on pottery, chemistry and design, which implies that Edward had at least a scholarly interest in the pottery. It is only certain that he designed the floral borders that decorated some pieces, and provided funds (which were eventually repaid). Given the comments made about him above, and in various other accounts, it may be assumed that he also offered much moral support and encouragement as well.

From the first, the Taylors' pottery received a good deal of attention from the press, perhaps because of Edward Taylor's high reputation as an artist and art educator. An article in *The Pottery Gazette* of January 1903 stated that E. R. Taylor "with the assistance of his son, Mr Howson Taylor" had recently established "a manufacture of a new kind of artistic pottery". "His first experiments, conducted at his house in Highfield-road [Birmingham], met with so much success that he was encouraged to set up a manufactory at West Smethwick, and a small showroom at 45, Newhall-street." The description of the wares is worth quoting in full, as it gives a good idea of the Taylors' beliefs in the precepts of the Arts and Crafts Movement and the wide range of wares and techniques already mastered at that early date:

> The "Ruskin Pottery", as the new ware has been christened, is shown in a great variety of forms, from tiles for fire-grate fittings to dainty little tea-cups and scent bottles. Every article, from the largest to the smallest, is fashioned upon the potter's wheel, and is free from any mechanical process, and from all imitation of what it is not. The decoration is underglaze, and takes the form either of free brush drawing in simple but graceful designs, or of a secret manipulation of the coloured glazes and of the firing, which results in some singularly beautiful mottled effects. Many of these resemble the markings of Mocha stones and Madrepore, but are not intentional efforts to mimic these. Deep blues and greens, and bluish grays, appear to be Mr Taylor's favourite tints, and these seem specially suitable for grate tiles, for rose bowls, and flower vases. The lustrous face of the tiles glows with ruddy reflection when there is a fire in the grate, but when there is no fire the green or blue face affords a cool decoration, while similar colours as applied to flower vases afford an effective background to the more vivid tints of the flowers themselves. Simple hues are employed for some very delicate tête-a-tête tea services. The articles in these instances are not only charmingly shaped, but are very thin, light, and smooth to the touch. Pale apple green and a sort of custard yellow tint are among those which are singularly refined, and with appropriate surroundings no less effective.

Ruskin Pottery made its debut at the Arts and Crafts Exhibition of 1903. William Howson Taylor exhibited tiles, vases, bowls and tablewares. He was assisted by E. Boswell and W. Forrester. Emily Boswell was a paintress working at Ruskin Pottery 1898–1912; Wilfred Holland Forrester was a thrower who was apprenticed at the pottery. The prices ranged from five shillings for a small blue jug to £4 for a twenty-four-piece tea set. London's *Morning Post* said of these: "The Taylor colours are as pure and good as any that have ever been produced." (*PG*, April 1903). Some Ruskin Pottery exhibited at the Arts and Crafts Exhibition, Leicester, in 1904, was illustrated in *The Studio*.

Perhaps the firm's greatest victory was the Grand Prize at the Louisiana Purchase Exhibition in St Louis in 1904. The Taylors' success there made them international contenders, and Tiffany & Co.* opened the American market for the wares. They exhibited a "number of vases, cups, saucers and candlesticks, &c. showing diverse and lovely effects obtained by well-designed simple shapes, broken tints of colour, and variety of surface texture. These specimens were remarkable for thinness and lightness of body and a limpid leadless glaze of fine quality." (*PG*, February 1904)

At the Glasgow Loan Exhibition of British Pottery in 1904, William Howson

Taylor exhibited forty-nine examples of Ruskin Ware (*PG*, April 1905). In late 1905 the firm issued its first catalogue, with fifteen plates, two of which were coloured. In addition they offered a coloured sheet illustrating buttons and "enamels" (see below).

The wares shown at the Arts and Crafts Exhibition in 1906 were listed as executed by W. Howson Taylor, E. R. Taylor and assistants. These were all vases, some with stands. Prices now ranged from 8/6d to £15, indicating an enormous jump in the reputation of the wares. The firm went on to win Grand Prizes at the Milan International Exhibition in 1906, International Exhibition, Christchurch, New Zealand, in 1906–07 and Franco-British Exhibition in 1908. The Museum of Industrial Art in Rome purchased several specimens at the Venice International Exhibition in 1909.

In an important article published in *The Art Journal* in 1908, John Service illustrated many pieces of Ruskin Ware, about which he was effusive:

> Some result in colour effects of red, brown, and purple, with green and light blue mingling with the purple; some in a brilliant ruby, possessing that quality of Chinese *sang-de-bœuf*, of colour within colour. One piece will be coloured with full green diaperings, the interstices being in delicate purple; another of the same class may have the interstices in *sang-de-bœuf* and purple; another, puce interstices. Some have white grounds with raised brown-green markings like crocodile skin. One fine specimen is in *sang-de-bœuf* with part of the ground showing in a delicate warm white, with ruby markings, as in Chinese porcelain of the Ming Dynasty. A remarkable effect is seen in a vase with a sky-blue ground with grey-white cloudings, and another in a transmutation colouring of purple-blue with bright green markings.

Although Taylor's ware had been referred to as Ruskin Pottery since at least 1903, the "RUSKIN POTTERY" trademark was only registered by W. H. Taylor in November 1909, for the Taylors had not actually received permission from John Ruskin's heir, Joan Ruskin Severn, to use his name until August of that year. No contact is known to have occurred between John Ruskin himself and either of the Taylors, but it is very likely that Edward Taylor in particular would have consumed Ruskin's writings as an art student, and could quite possibly have met him or attended some of his lectures.

Ruskin Ware received the Grand Prix at the International Exhibition in Brussels in 1910 (where Taylor's original exhibit was destroyed by fire) and Turin International Exhibition in 1911. There were very large displays of Ruskin Pottery at the Arts and Crafts Exhibitions of 1910, 1912 and 1916. One vase in 1916 was priced at £50! H. M. Pemberton included illustrations and an enthusiastic description of Ruskin Ware in his article in *The Art Journal* in 1908. Despite the high prices commanded by Taylor's best pieces, it was necessary to supplement their income:

> . . . although some of the choicest and irreproducible pieces in "Ruskin Ware", considered as works of art and deserving perpetuation, are altogether exclusive, and not to be measured in terms of pounds, shillings and pence, at the same time Mr Taylor has commercialised many of his productions, and brought some really artistic conceptions within the reach of every class of people able to appreciate pottery that is soulful. (*PG*, July 1915) (134)

The author goes on to recommend as "specially good sellers": Nos. 16 and 16 MD (orange effects); no. 75, a matt green; no. 5 L a "delightful tortoiseshell effect"; a lavender glaze "suggestive of mother-of-pearl"; and "kingfisher blue".

In March 1916, Taylor gave up the home trade, confining himself to the export market, "with the exception of buttons, which are made by girls" (*PG*, April 1917). Only three pieces were exhibited at the Arts and Crafts Exhibition in 1923. Five "High temperature Flambé vases" were shown in 1926, ranging from £8 to £33. In 1926, W. Howson Taylor presented a collection of Ruskin Pottery to the Birmingham Art Gallery in memory of his father (135). These are still on display there. In the face of increasing financial difficulties, Taylor compromised and allowed some commercial wares to be slip cast, most notably lamp bases and vases.

As time passed, William Howson Taylor's ardour for experimentation never flagged. In February 1928, *The Pottery Gazette and Glass Trade Review* recorded that he had made "over 700 experiments" in the previous six months (136). The last biscuit firing took place in 1933. In 1934, the following advertisement was published: "Customers desirous of purchasing specimens of Ruskin Pottery should do so now before all the stock is sold, as the sole maker, W. Howson Taylor of West Smethwick, is retiring from business." (*PG>R*, March 1934) Taylor continued, however, to experiment until his death in 1935. As pots dated 1933 are very common, it seems likely that the last biscuit firings were large ones, possibly to provide Taylor with a large stock of wares for further experiments (137). Neither the pottery nor the address itself appears in the local directory after 1933. However, it seems that Taylor continued to occupy the premises until 1935, continuing his experiments with the biscuit ware remaining from that last firing. On his retirement he destroyed his notes, fearing that they would pass into the hands of the unscrupulous and that cheap imitations of his wares would be made. Taylor and his wife retired to Devon in 1935, and he died within a few months. In 1937 the premises at 173 Oldbury Road were listed as being occupied by C. H. White Ltd., Wholesale Chemists.

Ruskin Wares

The Ruskin Pottery was justly proud that all its marvellous effects were achieved with leadless glazes (Colour XXXVIII). The agonies of those who suffered from lead poisoning had been widely publicised, and with their roots in the Potteries, the Taylors would doubtless have observed many cases themselves. John Service explained that their lustres were applied over the glaze (explaining why they scratch so easily) ". . . thus avoiding those which have to be reduced by lead . . .".

The body employed was, necessarily, a stoneware, which could withstand the high temperatures needed to achieve the glaze effects. Some pieces are of an eggshell thinness, and others quite thick.

Ruskin Pottery shapes are always simple, classic ones, often copied from Chinese ceramics or contemporary French art pottery. It was rightly believed that fussy details would detract from rather than enhance the effects of the glazes. Some pots were mounted in silver. Later slip-cast wares show an Art Deco influence.

In a booklet on the pottery which Taylor published in 1917, the Ruskin Wares were divided into three groups, soufflé, lustre and flambé wares.

Soufflé Wares "with and without hand-painted patterns. This group comprises a single colour note, or this varied slightly by mottlings, cloudings, or gradations of a harmonious colour. The colours range from dark blue and greens to

turquoise and pale green, from purple to mauve and warm pink, there are also greys and celadons. Many are enriched with hand-painted patterns adapted from plants, unconventionalised, except that they are painted in one flat colour and are kept subordinate."

LUSTRE WARES. "The lemon-yellow and orange lustres [Colour XX], with or without a green or bronze colour under-glaze pattern, are quite new in method, and are specially beautiful products, as are also the Kingfisher blue and pearl blister lustres." In 1924 William Howson Taylor issued a further booklet which listed yellow, orange, mauve, delphinium blue, pink, purple, turquoise, light green, grey green, brown, dark blue, kingfisher blue and mottled yellow lustres (*PG>R*, September 1924).

"REAL FLAMBÉ WARE, each piece being unique and unrepeatable. The colourings, textures and patternings of this real Flambé are as varied as is the number of individual pieces, and they include peach bloom, crushed strawberry, deep ruby, rouge Flambé (some of this last have green markings), ivory with pigeon's blood cloudings, purple-blue with turquoise cloudings, snake-green with ivory, grey, mauve or pigeon's blood diaperings, turquoise gradating to purple and with ruby veinings, dove-grey with diaperings, and ivory with grey diapers." These wares were fired in a special "red kiln". Howson Taylor restricted access to these firings, keeping his methods secret.

MATT GLAZES, usually in pastel shades, were used on slip-cast pieces such as lamp bases, which were produced during the last years of the pottery.

CRYSTALLINE GLAZES were mentioned as early as 1908, when they were shown at the Ideal Home Exhibition (*PG*, December 1908).

BUTTONS and "enamels". These prosaic wares still offer the best opportunities for collectors today (see Colour VIII). Many of them were mounted and so cannot be identified but, despite their seemingly mundane purpose, they offer small examples of every glaze effect used by Taylor. The buttons were not cheap: in 1912 a set of six shown at the Arts and Crafts Exhibition was priced at three shillings. Although it is sometimes said that the buttons were used for glaze experiments, they were one of the mainstays of the firm's production. Its advertisement in *The Pottery Gazette* in 1905 mentions only enamels and buttons. Apart from use as buttons, in which case they had self shanks, the enamels (which were buttons without the shanks, not enamels at all) were mounted in silver and gold, like jewellery, and sold to other potteries for mounting in vases and flower pots, and for mounting in wood. Beaten copper mounts set with Ruskin enamels were used for mirrors, firescreens, boxes, umbrella stands and so on. Hat-pins, studs, cuff-links and scarf pins were also made.

Good collections of Ruskin Pottery may be seen at Wednesbury Art Gallery and Museum and Birmingham City Museum and Art Gallery.

Marks: A "WHT" monogram is thought to be the first mark employed. Scissors, incised, sometimes with "RUSKIN", incised, was used on early wares. Later pieces bear a wide variety of impressed marks including "RUSKIN". Some pieces bear W. Howson Taylor's signature, incised; this signature was not, as is sometimes thought, reserved for important pieces, as it was applied before the decoration. Many pieces bear impressed dates. All the above marks may also be painted. The products of the last kiln are impressed "RUSKIN ENGLAND 1933", the first word

forming the top of an inverted triangle. A number of these bear Taylor's signature, probably because he knew that it would be the last biscuit firing.

References: A&CXS 1903, 1906, 1910, 1912, 1916, 1923 and 1926; Bennett, Ian, "Ruskin Pottery", *The Connoisseur*, November 1973, pp. 180–85; Bennett, Ian, *Ruskin Pottery: A Selection from the Ferneyhough Collection* (Ian Bennett and Haslam and Whiteway, 1981); Cameron; Coysh; "Edward Richard Taylor, Obituary", *PG*, February 1912; Godden 1964, 1988; Graves; Hall, Kate A., *A Notable Art Master – An Appreciation* [of Edward R. Taylor] (Birmingham, 1908); Haslam 1975; *KPOD Birmingham*; Pemberton; *PG*; *PG>R*; Powell, L. B., *Howson Taylor, Master Potter* (City of Birmingham School of Printing; Central School of Arts and Crafts, 1936); Rhead; "Ruskin Pottery", *PG*, January 1903; Ruskin Pottery, *Catalogue* (c.1913), [held at the National Art Library]; Ruston, James, *Ruskin Pottery*, (Sandwell Metroplitan Borough Council, second edition, 1990); Service, John, "British Pottery", *AJ*, 1908, pp. 53–57, 129–37, 238–44; "Studio Talk", *Studio*, vol. 33, 1904, p. 82; Thomas 1974.

Temple, Charles Henry
working *c.*1883–1906 +

Temple was a partner in the firm Temple & Messenger, 26–29 Sudlow Street, Wandsworth, London, *c.*1883–87. The only known product of this firm is a boldly painted stoneware vase, illustrated by Messenger. The firm failed apparently because of firing problems, and Temple went to work for Maw & Co. (Ltd)* as an in-house designer from 1887 until 1906. At Maw's, Temple designed and painted tiles shown at the Arts and Crafts Exhibitions of 1888, 1889, 1890 and 1893. He designed many portrait tiles and invented a photographic transfer process. Although Temple established his own studio for decorating Maw's blanks in 1906, he continued to supply designs to the firm. The decorated tiles were then fired by Maw's.

Marks: "T & M" for Temple & Messenger 1883–87; "C. H. TEMPLE" or "C. H. T.", painted.

References: A&CXS 1888, 1889, 1890 and 1893; Austwick; Messenger; Messenger, Michael, "Spring of Inspiration: The Tile Designs of Maw and Company", *Country Life*, 6 July, 1978, pp. 28–29.

Temple & Messenger

See C. H. Temple.

Tiffany & Co.
1853 to the present day

Tiffany's, best known as jewellers, played the same role in New York as did Liberty & Co.* in London. Associated with the Art Nouveau style in particular, they retailed the best-quality decorative arts in this style. Tiffany's prestige as agents were instrumental in opening up the important American market to British art pottery, made by Sir Edmund Elton*, J. Macintyre & Co. Ltd*, Pilkingtons Tile & Pottery Co. (Ltd)* and William Howson Taylor*. Other ceramics sold at Tiffany's included Doulton & Co. (Ltd), Burslem's* *rouge flambé* and other glaze effects on porcelain, the avant-garde porcelains of Royal Copenhagen, and the high-fired stonewares of the French art potters.

References: Cameron; Paul, Tessa, *The Art of Louis Comfort Tiffany* (Exeter Books, New York, 1987).

Tooth & Ault

Bretby Art Pottery, Church Gresley, Burton-on-Trent, Derbyshire
1882–87

After leaving the Linthorpe Pottery*, Henry Tooth* returned to T. G. Green & Co. (Ltd)*, from whom he had received his brief training. "He induced Mr Green . . . to spare him a kiln and small workshop for preliminary work, and there he evolved the first models in his now universally known 'Bretby Ware.'" (*PG*, June 1915) After this initial experimentation, he formed a partnership with William Ault*, with whom he built the Bretby Art Pottery. This partnership survived for only five years, after which William Ault moved to Swadlincote to start William Ault & Co.*. Henry Tooth continued the business as Henry Tooth & Co. (Ltd)*. In 1885 the firm advertised "Bretby Ware – A High Class Decorative Pottery, Rich and Harmonious in Colour, Artistic in Form and Treatment and moderate in price" (*PG Diary*).

Marks: "Bretby" beneath a rising sun, printed or impressed. Registered as a trade mark in 1884.

References: *MBD*; *PG*; *PG Diary*; "Tooth & Co Ltd, Bretby", *PG*, June 1915, pp. 645–47.

Tooth, Henry

1842–1918

Henry Tooth was born in Newport Pagnell, Buckinghamshire. He received little formal education and, after a variety of occupations, found himself employed in London as a theatrical scene painter. He then settled in the Isle of Wight, where he worked as an ecclesiastical and domestic decorator, specializing in stained and painted glass. There he met Christopher Dresser*, who induced him to become an art potter. As Tooth had no practical experience in this line, he spent three months at T. G. Green & Co. (Ltd)*'s, in Church Gresley, studying pottery methods. He then took up a post as manager of the Linthorpe Pottery*.

Tooth had studied chemistry in connection with his stained glass work, and he applied this knowledge to the development of the famous Linthorpe glazes, for which he took the entire credit. Nevertheless, Tooth was unhappy at Linthorpe and left in 1882. He returned to Derbyshire, and started the Bretby Art Pottery in Woodville in partnership with William Ault*, trading under the style Tooth and Ault*. After only five years, William Ault left to establish his own pottery, William Ault & Co.*.

Tooth's obituary noted that he ". . . found his recreation in his work; he was an arduous worker, and in the pursuit of any particular effect he was quite oblivious to any other aims, being wholly absorbed until his perseverence met with success or failure." He was a skilled muralist, and painted friezes in the factory's showrooms and their various exhibition stands, as well as in his local church. Indeed, he was even known to have painted the local Salvation Army Corps' drum!

References: "The Evolution of an Industry: Bretby Art Pottery", *PG*, May, 1905, pp. 541–43; Hart, Clive W., *Linthorpe Art Pottery* (Aisling Publications, Clevedon, 1988); "Henry Tooth", *PG*, October 1918, pp. 792; "Tooth & Co., Ltd., Bretby", *PG*, June 1915, pp. 645–47. (*See also* Linthorpe Pottery; Tooth & Ault; Tooth & Co.)

Tooth, Henry & Co. (Ltd)

*Bretby Art Pottery,
Woodville, near Burton-on-
Trent, Derbyshire
1887 to the present day*

In 1882 Henry Tooth* and William Ault* established the Bretby Art Pottery under the style Tooth & Ault*. In 1887, Ault departed, leaving Tooth to continue, with the financial assistance of John Downing Wragg. The early wares were similar to the Linthorpe Pottery*'s wares, which Tooth had been instrumental in developing. When Linthorpe closed in 1889, both Ault and Tooth purchased many of the moulds, including some designed by Christopher Dresser*. Bretby Ware was soon recognized as a reasonably priced artistic ware. Tooth was assisted by his son, W. E. Tooth (from 1903), and his daughter, Florence (Mrs J. B. Rigg).

In 1912 J. D. Wragg left the partnership and Tooth & Co. Ltd was registered with a capital of £6,000 in £1 shares. The first directors were Henry Tooth and W. E. Tooth (*PG*, December 1912). W. E. Tooth took over as manager in 1914, which post he held until 1926. The firm was then managed by W. F. Nickels and his sons, although Florence's son, J. Rigg, and S. Swinnerton were also active in the running of the firm (*PG*, November 1929).

In 1933 Fred Parker, who had formerly worked for W. H. Grindley & Co. (Ltd) and the Crown Staffordshire Porcelain Co. Ltd, acquired the firm. It was said that Neville Chamberlain presented Hitler with a Bretby jug in the shape of George VII on his famous visit to Munich in 1938. This jug played the national anthem whenever lifted, and Hitler allegedly instructed that it was to be taken to the air raid shelter during alerts!

During the Second World War, the pottery was requisitioned as a depot by the Ministry of Food. After the war, Fred Parker was assisted by his twin sons, Frederick Vernon Parker, who ran the sales department, and James Myatt Parker, who ran the works. The firm hired two Latvian refugees, T. Veckungs and E. Paupe, as modeller and mould-maker. They reorganized the business and scaled down production, specializing in hand-made earthenware vases, animal figures, ash trays, book-ends, tobacco jars, lamp bases and so on, decorated in bright and matt glazes.

Although Tooth's was clearly a commercial pottery that employed modern methods such as slip-casting, as opposed to a purist's art pottery that would only produce thrown pots, the firm's work was universally acknowledged as art pottery. No less a critic than Frederick Rhead*, writing in *The Artist*, noted:

> . . . art and commercialism are not necessarily hostile to each other. The productions of Messrs Tooth of Woodville . . . are a convincing proof of this . . . The suggestion . . . that the craftsman should avail himself intelligently of mechanical aids, is well exemplified in Messrs Tooth's dragon vase. The vase is "pressed" . . . but the "presser" is also an artist, for he has supplemented the work of the mould by vital touches, and for the sharp projections and spines which could not be made in the mould, he has rolled bits of clay between his fingers . . . and stuck them on where they are wanted . . . the beautiful olive green glaze with which the vase is covered – clear on the projections – dark, deep and mysterious in the hollows, Mr Tooth's glazes are as fine as the Orientals.

The firm participated at all the major exhibitions, winning a Diploma of Honour at the International Exhibitions in Brussels in 1910 and Turin in 1911; and a Grand Prix at the Festival of Empire, Crystal Palace, in 1911. Tooth attended the exhibitions personally and is said to have carried his sketch book with him everywhere, recording his inspirations.

138 Bretby Wares by Henry Tooth & Co. Ltd advertised in *The Pottery Gazette*, July 1904.

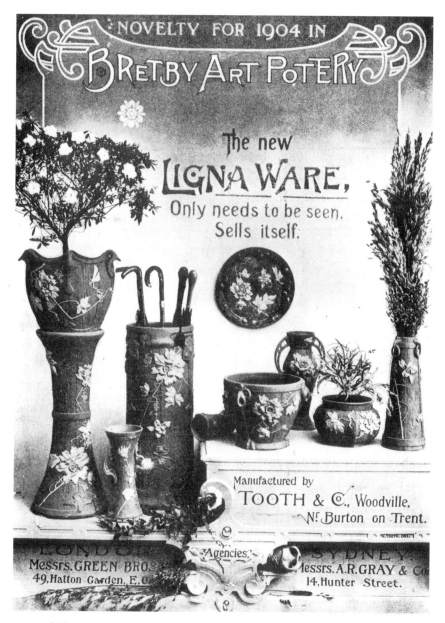

NOVELTY FOR 1904 IN

BRETBY ART POTTERY

The new LIGNA WARE, Only needs to be seen. Sells itself.

Manufactured by TOOTH & C°., Woodville, N° Burton on Trent.

Agencies.

LONDON
Messrs. GREEN BROS.
49, Hatton Garden, E.C.

SYDNEY
Messrs. A.R. GRAY & C°
14, Hunter Street.

Very little is known of Tooth's employees. It is known that he did a great deal of design work himself and that his son, W. E. Tooth, also had his own studio at the works. W. E. Tooth said that his sister, Florence (Mrs J. B. Rigg), "has in the past done a large amount of modelling in connection with Bretby productions, and has of recent years produced several models" (*PG>R*, November 1929).

The firm specialized in large wares such as umbrella stands and pots with pedestals (138 and 139). However, nearly every type of ornamental ware was made, down to ash and pin trays. Figures, including grotesques, were also made. Some of the figurines were very finely modelled. These included: *Italian Fisher Boy*, 1917, *Italian Boy and Girl*, 1918, *The Lady and the Shells*, 1919, *Polar Bear*, 1919, *Eastern Lady*, 1919, and *Alpine Soldier*, 1919. Animal models included cats, dogs,

lions and elephants. The firm also made such useful items as the patented "Ex Eau" flower pot support, which held the potted plant above any water which might accumulate in a jardinière (*PG*, June 1905).

Bretby Ware was well known for its self coloured glazes. These included Rose du Barri, Heliotrope, Saxe Blue, Green and Blood Red (*PG*, May 1913; *PG>R*, September 1921). The glazes were used to enhance relief-moulded wares.

Bretby also specialized in *trompe l'œil* wares known as "deception" pieces. These included nuts, biscuits, tomatoes, reels of cotton, cigars and pipes with matches, and scissors on trays. They also produced many wares whose surfaces imitated materials such as ivory, wood and metals. The word which appears most often in the many reviews of Bretby Ware is "novelty". The firm was continually striving to develop new effects, as can be seen from the list of wares below. Sometimes their efforts resulted in wares which must have been appalling, such as the "plant pot in the form of a cat's head with green eyes and open mouth showing the red tongue. It can be used as a vase for holding a plant pot, and then, at night, with a light inside, it would give a curious effect to an odd corner." (*PG*, March 1904)

Bretby wares

Many of these wares were made continuously from their introduction into the 1920s. Dates of introduction are based on the wares' first appearance in the trade press and are therefore only approximate. Where dated descriptions are given, these are the first printed references to the wares, unless otherwise noted.

APPLIQUÉ WARE, advertised in *The Pottery Gazette*, 1890.

BRONZE WARE, introduced in 1905.

BRONZE AND JEWELLED WARE. Bronze ware with inset ceramic "jewels". At least some of these were purchased from W. H. Taylor*. Introduced in 1905.

CALIPH WARE was a "green, purple and orange in a remarkable scheme of juxtaposition, resembling a mosaic" (*PG>R*, April 1926).

CARVED BAMBOO WARE. "It is an imitation of Japanese carved bamboo, on which

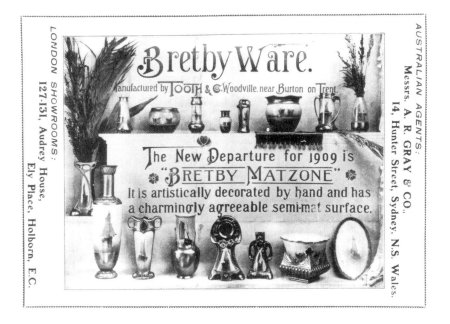

139 Bretby Wares by Henry Tooth & Co. Ltd advertised in *The Pottery Gazette*, April 1909.

illustrations of scenes from Japanese mythological lore are portrayed." (*PG*, March 1907)

CARVED IVORY AND EBONY WARE. Busts, including those of Dickens, Shakespeare, Scott and Burns, were made. "The ivory is very light on the face and head, and gradually tones heavier towards the neck and shoulder, until, by the time the plinth is reached, the colour has evolved into a distinct brown." (*PG*, May 1913)

CLANTA WARE. Tooth first exhibited Clanta Ware, with various metallic effects, at the British Industries Fair in 1915. This was ". . . a line introduced with the idea of supserseding foreign goods and to sell at Continental prices" (*PG*, June 1915). Clanta Ware was registered as a trademark in November 1914.

CLOISONNÉ WARE. This was Bronze Ware, "relieved by birds of rich plumage, or by flowers of exquisite colourings in 'Cloisonné' of gold" (*PG*, May 1908). In 1913 pink, pink and green, turquoise, and Royal Chinese yellow grounds were introduced (*PG*, May 1913).

COPPERETTE WARE. "Antique forms with hammered metallic effects". (*PG* May 1908)

DELHI WARE. These were wares "the chief feature of which is the beautiful iridescent shading. Some of the forms have a honeycomb ornamentation all over." (*PG*, April 1912)

DICKENSIAN WARE. Relief-moulded pots, with favourite characters from the novels of Charles Dickens picked out in enamels (*PG>R*, September 1929).

FIBROLINE WARE. "Finding that little has been done in this country to produce decoration of a high class for Coronation and other patriotic functions, for external or internal decoration, Mr Tooth has produced a distinctive line, which he has named 'Fibroline' comprising medallions, shields, and coats of arms made in sizes from miniatures 10 in. in diameter to $37\frac{1}{2}$ in. in diameter . . . and royal arms 7 ft long by 5 ft 6 in. high." Shown at the Festival of Empire, Crystal Palace, 1911 (*PG*, June 1911).

IVORINE WARE. "It is remindful of the old ivory productions, which it assimilates in a very definite manner." (*PG*, September 1914)

LIGNA WARE. "The novelty for 1904" (*PG*, February 1904). "It is a reproduction in pottery of hammered copper and brass work" (*PG*, March 1904). Another version was later released: "an imitation of wood with metal mounts" (*PG*, April 1912).

LUSTRE WARE. Lustre figures were shown at the Festival of Empire, Crystal Palace, and the International Exhibition in Turin both in 1911 (*PG*, June and July 1911).

MATZONE. "It is artistically decorated by hand and has a charmingly agreeable semi-matt surface" (*PG*, April 1909). The decoration "consisting chiefly of seascapes and landscapes . . . The majority of them have panels or 'set-off' portions on which the views are portrayed, surrounded with modelled ornamentation in perfect facsimile of bronze and other metals . . .". (*PG*, September 1909)

NERTON WARE. Glaze effects including gold-stone, blue aventurine, green, rose, royal blue, green and yellow and mottled glazes (*PG>R*, September 1920 and 1921). A matt version was introduced in 1921.

OLD IVORY WARE. (*PG*, April 1914)

PATINA WARE. The "shapes are all of ancient origin" (*PG*, September 1909).

POLISHED GRANITE was sometimes relieved with bronze or silver (*PG*, May 1913).

ROUGE FLAMMÉ figures were shown at the Festival of Empire, Crystal Palace, and at the International Exhibition in Turin both in 1911 (*PG*, June and July 1911).

TARSIA WARE, advertised in *The Pottery Gazette* in 1890.

ZUIDER-ZEE WARES. These were ". . . a series of Dutch figures, realistically depicted, forming part of the actual modelling, appearing in embossed relief, and these figures in relief are then coloured up in bright enamels to yield a very picturesque effect." (*PG>R*, April 1927)

Marks: "Bretby" beneath a rising sun, printed or impressed. Many of the firm's designs were registered, so moulded registration numbers may be found.

Moulded shape numbers may also be found. Very few of Bretby's advertisements included shape numbers, although an advertisement in *The Pottery & Glass Trade Review* of September 1921 includes Nerton Ware in shapes from 68 to 2217, and Carved Bamboo Wares in shapes from 901 to 2492. In 1925, the firm was employing some 2,600 models (*PG>R*, April 1925). This is evidence that the firm continually made use of old moulds for new decoration. One cannot, therefore, assume that a pot with a very low shape number is an early piece.

References: Blacker, Brown; Cameron; Coysh; Daniels, Stephen "Bretby and the Art of Mimicry", *Art & Antiques*, 23 April 1977; "The Evolution of an Industry: Bretby Art Pottery", *PG*, May, 1905, pp. 541–43; "Famous Ornamental Ware Manufacturer: Traditions Preserved at Bretby Art Pottery", *PG>R*, October 1951, pp. 1553–56; "The Famous Pottery at Bretby", *PG>R*, September 1929, pp. 1445–46; Godden 1964, 1972; "Henry Tooth", *PG*, October 1918, p. 792; Pinkham; *PG*; *PG>R*; Rhead, Frederick, "Pottery Decoration", *Artist*, vol. XIX, 1897, pp. 281–87; "Tooth & Co., Ltd., Bretby", *PG*, June 1915, pp. 645–47.

Tormohun Pottery

See Longpark Pottery.

Torquay Pottery Co. Ltd

Hele Cross, Torquay, Devon
1908–31
Torquay Pottery (1932) Ltd,
1932–45

These works, the property of the Torquay Terra-Cotta Co. Ltd*, remained empty for two or three years before Enoch "Nockie" Staddon, previously employed at the Bovey Tracey Pottery, opened the Torquay Pottery Co. there. Staddon installed such modern machinery as belt-driven throwing wheels. By 1915, about twenty people were employed, including the decorators Harry Crute and Harry Birbeck, and the modeller Vincent Kane.

The firm advertised "High Class Art Ware" and "Great bargain bazaar parcels from 10s 6d" in *Morris's Business Directory* of 1913–30. They made typical red-bodied Torquay wares for the lower end of the market, including motto ware and grotesques. Landscapes, cottages, windmills and fishing boats painted in garish colours were popular patterns. Thomas (1978) illustrates a wide range of the firm's ware, including teawares with Wemyss-type roses, wild roses on a streaky pink ground, a kingfisher-pattern jardinière (which has a yellow ground, rather than the blue usually associated with the pattern) and a range of mugs and character jugs with characters from the *Widecombe Fair* ballad.

The pottery introduced their Parrot ware, with sponged foliage, of which they claimed to be the sole makers, at the British Industries Fair in 1924. Queen Mary purchased a pair of these vases, and the pottery afterwards adopted the name Royal Torquay Pottery. Owls and flamingoes were added to the Parrot range. The 1920s saw the introduction of Jazz Age patterns, such as Mosaic and Cubist, and Egyptian motifs inspired by the opening of the tomb of Tutankhamun.

The pottery suffered severely during the Depression and a petition for winding up was issued in 1931. This winding up was not completed until June 1933 and in the meantime Staddon had formed a new company to run the pottery under the style Torquay Pottery (1932) Ltd. This firm was listed as being licensed by the Government to produce undecorated earthenware in 1945. The pottery eventually closed, and the premises were used by a laundry.

The pottery's subsidiary at Bovey Tracey produced nearly identical wares from c.1918 to 1920.

Marks: "Hele Cross Pottery", impressed on some early wares; a wide variety of marks incorporating all or part of the following: "TORQUAY POTTERY Co. HELE CROSS TORQUAY, DEVON", printed in black, painted, impressed or incised. "ROYAL" appears in marks from 1924.

References: Brisco, Virginia, "The Torquay Pottery Company", *TPCS Magazine*, July 1990, pp. 8–12; Jones; *MBD*; Patrick; *PG>R*; Thomas 1974, 1978; *TPCS Magazines*; TPCS 1986, 1989.

Torquay Terra-Cotta Co. Ltd
Torquay, Devon
c.1874–c.1906

This pottery was established c.1874 by "Dr Gillow, who discovered an excellent deposit of fine clay of a very durable quality and of a fine rich red" (Rhead). Thomas suggests that Gillow "discovered" this clay when he saw red earth turned over by grave-diggers at the cemetery across the street! According to *The Pottery Gazette*, Dr Gillow was a man "of enterprising spirit . . . with sound commercial knowledge, administrative capacity and cultivated taste" (1878). He hired Thomas Bentley of Hanley to manage the potting. Alexander Fisher senior, of Brown-Westhead, Moore & Co., came to head the art department. A Mr Ridgeway, of Stoke-on-Trent, came down to manage the company. He was succeeded by Thomas Bentley, 1874–84. George Ridgeway, son of Mr Ridgeway (listed in the 1881 census as a painter aged eighteen), was listed in *White's Directory of Devon* in 1890 as Manager and Secretary.

The pottery, with the assistance of skilled potters and artists from Staffordshire, had soon established a wide reputation. In 1877, *The Art Journal* printed extracts from a lecture, "Terra-Cotta", given by Dr Gillow to the Teign Naturalists' Society in Torquay. The editor commented: "The company at Torquay, under the guidance of Dr Gillow, has sent out some very meritorious and beautiful productions of various classes and orders – statuettes, plaques, vases, flower-pots, and so forth. They are, for the most part, painted on – by accomplished artists, and may be accepted as very excellent examples of Art."

The firm's display at the Paris Universal Exhibition of 1878 received an Honourable Mention. In 1881, John Phillips, the local historian, said: "The two potteries [Watcombe Terra-Cotta Co. (Ltd)* and Torquay Terra-Cotta Co.] at Torquay have performed a work far beyond the mere fabricating of things of beauty in red earth. They have created, and, by facilities which they afford, have fostered a keen appreciation of ceramic art." The firm benefitted from the boom in china-painting of the period, selling a wide variety of plaques for decoration by amateurs.

The firm's advertisements in 1882 read "Terra Cotta & Fine Art Pottery" and "Decorates the Highest Style of Art, in Barbotine, Underglaze & Enamel". (*PG Diary*, 1883)

A highly laudatory survey of the firm's products published in *Decoration* in 1888

lists the following styles: "Devonian, Compton, Wedgwood, Chantilly, Danish, Persian and Delhi". Also praised was *You Dirty Boy*, replicas of the Pears & Co. soap advertisement, which were produced for that company. Another review in *The Artist* the same year reported:

> The Torquay Company's clay is of great purity, containing no lime constituents, thus enabling the artist to use clay slips and the most delicate enamels; without fear of flying, in the course of firing. Indeed, this quality has led to the advancement and development of an entirely distinct mode of decoration, the skilful use of enamels, and so we find examples of unusual softness and sweetness of colour, in perfect harmony with the refined surface of the terra cotta.

At the Torquay Exhibition of 1890 the firm displayed statuettes of classical subjects, replicas of Focadi's *You Dirty Boy* and the new Stapleton Ware, a glazed ware in imitation of Linthorpe Pottery*, sometimes decorated with sgraffito work. The firm had in fact purchased at auction moulds, glazes and designs from the Linthorpe Pottery. It also registered the trade name "Crown Devon Ware" for a new range of art ceramics (*PG*, August 1890). Thomas believes these to have been "useful and ornamental articles decorated under a clear glaze with sprays of apple blossom in pink and white, with black branches, on a dark green ground".

It is not certain when the pottery finally closed. It still appeared in the *Pottery Gazette Diary's* Directory of Manufacturers of 1907. In 1908, it was taken over by the Torquay Pottery Co.*.

Artists, modellers, designers and decorators

MR BEECH decorated vases shown at the Paris Universal Exhibition of 1878.

JOHN BELL (1812–95) was an important Victorian sculptor. He designed many models for ceramic reproduction in majolica, Parian and terracotta. His *Dorothea* was made for Summerly's Art Manufactures in Parian by Mintons and in terracotta by the Torquay Terra-Cotta Co. Ltd.

THOMAS BENTLEY (d. 1884) was head of potting from 1874 until 1884. Among the figures he modelled were *Apollo, Ajax, Diana* and *Clytra.*

CHARLES BELL BIRCH modelled a figure of Dick Whittington. This figure was first produced by the Watcombe Terra-Cotta Co. (Ltd)* and then by the Torquay Terra-Cotta Co. Ltd. The figure was published by the London Art Union.

HOLLAND BIRKBECK (working 1878–1888) is known for his bird paintings. His plaques were shown at the Paris Universal Exhibition of 1878. He also worked for the Watcombe Terra-Cotta Co. (Ltd)*.

LEWIS F. DAY* designed a pair of vases, painted by Alexander Fisher senior, and a frieze which were shown at the Paris Universal Exhibition of 1878.

ALEXANDER FISHER JUNIOR (born *c.*1864), worked as a painter at Torquay, later becoming known for his Art Nouveau metalwork and jewellery designs.

ALEXANDER FISHER SENIOR (born *c.*1837), worked previously for Brown-Westhead, Moore & Co., and was best known for his bird paintings. His vases and plaques, including some with paintings after Landseer, landscapes and Greek ornaments, were shown at the Paris Universal Exhibition of 1878. He was author of the chapter on painting in *Hints on Fine Art Pottery Painting*, published in 1881. He also worked for the Watcombe Terra-Cotta Co. (Ltd)*. He sometimes signed his work "AF".

JOHN GIBSON (1790–1866). This eminent Victorian sculptor's *Tinted Venus* was reproduced in terracotta.

EMMELINE HALSE (1856–1930), of London, was a sculptor who worked in plaster, bronze, wax etc. She modelled *Homeless, Sunshine* and *Parted Friends* (a boy with his dead dog), which were shown at the Paris Universal Exhibition 1878. She studied at the Royal Academy schools and in Paris.

JEAN ANTOINE HOUDIN was a French sculptor whose statues *Jean qui pleure* and *Jean qui rit* were reproduced in terracotta, as well as in bronze and Parian by other manufacturers.

MISS LEVIN, of London, painted figure subjects shown at the Paris Universal Exhibition of 1878. She was praised as possessing "genuine poetic feeling" (*PG*, 1878).

M. LUSTLEIGH, working *c.*1878, was a bird painter.

JOHANNES MATTHAUS MOHR (1831–1903) was a sculptor of the German School. He worked at the Nymphenburg Porcelain factory. Thomas illustrates a picture of a figure thought to have been based on Mohr's *The Bather*. Mohr also worked for the Watcombe Terra-Cotta Co. (Ltd)*.

JAMES SKINNER, a porcelain painter, was listed in the 1881 census. He was probably the artist who decorated a pair of Argyle vases and a beer set shown at the Paris Universal Exhibition of 1878. He was a modeller at the Watcombe Terra-Cotta Co. (Ltd)* who later became the manager of the Kerswell Art Pottery*.

ARTHUR WALKER specialized in flower paintings. His vases were shown at the Paris Universal Exhibition of 1878.

ZOCCHI was a Florentine sculptor who modelled figures of Michelangelo and Raphael shown at the Paris Universal Exhibition of 1878. This was probably Emilio Zucchi (1835–1913), who was a very talented sculptor of the Italian School. His *Michel-Ange enfant* is in the Pitti Palace in Florence.

Marks: "TORQUAY", impressed; "TORQUAY TERRA COTTA Co. LIMITED" in an oval, impressed or printed; "TTC" monogram, impressed; "TORQUAY TERRA COTTA Co. LIMITED", in a garter, with the "TTC" monogram and "TRADE MARK" at the centre, printed or impressed (appears after 1900); "STAPLETON", impressed.

References: *Artist*, vol. IX, 1888, p. 335; Bénézit; Bergesen; Brisco, Virginia, "Early Days at the Torquay Terracotta Company", *TPCS Magazine*, July 1989, pp. 14–17; Brisco, Virginia, "The Torquay Potteries in 1881", *TPCS Magazine*, January 1986, pp. 8–11; Cashmore 1986; Cashmore, Chris, "Adverts for the Torquay Potteries in *The Pottery Gazette, 1883–87*", *TPCS Magazine*, April 1984, pp. 9–13; Coysh; Dunford; Godden 1964, 1972; Gunnis, Rupert, *Dictionary of British Sculptors, 1660-1851*, (Abbey Library, revised edition, 1963); *Official Catalogue British Section, Paris Exhibition 1878*; Petteys; Phillips, J., "The Potter's Art in Devonshire", *Report and Transactions of the Devonshire Association*, vol. 13, 1881, pp. 214–17; *PG; PG Diary*; Rhead; "Terra-Cotta", *AJ*, vol. XVI, 1877, pp. 214–15; *TPCS Magazines*; "Terra-Cotta Plaques", *TPCS Magazine*, April 1987, pp. 10–11; "Terracotta Plate by Alexander Fisher", *TPCS Magazine*, January 1990, pp. 20–21; Thomas 1974, 1978; "Torquay Terra Cotta Co. (Ltd)", *Decoration, The Arts Trades Review* supplement, June 1888, p. 7; TPCS 1986; *TPCS Magazines*.

Tor Vale Art Potteries
Teignmouth Road, St Mary Church, Torquay, Devon
1911–14

The pottery was owned by John Barker, of Staffordshire, who had worked for Henry Tooth & Co. (Ltd)*. The patterns included Wild Rose on a streaky violet ground, the Jacobean rose in pink and purple, powder blue Chinese flower pots, and self-coloured glazes. Vases were also decorated in a style very similar to pots that Samuel Shufflebotham's* "Leaded Lights Pottery" made at Pountney & Co. (Ltd)*. The firm made vases, flower pots, tea sets and toilet sets. James Main, who had also worked for the Aller Vale (Art) Pottery*, Longpark Pottery Co. (Ltd)* and Crown Dorset Pottery*, was one of the decorators.

Tom Lemon and Harry Crute purchased the Tor Vale Pottery in 1914, operating under the style Lemon & Crute*. As the purchase included biscuit stock, some wares with Lemon & Crute patterns may be found with Tor Vale's impressed windmill mark. Lemon & Crute may have continued to use the Tor Vale name briefly, for it appears in *Morris's Business Directory* of 1915. The firm is listed as an exhibitor at the British Industries Fair of 1915.

John Barker moved to the Watcombe Terra-Cotta Co. (Ltd)*, where he apparently remained until emigrating to Australia in the early 1920s. After an unsuccessful attempt to establish a pottery at Narrogin, Western Australia, John Barker and his son, John Leach Barker, devoted themselves to watercolour painting, for which they became famous.

Marks: "Tor Vale", painted in black, usually with a pattern number; a windmill, impressed; "TOR VALE".

References: "Devon Witches", *TPCS Magazine*, October 1989, pp. 14–15; *MBD*; "Notes on Lemon and Crute, and Tor Vale", *TPCS Magazine*, January 1988, pp. 13–15; Patrick; *PG*; Thomas 1978; TPCS 1986; *TPCS Magazines*.

Tranter & Machin
(Porcelain Art Pottery),
Wharf Street, Longton,
Staffordshire
1886–91
Stafford Street,
1892–98

This firm advertised art pottery in *The Pottery Gazette* of January 1895. It was probably not of very high quality, as the advertisement also stated: "Look! The Cheapest House in the Trade for Decorated Toilets, Jugs, Dinner and Tea Sets."

Trent Art Tile Co. Ltd
Swadlincote, near Burton-on-Trent, Derbyshire
c.1906–11

This firm appeared in the *Pottery Gazette Diary* of 1907. "H. Ashford ceased to act as receiver October 26." for a Trent Art Tile Co. Ltd, Birmingham (*PG*, December 1911). This firm may have been responsible for Art Nouveau tiles marked "TRENTHAM".

Turner, Hugh Thackeray
1853–1937

Turner was an architect who took up china painting in 1882. He became a member of the Art Workers Guild* in 1886. He exhibited his work at the Arts and Crafts Exhibitions of 1889, 1893, 1906, 1910, 1912, 1916 and 1926. He usually used bone china and earthenware blanks from J. Wedgwood (& Sons Ltd)*, but in 1906 two china bowls were listed as having been made, glazed and fired by Charles Ford of Hanley. These were illustrated in *The Art Journal* and *The Studio*. Turner's work received consistently high praise in the press and was frequently illustrated. In 1916 his ". . . art tea service with floral border and birds in centre, somewhat

after the old Persian style" and ". . . some handsome bowls with conventional floral decorations" were praised (*PG*, November 1916).

Pemberton said of Turner's works: "Charming in design and good in craftsmanship, they show a delightful sense of pleasure in the execution of even the smallest details . . . It is this feeling of pleasure in the 'doing' of the work that raises a piece of pottery above the level of the mere commercial commodity and causes it to rank as a work of art." The exterior of the bowl illustrated (140) has an Islamic floral design with Gothic lettering, and the interior a Celtic-inspired design with birds. Even the base is decorated with an elaborate mark including a circle of eight birds, a title, a date and a monogram.

References: A&CXS 1889–1926; "The Arts & Crafts Exhibition", *AJ*, 1906, p. 128; "Arts and Crafts Exhibition. Concluding Notice", *Studio*, vol. 37, 1906; Brighton 1984; Miller, Fred, "Art Workers at Home", *AJ*, 1895, pp. 311–14; Pemberton.

Unique Art Pottery Co.
*Duke Street, Fenton,
Staffordshire*
*c.*1911–13

According to *The Pottery Gazette* of August 1911, this firm was a "manufacturer of fancy art pottery in great variety . . . The principal lines are art vases, flower vases, flower pots, and clock sets. The assortment in art vases is a large one, including the 'Athens' shape, 'Greek' shape, and other classical forms. The variety of flower pots is extensive, both as regards shape and ornaments. The 'Trentham' shape in vases and flower pots, the 'Osborne' shape flower vase and the tall 'Oxford' vase are all good lines. The 'Denmark' is an embossed flower pot, shaded and gilt."

140 Bowl decorated by Hugh Thackeray Turner and displayed at the Arts & Crafts Exhibition 1906, illustrated in *The Studio*.

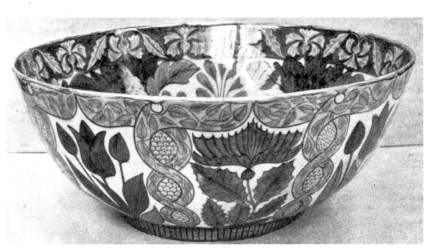

Upchurch Pottery

Rainham, Kent
1913–63

In 1907, the brothers Seymour and Sidney Wakeley were coal merchants, corn factors, farmers and hop growers. They probably purchased or built a pottery between the years 1907 and 1909. By 1909, they had added the manufacture of bricks, oven tiles and agricultural drain pipes to their activities. Possibly inspired by his friend Reginald Wells, the studio potter with whom Seymour shared an interest in aviation, Seymour started manufacture of art pottery at Upchurch in 1913. He hired Edward J. Baker (1876–1955), who had been working for Wells at the Chelsea Pottery, to run his new venture. Baker had also worked for Doulton & Co. (Ltd) Lambeth*. His family had run the pottery at Hoo, near Rochester, since *c.*1865. Baker's surviving recipe books show him to have been an avid experimenter.

By 1915, the Upchurch Pottery was exhibiting at the British Industries Fair. *The Pottery Gazette* of April 1917 reported:

> the products . . . can best be described as 'very arty'; most of the objects consisted of decorative bowls and vases with silk-like glazes in green, mauve and copper. One specimen that particularly attracted our attention had the upper part covered with a deep green glaze, which had been allowed to trickle downward over a coppery base. Owing to the nature of the glaze, the colour being largely dependent on the caprice of the fire, no two pieces of this ware can possibly be alike, and each, therefore, is a unique article worthy of the attention of the collector.

In 1918, their exhibits included ". . . bowls, vases, jars, etc. moulded on ancient Chinese, Korean and classic forms and glazed at high temperatures in pleasing shades of dull yellow, brown, blue, grey and green" (*PG*, April 1918). Queen Mary purchased a Roman-style vase from the exhibit (*P&GR*, February 1918). In 1919 the dull blue glazes were particularly admired (*PG*, April 1919). A much wider variety of colours was noticed in 1920: "'mutton fat white' and . . . a pinky mauve, blue-greens, turquoise, blue, plum-purple, brown and a number of attractive mottlings." (*PG*, April 1920).

By 1921, *The Pottery Gazette* was reporting that Upchurch had "now established its reputation". The pottery "showed an appealing collection of artistic salt-glazed [?] pottery. The pieces are offered chiefly in severe antique shapes, decorated with dull or matt glazes, the result being that the decorative effect is invariably part and parcel of the ware itself, and never gives one the impression that the pot is one thing and the decoration an afterthought." (*PG*, April 1921). In 1924 it was reported: "The range of the company's productions has been considerably extended of late years but this has been chiefly in the matter of variations in the glazes, and the blendings thereof, which has resulted in some unique and pleasing effects." (*PG>R*, June 1924) Further reviews describe a ware that would have been unpopular in the Jazz Age: "The shapes were mostly of the severe type in keeping with the sombre decorations." (*PG>R*, September 1925) "The shapes are classical and the glazes quiet, the chief claim of the wares being apparently their stolidity." (*PG>R*, April 1926). *See* 141.

Edward Spencer (1872–1938) is best known as a designer and craftsman in metals, as well as the founder of the Artificers' Guild. He encouraged Edwin Martin* when the latter developed his new style of Martin Ware in the late 1890s. It has been said that Spencer designed the Upchurch Pottery shapes but, given the simplicity of the shapes employed, particularly compared to the elaborate Art

141 Upchurch Pottery wares. *Left to right*: urn with blue-green matt glaze, impressed "UPCHURCH", h. 7.5 cm; Winnecott period vase with white exterior and pale blue interior, impressed "UPCHURCH", h. 8 cm; two-handled vase with streaky grey and blue matt glazes, impressed "UPCHURCH", h. 9 cm; jug with blue-green matt glaze, incised "Upchurch", h. 7.5 cm; Winnecott period marmalade pot with streaky brown and green glazes, impressed "UPCHURCH", h. 7.5 cm.

Nouveau metalwork that Spencer exhibited, this seems doubtful. Edward Baker's son Edward insists that the shapes were all designed by his father after illustrations of ancient Roman and Greek Pottery.

The principal link between Spencer and Upchurch is a pamphlet which he wrote. In this pamphlet, Spencer explained: "Our present experiments have been directed towards obtaining some of the more beautiful glazes and colour combinations of the Sung period." He described the glazes as the "green of trembling willow stems", "singed rose petal", "turquoise touched with lavender", "aubergine purple", "lard white" and "peach blossom red". He predicted: "Future kilns will contain examples of fine crackle in low toned whites and greys and perhaps in the long run we may attain to some blue that shall not too distantly resemble the wonderful tint of the 10th-century Chinese vases, that were like 'the sky after rain seen between the clouds.'"

In 1936, the pottery was purchased by Oscar Caradoc Davies. Oscar was a naval officer, who married Grace Barnsley in 1926. Grace Barnsley was the daughter of the architect and designer, Sidney Barnsley, a friend of Alfred Powell's*. Grace was trained in the hand painting of ceramics by Alfred and his wife Louise. Through them she began to work for J. Wedgwood (& Sons Ltd)* as a paintress, and later as a designer. She exhibited her work at the Arts and Crafts Exhibition Society's shows of 1923, 1926, 1928 and 1931.

Edward Baker, assisted by his sons Edward and James continued to run the pottery. In 1938 the Upchurch Pottery was purchased by Alice Buxton Winnecott. Mrs Winnecott introduced Claverdon Pottery, a line of tablewares and matt glazed vases in contemporary shapes. These largely superseded the earlier glaze effects and Greco-Roman shapes. Edward Baker purchased Upchurch from Mrs Winnecott c.1953. His eldest son, William, returned from London, where he had been working with the Fulham Pottery and Cheaver Filter Co. Ltd, to assist his ageing father. After Edward's death in 1955, William continued to run the pottery until it closed in 1963.

The Davies established The Roeginga Pottery (Roeginga being the Roman name

for Rainham) at nearby Rainham in 1938. Roeginga was run by Edward Baker junior, with Grace Davies as decorator. The Davies also operated the Tudor Café, and Pottery Shop, adjacent to the Roeginga Pottery.

Oscar Davies and Edward Baker junior joined the Navy at the outbreak of the Second World War. In 1947, Edward Baker junior returned to operate the pottery, now known as the Rainham Pottery, financed by the London retailer Alfred Wilson. In 1956, the pottery was purchased by Edward Baker junior, who styled it Rainham Potteries Ltd. In later years, the Rainham Pottery specialized in producing sporting trophies and commemorative wall plaques. Edward Baker retired in 1975, and the pottery was demolished.

Marks: "UPCHURCH", impressed; "Upchurch", incised.

References: Batkin; Bergesen, Victoria, "The Upchurch Pottery", *The Kent Antiques Advertiser*, vol. 1, No. 6, January 1991, pp. 16–20; Buckley; Cameron; *Chatham News*, 14 February, 1975, p. 7; *Gillingham Evening Post*, 17 February, 1975, p. 13; Haslam 1975; Haslam, Malcolm, *The Martin Brothers, Potters* (Richard Dennis, 1978); *KPOD*; Payne, George, "Researches and Discoveries in Kent", *Archaeologia Cantiana*, vol. XXXI, pp. 285–86; *PG*; *PG>R*; *P&GR*; Preston, J. M. *Industrial Medway: A Historical Survey* (Rochester, 1977); Spencer, Edward, *The Revival of Pottery at Upchurch* (Women's Printing Society, London, no date).

Voysey, Charles Francis Annesley

1857–1941

Voysey was articled to the architect J. P. Seddon. He went on to become a well-known architect in the Arts and Crafts style, and a prolific designer of wallpapers, furniture, textiles and tiles. He designed tiles for Maw & Co. (Ltd)*, Pilkingtons Tile & Pottery Co. (Ltd)* and J. Wedgwood (& Sons Ltd)*. Voysey joined the Art Workers Guild* in 1884, acting as Master in 1924. His tile designs for Maw & Co (Ltd). were shown at the Arts and Crafts Exhibitions of 1888 and 1889. His tile designs for Pilkingtons were shown at the Arts and Crafts Exhibitions of 1896 and 1903, and at the Glasgow International Exhibition of 1901. He was one of the first Royal Designers for Industry in 1936 and received a Gold Medal from the Royal Institute of British Architects in 1940.

In an interview published in *The Studio*, Voysey described his approach to design. "It seems to me that to produce any satisfactory work of art, we must acquire a complete knowledge of our material and be thorough masters of the craft to be employed in its production. Then working always reasonably, with a sense of fitness, the result will at least be healthy, natural and vital; even if it be ugly and in a way unpleasing, it will yet give some hope." Nikolaus Pevsner said:

> . . . his modifications and progressiveness, it would seem, were almost unconscious. Doctrines and hard-and-fast rules were not his way. In the

controversy between supporters of stylized and of naturalistic ornament, he did not take sides . . . The graceful shapes of a bird flying, drifting or resting, and of tree-tops with or without leaves, are favourite motifs of Voysey's, and there is an unmistakable kindliness in his childlike stylized trees and affectionately portrayed birds and beasts.

References: *Architect-Designers Pugin to Mackintosh* (Fine Art Society, 1981); A&CXS 1888, 1889, 1896 and 1903; Brighton 1984; Cameron; Durant, Stuart, *The Decorative Designs of C. F. A. Voysey* (Lutterworth Press, Cambridge, 1990); Fine Art Society 1973; Haslam 1975; Jervis; "An Interview with Mr Charles F. Annesley Voysey, Architect and Designer", *The Studio*, vol. I, 1893, pp. 231–37; Lockett; Pevsner, Nikolaus, *Pioneers of Modern Design* (revised edition, Penguin, 1975, originally printed as *Pioneers of the Modern Movement*, Faber & Faber, 1936); Tilbrook.

Vulliamy, Miss. B. G.

An article about Miss Vulliamy in *The Artist* in 1899 sketched the history of her ceramic efforts:

> . . . about eighteen months ago she began with hand-made grotesques, fashioned from bones, shells, or other natural objects. She says she was "struck by the many half-born expressions to be found in these – the smile of a cowrie shell or an ox's tooth, and so on". Suddenly someone said, "Why not turn your hand to pottery?". She did it, and rapidly passed through experiment to success, supplying Liberty's* and other dealers in different parts of England. Miss Vulliamy has now opened a sale-room of her own at 6, Pitt Street, Church St., Kensington, and wisely sells her own wares.

These wares were not potted by Miss Vulliamy but made by some unknown (and, from the poor quality of the pots in the illustration, justly so) potter. The wares illustrated were jugs, a beaker and a tobacco jar with grotesques wrapped around them.

In 1903 Wardle & Co. (Ltd)* advertised Miss Vulliamy's "registered novelties" (*PG*). Miss Vulliamy modelled the *Diplodocus* flowerpot for Wardle's in 1905. She is variously described in *The Pottery Gazette* as a modeller of "amusing and artistic creations" and of "grotesques" (*PG*, November 1905). The following year the same journal reported: "Miss Vulliamy, who is well known for her grotesque pottery, is full of original ideas. She is now busy as a Society entertainer, and gives unique costume sketches. It will be remembered that Queen Victoria bought several of her pottery productions." (*PG*, April 1906)

References: "The Grotesque and Quaint Pottery of B. G. Vulliamy", *Artist*, vol. 25, 1899, pp. 145–46; *PG*.

W

Wade, J. W. & Co.

Flaxman Art Tile Works,
High Street, Burslem
1892–1927
Wade, Heath & Co. (Ltd)
from 1927
Wade Potteries
until 1990
Wade Ceramics
1990 to the present day

This manufacturer of majolica (including *émail ombrant*) and transfer-printed tiles registered many of its designs. The firm also produced art pottery. *The Pottery Gazette* reported that the firm had "... introduced a charming novelty in art ware, flower-pots, vases and pedestals to which they have given the name 'Capucine faience'. It consists of bright and gay floral decoration on a light groundwork; the grouping is on very original lines, and the colours employed are well contrasted. Besides this, the 'Wade faience', another novelty, is likely to have a good run; it is being made in all classes of art ware ... Messrs Wade's tiles are far above the average, the designs being very chaste, and some of the relief tiles we have seen are far beyond many of their competitors, special attention being taken to ensure finished workmanship." (April 1895) The firm was listed in *The Pottery Gazette Diary* of 1907 as J. & W. Wade.

Marks: "FLAXMAN" or "Flaxman", moulded into tile backs; "WADE'S" or "W. & CO. B." on pottery.

References: Austwick; Barnard; Godden 1964; Lockett; Meigh; Niblett; *PG*; *PG Diary.*

Wardle & Co. (Ltd)

Washington Works, Victoria
Road, Hanley, Staffordshire
*c.*1881–1909
Wardle Art Co. Ltd
1909–35

In 1854, James Wardle established his pottery at Hope Street, Shelton. In 1859, he formed a partnership with the majolica manufacturer, George Ash, at James Street, off Broad Street, Hanley. Two years later, Wardle moved to William Street, off Broad Street, Hanley, operating under the style James Wardle & Co. until his death. His wife Eliza then formed a partnership with Joshua Seddon, under the style Wardle & Seddon, which was dissolved in March 1876 (*LG*, 10 March 1876, no. 24303). She then continued with the assistance of her son-in-law, David Jones, under the style Wardle & Co. Jones (1852–1906) had joined the firm in 1874. In his obituary he was credited with having secured Wardle & Co.'s international reputation. In 1881 the firm moved to its new Washington Works.

At first, Wardle & Co. specialized in medium-quality majolica and Parian wares. The firm regularly advertised majolica, green-glazed ware and earthenware in *The Pottery Gazette* (142). It was soon decided to exploit the craze for art wares. Initially these art wares were relief-moulded pots with monochrome majolica glazes. The firm soon expanded its range. In 1890 it was announced: "Messrs. Wardle & Co. of the Washington Works, Hanley, are engaged in bringing out several novelties in shapes and patterns in art ware for the American buyers when over here in the spring. As their chief trade is in the United States, they are constantly straining their ingenuity in placing on the market something fresh and novel, which is no light task, considering others are engaged in doing the same." (*PG*, January 1890) The firm advertised itself as: "Manufacturers of Hadrian, Papyrus, Vespasian & Dipt Ware ... Productions in umbrella stands, pedestals, pampas plume holders, vases,

large palm-tree pots, pots à fleurs, hanging pots, candlesticks, bric-à-brac, &c., &c.'' (*PG*, January 1890)

A major change came with the advent of the young Frederick Hürten Rhead*, who joined as art director 1899–1902, succeeded by his brother, Harry Rhead*, 1902–05. The Rheads brought tube-lining and *pâte-sur-pâte* decorating techniques to the firm, along with their two young sisters, Dolly and Charlotte Rhead*, who were proficient in both.

On 19 July 1899, the partnership between David Jones, William Wallace Wardle and Frederick Charles Wardle, trading under the style Wardle & Co., was dissolved (*LG*, 1 August 1899, no. 27110:) Frederick Charles Wardle, trading as Potteries Accountancy Co., was declared bankrupt in 1903. William Wallace Wardle's career seems to have been varied. He started business as a grocer and beer-seller in Rectory Road, Shelton, in 1901. He had severed his partnership in the Decorative Art Tile Co.* when he was declared bankrupt in 1906.

On 3 May 1900, David Jones became the sole proprietor of Wardle & Co. (*LG*, 18 May 1900, no. 27193). During the next five years, the firm suffered badly from the imposition of tariffs on their large American trade. Perhaps David Jones needed capital, for he brought three new partners into the firm. *The Pottery Gazette* announced in March 1903 that Wardle & Co. had registered as a limited company with a capital of £10,000. The business hitherto carried on by David Jones was now to be carried on by David Jones, C. T. Maling and F. T. Maling. The Maling brothers were the sons of C. T. Maling, and they had taken over the firm of C. T. Maling & Sons on their father's death in 1901. George Greenshields MacWilliam had been C. T. Maling & Son's and Wardle & Co.'s London agent for some years. He was now appointed chairman of Wardle & Co. Ltd. The firm staggered along for five more years. Perhaps because of the firm's financial difficulties, the Rheads left in 1905.

In April 1908, a receiver was appointed (*PG*, January 1909). David Jones died in November of that year. In April 1909, the firm announced that it had ''recently

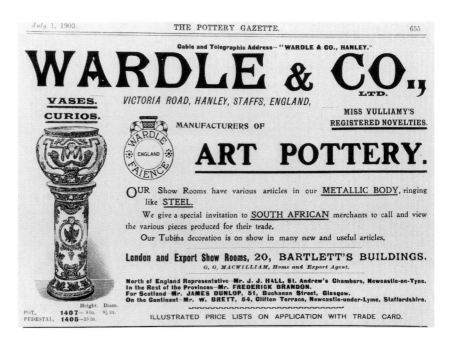

142 Wardle & Co. (Ltd) art pottery advertised in *The Pottery Gazette*, July 1903.

undergone a complete reorganisation under the supervision of Mr Bert Forester (late Managing Director of Messrs Thos Forester & Sons Ltd*, Longton)". It advertised:

> New Shapes. 53 Vases, 11 Flower Pots, 4 Pots and Pedestals and many New Articles in Fancies. New Decoration. Electrine, Foxland [a border design in sage green and other colours], Tropical, May Flower, Royal Amber, Rosemarie, Asiatic, Nonpareil. The Brilliant and Unexcelled ART COLOURS for which the Pottery has enjoyed a world-wide reputation for so many years, are still manufactured.

Also introduced in 1909 was Night on the Sea, with sailing boats, a series of scenes of old English homesteads and Daffodil (*PG*, April 1909).

Wardles' Art Pottery Ltd was registered with capital of £3,000 in £1 shares (*PG* June 1909). The decrease in capital from £10,000 in 1903 to £3,000 in 1909 gives an idea of the difficulties that the firm had been experiencing. Wardle's Art Pottery was now part of Harold Robinson's conglomerate, J. A. Robinson & Sons Ltd, which by 1918 also owned Arkinstall & Son, C. Ford, Ford & Pointon Ltd, The Alcock Pottery and Pratt's Pottery Ltd.

At the British Industries Fair of 1919, "Within Wardle's art ware bulked most largely in several shades of blue, pink, green and mauve, the goods principally plant pots in sets, with a fair number of vases, candlesticks, covered jars, toilet and trinket sets, '*et hoc genus omne*'" (*PG*, April 1918). At the British Industries Fair in 1919 Wardle's exhibited: "plain art decorative ware . . . saxe blue, bronze green, sage green, flower & fern pots, flower holders, vases and bulb bowls, candlesticks, animal figures"(*P&GR*, August 1918).

At the time of Harold Robinson's bankruptcy in 1924, the colour-makers Harrison Mayer had purchased the Goss pottery and some shapes from Wardle's Art Pottery. Consequently "WARDLES", impressed, may sometimes be found on Goss wares. Cauldon Potteries Ltd, who acquired Wardle's Art Pottery Co. in 1925, also continued to use some of Wardle's shapes, and these too might be so marked.

Wares

ARBORESCENT. "A rough crystalline appearance, ornamental and relieved by what apparently has the effect of incised leaves inserted in the centre of the piece" (*PG Diary*, 1885).

DIPT. Advertised in *The Pottery Gazette*, January 1890, these were majolica wares in art colours: "Crimson, Alpine Rose, Como Blue, Persian Blue, Turquoise Blue, Sage Green, Olive Green, Vienna Green, Orange & Golden Yellow."

FAUNA. A successful range manufactured at least 1906–7 (*PG*, December, April 1906, January 1907). A dressing table set illustrated in one advertisement shows a bird on branches.

GOLD IRIS. "The deep blue tint stands out with striking effect against the rich gold of the background . . ." (*PG*, November 1906).

GRAPHITO. A sgraffito range described as "old" (*PG*, October 1894).

HADCOTE. A range with coloured slip flowers painted on a mottled blue ground, which Wardles produced for Liberty & Co.*

HADRIAN. Advertised in *The Pottery Gazette*, January 1890.

HEROS. A range with lobsters and other marine life incised on a mottled green ground, which Wardles produced for Liberty & Co.*

IMPERIAL BLUE. Introduced in 1906 (*PG*, November 1906).

IMPERIAL ROCKINGHAM. Still in production in 1908.

MERCIAN. Advertised in *The Pottery Gazette*, July 1904.

MOSAIC. Still in production in 1909.

NUBIAN. ". . . produced in flower pots and vases, curios, &c.; and in general effect has a more delightful appearance than the old Egyptian black or the celebrated Greek metallic ware." (*PG*, April 1906).

PAPYRUS. Advertised in *The Pottery Gazette*, January 1890.

PÂTE-SUR-PÂTE. Mentioned in *The Pottery Gazette*, November 1906.

POMA. Mentioned in *The Pottery Gazette*, December 1904 and October 1907.

ROYAL AZTEC. ". . . all kinds of fancy articles, from their largest make of pedestals to the smallest of match strikers . . . superior uniformity in drawing as compared with the old Graphito work." (*PG*, October 1894)

SAMIAN. Advertised in *The Pottery Gazette*, July 1905.

TUBINA. A tube-lined range introduced in 1903. (*PG*, February, March and July 1903)

VESPASIAN. Advertised in *The Pottery Gazette*, January 1890.

Designers, decorators and modellers

E. BAGLEY.

CHARLES COLLIS* worked briefly for Wardle's as a tube-liner.

S. COOPER.

W. MURRAY.

ADOLPHINE "DOLLY' RHEAD worked as a tube-liner and decorator of *pâte-sur-pâte* from 1903 to 1905.

CHARLOTTE RHEAD* worked as a tube-liner and decorator of *pâte-sur-pâte* from 1901 to 1905.

FREDERICK ALFRED RHEAD*. Although he was art director for Wileman & Co.*, it is thought that he supervised the work of his sons, Frederick Hürten and Harry, as art directors at Wardle's. It is not certain whether this was a formal or informal arrangement.

FREDERICK HÜRTEN RHEAD*, art director 1899–1902, introduced tube-lining and *pâte-sur-pâte* to the pottery.

HARRY G. RHEAD*, art director 1902–25, was awarded a bronze medal at the Louisina Purchase Exhibition, St Louis, 1904.

MISS B. G. VULLIAMY* specialized in the design of grotesques. Her "registered novelties" were advertised in *The Pottery Gazette* in 1903–04. She modelled Wardle's *Diplodocus* flower pot commemorating the exhibition of the finest and largest specimen of that dinosaur at the National History Museum in the summer of 1905 (*PG*, November 1905).

Marks: "JW" or "WARDLE", impressed (from 1871); "W" with a mailed arm bearing a spear, printed (*c.*1885–90); "W ENGLAND" on a shield, surmounted by a crown, printed (*c.*1890–1935); "WARDLE FAIENCE" on a two-handled moon flask, with "England" in the centre, printed (*c.*1902–09); "WARDLE ART POTTERY CO., LTD." (1909–24). Shape numbers from 1000 to 3700 have been recorded. Some better-quality pieces bear signatures or initials.

References: Bergesen; Bumpus, Bernard, "America's Greatest Potter?", *The Antique Collector*, April 1986, pp. 38–43; Bumpus; Bumpus, Bernard, "*Tube-line Varia-*

tions", *The Antique Collector*, December 1985, pp. 59–61; "David Jones, Obituary", *PG*, December 1908; Godden 1964, 1988; *LG*; Marks, Mariann K., *Majolica Pottery: An Identification and Value Guide* (Collector Books, Paducah, Kentucky, 1983); Marks, Mariann K., *Second Series Majolia, Pottery: An Identification and Value Guide* (Collector Books, Paducah, Kentucky, 1986); Meigh; Moore, Steven and Catherine Ross, *Maling, The Trademark of Excellence* (Tyne and Wear Museums Service, Newcastle-upon-Tyne, 1989); Morris; *PG*; *PG&R*.

Wardle Art Co. Ltd *See* Wardle & Co. (Ltd)

Watcombe Terra-Cotta Co. (Ltd)
St Mary Church, Torquay, Devon
1869–1901

George Allen, a former Master of Dulwich College, discovered beds of fine red clay while workers were digging the foundations for his handsome mansion, Watcombe House. According to Archer, having taken opinions from experts at Bovey Tracey, Worcester and Staffordshire, Allen decided to start a pottery. He formed a company of "seven gentlemen, who elected him as chairman, and their idea seems to have been to develop the resources of the neighbourhood rather than personal profit".

Progress was rapid. In 1872, *The Art Journal* commented: ". . . certainly none have ever acquired so rapidly that high reputation which is based on the utmost excellence of terra-cotta productions." This rapid success was attributed to Charles Brock, superintendent of the works, "a gentleman of extensive knowledge and varied experience in terra-cotta manufacture, whose tastes and acquisitions had been perfected by long study and practice in the Staffordshire potteries".

The report went on to state that some eighty hands were employed, "a proportion of these being women and girls, but the men have all been carefully selected from different works in Staffordshire as skilled and accomplished artisans." These early pots included:

> elegant vases, endless in their variety of shape and ornamentation, mantelpiece spills, statues, and statuettes, jars, water-bottles, match-boxes, tazzas, garden-vases, ornamented flower-borders in conservatories, groups for terraces, halls and entrances, baskets of flowers, &c; and it must be added that the commonest articles of the daily service of our table have not been overlooked.

Also commended were statuettes, busts and baskets of flowers:

> Each leaf is separately modelled, and consigned to its place with an exactitude of form and precision of surface strictly imitative of nature in its minutest detail; and thus, with most perfect success, are modelled baskets of roses, passion flowers, lilies, ferns, and indeed a variety embracing the entire circle of the picturesque flora . . . One of the best, and of the largest size may be seen in the Art Court of the International Exhibition [London, 1871].

The Judges at the Centennial Exhibition, Philadelphia, in 1876, described the wares as ". . . the successful production, for commercial and popular purposes of decorative objects at very low prices."

In 1878 Archer commended, apart from the figures, "the ordinary wares, especially those glazed like the Japanese, there is a simple prettiness which is certain to be appreciated, and as they are very cheap their diffusion will conduce to

improved taste amongst those who use them''. He also noted that Charles Brock had invented ''a kind of fresco painting'', which ''consists of painting on unburnt tiles with coloured slips, which are partially absorbed into the body, and are, of course, imperishably fixed by burning''. The firm's display at the Paris Universal Exhibition of 1878 received favourable notices (*MA*, vol. 1 1878).

Commenting upon an exhibition at the Winter Gardens, Torquay, in 1888, *The Artist* said that Watcombe

> . . . has a reputation for the production of art pottery of rare excellence. The deep red of its clay is well utilized as a medium for the art potter to work out his designs as, for instance, in a few of the vases, we have impastoed light clay upon the darker, helped in the shadows by cutting incised lines through it into the red. These effects are further developed by rich glazes which are a specialty of this firm. The examples of underglaze painting, which formed the largest portion of their display, was characterized by a skilful use of colour and a harmonized blending of the design into the ground . . . Some of the vases, though very cleverly painted with fruit, flowers and birds, are slightly inclined to heaviness caused by the dark green ground upon which the designs are painted, and the forms of the vases are rather too severe in character to be in strict keeping with the imitative treatment of the ornamentation upon them.

Other ranges produced included Watcombe Wedgwood, a sort of imitation jasperware, made by sprigging lighter-coloured ornaments onto the dark red clay, and Watcombe Porcelain, which had transfer-printed or painted decoration covered with a clear glaze. Architectural terracotta was also made. In 1882, the firm advertised impasto, sgraffito and incised ware (*PG Diary*) (143). Plaques and medallions with portraits in low relief were also manufactured.

In 1881 Charles Brock returned to Staffordshire to work for G. L. Ashworth & Bros (Ltd)*, and he was succeeded by Samuel Stonier, previously the foreman. George Allen died in July 1883, and the firm went into liquidation. In 1883,

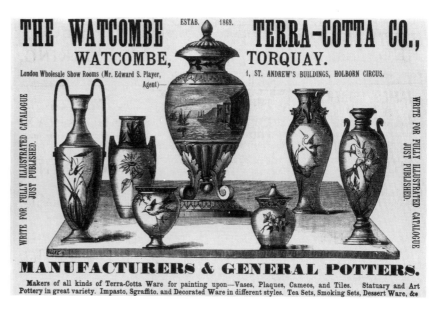

143 Watcombe Terra-Cotta Co. (Ltd) advertisement in *The Pottery Gazette*, 1880s.

Frances R. Evans, trading as Evans & Co, bought Watcombe in partnership with Mr Ball. Mr Ball was paid out in 1885 and Evans continued the business on his own account (*PG*, June 1900). The wares changed after Evans took over. Firstly, Watcombe had lost many of its best workmen during the brief period that it was closed. Secondly, the bankruptcy was evidence that a change towards more cheaply produced wares might be advisable. Nonetheless, many of the old moulds continued to be used. The firm now made a great many novelty items, of lesser quality than its previous productions. These included mice holding eggshell match holders and grotesque cress growers.

In 1900, W. Snowden Ward commented:

> It was established . . . with intent to reproduce all the well-known antiques, and to establish a universal taste for classic forms. The effort in this direction was strong and well-sustained, moulds were made for an immense number of classic and some more modern subjects, but the result was not so satisfactory as had been hoped . . . As the impossibility for creating sufficient demand for the terra-cotta became apparent, attention was turned to decorative pottery ware, which was being produced already at Aller Vale.

An example of these was "great plaques of terra-cotta, painted with large and brilliant chrysanthemums, poppies and other flowers that lend themselves to much show for little labour . . ." Watcombe Ware, with slip-painted flowers on a pale ground, Egyptian Ware, with sgraffito Egyptian designs cut through a pale slip ground, and Green-and-Straw Ware, with green glaze running down onto a pale yellow glaze, were illustrated (144–146).

On 11 May 1900, the creditors of F. R. Evans met at Exeter. The firm was purchased by Hexter, Humpherson & Co. (Ltd)* in 1901 and amalgamated with the Aller Vale Pottery Co. (Ltd)* in 1903, under the style Royal Aller Vale and Watcombe Pottery Co. (Ltd)*. After this merger, Watcombe primarily produced slip-decorated wares of the type produced at Aller Vale.

Busts, groups and statuettes

ANGEL, copied from a porcelain figure by Bing & Grondahl, Copenhagen, *c.*1870s.

BEAR holding a shell, 1880s.

BOAR, 1880s, a copy of a Greek original in marble at the Uffizi in Florence.

BRIGHT, JOHN, the Corn Law reformer, after an original by Alfred Bentley, 1870s.

BRISK, a telegraph messenger figure on a plant holder, *c.* 1880.

BYRON.

CARDINAL NEWMAN, from a sculpture by H. McDowell, 1880s.

CAT in a top hat playing a banjo, *c.*1900, white clay.

CHAUCER, *c.*1875.

CHERUB with a dolphin under one arm.

JOHN CLIFFORD, President of the Baptist World Alliance.

COCKATOO, *c.*1885.

CUPID AND PSYCHE, *c.*1875.

DICKENS, CHARLES, 1872.

DANTE.

DESDEMONA, shown at the Centennial Exhibition, Philadelphia, 1876.

DICK WHITTINGTON. This figure modelled by Charles Bell Birch was first produced

144 Watcombe Terra-Cotta Co. (Ltd) wares illustrated in *The Art Journal*, 1900.

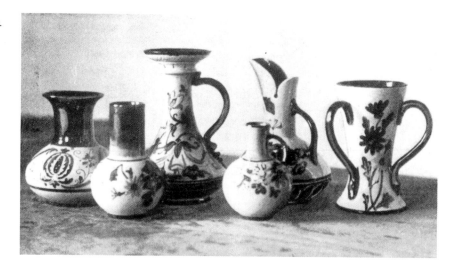

145 Watcombe Terra-Cotta Co. (Ltd) Egyptian Ware, illustrated in *The Art Journal*, 1900.

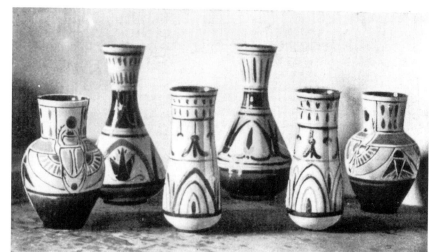

146 Watcombe Terra-Cotta Co. (Ltd) Green-and-Straw Wares, illustrated in *The Art Journal*, 1900.

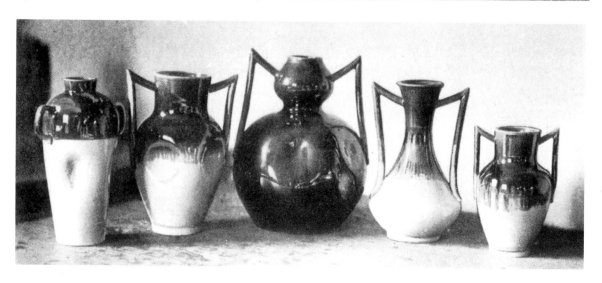

by Watcombe, and then by Torquay Terra-Cotta Co. Ltd*. The figure was published by the London Art Union.

DISCOBOLUS, 1900.

DOGGIE'S PORTRAIT, a boy painting a dog, 1880s.

FOUR SEASONS, copies of eighteenth-century Bristol and Derby porcelain figures, c.1880.

FROG PULLING A SNAIL SHELL, c.1890.

FROG wearing a top hat, white clay c.1900.

HAMLET, shown at the Centennial Exhibition, Philadelphia, 1876.

LAOCOÖN GROUP, 1900.

MARQUIS OF LORNE, 1872.

MEDITATION, mid-1870s.

MODERN STATESMEN SERIES: Gladstone by Albert Bruce Joy (copyright 1884), Lord Salisbury, John Bright)

MUSICAL composers series, 1900.

OPHELIA, shown at the Centennial Exhibition, Philadelphia, 1876.

OTHELLO, shown at the Centennial Exhibition, Philadelphia, 1876.

OUR SAVIOUR, bust "by an eminent Belgian sculptor", 1872.

PRINCESS LOUISE by Leifchild, 1872.

QUEEN VICTORIA, by W. G. Lawton, copyright 1897.

SCOTT, SIR WALTER.

SHAKESPEARE.

SPHINX.

TWO CUPIDS STRUGGLING FOR A HEART, after a bronze by François Duquesnoy (original by Fiammingo, 1594–1643).

VENUS DE MILO, 1900.

WHISTLING COON, The, c.1890.

WILLIAM TELL, modelled from an original by Joseph Kieffer, c.1890.

YOU DIRTY BOY, by G. Focardi, was used as an advertisement for Pear's Soap (also made at Torquay Terra-Cotta Co. Ltd*)

Designers, decorators and modellers

The names of sculptors whose works were copied are not listed here but, where particular pieces can be attributed to them, they are mentioned above.

ALFRED BENTLEY was listed in the 1881 census as a potter modeller. He modelled the John Bright bust.

HOLLAND BIRKBECK. "The style of decoration which finds most favour with their chief artist, Mr Birkbeck, is floral, freely decorated and natural in treatment." (*Artist*, 1888) He also worked for the Torquay Terra-Cotta Co. Ltd*.

HENRY BREWER* was a modeller for J. Wedgwood (& Sons Ltd)* before he came to Watcombe.

CHRISTOPHER DRESSER*. A number of Watcombe shapes and patterns have been attributed to Dresser. Some shapes and patterns were certainly taken from his books. There is, however, at this date no documentary evidence to prove that Dresser did actually design for Watcombe.

ALEXANDER FISHER SENIOR (born c.1837). Formerly with Brown-Westhead, Moore & Co., Fisher was best known for his bird paintings He was author of the chapter on painting in *Hints on Fine Art Pottery Painting*, published in 1881. Fisher also worked for the Torquay Terra Cotta Co. Ltd*.

SAMUEL KIRKLAND modelled the raised flowers for Watcombe's famous baskets of flowers (*AJ*, 1872).

ROBERT WALLACE MARTIN* worked for Watcombe for a few months in 1871. He modelled garden vases, masks for jugs and a statuette of a female nude.

JOHANNES MATTHAUS MOHR (1831–1903) was the modeller responsible for a plaque of Charles Brock. He also worked for the Torquay Terra-Cotta Co. Ltd*, after Watcombe's brief closure in 1883. Mohr was a sculptor of the German School. He had worked at the Nymphenburg porcelain factory.

T. G. READE, a painter.

J. G. SKINNER, was a modeller, who may have been the James Skinner listed as a porcelain painter in the 1881 census and who is believed to have worked for the Torquay Terra-Cotta Co. Ltd*. He later managed the Kerswell Art Pottery*.

Marks: "WATCOMBE TORQUAY", impressed, or printed; "WT" monogram impressed; "W" impressed on miniatures; "WATCOMBE PORCELAIN," printed; a woodpecker in a garter reading "WATCOMBE TORQUAY" or in a double ring with "WATCOMBE SOUTH DEVON", printed or impressed; "ST MARY-CHURCH ENGLAND", impressed; "Devon Ware", printed.

An artist's easel with "R. T. S." was the mark of Ralph Tuck & Sons, Fine Art Publishers, who retailed Watcombe's plaques, both painted and undecorated for use by amateur painters from 1883. Watcombe painters were discouraged from signing their work, so most signed pieces are thought to have been decorated by amateurs. Date codes, eg. 692 for June 1892, were used by Evans & Co. 1883–1900.

References: Archer, T. C., "The Watcombe Terra-Cotta Company", *AJ*, vol. XVII, 1878, p. 172 (reprinted in Haslam 1975); *Artist*, vol, IX, 1888, p. 335; Blacker; "Bottoms Up – identifying the marks on your pots", *TPCS Magazine*, October 1987, pp. 8–12; Brisco, Virginia, "Best Forms from the Antique", *The Antique Dealer and Collectors' Guide*, August 1989, pp. 40–42; Brisco, Virginia, "Christopher Dresser and Watcombe", *TPCS Magazine*, January 1989, pp. 7–9; Brisco, Virginia, "Terracotta Bust of Cardinal Newman", *TPCS Magazine*, October 1990, pp. 14–15; Brisco, Virginia, "The Torquay Potteries in 1881", *TPCS Magazine*, April 1986, pp. 8–11; Brisco, Virginia, "Watcombe Pilgrim Flasks", *TPCS Magazine*, July 1988, pp. 4–6; Brisco, Virginia, "The *Watcombe Terracotta Clay Company in 1871*", *TPCS Magazine*, July 1985, pp. 10–13; Cameron; Cashmore 1983, 1986; Cashmore, Chris, "Adverts for the Torquay Potteries in *The Pottery Gazette 1883–87*", *TPCS Magazine*, April, 1984, pp. 9–13; *Christopher Dresser* (Fine Art Society and Haslam & Whiteway Ltd, 1990); Collins, Michael, *Christopher Dresser 1834–1904* (Camden Arts Centre, 1979); Coysh; *General Report of the Judges of Group II, International Exhibition 1876*, p. 49; Godden 1964, 1972; Godden, Geoffrey, *Godden's Guide to Mason's China and the Ironstone Wares*, third edition (Antique Collectors' Club, Woodbridge, 1991); Halén, Widar, *Christopher Dresser* (Phaidon, Oxford, 1990); Haslam, Malcolm, *The Martin Brothers, Potters* (Richard Dennis, 1978); *KPOD Devonshire*; *MA*, vol. I, 1878; *Official Catalogue of the British Section, Paris Exhibition 1878*; Patrick; *PG*; Thomas 1974, 1978; Tilbrook; *TPCS Magazines*; TPCS 1986; Ward, H. Snowden. "Two Devonshire Potteries", *AJ*, 1900, pp. 119–23; "The Watcombe Terra-Cotta Works", *AJ*, vol. XI, 1872, p. 200.

Webber, James
High Street, Honiton, Devon
1881–c.1897

Webber was listed in the local directory from 1883 to 1897. From 1866 to 1873, F. Copp had been listed as a potter in High Street, Honiton. Webber's premises were probably taken over by Frisk & Hunt, who were later succeeded by Foster & Hunt*. J. Phillips wrote that Webber produced "highly-decorated and quaint pottery" in the "true Devon style of pottery decoration".

References: Cashmore 1983; *KPOD Devonshire*; Phillips, J., "The Potter's Art in Devonshire", *Report & Transactions of the Devonshire Association*, vol. 13, 1881, pp. 214–17.

Wedgwood, Josiah (& Sons, Ltd)
Etruria, Staffordshire
1759–1940
Barlaston, Staffordshire
1940 to the present day

Following the examples of Doulton & Co. (Ltd)* and Mintons*, Wedgwood set up an art pottery studio at Etruria in 1871. In late 1875 or early 1876, Wedgwood hired the well-known ceramic artist Thomas Allen. He was appointed Director of the Fine Art Studios in 1878. Allen continued as Wedgwood's Art Director until his partial retirement in 1898, retiring completely in 1904. The studio produced fine painted art wares and a limited number of *pâte-sur-pâte* wares, which really had little to do with the Arts and Crafts and Aesthetic movements or concepts, but rather continued the tradition of fine painting on ceramics carried on in all the better class of potteries of the period. These wares included plaques painted in the style used at Minton's Art Pottery Studio.

Studio artists *c.*1878

THOMAS ALLEN (1831–1915) studied at the Stoke School of Design while apprenticed to Mintons, where he painted china, majolica and tiles. He studied at the School of Design at Somerset House for two years, returning to Mintons until 1875. He may have worked for Minton's Art Pottery Studio*. He was Art Director at Wedgwood 1878–98, being semi-retired until 1904. Armstrong illustrated one of a series of large plates painted by Allen with "fancy heads of the women of Shakespeare".

MRS BOOTH.

JOHN HOLLOWAY specialized in animal, bird, marine and landscape paintings.

WILLIAM MAINWARING PALIN (1862–1947) was apprenticed to Wedgwood in 1876 and became Thomas Allen's assistant in 1878. He excelled in paintings of Cupid subjects, fruits and flowers, fishes and birds, and female heads in the style used at Minton's Art Pottery Studio. He studied at the South Kensington School of Art from 1880, later becoming known as a genre and mural painter. He was Vice President of the Royal Society of British Artists in 1914.

PEPIN was a painter who may have left Wedgwood's before 1878.

FREDERICK ALFRED RHEAD* was hired by Wedgwood's following his falling out at Mintons*. Despite some misgivings, Wedgwood was eager to procure his expertise in *pâte-sur-pâte*. He remained at Wedgwood from 1878 to *c.*1883.

LOUIS RHEAD was uncomfortable at Mintons* after his brother had left. He followed F. A. Rhead to Wedgwood in 1878. He left in 1880 to study at the South Kensington School of Art, returning as a freelance in 1881 and accepting a permanent position in 1882. In 1883 he emigrated to America.

SAM RHODES, a painter and gilder, worked with Thomas Allen and Marsden *c.*1878.

BEN STEWART worked with Thomas Allen *c.*1878. He was a flower painter, specializing in orchids.

THOMAS WATKIN, a painter and gilder working *c*.1865–*c*.1898, worked for Thomas Allen from *c*.1878.

During the 1880s Wedgwood introduced a number of commercial art wares, which were influenced by their contemporaries. Harry Barnard*, formerly with J. Macintyre & Co. Ltd*, joined the firm in 1898, introducing fine tube-lined decoration.

Commercial art pottery wares

AURO BASALT, black basalt with gilt raised paste decoration.

KENLOCK, black or red-bodied wares decorated with printed patterns, and enamelled in bright colours. The patterns were Oriental, naturalistic or humourous. They included Iris and Dragon.

LINDSAY, an Art Nouveau range introduced in 1901, designed by Courtney Lindsay and printed in colours.

MAGNOLIA, a red-bodied ware decorated with slip-painted flowers in orange and other pale colours, dipped in a Rockingham glaze. Usually decorated by A. H. Bentley and Harrison. Introduced *c*.1895.

MARSDEN. George Marsden (see Marsden Tile Co. Ltd*) worked with Thomas Allen, James Rhodes and Thomas Mellor in adapting Marsden's slip-decorating technique from tile manufacture to pottery.

Most interesting is the pioneering role that Wedgwood played in the reinstatement of hand-painted pottery. This was begun with the work of Alfred Powell*. His decorated Wedgwood blanks were exhibited in London in 1904. Eventually, Wedgwood established a studio for Alfred and Louise Powell in London, although the couple also supplied designs for paintresses in Etruria. *The Art Journal* noted in 1908: "The Powell-Wedgwood ware, produced by the collaboration of Mr Alfred Powell with the historic Staffordshire firm, is from this point of view one of the most significant of recent developments in art-potting. Here, broadly speaking, is an instance of the finest condition that the modern industrial organisation offers for art. The potteries at Etruria are rich in resource, traditional perfection of skill and repute. Mr Powell is free to develop his art of design without any submission to a style, or fashions of the trade."

A number of artists exhibited Wedgwood pottery painted by themselves at the Arts and Crafts Exhibitions. Very little is known about most of them, or the extent of their connection with the firm. This tradition was carried on and further developed at Etruria in the 1920s by Millicent Taplin and Grace Barnsley.

Artists who decorated Wedgwood blanks in association with the Powells

GABRIEL C. BUNNEY, studied at the Central School of Arts and Crafts and exhibited at the Arts and Crafts Exhibition of 1912.

CHARLES ERNEST EDWARD CONNOR (1876–1960) exhibited at the Arts and Crafts Exhibition of 1912.

CISSIE EGLISE studied at the Central School of Arts and Crafts and exhibited at the Arts and Crafts Exhibition of 1912.

ALLAN GWYNNW-JONES studied at the Central School of Arts and Crafts and exhibited at the Arts and Crafts Exhibition of 1912.

M. HINDSHAW exhibited at the Arts and Crafts Exhibitions of 1910, 1912 and 1923, and taught at the Central School of Arts and Crafts.

MARJORIE AND JESSIE JACK exhibited at the Arts and Crafts Exhibition of 1916 and worked as freelance designers for Wedgwood.

FREDERICK LESSORE (1879–1951), an art expert and sculptor, exhibited at the Arts and Crafts Exhibition of 1910.

RUTH LEIGH MALLORY exhibited at the Arts and Crafts Exhibitions of 1916 and 1926.

FRANK G. PARRETT studied at the Central School of Arts and Crafts and exhibited at the Arts and Crafts Exhibition 1912.

HUGH THACKERAY TURNER* exhibited at the Arts and Crafts Exhibitions of 1889 to 1926, although it is not certain that he used Wedgwood blanks exclusively.

Marks: "WEDGWOOD", impressed. A three-letter date code was employed from 1861 to 1929. "Lindsay WEDGWOOD ENGLAND", in a stylized tree, printed backstamp on Lindsay Wares. "Kenlock Ware", printed backstamp.

References: Armstrong, Walter, "The Year's Advance in Art Manufactures. No. VI. – Stoneware, Fayence, etc.", *AJ*, 1883, pp. 221–33; Batkin; Buckley; "Powell-Wedgwood Pottery", *AJ*, 1908, pp. 10–12; "Art Handiwork & Manufacture", *AJ*, 1905, pp. 381–82. (*See also* Alfred Powell, Louise Powell and Thackeray Turner.)

Wilcock & Co. (Ltd)

See Burmantofts Pottery.

Wileman & Co.
The Foley Potteries, Fenton
Staffordshire
1892–1925
Shelley's
1925–29
Shelley Potteries Ltd,
1929–65
Shelley China Ltd,
1965 to the present day

Joseph Ball Shelley joined the firm of F. Henry Wileman as a sales representative in 1862. He became a partner in 1872, and the pottery's sole owner in 1884. By 1885, his son, Percy Shelley (1860–1937), had joined the firm of J. Shelley & Son which continued under the style Wileman & Co. in 1892 and took over the pottery in 1896 upon his father's death.

Impressed by what he had seen at the Chicago World's Fair in 1893, Percy Shelley began to employ artists to upgrade the quality of the firm's wares. Rowland Morris arrived in 1895, remaining until his death three years later. Frederick Alfred Rhead* was then brought in as Art Director. He introduced Intarsio, Spano Lustre, Urbato and Pastello art wares. Grotesques and Toby jugs were also made. In 1899, *The Artist* reported that the firm employed "two hundred lady and girl artists" and "a score or so of male designers . . . The designs are mainly due to the taste and enterprise of Mr Percy Shelley, the proprietor of the firm, aided by Messrs Rhead, Messrs Stephen Hartly, Banks, Wood and Forester, the Misses Robinson, Price, Brown and others. Designs have been supplied by the late Rowland Morris, P. G. Riley, Miss Waterhouse and many other well-known artists." Most of these were or had been connected with the Burslem, Hanley, Stoke or Fenton Schools of Art.

Walter Slater joined the firm as Art Director in 1905. He had formerly been with Mintons and Doulton & Co. (Ltd), Burslem*. The firm was incorporated in 1929 as Shelley Potteries Ltd, with Percy Shelley and his three sons K. J. Shelley (d. 1933), P. N. Shelley and V. B. Shelley as the directors. The name was changed to Shelley China in 1965, and the following year the firm was taken over by Allied English Potteries, which is now part of the Royal Doulton Tablewares Group.

Art wares
CLOISELLO WARE, ". . . produced in two effects – turquoise blue and canary – with

colour treatments of the subjects in perfect harmony with the groundwork."
(*PG*, February 1913)

FLAMBOYANT WARE, ". . . consisting of many art shapes in a deep brilliant rose colour. It is on the lines of the old Chinese effects." (*PG*, July 1912)

INTARSIO WARE. Originally introduced by F. A. Rhead*, this ware was painted in rich but muted underglaze colours. According to *The Artist* (1899), the outlines were prepared by designers and then filled in by "lady artists and girls". Some fifty-six patterns are known. Rhead registered forty Intarsio designs in 1898. By 1900 some 200 paintresses were employed in decorating this ware. Intarsio Ware, designed by Walter Slater, was still in production in 1912. "It is Italian in style of treatment of a variety of brilliant colour combination on pure art forms. The different harmonies of colours are reminiscent of bright Persian effects. The range included art vases of many shapes, jardinières, flower vases, covered caddies, clock sets, and bowls with and without handles." (*PG*, July 1912) (147)

PASTELLO WARE. Introduced by F. A. Rhead*, this consisted "of figures, flowers and various natural objects executed on a dark ground, cameo-fashion, in a semi-transparent paste." (*Artist*, 1899)

PRIMITIF WARE. Glaze effects.

SPANO LUSTRA WARE. Introduced by F. A. Rhead*, this was sgraffito *porcelain* in one or two colours, covered with "iridescent lustres, which are applied, in a

147 Wileman & Co. Foley Intarsio clock, h. 29 cm.

liquid state or obtained by fumes in a kiln, according to the tint required". (*The Artist*, 1899)

URBATO WARE. Introduced by F. A. Rhead*, this was a sgraffito *porcelain* with multiple layers of coloured slip. Additional painted decoration was sometimes employed.

Marks: "W&C" monogram, surmounted by "THE FOLEY CHINA", with "ENGLAND" beneath (1882–1911); "SHELLEY" on a shield, surmounted by "LATE FOLEY", printed (after 1911).

References: Bumpus; Bumpus, Bernard, "Tube-line Variations", *The Antique Collector*, December 1985, pp. 59–61; Bunt; Godden 1964, 1988; Hill, Susan, "High Point in Style", *The Antique Dealer and Collectors Guide*, pp. 30–33; Niblett; "Mr Percy Shelley, Obituary", *PG>R*, October 1937; Rhead; Rix; "Some Beautiful English Pottery", *Artist*, vol. XXVI, 1899, pp. 76–84; Spours; Watkins; Watkins, Chris, William Harvey and Robert Senft, *Shelley Pottery* (Geffrye Museum, 1980); Wileman & Co. Pattern Books at the Henry Doulton Gallery, Nile Street, Burslem.

Wilkinson, Arthur J. (Ltd)

Royal Staffordshire Pottery, Burslem, Staffordshire
1885–1964

This firm was purchased by Edward Leigh and Arthur Shorter (brother-in-law of the deceased A. J. Wilkinson) in 1894. Vandyke Art Ware was introduced in 1905. This was "a special decoration which they are applying to all domestic earthenware. It consists of cleverly designed and arranged sprays of flowers on brown ground. It is an exceedingly tasteful conception, very skilfully carried out." (*PG*, June 1905)

In 1910 they introduced Oriflamme ware designed by J. Butler: ". . . a series of splashed, veined, and lustrous glazed effects on the company's earthenware body. Many failures have been experienced in the production of these chemical effects, but good results have been obtained . . . 'Oriflamme' is a beautiful, artistic, and comparatively inexpensive production." (*PG*, September 1910) These were exhibited at the Turin International Exhibition in 1911:

> These glazes are of the crystalline and lustrous order now so much in vogue, and their distinctive characteristic is their mottled or marbled effects and the prevalence of deep shades of blue and purple. Many of the pieces are also prismatic, changing their hues with kaleidoscopic variety in a changing light . . . the interior of the pieces is usually lustrous to a high degree, resembling sometimes copper, sometimes mother-of-pearl . . . (*PG*, July 1911)

Production of Oriflamme was halted during the First World War, but was resumed in 1919. Two of the new effects now added to the range were Azule and Coral, which exhibited "a submarine type of effect in exceptionally fine colourings, suggesting to the mind some of the wonderful effects seen in sunnier climes, where the denizens of the ocean disport amongst surroundings of coral, seaweed and plant life too beautiful for anything but the imagination to portray." Sunset was ". . . an evening sky type of treatment that is bewitchingly attractive in its colouration." (*PG*, June 1919)

Marks: Various printed marks incorporating the firm's name, "Ltd" being added in 1896; "ORIFLAMME AJW" in an oval with a banner, registered trade mark 1920.

References: Cameron; Godden 1964; *LG*; *PG*; *PG>R*.

Woodlands Art Pottery

Shorne, Gravesend, Kent

*c.*1918

The painter, designer and illustrator Reginald Hallward (1858–1948) resided at Woodlands, Shorne, from 1899 until at least 1918. He then moved to Merionethshire. The Woodlands Art Pottery was a small decorating studio in which Reginald, his wife Adelaide and their daughter Patience painted pottery and glass. These were included in an exhibition of Hallward's paintings at the Rowley Gallery, Church Street, Kensington, in 1918. *The Pottery Gazette* noted:

> The colourings are mostly quiet and simple, though a vivid turquoise blue is used with good effect on a few pieces of pottery. Several of the pottery designs are worked out in black on white, grey or yellow grounds, giving the impression of pen and ink, crayon or sgraffito work. The patterns are notable for their individuality, which makes them difficult to classify; they appear ultra-modern, and yet they also seem akin to some of the earliest styles ever applied to pottery. (July 1918)

Patterns shown included Dove and Myrtle, Forget-me-Not, Rose and Lily, Apple Tree, Pink Wreath, Tulips and Brown and Grey.

References: *Caddel's Year Book and Directory of Gravesend, Milton and Northfleet,* 1899–1915; "An Exhibition of 'Woodlands' Art Pottery and Glass", *PG,* July 1918, p. 543; *Reginald Hallward, 1858–1948* (Christopher Wood Gallery, 1984); Wood, Christopher, *A Dictionary of Victorian Painters* (Antique Collectors' Club, Woodbridge, 1978); "Woodlands Art Pottery", *P&GR,* January 1918, p. 79.

Woodlesford Art Pottery

near Leeds, Yorkshire

*c.*1892–1895

This pottery was worked by a succession of owners from at least 1819. After a closure in 1891, the pottery was reopened as an art pottery in 1892–93 by John and James W. Senior, Benjamin Batley and a few workers from Leeds Art Pottery (& Tile) Co. Ltd*. They made wares decorated with brightly coloured, thick, glossy glazes similar to those used at Leeds Art Pottery or Burmantofts Pottery*. Some very decorative vases were decorated with barbotine or enamel paintings of flowers or landscapes (148). The partnership was dissolved in 1895, the Seniors withdrawing. (*LG,* 13 September 1895, no. 26661)

Marks: "WOODLESFORD ART POTTERY Nr. LEEDS", impressed. Impressed shape numbers may also be found.

References: Cameron; Grabham; Lawrence; *LG.*

Wooliscroft, George (& Sons)

Patent Tile Works, Hanley, Staffordshire; Etruscan Street, Etruria

1849 to the present day

George Wooliscroft established a brickyard in 1849, producing bricks, quarry and encaustic tiles. He had acquired works at Etruria by 1887 and Hanley by 1900. The firm now produced hand-painted art tiles, lustred, enamelled, barbotine, *émail ombrant* and majolica tiles (149).

Marks: "WS" monogram; "DF&Co" monogram (for Derwent Foundry Co., Derby); "Etruria Hydraulic Tiles" with a water wheel, impressed.

References: Austwick; Barnard; Clegg, Peter and Diana, "Derwent Discovered", *GE,* spring 1985, No. 9, p. 4; Lockett; Rhead.

Right, **148** Woodlesford Art Pottery vase, marked "WOODLESFORD ART POTTERY NR. LEEDS 234".

Far right, **149** George Wooliscroft (& Sons) aerographed tile, *c.*1887, "ws" printed monogram, printed registration number "68882", and printed "402", 30.5 by 15 cm.

150 Wortley vases, marked "WORTLEY".

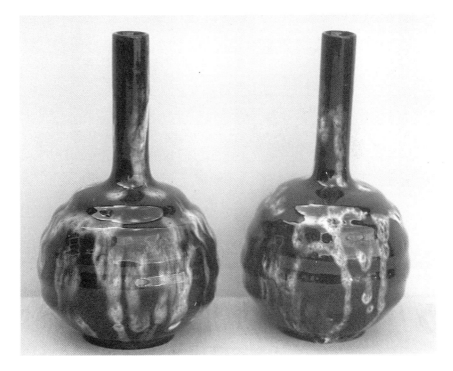

Wortley

Yorkshire

*?c.*1889

There were several potteries in Wortley, one of whom made glazed art pottery. Three Wortley firms – the Wortley Fireclay Co., Joseph Cliff & Sons and William Ingram & Sons – amalgamated with Burmantofts Co. Ltd in 1889 to form the Leeds Fireclay Co. Ltd. Lawrence describes Wortley wares as ". . . a sickly green and

yellow decorated with frogs or snakes". The pottery's range was, however, considerably wider than this. Rich flowing glazes in shaded colours and lustres were generally used on simple shapes (150 and Colour XL).

Marks: "WORTLEY", impressed: Impressed shape numbers from 107 to 200 have also been recorded.

References: *Burmantofts Pottery* (Corporation Art Gallery, Bradford, 1984); Hurst, Lawrence.

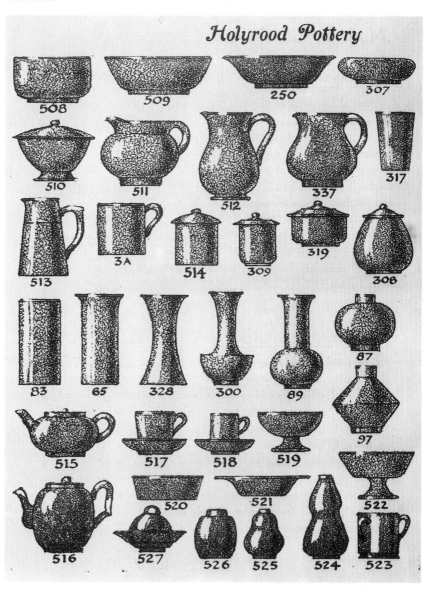

151 Wyse & Isles Holyrood Art Pottery, page from a catalogue.

Wyse & Isles
Holyrood Art Pottery,
Bouroughclough Square,
Edinburgh, Scotland
1918–27

Henry Taylor Wyse, a furniture designer, was an art master in Arbroath in the 1890s. He was later a lecturer at Moray House Training College. An undated catalogue of the firm's wares gives shape numbers ranging up to the 600s. The wares were sold both as finished Holyrood Ware and in biscuit, for decoration and return to the pottery for glazing and firing. The shapes included simple jugs, bowls, vases and teawares, as well as pottery beads and stones, sold separately or threaded as necklaces (151). The firm also made a line of calendars in pottery and suede.

The wares were hand-thrown and decorated with leadless glazes. A wide range of colours was obtained by the use both of oxidising and reducing fire. They also made reproductions of Greek terracotta Tanagra Figures (*PG>R*, September 1920). The firm's exhibits at the British Industries Fair in 1921 included Holyrood wares with dull glazed effects, ". . . embracing mixtures of colours, mottlings, spottings, and other simple but effective art effects" (*PG>R*, April 1921).

Marks: an impressed cross within a circle surmounted by "HOLYROOD".

References: Coysh; Holyrood Pottery Catalogue, no date; *PG>R*.

Young, James Radley
(1867–1933)
Hammer Pottery, Haslemere,
Surrey
1901–04

Young studied painting and modelling at the Sheffield School of Art before joining Carter & Co. (Ltd)* in 1893. He established the Hammer Pottery in 1901, where he produced lustre and sgraffito wares. He returned to Poole in 1904, remaining there until shortly before his death. He was credited with developing Carter & Co.'s lustrewares, and the design of a range of buff-bodied art wares during the First World War.

References: Cameron; Hawkins, Jennifer, *The Poole Potteries* (Barrie & Jenkins, 1980); *MBD*.

Bibliography

References in the text

A&CXS ARTS & CRAFTS EXHIBITION SOCIETY, *catalogues of the exhibitions* (1888–1957).

AUSTWICK AUSTWICK, J. and B., *The Decorated Tile* (Pitman, 1980).

BAINES BAINES, JOHN MAINWARING, *Sussex Pottery* (Fisher Publications, Brighton 1980).

BARNARD BARNARD J., *Victorian Ceramic Tiles*, second edition (Studio Vista, 1979).

BATKIN BATKIN, MAUREEN, *Wedgwood Ceramics, 1846–1959* (Richard Dennis, 1982).

BÉNÉZIT BÉNÉZIT, E., *Dictionnaire des Peintres, Sculpteurs, Dessinateurs et Graveurs* (Librarie Gründ, Paris, new edition, 1976)

BERGESEN BERGESEN, VICTORIA, *Majolica: British, Continental and American Wares 1851–1915* (Barrie & Jenkins, 1989).

BLACKER BLACKER, J. F., *Nineteenth Century Ceramic Art* (Stanley Paul & Co., 1911).

BRADFORD BRADFORD CITY ART GALLERY AND MUSEUM, *Design Themes in Nineteenth-Century Pottery* (Bradford, 1981).

BREARS 1971 BREARS, PETER C. D., *The English Country Pottery: Its History and Techniques* (David & Charles, Newton Abbot, 1971).

BREARS 1974 BREARS, PETER C. D., *The Collector's Book of English Country Pottery* (David & Charles, Newton Abbot, 1974).

BRIGHTON 1984 BRIGHTON MUSEUM, *Beauty's Awakening: The Centenary Exhibition of the Art Workers Guild* (Royal Pavilion, Art Gallery and Museums, Brighton, 1984).

BROWN BROWN, R. B., "Three South Derbyshire Art Potters", *Northern Ceramic Society Journal*, vol. 6, 1987, pp. 193–217.

BUCKLEY BUCKLEY, CHERYL, *Potters and Paintresses: Women Designers in the Pottery Industry 1870–1955* (Women's Press, 1990).

BUMPUS BUMPUS, BERNARD, *Charlotte Rhead, Potter and Designer* (Kevin Francis Publishing Ltd, 1987).

BUNT BUNT, CYRIL G. E., *British Potters and Pottery Today* (F. Lewis Publishers Ltd, Leigh-on-Sea, 1956).

CAMERON CAMERON, ELISABETH, *Encyclopedia of Pottery and Porcelain: The Nineteenth and Twentieth Centuries* (Faber & Faber, 1986).

CASHMORE 1983 CASHMORE, CHRIS and CAROL, *Collard, the Honiton & Dorset Potter* (Published by the authors, Brentwood, 1983).

CASHMORE 1986 CASHMORE, CAROL, "Ceramics for gentlemen of taste: the Torquay potteries and their products", *The Antique Dealer & Collectors' Guide*, August 1986, pp. 34–36.

CHAFFERS CHAFFERS, WILLIAM, *Marks and Monograms on European and Oriental Pottery and Porcelain*, (William Reeves, fifteenth edition, 1974).

CLAYTON CLAYTON, ELLEN C., *English Female Artists* (Tinsley Bros, 1876).

COYSH COYSH, A. W., *British Art Pottery* (David & Charles, Newton Abbot, 1976).

CROSS CROSS, A. J., *Pilkington's Royal Lancastrian Pottery and Tiles* (Richard Dennis, 1980).

CRUICKSHANK CRUICKSHANK, GRAEME, *Scottish Pottery* (Shire Publications Ltd, Aylesbury, 1987).

DUNFORD DUNFORD, PENNY, *A Biographical Dictionary of Women Artists in Europe and America since 1850* (Harvester, Wheatsheaf, New York, 1990).

EDGELER EDGELER, AUDREY, *Art Potteries of Barnstaple* (Nimrod Press, Alton, 1990)

FAS 1973 FINE ART SOCIETY LTD, The, *The Arts and Crafts Movement: Artists Craftsmen & Designers, 1890–1930* (1973).

FLEMING FLEMING, J. ARNOLD, *Scottish Pottery* (Jackson & Co., Glasgow, 1923. Republished EP Publishing Ltd, East Ardsley, Yorkshire, 1973).

FORSYTH FORSYTH, GORDON, *20th-Century Ceramics* (The Studio Ltd, 1936).

GODDEN 1964 GODDEN, GEOFFREY, *Encyclopaedia of British Pottery and Porcelain Marks* (Barrie & Jenkins, 1964).

GODDEN 1972 GODDEN, GEOFFREY, *Jewitt's Ceramic Art of Great Britain, 1800–1900* (Barrie & Jenkins, 1972).

GODDEN 1980 GODDEN, GEOFFREY, *An Illustrated Encyclopaedia of British Pottery and Porcelain* (Barrie & Jenkins, second edition, 1980).

GODDEN 1983 GODDEN, GEOFFREY, editor and main author, *Staffordshire Porcelain* (Granada, 1983).

GODDEN 1988 GODDEN, GEOFFREY, *Encyclopaedia of British Porcelain Manufacturers* (Barrie & Jenkins, 1988).

GRABHAM GRABHAM, OXLEY, "Yorkshire, Potteries, Pots and Potters", *Yorkshire Philosophical Society Transactions* (1916).

GRAVES GRAVES, ALGERNON, *The Royal Academy of Arts, A Complete Dictionary of Contributors and Their Work, From Its Foundation in 1769–1904* (SR Publishers, Ltd; Kingsmead Reprints)

HAMPSON HAMPSON, RODNEY, "English Rural Potteries of the 1920s", *Northern Ceramic Society Newsletter*, no. 37, March 1980.

HANNAH HANNAH, FRANCES, *Ceramics: Twentieth Century Design* (E. P. Dutton, New York, 1986).

HASLAM 1975 HASLAM, MALCOLM, *English Art Pottery 1865–1915* (London Antique Dealers' Club, 1975).

HASLAM 1977 HASLAM, MALCOLM, *Marks and Monograms of the Modern Movement* (Lutterworth Press, Guildford, 1977).

HILLIER HILLIER, BEVIS, *Pottery and Porcelain, 1700–1914: England, Europe and North America* (Weidenfeld & Nicolson, 1968).

HERBERT HERBERT, TONY, *The Jackfield Decorative Tile Industry* (Ironbridge Gorge Museum Trust, Telford, 1978).

HURST HURST, A., *A Catalogue of the Boynton Collection of Yorkshire Pottery* (The Yorkshire Philosophical Society, 1922).

JERVIS JERVIS, SIMON, *Dictionary of Design and Designers* (Penguin Books, 1984).

JERVIS, W. P. JERVIS, W. P., *The Encyclopaedia of Ceramics* (Blanchard, New York, 1902).

JOHNSON JOHNSON, JANE, *Works exhibited at the Royal Society of British Artists 1824–93* (Antique Collectors' Club, Woodbridge, 1975).

JONES JONES, TOM, "South Devon Motto Ware", *Antique Collecting*, March 1988, pp. 57–61.

LAWRENCE LAWRENCE, HEATHER, *Yorkshire Pots and Potteries* (David & Charles, Newton Abbot, 1974).

LEVY LEVY, MERVYN, *Liberty Style, The Classic Years 1898–1910* (Rizzoli, New York, 1986).

LOCKETT LOCKETT, TERENCE A. *Collecting Victorian Tiles* (Antique Collectors' Club, Woodbridge, 1979).

LOMAX LOMAX, ABRAHAM, *Royal Lancastrian Pottery, 1900–1958* (Abraham Lomax, Bolton, 1957).

MEIGH MEIGH, ALFRED, *Meigh's Lists* (privately circulated manuscript, Forsbrook, Staffordshire, 1937).

MESSENGER MESSENGER, MICHAEL, *Pottery and Tiles of the Severn Valley: A Catalogue of the C. H. Temple Collection* (Remploy, 1979).

MORRIS MORRIS, BARBARA, *Liberty Design* (Pyramid Books, 1989).

NIBLETT NIBLETT, KATHY, *Dynamic Design: The British Pottery Industry 1940–1990* (Stoke-on-Trent City Museum & Art Gallery, 1990).

OSWALD OSWALD, ADRIAN, in collaboration with R. J. C. HILDYARD and R. G. HUGHES, *English Brown Stoneware, 1670–1900* (Faber & Faber, 1982).

PATRICK PATRICK, DEENA, *Torquay Pottery Marks Book* (T.P.C.S., St. Albans, 1986).

PEMBERTON PEMBERTON, H. M., "Some Modern Pottery", *The Art Journal*, 1911, pp. 119–26.

PETTEYS PETTEYS, CHRIS, *Dictionary of Women Artists* (G. K. Hall & Co., Boston, 1985).

PINKHAM PINKHAM, ROGER, "A Tale of Three Potteries", *The Antique Dealer & Collectors' Guide*, September, 1977, pp. 80–84.

REILLY REILLY, ROBIN, *Wedgwood*, vol. II (Macmillan, London Ltd, 1989).

REILLY and SAVAGE REILLY, ROBIN and GEORGE SAVAGE, *The Dictionary of Wedgwood* (Antique Collectors' Club, Woodbridge, 1980).

RHEAD RHEAD, G. WOOLISCROFT, *British Pottery Marks* (Scott, Greenwood & Sons, 1910).

RHEAD and RHEAD RHEAD, G. WOLLISCROFT and FREDERICK ALFRED, *Staffordshire Pots and Potters* (EP Publishing, 1977, reprint of 1906 edition).

RICHARDSON RICHARDSON, DAVID, "Terracotta Art and Ornamental Wares", *Northern Ceramic Society Newsletter*, No. 74, June 1989, pp. 12–18.

RIX RIX, WILTON P., "Modern Decorative Wares", *The Art Journal*, 1905 (reprinted in Haslam 1975)

ROSE ROSE, MURIEL, *Artist Potters in England* (Faber & Faber, second edition, 1970).

ROYAL *Royal Academy Exhibitions 1905–1970* (EP Publishing Ltd, Wakefield, 1978).

RUMSBY RUMSBY, JOHN H. and EDWIN CHAPMAN, editors, *Tiles and Architectural Ceramics: A Bibliography* (Tile and Architectural Ceramics Society, second edition, 1988).

SPOURS SPOURS, JUDY, *Art Deco Tableware* (Ward Lock, 1988).

STUART STUART, DENIS, editor, *People of the Potteries* (Department of Adult Education, University of Keele, 1985).

THOMAS 1978 THOMAS, D. & E. LLOYD, *The Old Torquay Potteries* (Arthur H. Stockwell Ltd, Ilfracombe, 1978).

THOMAS 1974 THOMAS, E. LLOYD, *Victorian Art Pottery* (Guildart, 1974).

TILBROOK TILBROOK, ADRIAN J. and Fisher Fine Art, *Truth, Beauty and Design: Victorian, Edwardian and Later Decorative Art* (Fischer Fine Art Ltd, 1986).

TPCS 1986 TORQUAY POTTERY COLLECTORS' SOCIETY, *Exhibition of Torquay Pottery, 1870–1940* (August 1986).,

TPCS 1989 TORQUAY POTTERY COLLECTORS' SOCIETY, *Torquay Motto Wares* (T.P.C.S., Torquay, 1989).

WAKEFIELD WAKEFIELD, HUGH, *Victorian Pottery* (Herbert Jenkins, 1962).

WATKINS WATKINS, C., W. HARVEY, R. SENFT *Shelley Potteries* (Barrie & Jenkins, 1980).

WILLIAMSON WILLIAMSON ART GALLERY AND MUSEUM, *Della Robbia Pottery Birkenhead 1894–1906* (Wirral, no date).

WONDRAUSCH WONDRAUSCH, MARY, *Mary Wondrausch on Slipware* (A. & C. Black, 1986).

General bibliography

Decorative Arts

ANSCOMBE, ISABELLE, *A Woman's Touch, Women in Design from 1860 to the Present Day* (Penguin Books, 1985).

BRIGGS, ASA, *Victorian Things* (B. T. Batsford Ltd, 1988).

DAY, LEWIS F., *Everyday Art* (1882).

DENVIR, BERNARD, *The Late Victorians: Art Design and Society, 1752–1910* (Longman, 1986).

DRESSER, CHRISTOPHER, *Principles of Decorative Design* (1872).

DURANT, STUART, *Ornament* (Macdonald & Co., 1986).

EASTLAKE, CHARLES, *Hints on Household Taste* (London, 1868).

FINE ART SOCIETY LTD, with HASLAM & WHITEWAY LTD, *Architect-Designers, Pugin to Mackintosh* (1981).

GARRETT, RHODA and AGNES, *Suggestions for House Decoration in Painting, Woodwork and Furniture* (Macmillan, 1876).

GLOAG, JOHN, *Victorian Taste*, second edition (David & Charles, Newton Abbot; 1972).

HILLIER, BEVIS, *The Style of the Century, 1900–1980* (The Herbert Press, 1983).

JERVIS, SIMON, *Dictionary of Design and Designers* (Penguin Books, 1984).

LUCIE-SMITH, EDWARD, *The Story of Craft, The Craftsman's Role in Society* (Van Nostrand Reinhold Co., New York, 1981)

MATTHESON, JEAN, "Henry Cole and Victorian Taste", *The Antique Dealer & Collectors Guide*, April 1983, pp. 33–34.

PEVSNER, NIKOLAUS, *Pioneers of Modern Design*, revised edition (Penguin, 1975, originally published as *Pioneers of the Modern Movement*, Faber & Faber, 1936).

TILBROOK, ADRIAN J. and FISCHER FINE ART, *Truth, Beauty and Design; Victorian, Edwardian and Later Decorative Art* (Fischer Fine Art Ltd, 1986).

Aesthetic Movement

ASLIN, ELIZABETH, *The Aesthetic Movement: Prelude to Art Nouveau* (Ferndale Editions, 1981).

FINE ART SOCIETY LTD, THE, *The Aesthetic Movement and the Cult of Japan* (1972).

HAMILTON, WALTER, *The Aesthetic Movement* (Reeves & Turner, third edition, 1882).

Arts and Crafts Movement

ADAMS, STEVEN, *The Arts & Crafts Movement* (Chartwell Books Inc., New Jersey, 1987).

BRIGHTON MUSEUM, *Beauty's Awakening: The Centenary Exhibition of the Art Workers Guild* (Royal Pavilion, Art Gallery and Museums, Brighton, 1984).

CALLAN, ANGELA, *Women in the Arts and Crafts Movement 1870–1914* (Astragal 1979).

CRAWFORD, ALAN, editor, *By Hammer and Hand: The Arts and Crafts Movement in Birmingham* (Birmingham Museums and Art Gallery, 1984).

FINE ART SOCIETY LTD, THE, *The Arts & Crafts Movement: Artists Craftsmen & Designers, 1890–1930* (1973).

LAMBOURNE, LIONEL, *Utopian Craftsmen* (Astragal Books, 1980).

NAYLOR, GILLIAN, *The Arts and Crafts Movement* (Trefoil Publications, second edition, 1990).

Art Nouveau

BUFFET-CHALLIE, LAURENCE, *Art Nouveau Style* (Academy Editions, 1982).

HARDY, WILLIAM, *A Guide to Art Nouveau Style* (New Burlington Books, 1986).

HASLAM, MALCOLM, *In the Nouveau Style* (Guild Publishing, 1989).

LEVY, MERVYN, *Liberty Style, The Classic Years 1898–1910* (Rizzoli, New York, 1986).

MORRIS, BARBARA, *Liberty Design* (Pyramid Books, 1989).

WARREN, GEOFFREY, *All-Colour Book of Art Nouveau* (Octopus Books, 1974).

Periodicals

AJ	*The Art Journal*, 1849–1912.
Artist	*The Artist and Journal of Home Culture*, 1880–1904.
BAPS	*Barum Art Pottery Society Magazine*, 1990 to the present day.
CM	*The Cabinet Maker & Art Furnisher*, 1880–1902.
Decoration	*Decoration*, 1881–87; *Decoration & Arts Trades Review*, 1888–89.
GE	*Glazed Expressions*, Newsletter of the Tiles and Architectural Ceramics Society, 1981 to the present day.
JDA	*The Journal of Decorative Art*, 1887–1937
LG	*London Gazette*. This publication printed dissolution of partnership notices. A transcription of these was made available to the author by Geoffrey Godden.
MA	*The Magazine of Art*, 1878–1902; new series 1902–04.
NCS	*Northern Ceramics Society Newsletter*.
PG	*The Pottery Gazette*, 1878–1918.
P&G	*Pottery and Glass*, 1944–62.
P&GR	*Pottery and Glass Record*, 1918–40.
PG>R	*The Pottery and Glass Trade Review*, 1919–70.
PG Diary	*The Pottery Gazette Diary*, 1882–1940s.
PGRB	*Pottery Gazette Reference Book*.
Studio	*The Studio*, 1893–1964.
TI	*Tableware International*, 1970 to the present day.
TPCS Magazine	*Torquay Pottery Collectors' Society Magazine*, (1976 to the present day).

Directories

It should be noted that the information in directories and in *The Pottery Gazette Diary* was collected during the year *prior* to publication. Therefore a listing in a directory for 1905 is evidence of the firm's existence in 1904, rather than 1905. With the exception of *Morris's Business Directory*, of which the British Library has a complete set (1864–1930), few complete runs of local directories are extant. Furthermore, not every directory was published annually, nor were directories published during the War years.

KPOD	*Kelly's Post Office Directory*
MBD	*Morris's Business Directory of London, the Provinces and Foreign*, 1862–1930.

Index

Arabic numerals in italics refer to black and white illustrations; roman numerals refer to colour plates.